FROM ABACUS
TO ZEUS
A Handbook of Art History
Fourth Edition

JAMES SMITH PIERCE
University of Kentucky

PRENTICE HALL
Englewood Cliffs, New Jersey 07632

Editorial/production supervision
 and interior design: *Mariann Murphy*
Cover design: *Marianne Frasco*
Manufacturing buyers: *Herb Klein*
 and Patrice Fraccio
Supplements acquisitions editor: *Ann Knitel*
Acquisitions editor: *Bud Therien*

© 1991 by Prentice-Hall, Inc.
A Simon & Schuster Company
Englewood Cliffs, New Jersey 07632

Printed in the United States of America

10 9 8 7 6 5 4 3 2 1

ISBN 0-13-338021-1

Prentice-Hall International (UK) Limited, *London*
Prentice-Hall of Australia Pty. Limited, *Sydney*
Prentice-Hall Canada Inc., *Toronto*
Prentice-Hall Hispanoamericana, S.A., *Mexico*
Prentice-Hall of India Private Limited, *New Delhi*
Prentice-Hall of Japan, Inc., *Tokyo*
Simon & Schuster Asia Pte. Ltd., *Singapore*
Editora Prentice-Hall do Brasil, Ltda., *Rio de Janeiro*

Contents

Maps 179

Index 181

Table of Parallel Illustrations 197

Preface

ART must ultimately be explained in terms of art, not art terms. The description of visual form, the definition of stylistic categories, and the decoding of ancient myth and symbol, while fascinating pursuits in their own right, are of greatest value when they are mastered with the aim of comprehending the unique expressive power of individual works of art. This handbook has been prepared with that end in mind. Terminology and iconography have been defined with reference to specific works of art. This is done by keying entries to the splendid collection of over 1,150 reproductions in the fourth edition of H.W. and A.F. Janson's phenomenally popular and accessible *History of Art*. Thus, terms, processes, principles, subjects, and symbols are not only defined verbally but can be studied as they appear in particular contexts and in historical sequence.

For those who may have the third edition of Frederick Hartt's *Art* or the ninth edition of Horst de la Croix and Richard G. Tansey's *Gardner's Art through the Ages* at hand, a list of identical or similar illustrations in these art history surveys, paralleling those in the fourth edition of Janson's *History of Art*, is provided at the very back of this book. By consulting this table of parallel illustrations, most of the Janson figure numbers referred to in the entries in this book can also be located in Hartt and Gardner.

The numbers in italics found in the various entries (e.g. *271*) refer to figure numbers in the fourth edition of Janson's *History of Art;* numbers preceded by "fig." refer to the illustrations in this book. Words in italics are cross-references to other entries. If a term is printed in *italics,* a definition of it will be found in alphabetical order in Chapter One; mythological beings will be found in Chapter Two; the subjects of Christian art, arranged by category, will be found in Chapter Three; saints, in Chapter Four; and Christian signs and symbols, in Chapter Five.

Following Chapter Five is a chronological list of leading painters, photographers, sculptors, and architects from the fourteenth century to the present.

Entries indicate birth and death dates, nationality, customary media employed and places where the artist is known to have worked. An especially useful feature of this list is the simplified phonetic indication of the common pronunciation of the artist's name. Following the Chronology are maps locating art centers commonly mentioned in surveys of art history. A comprehensive Index not only alphabetically lists all entries from the five chapters but also includes the hundreds of terms defined within the major entries.

Simplified phonetic pronunciations are provided for unfamiliar names and terms, but they are only approximations of polite usage, introduced to prevent only the most ear-shattering barbarisms. In many cases, other pronunciations are equally acceptable. When a word has been taken over directly from a foreign language, it may usually be given the proper foreign pronunciation without raising too many eyebrows. Thus, "tablinum" (ta-bly'num) may even more "correctly" be pronounced ta-blee'num. In Chapter Four, the English names of saints are followed by their customary Italian, French, Spanish, and German names when the foreign form is markedly different from the English. An explanation of symbols, indicating French and German sounds not used in English, will be found preceding the chronological list of artists.

I am particularly indebted to Paulette Perone, who helped prepare the original list of entries, Arthur Irwin, who made many of the original architectural drawings, Catherine Hartkopf, who typed the original manuscript, the late H. W. Janson, who kindly consented to read the original manuscript and gave me the benefit of his wise counsel, and all those students at Case-Western Reserve University and the University of Kentucky, who, over the years, have insisted that I define my terms.

J. S. P.

CHAPTER 1

Art Terms, Processes, and Principles

ABACUS (ab'a-kus). The uppermost part of a *capital,* forming a slab upon which the *architrave* rests [*181*].

ABBEY (ab'ee). A *monastery* governed by an abbot. The church of an abbey is called an "abbey church" and is usually planned to allow for the special requirements of the monks such as a deep *choir* or many *altars* [*393–396, 403–406, 451, 452, 482, 483*].

ACANTHUS (uh-kan'thus). A prickly plant of the Mediterranean region with large, deeply cleft and scalloped leaves which are freely imitated on the *capitals* of the Corinthian and Composite *orders* and often used, in varying degrees of abstraction, to ornament *moldings,* brackets, *friezes,* etc. [figs. 34, 36; *181* right; *195, 288, 243*].

ACRYLIC. A water-soluable plastic painting *medium* containing acrylic resin, widely used since the 1960s [*1042–1044, 1047, 1049, 1055, 1057, 1059*]. Acrylic paints dry quickly and are water-resistant, non-fading and non-yellowing. They can be applied in thin *washes,* as in traditional *watercolor* painting, or used to achieve effects similar to *oil painting.* "Retarders" to slow drying time and compatible mediums for *glazing* and *impasto* are among the additives available to extend the range of possible effects.

ACTION PAINTING. A particularly dynamic form of Abstract Expressionism made with broad movements of the artist's arm while holding a brush, putty knife, etc., or while squeezing paint from a tube or throwing or dripping it from sticks and cans. Action painting is sometimes called "gestural painting," because it leaves a record of the artist's arm movements, which were thought to express emotion. The equivalent French term is "Tachisme" (tah-sheez'muh; fr. F. *tache,* blot, stain). Action paintings were often made on

1

unstretched canvas spread on the studio floor. Jackson Pollock's paintings of the late 1940s and 1950s [*1035,*] are quintessential Action Painting, but many artists used similar methods in the 1940s and long after [*1034, 1036, 1037, 1039*].

AESTHETIC (*or* esthetic; fr. Gk. *aisthetikos,* of sense perception). Pertaining to the beautiful or, more broadly, to art in general. The term was introduced in 1735 by the German philosopher Alexander Baumgarten (1714–1762). "Aesthetics" is the philosophical study of the beautiful and all problems associated with the character, creation, perception and evaluation of art. An "aesthetic" (as in the expressions "machine aesthetic" or "personal aesthetic") is a particular view of art or beauty. An "aesthete" is one devoted to the pursuit of the rarest forms of beauty. "Aestheticism" is the pursuit of "art for art's sake." The latter terms are no longer considered complimentary, but are used to refer to the development of excessively refined attitudes of taste toward the end of the nineteenth century.

AIR BRUSH. A device for spraying paint and varnish by means of compressed air [fig. 1]. The basic concept of blowing a fine mist of paint through a tube to form broad areas of color seems to be almost as old as painting [*30–32*], but the modern air brush was patented in 1893 by the British artist Charles Burdick. The very fine gradations of *value* possible with the adjustable spray have been used primarily by commercial artists for retouching photographs and creating photographic effects of subtle tonal modulation in illustration. Prominent Pop artists of the 1960s, some of whom had worked as commercial artists, sometimes used airbrush techniques, as did Photo Realists of the 1970s [*1057, 1059*].

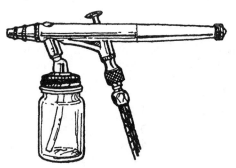

Fig. 1. Air brush.

ALBUMEN PRINT. A photographic *print* on paper coated with albumen (egg white) mixed with ammonium chloride [*907, 980, 982*]. Albumen paper was introduced in 1850 and became the most popular printing paper used during the rest of the century. Shortly before printing, the dry coating was made light sensitive by application of a solution of silver nitrate. Albumen prints have a glossy surface which enhances apparent depth, but old prints have yellowed and faded.

ALTAR. A structure upon which offerings are placed or sacrifices made to a deity [*226, 278, 314, 331*]. In Christian worship, the altar is a table used in celebrating the Eucharist (the sacrament of the Lord's Supper or "Holy Communion"). In Roman Catholic churches, altars support a consecrated stone slab [*321*] called a "mensa" (L., table). The principal altar in a large church is called the "high altar" (*424, 425*) to distinguish it from the many altars which may be placed in *chapels* [*451, 751, 752*] within the same structure.

ALTARPIECE. A painted or sculptured panel or shrine placed behind and above an *altar,* also called a "reredos" or "retable." Fourteenth- and fifteenth-century altarpieces are often very complicated, consisting of several panels or separate groups of sculpture. An altarpiece consisting of three panels is called a *triptych*; when it has more than three panels it is called a "polyptych" (pol-ip′tik) [*549–551*]. Some altarpieces have a decorated base, or *predella,* and have "shutters" or "wings" which can be opened in a series of "transformations" or "stages" to reveal other paintings or sculptures [*567*]. The shutters are usually painted in rather subdued colors on the outside— *monochrone* imitations of sculpture ("grisailles") being common in Northern Europe [*551*]—but when opened up for the feast days of the Church, they offer a brilliant and sumptuous display of color [cf. *710* and *711*].

AMBULATORY (am′byoo-la-toh-ree). 1. A place for walking, usually covered, as the passage around a *cloister* or *peristyle.* 2. The passageway around the *apse* of a church allowing circulation behind the high altar [fig.14; *451, 452*].

AMORPHOUS (fr. Gk. *a,* without, + *morphe,* form). Formless, lacking any distinct shape, organization, pattern, or division into parts. *See* FORMAL PRINCIPLES.

AMPHORA (am′fo-rah). A Greek storage jar with a large egg-shaped body and two handles, each springing from the shoulder of the jar and attached to the neck [*155, 158, 162*].

ANDACHTSBILD (ahn′dakhtz-bilt; pl. *Andachtsbilder*). Literally "devotional image," a term used for the highly emotive paintings and sculpture made, beginning in the late thirteenth century, for private devotion. Characteristic *Andachtsbilder* are such newly invented subjects as the *Pietà* [*505*] and "Christ as the Man of Sorrows," which emphasize personal grief and suffering.

APPROPRIATION. The borrowing, by an artist, of images or objects from one context and their insertion into another. This may involve little or no change in the borrowed object or image itself, but its meaning may be radically altered by combination with other appropriated forms, through a change of *medium,* or by transfer to a new setting with, perhaps, the addition of a new title or the substitution of the appropriator's signature for that of the original creator [*2, 1000, 1001, 1020, 1050, 1053, 1055, 1056, 1072, 1085, 1151*]. *See* READY-MADE.

APSE (aps, *not* ayps). A large *niche* facing the nave of a church. It is usually in the form of a half-cylinder covered with a half-dome [fig. 14; *321, 393*];

however, the apses of Byzantine churches, while semi-circular in plan on the interior, are often polygonal on the exterior [*341, 344, 346–348*]. Many Byzantine and some Western churches are tri-apsidal, having two minor apses flanking the main apse [*346*]. Traditionally, the apse projects from only the eastern end of a church, but in some German churches there are apses at both east and west [*395, 396, 405*]. Apses may also terminate the *transept arms* [*427, 429, 706*]. The many apse-like *chapels* projecting from the eastern flank of the transept arms and the *ambulatories* of Romanesque churches [fig. 14; *410*] are properly called "apsidioles."

AQUATINT. A *print* made by an *etching* process in which broad tonal areas of one or more *values* are printed from a metal plate [*844*]. The name (fr. L. *aqua*, water), refers to the similarity of the effects produced to the transparent *washes* of *watercolor*. Aquatint was perfected by Jean Baptiste Le Prince (1734–1781), whose "dust-box" method is still used. A copper or zinc plate is placed at the bottom of a tall box and a cloud of rosin dust generated with a bellows or flywheel. Bits of rosin settle on the surface of the plate and are fused to it by heating. The plate is then placed in an acid bath. The spaces between the rosin granules are etched and print darker or lighter according to the length of time the plate is left in the acid (usually only a few minutes). Since the rosin is acid-resistant, the spots covered by the rosin granules are not affected and will appear as flecks of white after the rosin is dissolved away and the plate inked, wiped and printed [fig. 2]. Broad areas which are to remain white after printing are "stopped out" (covered with a coat of acid-resistant varnish) before or after dusting. Aquatint is usually used in combination with the traditional linework of etching [*858*] and drypoint. Effects similar to those of the dust-box method have been obtained by shaking rosin dust from a muslin bag, applying the rosin suspended in a wine solution (spirit ground), and, more recently, simply covering parts of the plate with spray paint.

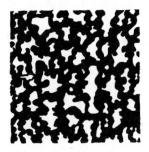

Fig. 2. Enlargement of pattern of rosin granules (white) in an aquatint.

AQUEDUCT (fr. L. *aqua*, water, + *ductus*, conducting). In ancient Roman architecture, a masonry channel conveying large volumes of water to cities over great distances by the force of gravity. As an aqueduct crossed valleys and lowlying country, it was elevated on *arches* [*261*].

ARCH. Almost any curved structural member which is used to span an opening is commonly, and very loosely, called an "arch" and the opening which it spans an "archway." In precise usage, however, the term is restricted to spanning members which are constructed of wedge-shaped blocks, called "voussoirs" [voo'swarz; figs. 3, 7], which hold each other firmly in place and

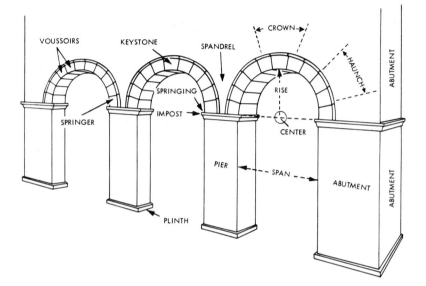

Fig. 3. Arcade.

prevent each other from slipping because they are smaller at the bottom than at the top. An arch made of voussoirs is often called a "true arch" to distinguish it from structures which may have a similar shape (usually curved) but are constructed in some other way. A "corbeled arch," for example, is made of overlapping courses of stone, each block projecting slightly further over the opening than the block beneath it. The weight of blocks above the supported ends of the projecting blocks help prevent the unsupported ends from tipping and falling [fig. 4; *147, 148, 152*]. When stone is used, a wider space can be

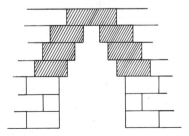

Fig. 4. Corbeled arch.

spanned with a corbeled arch than with a single horizontal *lintel*, but the true arch is vastly superior to both in sturdiness and in the distances which can be spanned. The wedge-shaped voussoirs make full use of the strength of stone under compression while reducing the need for tensile strength to resist the bending and stretching caused by the pull of gravity or the downward pressure of a load above (*see* POST-AND-LINTEL CONSTRUCTION). The voussoirs at the top, or "crown," of the arch convert the downward pressure into lateral (sideways) pressure, or *thrust*, which is transmitted from the upper voussoirs down around the opening and finally into the ground through the wall or *pier* on which the arch rests [fig. 3]. Thus, the stones are relieved of the severe squeezing and stretching to which a lintel is subjected because of its tendency to sag where it is not supported. In a true arch, each voussoir supports its neighbor. The stones of a corbeled arch also support each other and are not subject to the bending pressures of a lintel, but they have unsupported ends which are subject to strong "sheering" stress, because the tip of each block projecting over the opening may be pinched off by the pressure of the blocks above, which press the tip against the edge of the block below. The true arch, however, is not without its own peculiar weakness. The lateral thrust is strongest at the "haunches" of the arch (the parts midway between the crown and the "springing") [fig. 3]. The "keystone," and the other voussoirs at the crown, press out against the voussoirs at the haunches, which may buckle and allow the crown to fall if they are not properly buttressed [fig. 5].

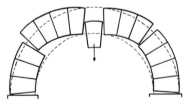

Fig. 5. Failure of arch at haunches when keystone is driven downward due to overloading.

The lateral thrust at the haunches can be counteracted by the thrust of arches placed to either side, as in an "arcade" (a series of arches) [fig. 3; *261*], but, unless the arcade is circular or oval in plan [*262, 263*] the lateral thrust of the arches at the end must finally be counteracted by the sheer mass of an "abutment" [fig. 3]. Many shapes and sizes of arches have been devised [fig. 6], but some are more efficient than others in overcoming the problem of lateral thrust. In general, it can be said that the more the shape of the arch approaches the vertical, as in the pointed arches used in Gothic construction [fig. 63; *421* right, *469*] and in some Romanesque churches [*414*], the more stable it will be. Conversely, the more closely it approaches the horizontal [fig. 6], the greater will be the lateral thrust and the weaker it will be.

Most arches do not spring directly from the ground but are raised on *piers* [fig. 3] or columns. When an arcade is supported on *columns* [*280, 318, 321, 589*], it is sometimes called an "arcade-on-columns" to distinguish it from an

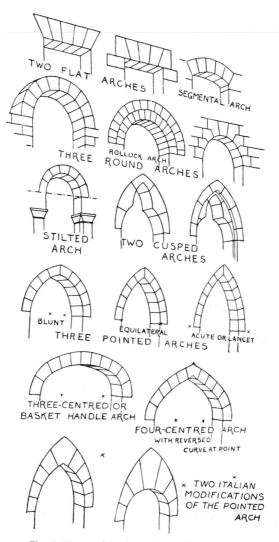

Fig. 6. Various forms of arches (Sturgis).

arcade on piers [261, 423, 581], which is the more ancient and familiar type of arcade. After the foundation for the arcade is prepared, a "plinth" (base block) is usually laid for each pier. When each pier is finished, it is frequently capped with an "impost," upon which the lowest voussoirs, called the "springers," will be laid. The top of the impost, from which the arch will rise, or "spring," is called the "springing." Before the voussoirs can be set in place, however, a supporting frame, called the "centering," must be built. If the span to be arched is not too wide, the centering can be placed on the impost and no additional support will be required [fig. 7]. The voussoirs are then laid up with mortar and, after the topmost voussoir, the "keystone," has been slipped

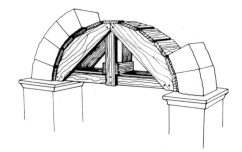

Fig. 7. Centering.

into place, work must stop until the mortar has set. When the mortar is thoroughly dry, the centering can be taken down and used to construct another arch. The outside curve of the arch is called the "extrados" and the inside curve is called the "intrados" [fig. 8]. The surface between any two arches of an arcade is called a "spandrel" [fig. 3].

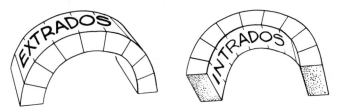

Fig. 8. Extrados and intrados of the arch.

ARCHITECTURE. See ARCH, AXONOMETRIC DRAWING, BAY, CANTILEVER, **CHURCH ARCHITECTURE,** DOME, **DOMESTIC ARCHITECTURE,** ELEVATION, FAÇADE, FERROCONCRETE, **GREEK AND ROMAN TEMPLE ARCHITECTURE,** MASONRY, MASTABA, MOLDING, MONASTERY, **MOSQUE ARCHITECTURE,** ORDERS, PAVILION, PIAZZA, PICTURESQUE, PILLAR, PLAN, POST-AND-LINTEL CONSTRUCTION, PROGRAM, PYLON, **ROMAN ARCHITECTURE,** RUSTICATION, SCALE, SECTION, SKELETAL CONSTRUCTION, SPAN, STUCCO, THRUST, TRUSS, VAULT, WALL, ZIGGURAT.

ARCHITRAVE (ar'kih-trayv). **1.** The lowest member of an *entablature,* resting directly on the *capitals* of *columns* or *pilasters* [fig. 36; *181*]. **2.** The *molding* framing a window or doorway [*198,* background; *285*].

ARCHIVOLT (ar'kih-volt). The *molding* framing an *arch* [fig. 3]. In Romanesque and Gothic architecture, each one of the series of arches framing the *tympanum* of a portal may be called an archivolt [fig. 56]; they are often highly ornamented or carved with figures [*416, 435, 437, 493*].

ARMATURE (ahr'muh-chur). 1. A skeletal framework of pipe, rods, wire, or wood used by sculptors to support clay, wax, plaster, and other soft or brittle *modeling* materials to prevent them from sagging, cracking, or collapsing under their own weight. 2. A framework of iron rods used to support the weight of stained glass windows and anchor them against wind pressure. The window is fastened to the rods by copper ties extending from the strips of lead which join the pieces of colored glass together. The grid pattern of the armatures of large stained glass windows is often worked into their design [517].

ART BRUT (ahr brü; F., raw art). A term coined by the French artist Jean Dubuffet to characterize powerfully expressive works by self-taught (autodidactic) artists working largely outside both the traditions of the *fine arts* and *folk art*. Dubuffet's extensive collection of *art brut*, including works by people isolated from society in prisons and institutions for the mentally ill, was a stimulus for his own "anti-cultural" work [1038]. Dubuffet's collection is now the core of the Collection de l'Art Brut housed in Lausanne, Switzerland. Current English synonyms are "outsider" and "isolate" art.

ARTICULATED (ar-tik'yoo-lay-ted; fr. L. *articulare*, to divide into joints). Divided into distinct units; the term is often used in describing architectural designs [413, 613].

ASSEMBLAGE. A three-dimensional work of art composed of two or more preformed and only slightly altered *found objects* [1086]. Also the process of creating such a work. In 1913, Marcel Duchamp simultaneously established the principles of assemblage and *kinetic sculpture* by joining two *readymades:* a free-spinning bicycle wheel fastened to the top of a wooden stool. Assemblage is an extension into three dimensions of the principle of *collage*. Picasso, who with Braque, developed the technique of collage, also created a number of assemblages in the 1930s and later. His famous "Bull's Head," composed in its original form of nothing more than a bicycle saddle and handlebars, is a classic example of assemblage, but it is normally seen in a solid bronze *cast* [2]. In the 1950s Robert Rauschenberg revived the idea of assemblage in what he called "combines" [1085].

ASYMMETRICAL (ay-sih-met'rih-kul). Not symmetrical, but not necessarily unbalanced. *See* SYMMETRY, BALANCE.

ATMOSPHERIC PERSPECTIVE (also called "aerial perspective"). The representation of spatial effects which are caused by the interposition of the atmosphere between the viewer and distant objects; these effects include the blurring of outlines, loss of detail, alteration of *hue* toward blue, and diminution of color *saturation* and *value* contrast—all of these effects become increasingly evident with the distance of objects from the viewer. Atmospheric effects were represented by ancient Roman fresco painters [306] and, after the long interval of the schematic art of the Middle Ages, again interested European artists beginning in the fourteenth and fifteenth centuries [548, 633, 636, 675, 676, 691, 721, 818]. Chinese and Japanese painting during the period of the European Middle Ages was surprisingly atmospheric, although it was largely restricted to effects obtainable with black ink.

Atmospheric effects, with the exception of shifts in hue and saturation, can also be obtained in *relief sculpture* [*213, 286–291, 579, 752, 809*].

ATRIUM (ay'tree-um). 1. The open entrance court of a Roman house [fig. 25; *275*]. 2. The open court in front of a church [*316, 423*].

ATTIC. A story above the main *entablature* of a classical building, frequently ornamented with *pilasters* aligned with the *order* below [*300, 666, 709, 733, 810, 901*].

AUTOCHROME (fr. Gk. *aut*, self, + *chromos*, colored). A photographic color *transparency* [*1119*] consisting of a glass plate coated with a layer of red, green and blue grains of starch and a black-and-white panchromatic emulsion (sensitive to all colors). The Autochrome process, patented by Auguste and Louis Lumière in 1904, was the first popular form of color photography. After a long *exposure* through the glass plate and dyed starch grains, which acted as color *filters*, the black-and-white emulsion was developed by reversal processing into a *positive* image. Viewed against the light through this emulsion, the microscopic grains color the image. These specks of the *primary colors* of light, fuse in the eye, as in a Pointillist painting [*945*] to create a softly glowing full-color representation of the subject photographed. Autochrome plates were produced at the Lumière factory in Lyons until the 1930s when Autochrome and other additive color processes were superseded by the subtractive Kodachrome process. Kodachrome *film* requires a much shorter exposure and provides a practically grainless image composed of three color layers: cyan (blue-green), magenta (red-violet) and yellow. These *hues* are the *complementaries* of the *primaries* of light: red, green and blue. The complementary dyes in the three layers variously transmit the primaries to create a full-color image.

AUTOMATISM (aw-tom'uh-tis-um). The creation of forms without conscious control. Marcel Duchamp and Hans Arp [*1021*] were among the first twentieth-century artists to emphasize chance as a major element in the creative process by randomly dropping lengths of string and scraps of colored paper and gluing them down just as they had fallen. Automatism was a fundamental principle of Surrealism and various methods such as "automatic writing" (serious scribbling and doodling), *decalcomania* and *frottage* were developed to release the unconscious mind in a free flow of imagery. Automatism continued as an important principle in *Action Painting* during the 1940s and 1950s when many artists used broad gestural forms of automatic writing and let their *compositions* develop without having a clear idea of their final form.

AVANT-GARDE (ah-vahnt-gahrd'; F., advance guard). Those artists, critics, and patrons who, like troops moving at the head of an advancing army, are leaders of taste, espousing innovative, unconventional, or experimental concepts and techniques despite the opposition of established opinion. The English equivalent, "vanguard," is also used to describe both those who are ahead of their times and the art which they champion.

AXIS (*pl.* axes). An imaginary line passing through a figure, building, *composition,* etc., about which its principal parts are arranged. In diagrams, the axis is usually represented by a broken line [figs. 9, 38, 43; *148, 365*].

Fig. 9. Vertical axis (a) of a figure from Masaccio's "Tribute Money" [*602*].

AXONOMETRIC DRAWING (fr. Gk. *axon,* axis, + *metron,* measure). An architectural or mechanical drawing presenting an object in three dimensions with all lines drawn to the same *scale,* so that exact measurements can be taken of height, width and depth [fig. 40b; *412, 622*]. Axonometric drawings combine in a single diagram the advantages of true measure found in simple *plan, elevation* and *section* drawings while also conveying a sense of depth. However, they may be more confusing to the inexperienced eye than drawings in precise linear perspective [fig. 58], because parallel lines do not converge. "Isometric" (fr. Gk. *isos,* equal) drawings overcome somewhat the visual distortions of axonometric drawings by keeping all horizontal lines at the same angle (30°) to the bottom edge (baseline) of the drawing. Lines in all dimensions are exactly measureable, but angles are not true. In axonometric drawings, however, measurements of angles as well as lines are true.

BALANCE. The achievement of equilibrium among the various parts of a composition is a problem which all artists must face; indeed, for some artists, it appears to be among their most compelling concerns [*161, 202, 794, 945, 1018, 1026*]. For the architect and sculptor it is more than a visual problem; it is a structural necessity as well, since every building or statue must be physically supported in some way. By drawing analogies with such problems of purely physical balance, it is possible to suggest, in a limited way, some of the factors involved in visual balance. If the parts of a composition are represented as weights balanced on a seesaw, with the fulcrum standing for the vertical *axis* of the composition, it will be seen that one of the simplest ways to achieve balance is to place units of equal weight on either side of the fulcrum and equidistant from it [fig. 10a]. This is analogous to *symmetrical* composition in the visual arts [*178, 277, 401, 598, 607, 855*]. Unequal weights may also be balanced by placing them at different distances from the fulcrum [fig. 10b, c]. This is analogous to *asymmetrical,* or "informal," balance [*4, 162, 230, 407, 528, 611, 639, 710, 719, 781, 945*], although, in pictures, objects of the same apparent visual "weight" appear to be heavier on

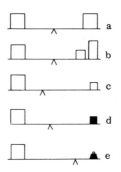

Fig. 10. Physical analogies of visual balance.

the right-hand side of the picture than on the left. In the eighteenth century, asymmetrical compositions in architecture, which were quite novel at the time, were called "irregular" [892, 894] to distinguish them from symmetrical, or "regular," buildings. There are many other factors, which are important in maintaining visual balance, that are less easily suggested by analogy to physical balance. Variations in *hue, value,* or *saturation* may alter pictorial balance by making one area more insistent than another. By darkening the little cube of fig. 10c, for example, it is given apparent weight, because dark colors usually look heavier than light colors [fig. 10d]; yet, when the smaller cubes in both fig. 10c and fig. 10d are compared only to each other, the light cube looks larger than the dark cube, because lighter objects tend to look larger than darker objects. Altering the shape of the little cube can make it look even heavier, especially if that shape is associated with extremely heavy objects [fig. 10e]. This indicates that adjusting the parts of a composition may be much more than a formal problem. In representational art, associational or psychological factors must be taken into account. When a small area represents a face or a human figure [822, 1056, 1075], for example, it may have much greater psychological weight than a larger area which is not so highly charged with emotional interest. *See* SYMMETRY.

BALLOON. A rounded outlined shape in a *cartoon* or comic strip "panel" (single picture in a series) which contains the words or thoughts of a character [1091]. The speaker is indicated by a curved line or wedge shape pointing toward the head. Thoughts are usually distinguished from spoken words by a series of small ovals drawn as though rising from the head of the thinker toward the balloon, which may assume a cloud shape [1055].

BALUSTRADE (bal'uh-strayd *or* bal-uh-strayd'). A handrail supported by short *pillars,* each called a "baluster" [bal'uster; fig. 49; 661, 847]. By extension, any low wall or "parapet" [390]. On many Renaissance and Baroque buildings, balustrades appear above the main *entablature* [647, 665, 808, 810, 826; cf. 850, 853].

BAPTISTERY. A chamber or freestanding structure containing a basin (font) [441] for performing the rite of Baptism. In Italy, baptisteries are frequently independent buildings separate from the main body of a church [428, 429, 431].

BASILICA. Originally, any large hall, as the public halls erected by the ancient Romans on the *forums,* or public squares, of their towns [*260, 270–274*]. The term was adopted by the Early Christians to designate their churches which, since the new religion was congregational, were necessarily meeting-halls and retained some of the features of the familiar secular meeting-halls: colonnades, *clerestory* windows, and an "exedra" (*pl.* exedrae) or *apse* [*316–321*]. The term is sometimes applied to any church which, like the Early Christian basilicas, has a longitudinal *nave* terminated by an apse and flanked by lower *side aisles.*

BAY. The space between any two of a series of similar architectural members, usually principal supports [fig. 14; *421, 470*].

BIOMORPHIC. Having the form of a living organism. In twentieth-century art, two- and three-dimensional forms which are characterized by free-flowing curves, usually abstract or minimally representational, are called "biomorphs" or "free forms" [fig. 11; *1023, 1024, 1026, 1034, 1065–1068, 1075*]. Amoeba-like biomorphs, introduced by Hans Arp in the second decade of the twentieth century, were especially popular during the 1930s and 1940s.

Fig. 11. Biomorph (after Arp).

BLACK-FIGURED. A term applied to a type of Greek vase painting, practiced in the seventh and sixth centuries B.C., in which the figures and objects were painted primarily in black against a lighter ground, or field, usually the natural clay, which becomes orange-red after firing [*161, 162*]. Details were crisply incised into the black figures before firing. *See* RED-FIGURED.

BLIND ARCADE. An arcade attached to a wall so that the arches, although they project from the wall, are not open but blocked with *masonry* [fig. 63; *414, 416, 423, 426, 431*]. Any architectural features which are normally open, such as arches, windows, doorways, or *tracery* patterns, are called "blind" when their openings are blocked and they are simply used to ornament a surface [*474, 614, 661, 754*].

BLOCK BOOK. A type of devotional picture book, popular in the fifteenth century, in the production of which the text was carved in relief on the same

block as the picture, rather than being set separately in movable type as became the practice later.

BOOK OF HOURS. A book for private devotions containing prayers for the different canonical hours of the day (matins, prime, tierce, sext, nones, vespers, and compline). In the later Middle Ages, books of hours were often sumptuously *illuminated* for the use of persons of high rank and, in addition to the various prayers, or offices, they frequently contained a calendar illustrated with the Labors of the Months [*542–544*]. Books of hours are sometimes referred to simply as "Hours" and may be identified by the name of the owner, as the "Hours of Jeanne d'Evreux" [*538*] or *Les Très Riches Heures du Duc de Berry* ("The Very Rich Hours of the Duke of Berry") [*542–544*].

BURIN (byur'in). The pointed steel cutting tool, or graver, used to make the lines, or "tailles" (tī'ee; F.), of an *engraving* [fig. 12]. It is fitted with a broad wooden handle against which considerable pressure from the whole arm can be exerted through the palm of the hand to engrave the hard metal plate. The blade is grasped between the thumb and first or second finger.

Fig. 12. Burin.

BUST. A sculpture of a person showing only the upper part of the body, usually including a portion of the shoulders and chest [*88, 101, 816*]. It is a form of portrait particularly favored by the ancient Romans [*268*] and revived during the Renaissance with the renewed interest in individual likeness [*591*].

BUTTRESS. A vertical mass of masonry built against a wall to strengthen it, often against the *thrust* of an arch or *vault* on the other side [fig. 14; *334, 410, 417, 452, 453, 457*]. The "flying buttress" system, used in Gothic churches, is a means of transmitting the thrust of the *nave* vaults through a masonry strut (often, itself, called the flying buttress) which carries it across the open space above the roofs of *side aisles* and *ambulatory* to a tall *pier* rising above the outer wall [fig. 63; *427, 456, 467, 470, 471, 473*].

CALLIGRAPHY (ka-lig'rafee; fr. Gk. *kallos*, beauty, + *graphia*, writing). The art of ornamental penmanship or—in Chinese and Japanese writing especially—brushwork [*384*]. Drawings and paintings are said to be "calligraphic" (kalih-graf'ik) when they are essentially linear, resembling the spontaneous tapering and swelling of the cursive line and sudden accents of handwriting [*380, 383, 399, 400*].

CALOTYPE (fr. Gk. *kalos*, beautiful, + *typos*, image). The first negative-positive process of photography, patented by William Fox Talbot (1800–1877) in 1841. Calotypes [*904*], which were also called "Talbotypes," were

made from paper *negatives* sensitized with silver iodide. Shortly before *exposure* in a *camera,* the negative was brushed with a solution of silver nitrate, gallic acid and acetic acid to increase sensitivity. Exposure time in bright sunlight was only about one minute. This was much faster than the 20–40 minutes required for the first *daguerreotypes.* After exposure, the image was developed in a gallic acid-silver nitrate solution, fixed with hyposulfite of soda, and washed with water. Calotype *positives* were made by superimposing the negative on *printing out paper* held in a frame and exposed to sunlight. Despite the relative convenience of the calotype process and the advantage of multiple *prints* from each negative, the coarse and contrasty positives could not compete with the exquisite image quality of the daguerreotype. The process became obsolete with the introduction of glass *wet plate* negatives in 1851.

CAMERA. A lightproof box equipped for holding light-sensitive *film* or plates opposite a *lens.* The first cameras [fig. 23] were simple adaptations of the *camera obscura,* but by the mid-nineteenth century they were equipped with devices for reducing the amount of light passing through the lens [see *f-stop*] and with *shutters* for controlling *exposure.* They were often mounted on adjustable folding tripods. The subject was studied upside down on a ground-glass screen at the back of these "view cameras" with a dark cloth draped over the photographer's head. Small handheld cameras for instantaneous photography (snapshots) were not practical until the marketing of *silver-gelatin* emulsions on roll *film* in the 1880s. In 1888 George Eastman introduced the Kodak camera, advertising it with the slogan: "You press the button. We do the rest." Actually, besides pushing a button to make the exposure, one had to turn a key to advance the film and pull a string to cock the shutter, but anyone who could do this and point the camera in the right direction could make a snapshot outdoors in sunlight. The Kodak was sold loaded with enough film for 100 circular pictures. The entire camera was then returned to the factory for processing, printing, mounting and reloading. The era of "miniature photography" began with the introduction in 1924 of the small Leica camera manufactured by Ernst Leitz, a German optical company. The camera had a sharp, "fast" lens and used film only 35mm wide. Prints were made with an *enlarger.* The silent shutter and small interchangeable lenses and lens-coupled rangefinders of later models made the Leica an ideal tool for such photojournalists as Henri Cartier-Bresson [1123] and Robert Capa [1135] who sought to capture the "decisive moment" on crowded streets and battlefields. See LENS, *f*-STOP, SHUTTER, EXPOSURE, CARTE DE VIS-ITE, STEREOSCOPE.

CAMERA OBSCURA (L., dark room). A drawing device, consisting of a lightproof box fitted with a *lens* projecting a reduced image of an external subject upon a translucent screen for tracing [fig. 13]. Camera obscuras were at first literally "dark rooms" with a small hole in one wall through which an inverted image of the sunlit world outside was projected on an opposite wall. Such images were described by Aristotle and medieval scholars, and they were used as drawing aids as early as the sixteenth century when a lens was fitted to the hole to form a sharper and brighter image. By the seventeenth century,

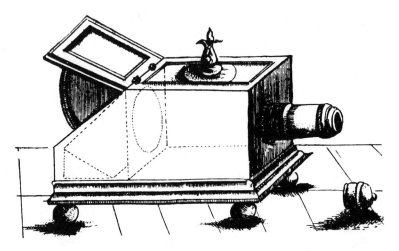

Fig. 13. Seventeenth-century camera obscura (Zahn).

small portable camera obscuras were built with telescoping boxes or tubes for adjusting focus and an internal mirror set at a 45° angle to reflect an uninverted (but reversed) image on a plate of milky white translucent "opal glass," placed over an opening on the top. The variable focus of objects at different distances represented in the paintings of Jan Vermeer [794] indicate familiarity with the visual effects of the camera obscura.

CAMPANILE (kam-pa-nee'lee; fr. It. *campana*, bell). An Italian bell tower, especially one that is freestanding [319, 423, 428, 486].

CANOPY. 1. In Gothic architecture a small ornamental roof-like projection often used to shelter a statue [435, 495, 506, 567, 568]. **2.** A covering above a throne, bed, altar, etc. The canopy on *columns* which is sometimes placed over Christian *altars* [318, 391, 424, 748] is usually called a "baldachin" (bawl'da-kin; fr. It. *baldacchino*, bal-da-kee'no) or "ciborium" (sih-bo' ree-um).

CANTILEVER (kan'tih-lee-vur). A beam or slab projecting a considerable distance beyond a post or wall but held down at one end only [1097, 1100]. By cantilevering structural steel beams and *ferroconcrete* slabs, twentieth-century architects have created overhanging stories which seem to defy the pull of gravity [23, 24, 1102, 1109, 1111, 1115, 1116].

CAPITAL (fr. L. *capitellum*, little head). The crowning member of a *column, pilaster, pier,* or shaft. Column capitals, while forming a satisfying visual transition from the vertical shaft of the column to the horizontal *entablature,* may also increase the structural efficiency of the column by providing broader support for the load. Capitals are often richly ornamented, as the Egyptian papyrus capitals [79], the capitals of the Corinthian *order* [figs. 34, 36; *195*], or the Byzantine "basket capitals" [337, 343], but they may also be severely simple, as the capitals of the Doric order [fig. 36; *181, 183–189*] or the cubiform "cushion" capitals used in some Romanesque churches [418].

CARTE DE VISITE (Fr., visiting card). A small *photograph*, usually a 3½ x 2¼″ portrait mounted on a 4 x 2½″ card, rarely actually used as a visiting card. The production and collecting of *cartes de visite* became a fad in the 1860s when millions were made of ordinary people as well as celebrities and such political figures as Napoleon III, Queen Victoria and Abraham Lincoln. *Cartes* were made by the *wet plate process*, several *exposures* being made on one plate and printed on *albumen* paper. André-Adolphe-Eugène Disdéri (1819–1889), who at the height of the fad had studios in London and Paris, introduced the format and devised methods of making eight or ten exposures on a single plate. A four-lens camera was popular for making multiple *negatives*. Uncut prints from such multi-image plates of a single subject in different positions give a sense of sequential movement and can be seen as a form of *chronophotography*, although this was not their original purpose.

CARTOON (fr. It. *cartone*, a big sheet of paper). **1.** A humorous or satirical drawing [*869, 906, 924*]. **2.** A full-size drawing for a painting, made to be transferred to a wall, canvas, or panel as a guide in painting the finished work [*643*]. In *fresco* painting, the cartoon may be transferred by pricking it with a needle and "pouncing" it with charcoal dust so that the main lines of the composition appear as dots on the plaster surface of the wall.

CARYATID (karry-at'id). A female figure used as a *column* [*176, 196, 197, 699, 899*]. A male supporting figure is called an atlas (pl. atlantes; at-lan'tees); when the figure only partly emerges from a pedestal [*742, 775*], it is called a "herm" or "term" after similar figures of Hermes used to mark the terminal points of property in antiquity.

CASEIN (kay'seen; fr. L. *caseus*, cheese). A painting *medium* made from fresh milk curd. Casein paint is quick-drying and *mat*. It is rather opaque and more brittle than egg *tempera*. Thus, it is usually used on smooth, rigid surfaces rather than on canvas [*958*]. Casein is such a strong adhesive that it has long been used to glue together the wood panels used for paintings in a variety of media.

CASTING. A method of reproducing a work of sculpture by pouring a hardening liquid into a mold bearing its impression. In this way a piece of sculpture, created in a medium which is easily worked but perishable, can be preserved in one that is much more permanent. Bronze has traditionally been used for this purpose, and for almost five thousand years it has been cast by the "cire-perdue" (seer per-doo'; F.), or "lost-wax" process. Because of the great weight and expense of bronze, solid casting is used for only very small figures; larger figures are hollow cast. In making a solid casting by the lost-wax process, the figure is first modeled in wax, allowance being made for the fact that the finished work will be in metal instead of translucent wax. The wax model is then surrounded with a mantle of clay. When the clay is dry, the whole piece is baked and all of the wax melted out through a hole. The molten bronze is then poured in to fill the hollows left behind by the wax. Before the cast can be removed, the mold, too, must be destroyed. Thus, in the cire-perdue process, since neither the wax model nor the mold survive, only one cast can be made. To make a hollow casting, a core of clay is made first and the wax is modeled over it. When the piece is finished, it is covered with a mantle

of clay, as in solid casting, and the wax is melted out. Metal rods, inserted through the mantle and core, hold them firmly in place during the melting process. The narrow space, which is left between them, is then filled by the molten bronze. When the mantle is broken, and the core removed, the hollow shell of the bronze cast remains. A large piece of sculpture must be cast in several separate sections which can later be riveted or welded together. After the bronze has hardened, it is "chased" with hammers, chisels, files, and gravers to remove imperfections and to bring out or add details. Since a complex system of channels and ducts must be made in the mold to allow for the escape of wax, for the pouring of bronze, and for the escape of air as the bronze is poured, chasing involves the removal of the several projections which are usually formed by excess bronze flowing into these channels during casting. After chasing, the cast may be treated with acids to form the surface coloring—usually greenish—called "patina" (pa-tee'na; It.), which may also be produced naturally through outdoor exposure, burial, or immersion in water for long periods of time.

When more than one cast is desired, the sand casting method may be used. In this process, the plaster model [891], which may itself have been cast from a clay or wax original, is tightly packed in firm, damp sand mixed with loam. When half of the sand mold has been made, the iron frame which holds it is turned over together with the model and the other half of the mold is made. The model is then removed and, if the cast is to be hollow, a sand core is made by packing sand into the mold, after treating it to prevent the core from sticking to it. Once the core has been formed, it is removed from the mold and its surface is shaved so that a space, as wide as the desired thickness of the cast, is left between the core and the mold. Then, as in the lost-wax process, the core is suspended within the mold by rods driven through them both; the channels for the introduction of the molten bronze and for the escape of the air are cut; the mold is dried in an oven; its surfaces are smoked to prevent the metal from sticking; and finally the bronze is poured. After the bronze has cooled, the mold and core are removed and the cast is chased. Since the model has not been destroyed, as in the lost-wax method, an "edition" of many casts can be made by simply repeating the process.

CATACOMB. An ancient Roman underground cemetery, consisting of an often complex network of corridors connecting a multitude of chambers on as many as five levels. In the walls of the corridors (*ambulatories*) are tiered recesses for graves (loculi). Opening off the corridors are square, round or octagonal burial chambers (cubicula; *sing.* cubiculum) for the tombs of the members of wealthy families or organizations. *Fresco* paintings on the walls and ceilings of some of the cubicula are among the earliest surviving works of Christian art [315].

CATHEDRAL. The church of a bishop, containing his "cathedra" or throne. In Italy, a cathedral is often called a "duomo" (dome).

CELLA (sel'la; L.). **1.** The main chamber of a Greek or Roman temple, built to house the cult image [182, 186, 187, 254]. **2.** The whole main body of a temple, excluding the *portico*.

CHAPEL. 1. A small church [*391, 591–594, 656*]. **2.** A compartment in a church containing an *altar* dedicated to one of the many saints, but often referred to by the name of the donor [*738, 751*]. The chapels projecting from the *ambulatories* of Romanesque and Gothic churches are called "radiating chapels" [fig. 14; *451, 452*].

CHARTREUSE (shar-trurs'). A *monastery* of the Carthusian order [*465*].

CHÂTEAU (sha-toh'; *pl.* châteaux; sha-toh' *or* sha-tohz). The French word for castle, applied originally only to fortified dwellings, but now, to any French country house [*543, 731, 776, 807*].

CHIAROSCURO (kyah'ro-skoo'ro; It. fr. *chiaro*, light, + *oscuro*, dark). The gradations of light and dark within a picture, especially one in which the forms are largely determined, not by sharp outlines, but by the meeting of lighter and darker areas [*640, 695, 783–787*]. *See* VALUE, TONE, SHADOW, LINE, SFUMATO.

CHLORIDE PRINT. A photographic *print* made on paper coated with a gelatin emulsion containing silver chloride [*1126*]. Introduced in the 1880s, it has a blue-black tone and is "slower" (less sensitive to light) than *silver bromide* paper.

CHOIR. The area in a church reserved for singers and clergy, usually extending from the *crossing* to the *apse;* also called the "chancel" [fig. 14; *393*]. Sometimes, as in "pilgrimage choir," the term denotes the entire east end of a church beyond the crossing, including apse, *ambulatory*, and radiating *chapels* [*452*]. This larger unit may also be called the "chevet" (shuh-vay'; F.).

CHOIR SCREEN. A screen, often elaborately carved, separating the *choir* from the *nave* of a church [*351, 502*]. In England, the choir screen is called a "rood screen," because it is usually surmounted by a cross, or "rood" [*418*]. In Byzantine churches, the choir screen, decorated with *icons*, is called an "iconostasis" [*348*].

CHRONOPHOTOGRAPH (fr. Gk. *chronos*, time, + *phos*, light, + *graphos*, drawing). A multiple-exposure *photograph* of a subject in continuous motion, showing different positions exposed separately at very short intervals on a single *negative* [*987b*]. The term "chronophotography" was coined by the French physiologist Étienne-Jules Marey to describe the photographic motion studies which he began in 1882. Chronophotographs record the continuity of motion more effectively than the earlier multiple-camera/single-exposure technique of Eadweard Muybridge [*986*]. Marey devised a gun-like automatic revolving-disk camera to record the flight of birds and a camera which intermittently exposed a roll of sensitized paper or *film* sixty times per second with *exposures* of 1/1000 second. To clarify overlapping exposures and create a graph-like record of motion, Marey dressed a man in a black suit marked with white stripes along the arms and legs [*987a*]. Marey's striking new means of recording motion were adopted and developed by the Italian Futurists and other twentieth-century painters in their evocations of modern dynamism [*1002, 1004, 1009*].

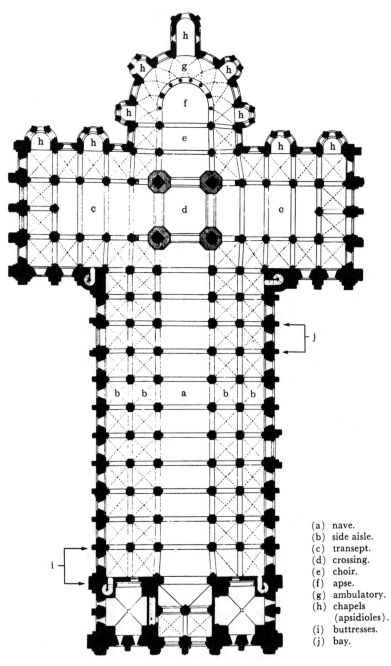

(a) nave.
(b) side aisle.
(c) transept.
(d) crossing.
(e) choir.
(f) apse.
(g) ambulatory.
(h) chapels
 (apsidioles).
(i) buttresses.
(j) bay.

Fig. 14. Plan of St.-Sernin, Toulouse.

CHURCH ARCHITECTURE. *See* ALTAR, ALTARPIECE, AMBULATORY, APSE, ARCH, ARCHIVOLT, ATRIUM, BAPTISTERY, BASILICA, BAY, BLIND ARCADE, BUTTRESS, CAMPANILE, CANOPY, CAPITAL, CATHEDRAL, CHAPEL, CHOIR, CHOIR SCREEN, CLERESTORY, CLOISTER, COFFER, COLUMN, COMPOUND PIER, CROSSING, CRYPT, DOME, DRUM, FINIAL, GABLE, GALLERY, HALLENKIRCHE, JAMB, LANTERN, LINTEL, ORDERS, PROFILE, MOSAIC, NARTHEX, NAVE, NICHE, ORIENTATION, PENDENTIVE, PINNACLE, QUATREFOIL, RESPOND, RIB, ROSE WINDOW, SACRISTY, SANCTUARY, SARCOPHAGUS, SIDE AISLE, TABERNACLE, TRACERY, TRANSEPT, TRIFORIUM, TRUMEAU, TRUSS, TURRET, TYMPANUM, VAULT, WEST WORK.

CLERESTORY (or Clearstory). A clear story, i.e. a row of windows in the upper part of a wall [fig. 63; *271*]. In churches, the clerestory windows above the roofs of the *side aisles* permit direct illumination of the *nave* [*316, 318, 319, 321, 414, 454, 464, 469, 470, 472, 506*].

CLOISTER (cloys'ter). 1. A court bounded by covered walks or *ambulatories,* frequently found on the south side of the churches of *monasteries* [fig. 35]. 2. The covered walk of such a court, usually provided with an *arcade* or colonnade.

CLOSED FORM. An individual element or the whole *composition* of a painting, sculpture or building which is self-contained and does not refer to the surrounding environment. In pictures and *reliefs* with closed compositions, forms and figures are usually *symmetrically* placed and face the viewer or refer to the center [*12, 71, 115, 118, 132, 162, 213, 327, 338, 437, 523, 527, 555, 598, 604, 607, 611, 626, 635, 638, 642, 657, 672, 710, 716, 945, 993, 1130, 1138, 1140, 1142*]. Closed form in freestanding sculpture and architecture usually consists of relatively unpenetrated mass with few projecting elements [fig. 48; *80, 84, 120, 165, 170, 198, 573, 597, 613, 647, 826, 851, 967, 1064*]. *Cf.* OPEN FORM.

CODEX (*pl.* codices, ko'dih-seez). A *manuscript* in the form of the type of bound book used today. The codex replaced the scroll, or "rotulus," of antiquity.

COFFER. 1. A casket or box. **2.** A recessed panel in a ceiling [*265, 430, 589, 598, 672, 756, 896*]. A coffered ceiling appears to be massive, but the coffering may actually make it lighter.

COLLAGE (ko-lahj'; fr. F. *coller,* to glue). A composition made by pasting various materials, such as strips of newspaper, wallpaper, cloth, etc., to a flat surface [*1001, 1020, 1021, 1050, 1085*]. *See* PHOTOMONTAGE.

COLOR. *See* HUE, VALUE, SATURATION, PRIMARY COLOR, SECONDARY COLOR, COMPLEMENTARY COLOR, COOL COLOR, WARM COLOR, LOCAL COLOR, SHADE, TINT, TONE, FLAT COLOR, MONOCHRONE, POLYCHROME.

COLOR FIELD PAINTING. Painting on a large scale using such broad areas of a single color that they may fill the entire field of vision when viewed closely.

Close viewing transforms the surface color into "film color," like the blue of the sky, textureless and having no definite location. Sometimes the effect is obtained by saturating unprimed canvas with highly diluted pigments (staining) using a squeegee (rubber blade). Color Field painting was developed in the 1950s by such artists as Barnett Newman, Mark Rothko [1041], Helen Frankenthaler [1042] and Morris Louis [1043]. In extreme forms, Color Field painting is "holistic" and "non-relational," i.e. there may be no clear division into parts related to each other and to the whole, as in traditional *composition*.

COLOSSAL ORDER. Any *order* in which the *columns* or *pilasters* rise through more than one story [616, 665, 666, 705, 747, 830].

COLUMN (kol'um). A cylindrical upright or *pillar*. All columns of the classical *orders*, except the Greek Doric, consist of a base, a tapered shaft, and a *capital* [fig. 36]; the Greek Doric column has no base [174]. Columns are usually used in a row (colonnade), with a space (intercolumniation) between each column, to carry an *entablature*, an arcade, or other load, but they are also sometimes used singly for decorative or commemorative purposes [292, 765]. "Engaged columns" are columns which, instead of being freestanding, are attached to a wall; they may be "half-columns" or "three-quarter columns," which cast a deeper shadow than half-columns [79, 198, 253, 263, 614, 705, 709, 747, 754, 759, 826]. Although engaged columns are essentially non-structural, they serve to *articulate* the wall and to express visually the support which the wall actually provides. Columns which are placed slightly in advance of a wall, but which carry projecting sections of the entablature, are said to be "en ressaut" [ahN ruh-so', F.; 271, 278, 300].

COMBINATION PRINT. A photographic *print* made from two or more separate *negatives*. Oscar Rejlander introduced combination printing in 1857 with his remarkable 16x31" "The Two Paths of Life" [980]. This complex allegory of Industry and Dissipation, made in competition with the high moral and aesthetic tone of *salon* painting, was printed on two sheets of paper from thirty negatives of individually photographed figures and groups. Additional negatives were used for printing the setting. Henry Peach Robinson followed Rejlander's example the following year with his "Fading Away" [981], a sentimental family scene of a dying girl printed from five separate negatives. Rejlander's pictorial print was criticized for its nudity and Robinson's for its morbidity. Both raised questions about the suitability of such pictorial effects to the fundamental nature of the new medium. Combination printing is a process distinct from *photomontage* and multiple-exposure photography (see *chronophotography*), but all are forms of composite photography.

COMPLEMENTARY COLOR. A *hue* which complements another in that they form a neutral gray when mixed together, but present a sharp contrast when *juxtaposed*. Contrast increases with the *saturation* of the two hues, highly saturated complementaries appearing to vibrate or flicker when set side by side. The complementary of any one of the *primary colors* is obtained by

mixing the other two primaries: the complementary of red is green (yellow + blue), the complementary of yellow is violet (red + blue), and the complementary of blue is orange (red + yellow). The colors represented in the "color wheel" in fig. 15 are arranged so that they are directly opposite their complementaries. Complementary contrasts have long been used in works of art to intensify the effect of the color composition [243, 310, 996, 1057], but complementaries were first used as part of a scientific program by Seurat and other "pointillists." The pointillists went so far as to imitate the effect of the projection of "negative after-images" onto the visual field outside the eye [945]. Negative after-images are the patches of complementary color formed in the retina by prolonged exposure of the eye to colors of high saturation. Twentieth-century "Op" artists sometimes juxtaposed bands or squares of highly saturated complementary colors to create flickering color vibrations so powerful that they can be painful to see, because of the conflict between after-image and surface color [1049].

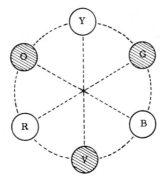

Fig. 15. Color wheel: R (red), 0 (orange), Y (yellow), G (green), B (blue), V (violet).

COMPOSITION. The organization or arrangement of the forms in a work of art. In making and evaluating works of art, organization is of such central importance that many works are simply titled "Arrangement" or "Composition" [926, 996, 1018]. Some of the individual concepts and principles of composition which are commonly used are discussed under separate entries (see ATMOSPHERIC PERSPECTIVE, AXIS, BALANCE, CHIAROSCURO, CLOSED FORM, COLOR, CONTOUR, CONTRAPPOSTO, DRAPERY, FIGURE-GROUND RELATIONSHIP, FOCAL POINT, FORESHORTENING, FRONTAL, GROUND-LINE, GROUND PLANE, LINE, MODELING, MOTIF, OPEN FORM, PERSPECTIVE, PICTURE SPACE, PICTURESQUE, PLAN, PLANE, PROFILE, PROPORTION, RHYTHM, SCALE, SHADOW, SHAPE, SUBJECT, SYMMETRY, VANISHING POINT, VIEWPOINT, VOLUME). Here, however, their interrelation within a single work is considered in a brief analysis of Rembrandt's "The Blinding of Samson" [fig. 16; 783]. One of the very great pleasures in looking at this work, or any work of art, is the discovery of different patterns and relations among the forms and colors.

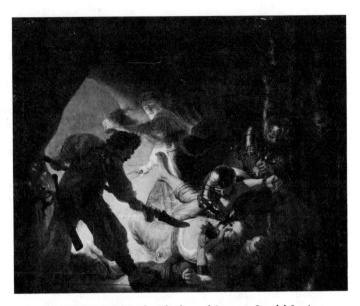

Fig. 16. REMBRANDT. *The Blinding of Samson.* Staedel Institute, Frankfurt.

These patterns are often so intermixed and superimposed that there can be no single prescribed way of distinguishing them; one will select different patterns at different times according to one's "mental set" at the moment and they may seem to change their meaning accordingly. In a sense, then, there are many pictures within any single picture; it is rarely possible to single out only one pattern as *the* composition. Some of the larger patterns that can be distinguished in "The Blinding of Samson" are diagramed in figs. 17–22. These crude diagrams are worthless in themselves; they do not provide the "key" to the work, but are meaningful only in so far as they bring out, by contrast with their crudity, the unique subtlety of variation within the broad patterns they describe. Fig. 17 indicates the sharp angular shapes that, within the context of the subject, are very aggressive. Their edges form a set of dynamic oblique relationships that are anchored only by the horizontal and vertical edges of the canvas. The only vertical in the picture is the rigid arm of the soldier who holds Samson firmly to the ground. Fig. 18 indicates the major directional lines on the *picture plane* which point with excruciating concentration to the gouging of Samson's eye. Only the major oblique *axis*, running from the upper left-hand corner to the lower right, can be interpreted as also pointing decisively away from Samson, because the fleeing figure of Delilah—who holds the hair and scissors which have cost Samson his strength—is disposed along this axis. One naturally looks back and forth between the cause (the hair) and the effect (the gouging). Fig. 19 indicates the two major movements back into the *picture space*. The figures have been disposed along these two crossing paths and receive something of their great energy from the dramatic rushing movement. The figure of the halberdier, in the extreme foreground,

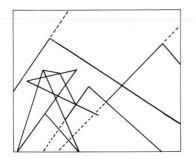

Fig. 17. Schematization of angular shapes on the picture plane.

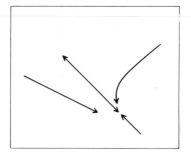

Fig. 18. Major movements across the picture plane.

Fig. 19. Movements back into the picture space.

Fig. 20. Forward movement through the picture space.

Fig. 21. Curving and interlacing forms.

Fig. 22. Pattern of lights and darks.

provides a shallow secondary thrust into the picture space as he points his weapon at Samson's face. The spatial movement might also be interpreted as in Fig. 20, rushing forward along the line of soldiers, turning at Samson's head, and then rushing off again in the opposite direction back along the hurtling body of the fleeing Delilah. Fig. 21 indicates the complex pattern of interlacing forms which tells both on the picture surface and in depth,

activating the larger compositional movements in a tight knotted rhythm that adds to the tension of Samson's moment of anguish. The twisting and turning is tightest toward his bound body and is almost inseparable from his own contorted limbs. Fig. 22 indicates the broken and twisted pattern formed by contrasting areas of light and dark which also contributes to the movement and tension of the scene. The areas of greatest emotional impact—Delilah's face, the scissors, Samson's head—are spotlighted; *highlights* glinting from the armor and weapons of the soldiers offer a hard contrast to Samson's vulnerable flesh. The red costume of the halberdier, Delilah's blue-green skirt and Samson's yellow trousers also contrast sharply and mark the conflicting parties, but effects of *hue* and *saturation*, while usually essential to the composition of a painting, can only adequately be studied in the original. The most accurate diagram of the color composition or the finest color reproduction is no substitute. A diagram lacks the sensuous appeal and delicate modulations of the original; the reduced size and imperfect color of a reproduction will always upset the balance of compositional elements to some degree. The full impact of all the formal elements working together can only be received while one stands before the original. Everything which one has studied about art is a preparation for that experience. It is a contemplative experience which takes a great deal of time and even something of the creative power of the artist who made the work, because, in many respects, looking at works of art is a *recreative* activity: one must select and analyze the formal elements and consider their expressive force much as the artist himself did while putting them together.

COMPOUND PIER. A *pier* with *columns, pilasters,* or shafts attached to it, frequently used along the *naves* of Romanesque and Gothic churches [fig. 63; *414, 418, 422, 424, 462, 470, 477, 481, 488*]. The attached members usually support or respond to arches or *ribs* above them.

CONCEPTUAL ART. Art in which the concept or ideas presented or suggested are considered more important than the particular character of the visible objects, words or events through which they are communicated [*1093*]. During the 1960s and 1970s, attempts to escape the material aspects of art tested the limits of the concept of art itself.

CONNOISSEUR (kon-ih-sur'; F.). A person—often a museum curator, art collector, or art dealer—who is devoted to the study of individual works of art and the personal *styles* of individual artists. Connoisseurs are particularly concerned with gauging the quality and condition of works with respect to others of their kind and to distinguishing among originals, copies, replicas (copies by the same artist who made the original), and outright forgeries.

CONSTRUCTION. In sculpture, a work made by the joining together of a number of separate parts by nailing, bolting, gluing, welding, etc., rather than by traditional processes such as *modeling, casting* and carving [*1073, 1074, 1075, 1076, 1077, 1078, 1087*]. Beginning in 1912, Picasso extended the technique of *collage* into three dimensions with constructions made by cutting and assembling pieces of sheet metal, wood and wire in Cubist evocations of

musical instruments. These and totally abstract constructions by Vladimir Tatlin [1071] and other Russian Constructivists, made soon after, were often composed as essentially light *open forms* with hollow *volumes* which challenged the traditional association of sculpture with mass. *See* ASSEMBLAGE.

CONTINUOUS NARRATION. The representation, within a continuous spatial setting, of events which occurred at different times, so that the same characters may appear more than once. This may be done by spreading out the individual episodes along a continuous band, similar to the arrangement of a comic strip but without divisions between episodes [292, 310, 328, 445, 521, 541, 609, 658], or the different episodes may be arranged in depth so that earlier events appear in the background [557, 581, 602]. In the course of the sixteenth century, continuous narration was largely abandoned in favor of unity of time and place.

CONTOUR. The outline of an object or *shape*, especially when it suggests *volume* or mass. In "contour drawings," in which the outlines of objects are set down with little or no *modeling*, it is possible to suggest their roundness and solidity with a force that is surprising when one considers the extreme simplicity and abstraction of the technique [35, 214, 243, 250, 303, 380, 400, 954, 988]. One of the ways in which this is done is by breaking or blurring the contour lines to suggest the disappearance of a surface as it curves out of sight. If the different contour lines touch each other too frequently, they may create two-dimensional shapes which tend to flatten the figure. Another way to enhance the apparent *plasticity* of the forms is by varying the thickness of the lines to bring some parts forward and others back; a sudden accent or swelling indicates the fullness of the form and a tapering line suggests its attenuation.

CONTRAPPOSTO (kon-tra-pah'stoh; It. fr. L. *contrapositus*, placed opposite). The graceful disposition of the parts of the body so that they form oblique axes turning around a central vertical *axis* [fig. 9; 652]. In extreme forms, the head, torso, legs, and arms may be twisted to such an extent that they are turned in nearly opposite directions and almost literally "counterpoised" [10, 230, 232, 643, 817]. Usually, however, they are simply "counterpoised," attention being paid to "ponderation" (the distribution of weight throughout the figure) so that the weight-bearing leg, or *engaged leg*, for example, is distinguished from the raised leg, or *free leg*, and the resulting shift in the axes of hips and shoulders is observed. Above all, the stiff *frontality*, parallel alignments, and rectangular contrasts of direction, which are characteristic of Egyptian and Archaic Greek sculpture, are avoided [cf. 84–87, 137, 165–167]. Contrapposto was developed by Greek sculptors and painters as a means of avoiding such stiffness and increasing the animation of their figures [201–230]. During the sixteenth century, the device was pressed to extremes of virtuosity and was often pursued for its own sake as a formal exercise or as proof of artistic skill, the problem being to make the members of the body elegantly conform to an imaginary three-dimensional spiral running continuously through the entire figure [689, 699, 700, 735].

COOL COLORS. Blue and associated *hues* such as blue-green and blue-violet. Cool colors normally appear to recede and *warm colors* to project. A cool color in which this tendency is significant is called a "retreating color."

CORNICE (kor'nis). **1.** The topmost member of a classical *entablature* [fig. 36; *181*]. **2.** Any horizontal member projecting from the top of a vertical surface, such as a wall, pedestal [fig. 36], or building [*597, 969*].

CRENELLATED (kren'eh-layted; fr. Old Fr. *crenel,* a notch). Furnished with battlements, i.e., notched parapets (low walls) placed at the top of a fortified building [*125, 491, 530, 533, 543, 892*]. Each indentation in a crenellation is called a "crenel" and each solid section, a "merlon."

CROMLECH (krahm'lek). A prehistoric monument formed of great stones set on end and arranged in a circle, as at Stonehenge [*51–53*].

CROSSING. The area in a church where the *transept* intersects the *nave* [fig. 14; *393*], sometimes covered with a dome [*428, 429, 850*] or marked by a "crossing tower" [*410, 411, 475–477*].

CRYPT (kript). A *vaulted* chamber, wholly or partly underground. In a church, the crypt, housing a *chapel* or tomb, is usually located under the *choir,* which is, as a result, sometimes raised considerably above the level of the *nave* [*404–406*].

DAGUERREOTYPE. A direct positive *photograph* fixed on a silver-coated copper plate [*903*]. Daguerreotypy, invented by the painter Louis-Jacques-Mandé Daguerre and made public in 1839, was the first practical photographic process. It was time consuming [fig. 23], involving: buffing the plate,

Fig. 23. Daguerreotype apparatus (1847).

sensitizing it in a box filled with fumes from heated potassium iodide crystals, placing it in the *camera,* exposing it about thirty minutes by removing a *lens* cap, developing the image by placing the plate in another box filled with fumes of heated mercury, then "fixing" the image with hyposulfite of soda solution to stop development. The resulting image is lustrous, grainless and (depending on the camera lens) richly detailed, but each image is unique and the surface so delicate that each daguerreotype was normally protected with a sealed cover glass and enclosed in a velvet-lined case. In the 1840s, *exposure* times were reduced to less than a minute by a second preliminary sensitizing treatment with bromine fumes. In the 1850s, daguerreotypy was superseded by the collodion *wet plate process.*

DECALCOMANIA (dee-kal'ko-may'nee-uh; F. *decalcomanie,* transfer). **1.** A type of *automatism* used by Surrealist painters in which images are made by pressing one freshly painted or inked surface against another. The method was used by Max Ernst to introduce an element of chance in the development of some of his paintings [1022]. **2.** The transfer to ceramics and other objects of designs printed on specially prepared paper.

DIPTYCH (dip'tik). Two panels or leaves hinged so that they can be folded together. In late antiquity small ivory diptychs were carved with delicate reliefs for commemorative and religious purposes [331, 332, 585]. In the later Middle Ages, diptychs for private devotional use were painted with an image of Christ or the Virgin on one panel and the owner—sometimes recommended by his patron saint—on the facing panel [562].

DOLMEN. A prehistoric monument composed of huge upright boulders (megaliths) supporting a massive slab in such a way as to form a chamber, generally thought to have served as a tomb [50].

DOME. A *vault* of regular curvature raised on a circular or polygonal base. The pressures at work within a dome are similar to those within an *arch.* Thus, if one imagines the shape of a circular dome to be formed by rotating an arch around its vertical *axis,* it will be understood that there will be considerable *thrust* at the haunch, as in an arch [fig. 5], as well as around the base of the

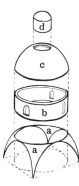

Fig. 24. Dome: (a) pendentive, (b) drum, (c) dome, (d) lantern.

dome. To counteract this thrust, the dome may be loaded at the haunch, as in the Pantheon at Rome where a stepped abutment is used [268; cf. 757]. This, however, diminishes the exterior effect of the dome. To increase the visibility of the dome, it may be raised on a cylindrical or polygonal *drum* [fig. 24; *346, 647, 847*], but a dome of any size, when it is removed from the body of the building and lifted high in the air, may have to be held together with chains or rings of heavy timbers to counteract the outward thrust. The height and curvature of a dome may also be enhanced by covering it with a lighter and more prominent outer dome [*350, 486, 666, 668, 813, 827*]. *See* LANTERN, PENDENTIVE.

DOMESTIC ARCHITECTURE. *See* BALUSTRADE, CHÂTEAU, CRENEL-LATED, DOMUS, DONJON, GALLERY, HÔTEL, KEEP, LOGGIA, PALAZZO, SALON, TROPHY, TURRET, VESTIBULE, VILLA.

DOMUS (doh′mus). The Latin word for "house." A large house of a well-to-do Roman family and its servants, such as those excavated at Pompeii [fig. 25; *275*] consisted of groups of rooms clustered around two open courts: the *atrium,* which was semi-public in that it was used for receiving guests and conducting business, and the *peristyle,* a private garden surrounded by a colonnade. Before entering the house, which was built close to the street, one stepped into a recess (vestibulum) between the street and the door and, after entering, walked through a short passage (fauces) to reach the atrium which had a shallow pool (impluvium) in the center to catch the rain dropping through an opening in the roof. Walking through the atrium, one passed deep recesses (alae, or "wings"), to either side, and might then enter the *ambulatory* around the peristyle either by going through the wide recess called the *tablinum* or through a narrow passage (andron), to one side of it, which could be used when the tablinum was occupied. A broad and deep recess (exedra), corresponding to the tablinum of the atrium, was often placed at the rear of the peristyle.

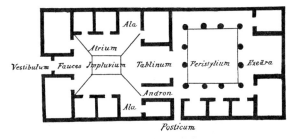

Fig. 25. Plan of a Roman House (Mau).

DONJON (dun′jun; F.; archaic English spelling of "dungeon'). The *keep* or central tower in a castle.

DRAPERY. The draping of fabric is one of the most important expressive devices available to the sculptor or figure painter, often exceeding in importance the

posture and gesture of the figure which it clothes. Sometimes drapery dominates most of the visible surface of a work and requires only a hint of an associational context to convey almost by itself, through abstract form, most of the expressive content of the work [18, 286, 287, 437, 494, 573, 724, 796]. Drapery was developed by the Greek sculptors as a graceful linear counterpoint to the full volumes of the body; toward the end of the fifth century B.C., the blending of flesh and fabric in figures clothed with "wet drapery" became a prime artistic problem [210, 212, 213]. "Flying drapery" was introduced to enhance the apparent movement and excitement of figures [211, 215, 229] and remained an important expressive device throughout the Middle Ages [399, 407, 438, 446, 524, 565] and long after [576, 579, 612, 627, 635, 691, 711, 743, 889, 949, 1069]. During the sixteenth century, wet drapery was again treated as a formal problem in very much the same way as it had been in antiquity [11, 684, 734]. When placed in an appropriate context, drapery can be charged with a broad range of emotional qualities from the most forbidding stillness [338] or profound gravity [218, 580, 718], through flights of gaiety [822] and frivolity [831], to terror [11] and the heights of religious exaltation and ecstasy [693, 750]. The power of drapery as a vehicle of expression explains, in large measure, the use of flowing garments in portraits, even after close-fitting clothes had become the fashion [845, 886, 934].

DRÔLERIES (droh-leh-ree; F.). Fanciful designs of a playful character in the margins of medieval *manuscripts* [538] or on church furniture such as choir stalls.

DRUM. 1. A cylindrical or polygonal wall rising above the body of a building, usually introduced to support a *dome* [fig. 24; 334, 336, 346, 486, 646, 647, 666, 813, 847, 850]. 2. One of the cylindrical blocks, often *fluted*, forming the shaft of a *column* [184].

DRYPOINT. A *print* made from a design scratched into a metal plate with a steel needle held like a pencil [572]. In drypoint, which is really a form of *engraving*, the curl of metal, or "burr," turned up at one or both sides of the furrows which are scratched into the metal, is not scraped away as it is in regular line engraving, but is often left on the plate to hold thick deposits of ink [fig. 26b]. In printing, which is carried out in the same way as in engraving, the burr leaves deep velvety blurs of ink that are particularly effective in creating rich atmospheric effects. Drypoint is often used in conjunction with engraving and *etching;* Rembrandt, in particular, used it to deepen the *chiaroscuro* of his etchings [785].

EARTH ART. Very large-scale outdoor sculpture, sometimes actually made of earth or rocks (earthworks). Works of Earth Art, or "Land Art" as it is also called, are often *environmental,* i.e. they can be entered or walked upon [1083]. They may be permanent, as Stonehenge [51] or the work of prehistoric Ohio "Mound Builders" [54], but Land Art may also be temporary, lasting, in finished form, for only a few hours or days, as the vast projects conceived and directed by Christo during the 1970s and 1980s [1084].

ECHINUS (eh-kī'nus). In the Greek Doric *order*, the quarter-round (ovolo) *molding* beneath the *abacus* [*181*].

ELEVATION. 1. One side, or face, of a building. 2. An undistorted and measurable drawing of one side, or part of a side, of a building [*174, 216, 469, 897*]. To avoid *foreshortening* or convergence of parallel edges, the building is presented parallel to the *picture plane*.

ENAMEL. Colored glass applied to metal in powder or paste form and fused by firing. In the Middle Ages, two basic types of enamelling were used, "cloisonné" and "champlevé." In making cloisonné (klwah-zoh-nay'; F. fr. *cloisonner*, to partition) enamels [*385*], the surface to be decorated is divided into compartments with strips of metal (cloisons), usually gold; the compartments are then filled with enamel and the whole piece fired in a kiln. In making champlevé (shahN-luh-vay'; F. fr. *champ*, field, + *lever*, to raise) enamels, the areas to be filled with enamel are dug out with a cutting tool. Often, broad areas of metal are left raised and decorated by engraving. To make the engraved lines more clearly visible, they are usually filled with a black substance [*449*] called "niello" (nyel'lo, It.; a mixture of powdered lead, silver, copper and sulfur). The extraordinary transparency and translucence of enamels satisfied the medieval taste for glowing color.

ENCAUSTIC (en-kaws'tik; fr. Gk. *en*, in, + *kaiein*, to burn). A method of painting with pigments suspended in molten wax much practiced in antiquity [*312, 357*]. Encaustic colors are remarkably brilliant and durable. Some twentieth-century artists have used encaustic [*26, 1053*], but the technique has never been widely revived.

ENGAGED LEG. The leg on which a standing figure appears to place its weight. *See* FREE LEG, CONTRAPPOSTO.

ENGRAVING. A print made from a design cut with a *burin*, or graver, into a metal plate. Engraving is an "intaglio" (in-tal'yo) process rather than a relief process like *woodcut*, i.e. lines are cut into the surface of the plate and it is these lines that are printed, whereas, in making a woodcut, the spaces between the lines of the design are cut away, leaving the lines raised in relief [fig. 26a]. Engraving, then, is a "positive" process; the lines, or "tailles" (tī'ee; F.), made by the engraver with his burin are directly registered in the print. Lines are not easily cut into the metal plate (usually copper), so to facilitate cutting, the plate is often placed firmly on a small cushion filled with sand. The burin is held in one hand and, as it is pushed forward, the other hand is used to rotate the plate against the pressure of the burin. Thus, engraved lines are normally curved; they are thin where the burin begins the cut, they swell as more pressure is applied, and they taper again as the burin is lifted from the plate [fig. 27a; *5, 571, 716, 717, 832*]. After cutting, the plate is burnished to remove the bits of metal (burr) still clinging to the sides of the tailles [fig. 26b]. Ink is forced into the engraved lines with a dabber or roller, but ink remaining on the surface is entirely wiped away unless special tonal effects are desired. If this is the case, smudges of ink may be left on the surface of the plate. The paper that is to receive the impression is dampened

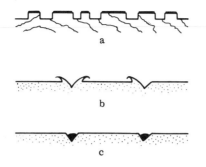

Fig. 26. (a) Cross-section of woodcut with lines inked. (b) Cross-section of engraved plate with double "burr" and single "burr." (c) Cross-section of engraved plate with "burr" burnished away, lines inked, and surface wiped.

to ease its entry into the ink-filled furrows under the very great pressure of the press; the forcing of the paper into the furrows accounts for the characteristically raised lines of intaglio prints. The plate, with the paper placed on top of it, is passed on a heavy metal plate, or "bed," between two steel rollers arranged something like the clothes-wringer on a washing machine. The pressure of the rollers forces the whole plate to dig into the paper, leaving a distinct "plate mark" around the edges of the print; this clearly distinguishes intaglio prints from woodcuts and *lithographs* which are not subjected to such great pressure. As in most printmaking processes, the printed design is reversed, a fact which must be taken into account while cutting the plate. Since the more delicate lines of the plate are soon damaged by the pressure of the rollers, engravings are usually issued in limited "editions." Since the nineteenth century, it has become customary to indicate in pencil on the margin of each print its precise number in the sequence of impressions; thus, the inscription '23/50' would indicate that the impression is the twenty-third in an edition of fifty. After taking the specified number of impressions, the plate should be "canceled." This is sometimes done by engraving a large 'X' across it and sometimes the plate is simply polished smooth and used to make another engraving. Sometimes the plate will be reworked after an edition has been "pulled" and a new edition of the plate will be printed; in this case, the different editions are distinguished as "State I," "State II," etc. Trial impressions taken in the course of engraving are called "proofs."

Fig. 27. Exaggeration of the characteristics of (a) an engraved and (b) an etched line.

ENLARGER. A projector used to magnify or reduce the size of a *photograph*. Modern enlargers use an electric light source projected through a *negative* or slide and focused through a *lens* onto photographic printing paper, flattened and framed in an easel. The enlarger head (usually containing a lamp, bellows, negative carrier and lens) is mounted on a vertical support. The size of the projected image is varied by raising or lowering the enlarger head. Nineteenth-century enlargers [fig. 28] used the sun as the light source for projection. *See* NEGATIVE.

Fig. 28. Solar enlarger (1864).

ENTABLATURE (en-tab′la-chur). The group of horizontal members resting on the *columns* or *pilasters* of one of the classical *orders*. The entablature is usually divided into three major parts: *architrave, frieze,* and *cornice* [fig. 36; *181, 189, 196, 198, 255, 325, 665*]. Sometimes the entablature may break forward from the surface of the wall and project over columns and pilasters [*278, 300, 614, 769, 826*] and sometimes it may be used, without supporting members, to terminate the top of a wall [*847, 850, 853, 895*].

ENTASIS (en′ta-sis). The gently swelling convex curvature along the line of taper of classical *columns*. The entasis of columns gives them a sense of elasticity as though they were responding to the load of the *entablature* above them. Moreover, entasis prevents the sense of weakness that results from the illusion of concavity in straight or regularly tapered columns. The entasis of early Greek Doric columns [*184*] is pronounced, but becomes ever more subtle until, in the columns of the Parthenon [*188*], it is barely perceptible.

ENVIRONMENT. A work of art, distinct from architecture, which can nevertheless be entered by the viewer, although in practice this may be prohibited

[51, 1091, 1092]. Environments are usually composed of a number of separate objects and made from a variety of different materials. Environments are probably as old as art. Even such animals as the bower bird create environments as part of a mating ritual. Gardens [fig. 45; 849] have for millenia offered a rich *aesthetic* experience unfolding in time. *See* PICTURESQUE. During the Baroque period when such gardeners as André LeNôtre [812] worked on a vast scale, interiors too were conceived as total environments fusing the arts in a single, often overwhelming, visual experience [751–753, 768, 769–771, 809, 811, 820]. In the twentieth century, after decades of the intense pursuit of the *fine arts* as separate disciplines defined by a particular *medium*, some Dada and Surrealist artists such as Kurt Schwitters, Salvador Dali and Marcel Duchamp created environments using *mixed media*. During the 1950s and 1960s the concept spread among a number of vanguard *schools* [1082, 1089, 1091, 1092].

ENVIRONMENTAL SCULPTURE. Sculpture on a scale large enough to be entered or walked upon, usually distinguished from an *environment* by its apparent solidity and conception as a single continuous object [54, 1076, 1083].

EQUESTRIAN (fr. L. *equus,* horse). In painting and sculpture, an adjective used to describe representations of men and women on horseback [296, 514, 588, 629, 665, 717, 809, 815, 860]. Equestrian statues present a particularly difficult problem of casting and of support on the thin legs of the horse, particularly if it is "rampant" (rearing) with only two legs fastened to the base.

ETCHING. A *print* made from a design scratched with a needle into an acid-resistant coating, or "ground," covering a metal plate and etched, or "bitten," into the metal by immersion in acid [318, 685, 785, 858]. The acid will only attack the parts of the metal (traditionally copper) which have been exposed by scratching away the ground. The longer the plate is left in the acid bath, the deeper and wider will be the lines etched into the metal and the darker they will appear when printed. Repeated bitings may be made to develop certain areas while others are "stopped out" with varnish to prevent further biting. When the artist is ready to make a trial impression, or "proof," the ground and stopping-out varnish are removed with a solvent and the plate is printed in the same way as an *engraving,* since both are intaglio processes. If the etcher wishes to eliminate some lines, he may scrape them out; if he wants to deepen some lines or add others, he may reground the plate and proceed as before or simply reinforce lines or add others by engraving with a *burin* or scratching with a *drypoint* needle. Etched lines appear much coarser and freer than engraved lines and unless the etcher intentionally imitates engraving, they will not have the even, curving, swelling and tapering character typical of engraved lines [fig. 27]. Since etching is a much less demanding and more flexible technique than engraving, it largely replaced it as a medium for creative artists during the sixteenth century. Steel engraving, however, long remained a standard medium for book illustration, because a much larger number of impressions can be taken before the lines begin to break.

EXPOSURE. In photography, the presentation of sensitized *film,* plates and papers to light. The exposure time required to produce a satisfactory image is

affected by a number of variables: the "speed" (light sensitivity) of the emulsion; the intensity of the light illuminating the subject; the speed of the *lens* (relative ability to transmit light); the speed of any *filter* used; and the *f-stop* and *shutter* speed selected. Capturing rapid action with a *camera* in more than a blur [*1135*] requires strong light, fast film and a fast lens to compensate for the necessarily fast shutter speed (1/250–1/4000 second). In the early years of photography, the sensitized coatings and lenses available were very "slow," requiring such long exposures that *photographs* of busy city streets appear deserted: people and carriages moved too quickly to register. Portrait photographers had to clamp the heads of their subjects to posts to keep them from blurring. The earliest surviving photograph [*902*], a view taken from a window by Nicéphore Niépce (nyeps) in 1826, required an exposure time of about eight hours, allowing the sun to illuminate walls facing both east and west. The development of fast emulsions, fast lenses, and bursts of high intensity light (flash and stroboscopic photography) made it possible to reduce exposure times to the point where photographers could record individual moments of continuous action in "multiple exposure" photographs [*986, 1142*], *chronophotographs* [*987*] and motion pictures.

FAÇADE (fa-sahd'). The front or principal face of a building, but, sometimes, any one of its sides [*416, 457, 458, 492, 613, 614, 616, 665, 709, 808, 827, 901*].

FASCES (fa'seez; L. fr. *pl.* of *fascis*, bundle). A bundle of rods bound with straps, usually containing an ax with its blade projecting beyond the rods [*846*]. The fasces was a symbol of authority carried before the magistrates of ancient Rome. More recently it has been used as a symbol of unity, the bundle being stronger than the individual rods. As such, it was used as one of the national symbols of the United States of America. It appears in *relief* to either side of the Speaker's desk in the U.S. House of Representatives. During the twentieth century in Italy, Mussolini's Fascist party derived its name from the fasces and adopted it as its principal symbol.

FERROCONCRETE (or Reinforced Concrete). Concrete strengthened with steel rods and mesh which are laid up within the formwork before the concrete is poured. The steel adds tensile strength to the usual strength of ordinary concrete under compression. Introduced in France during the nineteenth century, it is now more widely used for large buildings than masonry or steel frame construction. A great variety of textures and patterns can be created by leaving the rough imprint of the formwork in the surface of the concrete [*1111, 1112*]. Other variable factors within the control of the architect are the choice of color and the composition of the aggregate with which the cement is mixed. The variety of forms and shapes into which the concrete and the reinforcing rods can be set is practically infinite.

FÊTE GALANTE (fayt ga-lahnt'; *pl.* fêtes galantes; F., elegant fete or entertainment). A term used to describe the subjects of many of the paintings of Watteau and his followers in which elegant young men gracefully and rather wistfully court fashionably dressed young women in parklike settings [*818*].

FIGURE-GROUND RELATIONSHIP. The relation of any object, shape, or line to the "field," or background, against which it is seen. The "figure," which is seen as a positive element, always appears to lie in front of the continuous "ground" running behind it. Even the black letters on this page seem to lie slightly in front of the white ground of the paper. Every time a figure is isolated as an object of interest it appears to lie against a ground. In some cases, however, the relation may be so tenuous that a reversal of figure and ground may occur; this frequently happens in abstract designs in which the area occupied by the ground is nearly equal to that filled by the figure. The wave motif on the plinth of the column base shown in fig. 33, for example, can be seen either as white waves against a dark ground or dark waves against a light ground. The desire to separate figure from ground is so strong that it is very difficult to see both the white waves and the black waves as lying together in the same plane. An artist is usually careful to avoid any ambiguity between figure and ground and makes his figures stand out by establishing a clear contrast with their grounds. Sometimes, the "negative shapes," formed by the parts of the ground lying between the outlines of the figures, can be used to support and reinforce the character of the "positive shapes" of the figures. This is particularly true when both positive and negative shapes occupy about the same area and have a similar configuration when isolated as figures by themselves [141, 144, 215, 243, 950, 954, 958, 1014, 1016, 1017, 1026, 1048, 1053, 1054, 1083, 1143, 1144].

FILM. In photography, a thin flexible transparent material coated with a light-sensitive emulsion. Celluloid roll-film was introduced in the 1880s and first incorporated into *camera* design by George Eastman (1854–1932) whose simple Kodak camera (1888) made it possible for almost anyone to be a photographer. Film eventually superseded the rigid plates originally used in photography.

FILTER. A transparent material (usually glass, plastic or gelatin) placed in front of the *lens* of a *camera* or *enlarger* to alter the quality of light. Filters may be selected to enhance the natural appearance of a photographic image or to distort it beyond recognition. Yellow and red filters are commonly used in black-and-white landscape photography to increase contrast by darkening the sky and accentuating clouds [1128]. In color photography, filters are used to match the "color temperature" (*hue* from *cool* to *warm*) of the illumination to the color of light for which a particular film emulsion is balanced. Rotating "polarizing" filters, which variously reduce light coming from particular directions are used to soften glare and reflections and to increase contrast.

FINE ARTS (equivalent of F. *beaux-arts*). The visual arts, especially painting, sculpture and architecture, conceived in terms of sophisticated *aesthetic* traditions requiring years of highly specialized training. This essentially elitist view of art, as distinguished from craft, began to take form in the Renaissance and became fixed with the establishment of state-sponsored art academies in the seventeenth and eighteenth centuries. Distinctions made between the fine arts and "minor," "decorative" or "applied" arts, in which function and craft are

supposedly more important than considerations of beauty, have fallen into disfavor with those who have a more catholic and democratic view of art. Categorical value distinctions between fine art and *folk art* have also softened as critics have become conscious of social and cultural biases upon which they are founded.

FINIAL (fin'ee-ul; fr. L., *finis*, end). A terminal ornament at the highest point of a *gable, pinnacle,* spire, gate-pier, etc. [fig. 63; *435*].

FLAT COLOR. In painting, any color that is broadly applied with little or no *modeling* or variation of texture, *hue, value,* or *saturation* [*243, 989, 1012, 1018, 1045, 1046*]. When used in representational painting, flat colors normally indicate the basic hue of an object: green for grass, blue for sky, brown for wood, etc. Flat colors are also called "solid" colors.

FLUTING (floot'ing). The decorative treatment of the shaft of a *column, pilaster,* or other surface with shallow, vertical grooves (flutes). In the Greek Doric *order,* adjacent flutes form a sharp edge, or "arris" [*189*], but in the Ionic, Corinthian, and Composite orders, they are separated by a flat surface called a "fillet" [fig. 36; *195*]. The fluting on the lowest third of a shaft is sometimes filled with a convex *molding* to protect the fillets, in which case the flutes are said to be "cabled" [*598, 616, 623, 752, 768, 769*].

FOCAL POINT. In any composition, representational or abstract, a dominant area of major interest upon which the eyes focus more frequently than on others. If a picture contains a *vanishing point* it may or may not be a major focal point [cf. *642* and *689*]. Some compositions forming a continuous all-over pattern may have accents but no major focal points at all [*367, 1035, 1036, 1047, 1110*].

FOLK ART. Art made by people who have no special training in the *fine arts* [*55, 56, 58, 59, 63–66, 68–73*]. In Europe, the distinction has long been made between folk art and "naive art." Folk art is considered to involve the repetition of traditional types, often requiring considerable skill, whereas naive art is highly individual and often eccentric and intuitive in form and technique [*961*]. In North America, the distinction is commonly blurred and both categories are called folk art, perhaps because "naive" can have a derogatory connotation. The term "autodidactic" (self-taught) is sometimes used as an alternative to "naive." Although cumbersome, it preserves this real and useful distinction without being insulting. A self-taught individual is an "autodidact" (aw-toh-dī'dact). *See* ART BRUT.

FORESHORTENING. A method of representing objects or parts of objects as if they were seen at an angle and receding into space instead of being seen in a strictly *frontal* or *profile* view. The rod drawn in fig. 29a is shown in an unforeshortened side view, but the rod in fig. 29b is represented as though it were seen obliquely and appears to project or recede. The effect is achieved by employing the principle of continuous diminution in size along the entire length of the receding object. The term is reserved for single objects only and is not applied to regular diminution used in suggesting the recession of a large

interior space or landscape. In the eighteenth and nineteenth centuries, when a critic praised an artist's "drawing," he generally meant skill in handling difficult problems of foreshortening [*9, 10, 639, 641, 659, 672, 673, 742, 745, 803, 878, 861*]. *See* PERSPECTIVE.

Fig. 29. Rod: (a) unforeshortened, (b) foreshortened.

FORMAL PRINCIPLES. *See* AMORPHOUS, ARTICULATED, ASYMMETRI-CAL, AUTOMATISM, AXIS, BALANCE, BIOMORPHIC, CHIAROSCURO, CLOSED FORM, **COLOR,** COMPOSITION, CONTINUOUS NARRATION, CONTOUR, CONTRAPPOSTO, DRAPERY, FIGURE-GROUND RELA-TIONSHIP, FOCAL POINT, FOUR-DIMENSIONAL, FRONTAL, GROUND-LINE, HAPPENING, ILLUSIONISM, JUXTAPOSITION, LINE, MINIMAL ART, MODELING, MODULE, OPEN FORM, MONUMENTAL, ORDERS, ORIENTATION, PAINTERLY, PERSPECTIVE, PICTURE SPACE, PIC-TURESQUE, PLAN, PLANE, PLASTICITY, PROFILE, PROPORTION, REGISTER, RHYTHM, SCALE, SFUMATO, SHADOW, SHAPE, SIMUL-TANEITY, SYMMETRY, TACTILE, TRANSPARENCY, VANISHING POINT, VIEWPOINT, VOLUME.

FORUM (*pl.* forums *or* fora). In Ancient Roman cities, a public square enclosed by colonnades (rows of *columns*), often containing a temple and bordered by a *basilica* and other public buildings. The forum at Rome (Forum Romanum), in a valley by the Capitoline and Palatine hills, was extended by a sequence of fora added by successive emperors [*260*]. The public square or marketplace in Greek cities was called the "agora" (Gk., assembly) and might be bordered by a "stoa" (covered colonnade).

FOUND OBJECT (fr. F. *objet trouvé*, oh-zhay′troo-vay′). Any accidentally encountered object, natural or man-made, selected by an artist for presenta-tion as a work of art in itself or used as part of a work of art. If the found object has been altered in any obvious way, it is known as a "Found Object Assisted." If two or more found objects are put together, the work so con-trived is called an *assemblage*. The principle of the found object was intro-duced by Dada artists in the second decade of the twentieth century. The Surrealists saw the found object as yet another instance of the importance of chance in freeing the subconscious. In this sense, it can be viewed as a form of *automatism*. *See* READY-MADE.

FOUR-DIMENSIONAL. Involving the fourth dimension (time). Painting has traditionally involved only two actual dimensions (length and breadth) and

sculpture only three (length, breadth and depth). However, the suggestion of the third dimension on a two-dimensional surface has long been assumed to be an essential part of picturemaking. *See* PERSPECTIVE. In buildings, gardens and planned towns, the gradual revelation of space with movement of the observer and the sequential experience of separate spaces, i.e. "space-time" or four-dimensional relationships, have long been a conscious part of their design. Before the twentieth century, painting and sculpture, however, were basically restricted to three-dimensional relationships. For noteworthy exceptions, *see* CONTINUOUS NARRATION, KINETIC SCULPTURE. In the twentieth century, artists began to break away from traditional static notions of painting and sculpture and introduced actual motion into their works [*1071, 1075, 1080, 1084*], induced the observer to see their work from different *viewpoints* [*1082, 1083, 1092*], or explored new ways of suggesting the fourth dimension [*12, 998–1004, 1008, 1009, 1014, 1016, 1017, 1057, 1068–1070, 1085, 1141, 1142, 1148, 1150*]. *See* SIMULTANEITY.

FREE LEG. The relaxed and slightly lifted leg of a standing figure. Unlike the *engaged leg*, it bears little weight. *See* CONTRAPPOSTO.

FRESCO (It., fresh). A painting made on fresh, wet lime plaster with *pigments* suspended in water [*304–311, 526, 528, 532–535, 598, 600–603, 606, 608, 609, 611, 630, 638, 639, 656–659, 671–673, 693, 741–745, 753, 769, 770*]. The fresco technique is usually used for decorating walls and ceilings. The plaster absorbs the colors and, when it dries, makes a very durable painting that is literally part of the wall, not simply applied to its surface. Since plaster dries rather quickly, only a small section (giornata), large enough to be painted at one time, is laid up with wet plaster. In Italian fourteenth-century frescoes, this final layer (intonaco) was usually applied over an outline drawing (*sinopia*) of the composition, which had previously been made on a layer of rough plaster. Since the artist must work quickly, completing the part to be painted before the plaster dries, the medium encourages a rather broad technique which reveals the individual brushstrokes [*658*]. The colors in true fresco painting are much paler than those in *oil painting* or *tempera* painting, because they are absorbed by the white plaster. True fresco painting is sometimes called "buon fresco" (boo-on fres'ko; It., good fresco) to distinguish it from "fresco secco" (fres'ko sek'ko; It., dry fresco), the method of painting on the surface of the dry plaster with pigments mixed in a binding *medium* — a much less permanent technique which often results in flaking [*527*]. In practice, both techniques were usually employed: "buon fresco" for the basic painting and "fresco secco" for touching up. Fresco painting was especially favored in Italy from the time of the ancient Romans through the eighteenth century.

FRIEZE (freez). 1. The middle member of an *entablature*, between the *architrave* and the *cornice* [fig. 36; *181*]. In the Doric *order*, the frieze is decorated with *triglyphs* and *metopes* [*188, 191, 647, 853, 855*] and in the other orders it may be carved with various ornaments, figures, or inscriptions [fig. 34; *176, 198, 255, 268, 277, 616, 623, 709, 733, 811*], but it may also be left bare [*253, 665, 757, 769*]. 2. Any long horizontal band of ornament resembling a frieze, whether decorated or not [*226, 228, 285, 286, 301, 310*].

FRONTAL. An adjective used to describe an object which faces the viewer directly and is not set at an angle or *foreshortened*. A "frontal view" is one in which the viewer places himself directly opposite one of the principal faces of an object. In early stages of the development of the arts, frontal and *profile* views are usually favored over "angle views" [*84–87, 111, 137, 166, 170, 171, 432, 494, 519*]. In later stages of development, angle views may be favored over frontal and profile views [*224, 232, 302, 309, 473, 506, 689, 700, 745, 749, 773, 822, 972, 973*]. *See* VIEWPOINT.

FROTTAGE (fro-tahzh'; F. fr. *frotter*, to rub). The process of reproducing a textured surface by laying a piece of paper upon it and rubbing the paper with a pencil, charcoal stick, crayon, etc. Frottage was used by the Surrealist Max Ernst, who combined various rubbings in *collages* and used them as starting points for drawings and paintings.

f-STOP. A camera *lens* aperture setting, indicating a ratio between the focal length of the lens and the diameter of the selected aperture. An early device for controlling the quantity of light entering a lens was a metal plate, pierced with holes of various diameters, which blocked or "stopped" some of the light. This was superseded by a continuously variable "iris diaphragm" of overlapping metal leaves, placed inside compound lenses. The standard "f-numbers" are 1, 1.4, 2, 2.8, 4, 5.6, 8, 11, 16, 22, 32, 45, 64, etc. The higher the f-number, the smaller the aperture and quantity of light transmitted. Each "stop" passes half as much light as the preceding setting. The "speed" of a lens is measured by the f-number of its maximum effective aperture. A "fast" modern lens might be marked $f/1.4$; a "slow" lens, $f/4$. The unstopped lenses used in early *cameras* were about $f/11$. In general, higher f-stops increase the sharpness of the image and "depth of field" (the range of distances, near and far, within which objects are in sharp focus). Members of the $f/64$ Group in California during the 1930s, as their name indicates, preferred "straight" (unmanipulated) sharply focused, realistic images with very broad depth of field [*1127, 1128*].

GABLE (gay'bul). **1.** The triangular area formed by a pitched roof at the end of a building; it extends from the eaves or *cornice* to the ridge of the roof [*319, 403, 471*]. In classical architecture, the gable is called a *pediment*. **2.** Any member resembling a gable in shape, such as the triangular structures erected over the portals of Gothic churches [*435, 468, 473, 893*] or Gothic picture frames [*537*]. When relatively small, such ornaments are often called "gablets" (gay'blets).

GALLERY. 1. In churches, a story over a side aisle, open toward the *nave* [*340, 341, 344, 412, 413, 419–422, 424, 425, 454*]. Also called a "tribune." In Romanesque churches, arcaded galleries are also frequently used on exteriors, appearing in ornamental profusion in some large German and Italian *cathedrals* [*426, 428*] where they are called "dwarf galleries." **2.** In domestic architecture, a long room or corridor, often used for the display of paintings and sculpture. Grand examples, decorated with ceiling paintings, are the gallery of the Palazzo Farnese in Rome [*742*] and the Galerie des Glaces at Versailles [*811*]. The modern term "art gallery," a place where art is exhibited

to the public, is derived from the name for such rooms in private residences. Both public and commercial art galleries and museums proliferated during the nineteenth and twentieth centuries [1116, 1127] altering traditional modes of patronage. After the French Revolution, the former royal palace of the Louvre [808] was opened as the first national art gallery in 1793. The earliest gallery seems to have been the "pinakotheke" (Gk., picture chest) located in the north wing of the Propylaea on the Acropolis [190–193] at Athens.

GELATIN-SILVER PRINT. A photographic *print* made on paper coated with a silver halide suspended in gelatin. The gelatin coating is colorless and smoother and more transparent than the *albumen* coatings which it began to replace in the 1880s. Although gelatin emulsions scratch easily, they remain the standard coating for *films* and papers.

GENRE (zhahn-ruh; F. fr. L. *genus,* kind, class). Representations of everyday life, usually restricted to those made for their own sake rather than for some religious, moral, or symbolic purpose. Genre scenes and figures are common in Hellenistic and Roman art and in Western art since the sixteenth century [16, 25, 232, 303, 692, 728, 801, 823, 870, 875, 884, 915, 920, 928, 930].

GISANT (zhee-zahN; F., recumbent figure; *pl.* gisants). A tomb effigy of the deceased as a corpse. On fourteenth- and fifteenth-century Gothic tombs, the gisant was sometimes shown in a hideous state of decomposition, as a "memento mori" (reminder of death) for the living. Germain Pilon's Renaissance gisants of Catherine de' Medici and Henry II at St. Denis [736, 737], however, have been given an ideal beauty that evokes pathos only when we remind ourselves that such apparently noble people are now dead.

GLAZE (fr. Middle English *glasen,* fr. *glas,* glass). 1. A glassy coat applied to pottery to seal and color it [622]. 2. A thin, transparent or semi-transparent film of *oil paint* brushed over another layer of paint, allowing it to show through and usually altering its color. Thus glazes of red and flesh color laid over glazes of blue which, in turn, may be laid over a brown *underpainting* will approximate the healthy glow of living flesh, as in the paintings of Velasquez and Fragonard [799, 822]. Opaque *impastos* and "scumbles" may be added over transparent glazes to provide *highlights* and additional shadows. Both glazing and scumbling allow lower layers of paint to show through, but in glazing, the lower layer is seen because the glaze is transparent, and in scumbling, it is seen because there are breaks in the rough, opaque paint as it is rubbed or dragged across the canvas [11, 680, 688, 691, 799, 881, 927, 991, 993, 1034, 1037, 1040, 1047, 1051].

GOLD GROUND. The spatially neutral background of gold leaf against which figures were placed in medieval *mosaics,* panel paintings, and *miniatures* [339, 345, 408, 447, 522, 523, 525, 530]. In mosaic decoration, the gold leaf was usually applied to the back of each transparent glass *tessera;* the light is refracted as it passes into the glass, then reflected by the gold leaf, and refracted again as it passes back out through the glass. The individual reflection and refraction of light within each of the hundreds of tesserae, each set at a slightly different angle than the rest, creates a golden radiance which

appears to emanate from within the wall itself and shimmers with the slightest movement of the viewer. In painting, gold leaf is attached with size mixed with a pigment called "bole," usually a dull red which actually adds to the richness of the ground when the thin leaf begins to flake [525, 540, 541]. In panel painting, the gold ground is frequently tooled and built up ornamentally with plaster.

GOSPEL BOOK. A book containing the four Gospels of the New Testament which tell of the life and death of Christ and are ascribed to the Evangelists Matthew, Mark, Luke, and John, respectively. In medieval Gospel books, the symbol or "portrait" of each Evangelist often appears as a frontispiece to his Gospel [388, 397, 399, 408, 409, 444, 447].

GRAFFITI (gruh-fee'tee; *sing.*, graffito; fr. It. *graffio*, a scratch). Words and images scratched, painted, or chalked in public places, usually illicitly and surreptitiously. Jean Dubuffet (1901-1985), who saw graffiti as *art brut* (raw art), adopted their subversive character as part of his anti-cultural stance [1038]. The marketing of paint in spray cans led, during the 1970s in New York City, to a sudden efflorescence of large, colorful graffiti on subway cars and stations. During the 1980s, such professional artists as Keith Haring, developed graffiti-inspired styles and the graffitists themselves were encouraged to paint on canvas and exhibit their work in art galleries.

GRAPHIC ARTS. This rather ambiguous term always includes the traditional *printmaking* media (*woodcut, engraving, etching, lithography, silkscreen,* etc.), in which *line* and *value* have usually been more important than *color,* but *photography* and drawing are often meant as well. At its most inclusive, it encompasses all the two-dimensional arts, including painting. "Graphic design" is the preparation of words and images for printing, usually in such commercial applications as book production, posters, advertisements, and packaging. "Graphics" is a synonym for both "graphic arts" and "graphic design." It is also popularly used to refer to printed and televised graphs, charts, and illustrations, each one of which is colloquially called a "graphic."

GREEK AND ROMAN TEMPLE ARCHITECTURE. *See* CARYATID, CELLA, MOLDING, NAOS, ORDERS, PEDIMENT, PERIPTERAL, PERISTYLE, PODIUM, PORTICO, PRONAOS, STEREOBATE, THOLOS.

GREEK VASES. *See* AMPHORA, BLACK-FIGURED, HYDRIA, KRATER, KYLIX, LEKYTHOS, RED-FIGURED.

GROUNDLINE. The single line or edge used to indicate the level of the ground in the drawings of children and in the paintings and reliefs of the Egyptians, Sumerians, Assyrians, early Greeks, etc. [17, 72, 73, 74, 113, 123, 132, 156, 160, 162, 214, 243]. Since all figures and objects are oriented in relation to the groundline, it is a simple but effective means of organizing a composition. Compositions with groundlines present a marked contrast to the less precisely oriented clusters of figures in the art of younger children and prehistoric man [32, 35, 43, 71]. In more advanced stages of compositional organization, more than one groundline may be introduced for figures intended to be

further back; thus there is the suggestion of a *picture space*. The groundlines may be further elaborated by making them ripple to suggest the contours of the topography [*103, 115*] or by placing some of them obliquely to connect with other groundlines [*122*].

GROUND PLANE. In a picture or relief, the surface, apparently receding into the *picture space*, upon which people and objects seem to stand [fig. 44; *583, 638*].

GUM PRINT. A photographic *print* made with a photosensitive coating of gum arabic rather than gelatin [*985*]. This was a popular process with photographers who, toward the end of the nineteenth century, sought to merge the effects of painting with photography. The gum arabic was often *pigmented* and applied to paper of various colors and textures. When ammonium bichromate was used to sensitize the gum arabic solution, exposed areas would harden while unexposed areas would dissolve, revealing the color of the paper.

GUTTAE (gut'ee; *sing.* gutta; L., drops). In an *entablature* of the Doric *order*, peg-like projections beneath the *regulae* and *mutules*, possibly derived from the pegs used in wooden structures [fig. 36; *181, 183*].

HALLENKIRCHE (hahl'en-keersh'eh). The German word for "hall church," a church with *nave* and *side aisles* of equal height [*481*].

HAND. The unique *style* of a painter, sculptor, draftsman, etc., by which his work is recognized, especially in so far as it is recognizable by his *handling* of a *medium*. An artist may remain anonymous, like the "Foundry Painter" [*163*] or the "Master of the Hausbuch" [*572*], yet still have a clearly recognizable "artistic personality." The "hand" of such an artist is quickly discerned in his works. Sometimes, different hands may be distinguished within a single work, especially a *workshop* production. Much of the work of the *connoisseur* is devoted to distinguishing such hands and assigning an "oeuvre" (erv'r; F.), or body of work, to a given "master."

HANDLING. The particular way in which an artist works with his *medium*. Since the brushstrokes of a painter, the chisel strokes of a sculptor, or the pen strokes of a draughtsman may be even more personal than his handwriting, they are usually a principal means of identifying his individual *style*.

HAPPENING. An art event which may be partially planned as to objects, places, times and actions, but which intentionally incorporates a large measure of chance and therefore can neither be rehearsed in detail or exactly repeated. Although the composer John Cage and several artists associated with Pop Art (among them Jim Dine, Red Grooms and Claes Oldenburg) helped develop the concept in the 1950s, Allan Kaprow coined the term in 1959 and was largely responsible for defining its parameters and ramifications. Happenings were intended for places not usually associated with art or theater and were different from traditional theater in that they were essentially non-narrative, non-verbal and not designed for audience reaction but for participants only.

HARD-EDGE PAINTING. A term coined in the late 1950s to describe large-scale abstract paintings with bold sharply defined areas of *flat color*. The

hard-edge paintings of such artists as Ellsworth Kelly [1045], Frank Stella [1046] and Kenneth Noland offered a strong contrast to the irregularity and apparent spontaneity of Abstract Expressionism [cf. 1035, 1036].

HATCHING. A series of parallel lines used in drawing and printmaking to darken, or lower the *value*, of an area. In simple parallel hatching a single set of lines is used [fig. 30a; 631, 646]. In "crosshatching," a network of lines of darker value is made by drawing one set of hatchings over another [fig. 30b; 572, 719, 869]. An even denser network of lines, called "double crosshatching," may be made by superimposing still another set of parallels over simple crosshatching [fig. 30c; 785]. The roundness or *plasticity* of an object can be emphasized by "contour hatching," a series of curving lines defining the changing surfaces of three-dimensional forms [fig. 30d; 714, 716, 717, 719, 906]. By systematically varying the intervals between the lines of contour hatchings or by setting up a *foreshortened* grid of contour crosshatchings [fig. 30e; 645], striking effects of spatial recession can be created.

a b c d e

Fig. 30. Types of hatching: (a) parallel hatching, (b) crosshatching, (c) double crosshatching, (d) contour hatching, (e) foreshortened contour crosshatching.

HELIOGRAPH (fr. Gk. *helios*, sun, + *graphos*, a drawing). The name applied by Joseph-Nicéphore Niépce (nyeps), inventor of photography, to his *photographs*. The first permanent photograph taken from nature [902] in 1826 was made on a pewter plate coated with an asphalt compound (bitumen of Judea). It was placed in a *camera obscura* and exposed for eight hours to a view of the buildings outside the window of Niépce's attic workshop. The brightest parts of the image, focused on the plate, bleached the asphalt to a light gray and hardened it. Applying a solvent (a mixture of oil of lavender and white petroleum), the dark, unhardened areas and some of the middletones were removed, revealing the dark gray pewter beneath. Thus, the process of heliography, like daguerreotypy, resulted in a unique direct *positive* image.

HIGHLIGHTS. Those parts of an illuminated object which reflect the most light. In all kinds of *relief sculpture* much of the illusion of space and *plasticity* results from careful control of those edges and internal surfaces which catch the light, but this is especially true of sculpture in low relief [99, 100, 103, 124, 289, 579]. When *modeling* an object in a painting, the artist usually determines the location of the highlights, middle lights (or middletones), and "darks" in reference to a point source of illumination or, in considering his composition as a whole, according to those parts he wishes to emphasize for expressive reasons. In sixteenth-century Venetian painting and in many

Baroque paintings, sudden and dramatic highlights are common. Often, in these paintings, there is not only a sudden change in *value* but in the texture of the paint as well, a thick *impasto* being employed to snap the area forward [*11, 675, 680, 779, 780, 786, 787, 799*]. Highlights in drawing, printmaking, and *watercolor* painting, however, are usually formed by leaving the white of the paper uncovered rather than by adding a light pigment [*8, 9, 571, 631, 645, 646, 713, 714, 717, 719, 785, 858, 869, 906, 924*].

HÔTEL (oh-tel). A large French town house [*474, 820*].

HUE. That property of a color which gives it its name—red, green, violet, etc. The continuous band of the visible spectrum is usually divided into six basic hues—red, orange, yellow, green, blue, and violet—ranging from the *warm colors* to the *cool colors*. Intermediate hues can easily be described by reference to the neighboring hues, e.g. "orange-yellow," "blue-green," etc. White and black and the grays resulting from their mixture are "achromatic" colors; they are distinguished only by *value*, not by hue.

HYDRIA (hī'dree-uh; *pl.* hydriae; fr. GK. *hydor*, water). A full-bodied ancient Greek water jar with two horizontal handles at the shoulder for lifting and one vertical handle, joined to the neck, for pouring [*155*].

ICON (eye-kon; fr. Gk. *eikon*, image). One of the panel paintings of Christ, the Virgin, or the saints which are venerated by Orthodox Christians [*357, 358, 359*]. *See* CHOIR SCREEN.

ICONOGRAPHY (ī-kuh-nahg'ruh-fee). The study of subject-matter in the visual arts. Iconographers investigate the ways in which a particular *subject* has been presented by various artists over time, noting recurring conventions and changes in meaning. This may involve the interpretation of attributes, signs, and symbols, both traditional and concealed, as well as matters of *composition*, setting, costume, and gesture. Chapters II–V of this book offer many examples of the iconographical approach to art.

ILLUMINATED MANUSCRIPT. A *manuscript* decorated or illustrated with paintings and drawings, especially one ornamented with gold and silver and brilliant colors [*383, 384, 387, 388, 399, 401, 408, 409, 447, 450, 538, 543*]. *See* BOOK OF HOURS, CALLIGRAPHY, CODEX, DRÔLERIES, GOSPEL BOOK, MINIATURE, PAPYRUS, PARCHMENT, PSALTER, VELLUM.

ILLUSIONISM (fr. L. *illudere*, to mock). The endeavor of artists to represent visual phenomena as completely as possible within the limitations of their particular *medium* and the conventions of the time. The degree of illusionism achieved in any work cannot be measured absolutely, but only in relation to the methods of representation already established. When the Madonnas of Cimabue [*522*], Giotto [*529*], and Masaccio [*604*] are compared, it is apparent that each marks a different stage of technical progress in the recording of visual phenomena, but, in all probability, each painting appeared strikingly lifelike at the time it was painted. (Whether or not one is superior to another

in artistic quality is another matter altogether.) When one of the primary aims of an artist is to astonish the viewer with the apparent reality of an illusion, the French term "trompe l'oeil" (trohmp lur; "deceive the eye") is often used to describe both the object and the act of deception.

IMPASTO (im-pah'sto; It. *im*, in, + *pasta*, paste). Paint applied with the consistency of a thick paste, often used by Venetian and Baroque masters in sudden patches (impastos) of high *value* for *highlights* [*11, 680, 779, 780, 786, 787, 799*]. Among more recent painters noted for their heavy impasto are Cézanne [*941*], Van Gogh [*947, 948*], Rouault [*991*], Nolde [*993*], Kokoschka [*994*], Dubuffet [*1038*] and De Kooning [*1037*]. *Cf.* GLAZE.

INSTALLATION. A temporary work of art, often an *assemblage* or *environment*, created for a specific space, usually an art *gallery* [*1092, 1093, 1095*]. Installations became a popular form of exhibition during the 1970s and 1980s.

INSULA (in'soo-la; *pl.* insulae; in'soo-lee; L., island). **1.** A block in a Roman city. **2.** A large building or group of buildings in a Roman city, similar to a modern apartment house with shops on the ground floor and living quarters above [*276*].

JAMB. The side of a doorway or window frame [fig. 56]. The jambs of the portals of Romanesque and Gothic churches are frequently "splayed" (beveled or spread outward) and decorated with figure sculpture [*439, 453, 493*]. The part of the jamb from the window or door to the surface of the wall is called the "reveal" or, if it is splayed, the "splay." Much of the effect of mass in Romanesque architecture is due to the splays of windows and doorways which make walls seem even thicker than they actually are [*403, 415*].

JUXTAPOSITION (fr. L. *juxta*, near, + *position*). The placing of elements in close proximity. When this is done, the elements are said to be "juxtaposed."

KEEP. The massive central tower of a castle, used as a dwelling place by the lord of the castle and, in case of attack, as a final point of defense [*543*]. Also called *donjon*.

KINETIC SCULPTURE. Sculpture which is made to be seen while all or part of it is set in motion by mechanical or natural means [*1071, 1075, 1080, 1084*]. Many pieces of static sculpture, however, are intended to be set into apparent motion through the effect of parallax (apparent change in the position of objects — or parts of objects — relative to each other when seen from different *viewpoints*) and apparent changes in the shapes of solid and hollow *volumes* as the observer walks around them [*229, 700, 821, 1065–1070, 1073, 1074, 1088*] or through them [*1049, 1076, 1092*]. Early forms of kinetic sculpture (although they were not called that at the time) are fountains [*628, 747, 759*], fireworks [*927*], stage machines and hydraulic and spring-driven automata, all of which were highly developed during the seventeenth and eighteenth centuries. During the twentieth century, a number of artists introduced actual motion into abstract sculpture. Among the pioneers were the Italian Futurist

Giacomo Balla (c. 1915), the Russian Constructivists Tatlin [1071] and Naum Gabo (1920), and Laszlo Moholy-Nagy (1920s) at the Bauhaus in Germany. These artists used mechanical methods of generating motion, but the delicately balanced breeze-activated *mobiles* developed by Alexander Calder in the 1930s have perhaps been the most influential of all forms of kinetic sculpture [1138]. The most perverse example of mechanical sculpture is Jean Tingueley's "Homage to New York" (1960) which was designed to destroy itself in the sculpture garden of the Museum of Modern Art in New York.

KOUROS (koo'ross; *pl,* kouroi; Gk., a youth). An Archaic Greek statue of a standing nude youth [166, 167]. The Archaic Greek statues of clothed maidens [171, 172] are known as "korai" (*sing.* kore; kor'ay).

KRATER (kray'ter). An ancient Greek pottery bowl with a deep, broad body, wide mouth, and two handles, used for mixing wine with water [155].

KYLIX (kī'lix; *pl.* kylikes; kī'lih-keez). An ancient Greek drinking cup with two horizontal handles near the rim of a broad, shallow bowl standing on a slender stem with a relatively small foot [fig. 31; 155, 161, 163, 164].

Fig. 31. Kylix (sixth century B.C.).

LANTERN. 1. A *turret* crowning a dome, roof, or tower, usually pierced with windows for light or louvres for ventilation [fig. 24; 350, 423, 425, 486, 618, 666, 813, 827, 850]. **2.** A tower above the *crossing* of a church [410, 475].

LAPIS LAZULI (lap'is laz'yoolee). A semiprecious blue stone [112] found in the Near East, used for carving and pulverized to make true ultramarine blue, a very intense and expensive pigment used by medieval and Renaissance artists, especially for painting the robe of the Virgin [522, 523, 529, 530, 541, 555].

LEKYTHOS (lek'ih-thos; *pl.* lekythoi). A nearly cylindrical ancient Greek oil flask, tapered at the bottom, with a slender vertical handle springing from a rather flat shoulder and attached to a long narrow neck with a small mouth for pouring [fig. 32; 155]. "Whiteground" lekythoi, covered with a yellowish-white slip (diluted clay) and often decorated with delicate brush drawings of domestic scenes and scenes of farewell, were used as funerary offerings [214].

Fig. 32. Lekythos.

LENS. A transparent material, usually glass or plastic, having one or more curved surfaces, which bend light rays. In *cameras,* lenses are used to "focus" (form a clear image) on the "film plane" (focal plane). A simple double convex lens (curved outward on both sides like a magnifying glass) was recommended for use with the *camera obscura* as early as 1550. Modern camera lenses, however, are "compound" (composed of several elements) to reduce "aberrations" (imperfections) affecting the clarity, shape, and color of the focused image. Lenses vary in "focal length" (the distance from the lens to the "focal plane" where the image is formed). "Long-focus" and "telephoto" lenses, which have a long focal length and offer a narrow "field of view," magnify distant objects. A "wide-angle" lens has a relatively short focal length which broadens the normal field of view (about 50°). Since they reduce the normal distance between subject and camera, wide-angle lenses are particularly useful in photographing interiors [*1106, 1123, 1131*] and large buildings [*1111, 1117*]. They have the additional advantage of increased "depth of field" (distance within which objects are in sharp focus). Camera lenses are usually fitted with internal diaphragms to vary the amount of light transmitted. *See ƒ*-STOP. In some cameras, *shutters* are also integrated with the lens.

LINE. In drawing, a mark left by a moving point. Since we are all familiar, to some degree, with the varieties of line made by different movements of the hand, lines are often evocative of states of feeling associated with those movements. Thus, lines are frequently described as nervous, gentle, strong, angry, tense, etc. Variations in direction, thickness, and density may record the sudden movements and pressures usually required to make a jagged line or the gentle and relaxed motions required to draw a light, undulating line with any rapidity [cf. *8, 9, 214, 215, 380, 399, 400, 682, 906, 954, 988, 990, 1025, 1026*]. The outlines, silhouettes, or edges of objects are also often called "lines." Although such "lines" may not actually have been made by a moving point they often have much of the same character. Sometimes, a painting— and even a sculpture or a building—with few or no lines drawn on its surface, is described as "linear," if its edges are sharply defined [*433, 556, 613*] or its

parts are very slender [465–481, 567, 1035, 1071, 1073–1075, 1088, 1092, 1140, 1143]. A distinction, introduced by the art historian Heinrich Wölfflin (1864–1945), is still often made between linear and *painterly* modes of presentation. Painterly works in any medium, whether actually painted or not, are conceived in broad masses of light and dark; edges are blurred rather than sharply defined [11, 21, 675–680, 688–696, 749–753, 774–777, 784–787, *818, 822, 844, 902, 927, 934, 983, 985, 1037, 1039, 1041, 1043, 1044;* cf. *611* and *689, 613* and *760, 616* and *754, 624* and *816, 863* and *867*]. In any work, linear or not, lines may be implied by separate edges or points brought into alignment with each other [fig. 52]. The eye quickly relates these separate elements; children, for example, in connecting the numbered points in a follow-the-dots picture, often lose interest and put down their pencils once the direction of the "line" established by the dots becomes clear.

LINTEL (lin'tul). A horizontal beam, of any material, spanning an opening, as over a window or doorway, or between two pillars [fig. 46; *52, 95, 152*]. The lintels of the portals of Romanesque and Gothic churches are often highly ornamented [fig. 56; *433, 437, 493*]. See POST-AND-LINTEL CONSTRUCTION.

LITHOGRAPH (fr. Gk. *lithos,* stone, + *graphos,* a drawing or writing). A *print* made from a design drawn on a slab of fine-grained limestone. The lithographic process is based on the principle that water and grease will not mix. The design is drawn on the flat surface of the stone with greasy lithographic crayons or pencils, or with a pen or brush dipped in lithographic ink (tusche). Sometimes, a plate of zinc or some other metal, which has been given a granulated surface that will hold both grease and water, is used instead. Once the surface is moistened with water, the greasy printing ink, which is rolled over it, will only adhere to the greasy lines of the drawing. Prints are made by placing a dampened sheet of paper on top of the stone or plate, and passing them, on a traveling bed, through a special press which rubs the back of the paper. Any of the common drawing techniques can be used in making a lithograph; no special style or technical skill is required of the artist as in the preparation of a *woodcut, engraving,* or *etching.* If the artist does not choose to be burdened with a plate or heavy stone, all he needs is a piece of paper and a lithographic crayon; later, his drawing can be directly transferred to the stone and it will not even be reversed in printing as in the other graphic processes. Unless such special effects as scratching are used, a lithograph is easily mistaken for an original drawing; only the flat and even character of the ink betray it as a print. Lithography was invented at the end of the eighteenth century and was widely used during the nineteenth century for magazine and book illustration [*869, 906, 938, 955, 995*]; it remains, in one form or another, an important means of commercial book production, since thousands of impressions can be made from a single plate. This book, for example, was printed by a photomechanical process known as "offset lithography."

LOCAL COLOR. The basic color of an object in normal daylight, free from modification by shadows cast by nearby objects or unusual illumination such

as artificial light, the warming effect of sunrise and sunset, and color reflected from surrounding surfaces. *Cf.* FLAT COLOR.

LOGGIA (lo'ja *or* lah'ja). A covered passage or gallery with an open arcade or colonnade on one or more sides. It may be an integral part of a building, connect two separate buildings, or stand alone [*251, 665, 696, 701, 767, 827*].

LUNETTE (loo-net'; F., little moon). Any semicircular opening or surface, as on the wall of a vaulted room, over a doorway, window, etc. [*592, 622, 623, 746, 847, 853*]. A lunette over the portal to a medieval church is called a *tympanum.*

MADRASAH (ma-dras'a; Arabic, place of study). A collegiate mosque, or theological school, usually built with a vaulted hall opening onto each side of a square court with a fountain in the center [*371*].

MANUSCRIPT (fr. L. *manu scriptus,* written by hand). A handwritten book or document, either original or a copy. *See* CALLIGRAPHY, CODEX, ILLUMINATED MANUSCRIPT, PAPYRUS, PARCHMENT, VELLUM.

MASONRY. Construction in stone, brick, or concrete. Stones, bricks, and concrete blocks are usually laid in mortar, a mixture of lime or cement with sand and water, which binds them together. "Dry masonry" is stonework or brickwork laid without mortar [*188*]. Stones and bricks are laid in "courses" (level rows). A brick or squared stone laid lengthwise is called a "stretcher." Those laid perpendicular to the face of the wall are "headers." Headers serve to bind the face to the "backing," the rougher stonework or brickwork behind the face. *See* FERROCONCRETE, RUSTICATION, WALL.

MASTABA (mas'ta-ba; Arabic, a stone bench). A rectangular Egyptian tomb with a flat roof and "battered" (sloping) walls, covering a subterranean burial chamber and containing a chapel for offerings and a compartment, called the "serdab," with a statue of the deceased [*75*].

MAT (*also* matt *or* matte). 1. Lusterless or dull rather than glossy and highly reflective. *Watercolors* are usually mat when dry, whereas *oil paint* is naturally glossy, an effect which may be enhanced by the application of varnish. *Acrylic* paint is normally glossy unless a special mat *medium* is mixed with it. Photographic printing paper is available in a variety of surfaces from mat to glossy. 2. A border, usually cut from cardboard, serving as a transition between a *print,* drawing, etc. and its frame or used solely by itself to frame the work. Valuable watercolors, drawings and prints (including photographs) are normally stored away from light in acid-free mats with a hinged backing.

MEDIUM (*pl.* mediums *or* media). 1. The physical material with which an artist works (marble, clay, ink, oil paint, steel, concrete, etc.). In creating a work of art, an artist usually "thinks in terms of his medium," attempting only what can be conveniently achieved within its physical limitations. Sometimes, however, he may display his skill in a technical "tour de force," which defies the intrinsic nature of his medium and wins applause for its sheer difficulty, quite

apart from any expressive power the work may have [*21, 302, 479, 549, 567, 571, 698, 700, 714, 717, 750–753, 762, 891*]. Beginning in the nineteenth century and continuing far into the twentieth century, a purist aesthetic based on "truth to material" and the "expression of structure" spread with moral fervor from architectural criticism to the criticism of the other arts; only certain forms were thought proper to a given medium: massive, chunky forms in stone sculpture, for example, or a neutral grid pattern "expressing" the steel skeleton in skyscraper design. Such limitations can be a spur to creation, as in the work of Mondrian [*1018*], Brancusi [*1064*], Henry Moore [*1065, 1066*], or Mies van der Rohe [*1110*], but, as Henry Moore himself pointed out, if "truth to material" were the sole criterion of excellence, "a snowman made by a child would have to be praised at the expense of a Rodin or a Bernini." See MIXED MEDIA. **2.** The fluid, or "vehicle," in which *pigment* is suspended to make paint, allowing it to spread easily and adhere to a surface. The medium of *oil paint* may be one of various drying oils; gum and water is the usual medium of *watercolors;* egg yolk and water is the medium for egg *tempera,* etc. The same pigments may usually be mixed with many different mediums.

MEGALITHIC (fr. Gk. *megas,* large, + *lithos,* stone). Made of great stones, as prehistoric *cromlechs* and *dolmens* [*50–52*]. Each huge stone in such a structure can be called a "megalith." Walls made of megaliths, so huge that they seem to have been laid by such giants as the one-eyed Cyclopes of Greek mythology (*see* Chapter Two), are also sometimes called "Cyclopean" [*152*].

MEGARON (meg′a-ron; *pl.* megarons *or* megara; fr. Gk. *megas,* large). A large oblong hall in a Minoan or Mycenaean palace, having a hearth at the center and four columns supporting the roof. Entry to the hall was gained by first passing through a porch with two columns and then a *vestibule* [*139, 153*]. The megaron is thought to be the antecedent of the *naos* and *pronaos* of the Greek temple.

METOPE (met′oh-pee; Gk., fr. *meta,* between, + *ope,* opening). In the *frieze* of an *entablature* of the Doric *order,* one of the panels between the *triglyphs,* sometimes ornamented [*174, 181, 183, 188, 191, 647, 853, 855*]. Originally, in wooden temples, the metopes may have been openings between the ceiling beams.

MEZZANINE (meh′za-neen; F., fr. It. *mezzanino,* fr. *mezzano,* middle). A low story between two higher ones, especially one just above the ground floor [*969, 970*].

MIHRAB (mee′rahb; Arabic). A *niche* on the wall of a mosque, indicating the *qibla* or direction of Mecca [*365, 366*]. To the right of the mihrab is a "minbar," a pulpit from which the "imam" (ih-mahm′), a religious leader, recites prayers and reads from the Koran, the sacred book of the revelations of Allah (God) to Mohammed, the founder of Islam, the religion of Moslems.

MINARET (min-a-ret′). One of the towers of a mosque, tall and slender in its developed form and ringed with one or more balconies from which the muezzin (moo-ez′in) calls the faithful to prayer [*342, 364, 372–375*].

MINIATURE (fr. Medieval L. *miniatura*, fr. *miniare*, to color with minium, a red pigment used for illuminating manuscripts). **1.** Any painting or drawing in an illuminated manuscript [*327, 328, 353, 383, 408, 409, 450, 538*]. **2.** A very small portrait intended as a keepsake [*313, 563, 725*].

MINIMAL ART. Painting and sculpture characterized by extreme simplicity of form and/or process. The term was commonly used in the 1960s to describe such paintings as those by Ellsworth Kelly [*1045*] and Frank Stella [*1046*] which rejected the personal expressionism and formal complexity of *Action Painting*. Some of the works of sculpture which displayed this tendency were also called *Primary Structures* [*1077–1079*]. Such early twentieth-century abstractionists as Kazimir Malevich [*1005, 1006*], Hans Arp [*1021*], and Piet Mondrian [*1018*] are considered predecessors of Minimalism.

MIXED MEDIA (*or* mediums). **1.** A term indicating the use of two or more *mediums* in the making of a work of art. The term has gained currency among those who are unable or unwilling to list the often complex combination of mediums used in works by the many twentieth-century artists who have abandoned the use of traditional mediums in unmodified form. It is a convenient, albeit totally vague, way of designating a medium without actually doing so. **2.** During the 1960s, the term began to be used as a generic designation for complex environmental works, events, *Happenings*, or performances combining such normally distinct art forms as dance, mime, film and music. Also called "Intermedia" and "Multimedia."

MOBILE (moh'beel). A delicately balanced construction of movable parts made to be suspended in such a way that the parts will be set in motion by movements of the air. Alexander Calder was the first to make this form of *kinetic sculpture* [*1075*]. A sculpture by Calder which is not intended to move is called, by contrast, a "stabile."

MODELING. **1.** The creation of three-dimensional forms by working some soft material such as clay. Modeling is often an additive process; it differs from the entirely subtractive process of carving in that material may be added as well as taken away. **2.** By analogy, in painting and drawing, the suggestion of the three-dimensional character of a body by altering the *value* of colors along its surface, as though light were falling with greater intensity on some parts than on others. In painting, this may be accomplished by applying *shades* and *tints* of the basic *hue*. Sometimes, however, the basic hue is used at its highest *saturation* for the lowest dark, while tints of the same hue are used for the rest of the area being modeled. In this case, the colors are more luminous since none of them are deadened by mixture with black, but the darks, because of their higher saturation, may be more insistent than the lights. The darks, then, will tend to project and may counteract, to a degree, the effect of *plasticity* which is usually the purpose of modeling in the first place [*530, 540, 541, 607*]. In "color modeling," used extensively by Cézanne [*941–943*], the tendency of *cool colors* to recede and *warm colors* to project, is exploited; reds, oranges, and yellows are used to bring *planes* forward and blues to keep them back in the *picture space*. Color modeling is usually used as a supplement to traditional modeling rather than as a total replacement for it. *See* SHADING.

MODULE (mod'yool). The basic unit of measure determining the major divisions and *proportions* of an object, figure, building, or site. In determining the proportions of the human body, for example, the height of the head is usually used as the basic module.

MOLDING. An ornamental band of grooves or projections which lend intricacy to the surfaces of buildings by catching and modulating the light and casting shadows. Complex moldings are usually compounded of a few basic and familiar forms [figs. 33, 34]. Moldings, whether used singly or as members of a compound molding, may be smooth and continuous or have their surfaces "enriched" with carving. In classical architecture, only certain types of ornament are customarily applied to certain types of molding, because of the particular affinities of form between the ornaments and the *profiles* of the moldings. The "egg-and-dart" *motif*, for example, is usually applied to the ovolo molding, the "leaf-and-dart" to the cyma reversa, and the "bead-and-reel" to the astragal, etc. [fig. 34; *176, 289, 623, 630, 632*].

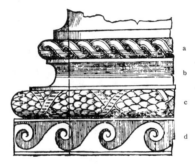

Fig. 33. Column base after Serlio: (a) torus molding with guilloche ornament, (b) scotia molding, (c) torus molding with leaf garland, (d) plinth with Vitruvian scroll.

MONASTERY(fr. Gk. *monasterion*, a place for living alone). The dwelling place of a community of monks. The many parts of a large monastery are indicated in fig. 35, based on a ninth-century plan preserved in the library of the monastery of St. Gall, Switzerland [cf. *395, 396*]. The monks slept in the "dormitory," ate in the *refectory*, copied *manuscripts* in the *scriptorium*, lodged guests in the "hostelry," distributed alms in the "almonry," nursed the sick in the "infirmary," and in the "novitiate"—itself a monastery in miniature—instructed the novices in the monastic life. *See* ABBEY, CHARTREUSE, CLOISTER.

MONOCHROME (fr. Gk. *monos*, one, + *chroma*, color). A painting in various *values* of a single color. A painting made only in grays is known as a "grisaille" (greez-eye'; fr. F. *gris*, gray). During the Renaissance and Baroque periods, monochromes were used as imitation (fictive) sculpture [*550*, top; *551* bottom; *742*], as preparatory *underpaintings* [*640*], or simply for their own sake. Variations in *hue* are so subdued in Cubist paintings that their effect is essentially monochromatic [*999, 1000, 1009, 1010*]. Black-and-white

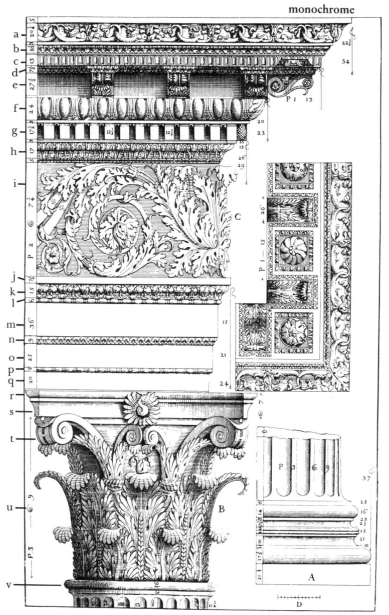

(a) Cyma recta molding with interlaced dolphins, forming the 'cymatium,' or top member of the cornice.
(b) Cyma reversa molding with leaf-and-dart motif.
(c) Fascia enriched with fluting.
(d) Cyma reversa molding with leaf ornament.
(e) Modillions with acanthus leaf ornament.
(f) Ovolo molding with egg-and-dart motif.
(g) Dentils.
(h) Cyma reversa molding with leaf ornament.
(i) Frieze with rinceau of acanthus leaves.
(j) Fillet molding.
(k) Cyma reversa molding with acanthus ornament.

(l) Astragal molding with bead-and-reel motif.
(m) Fascia.
(n) Cyma reversa molding with leaf ornament.
(o) Fascia.
(p) Astragal molding with bead-and-reel motif.
(q) Fascia.
(r) Ovolo molding, which, together with (s), forms the abacus of the capital.
(s) Cavetto molding with acanthus flower.
(t) Volute.
(u) Acanthus leaves on the bell of the capital.
(v) Astragal molding.

Fig. 34. Corinthian capital and entablature after Palladio.

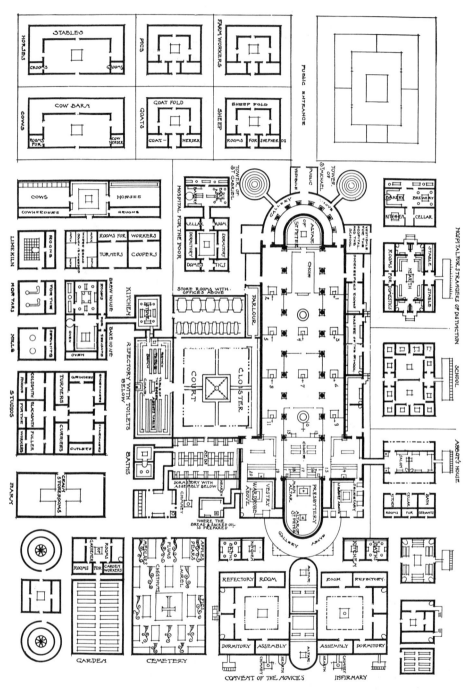

Fig. 35. Plan of a monastery redrawn after a ninth-century manuscript (Porter).

reproductions, unfortunately, reduce even the most colorful painting to variations of gray, a false "grisaille."

MONOLITH (fr. Gk. *monos,* one, + *lithos,* stone). A single very large stone. *Columns* or *obelisks,* which are carved from a single stone, are said to be "monolithic." In European archaeology, a long unshaped or roughhewn monolith, set upright by itself or as part of a row or circle of similar stones, is also called a *megalith* or "menhir."

MONUMENTAL. An adjective frequently used in art criticism to describe any structure, painting, figure, etc., which is grand, massive and apparently permanent like a monument, regardless of its actual size. The term is also used to describe any work that is merely large, even though it may be small in intrinsic *scale.*

MOSAIC. A method of decorating walls, pavements, and vaults with patterns or pictures composed of small pieces of colored stone or glass (*tesserae*) set in a wet cement which, upon hardening, holds them in place. Mosaics were widely used in ancient Roman houses and Early Christian and Byzantine churches [*302, 321, 322, 325, 326, 337–339, 345, 349, 351, 354, 355, 362*]. *See* GOLD GROUND.

MOSQUE ARCHITECTURE. *See* MADRASAH, MIHRAB, MINARET, QIBLA, STALACTITES.

MOTIF (moh-teef'). 1. Any prominent feature of the *subject* or form of a work of art. 2. The natural landscape serving as the subject of a landscape painting. The Impressionists made a point of painting "en plein air" (in the open air), directly from the motif, rather than in the studio from sketches [*913, 921*].

MURAL (fr. L. *murus,* wall). A large painting, in any *medium,* made for a particular wall, whether painted directly on its surface or painted on a canvas or panel affixed to it. *Cf.* FRESCO.

MUTULE (myoo'chool). One of a series of flat blocks with *guttae* under the projecting *cornice* of an *entablature* of the Doric *order* [*174, 181, 188, 189*].

NAOS (nay'os). The Greek word for the *cella,* or main body, of a temple [*182*].

NARTHEX. The entrance hall or porch preceding the *nave* of a church [*320, 393*]. In churches with an *atrium,* the narthex is often simply one side of the open *ambulatory* [*317, 423, 425*]. At Hagia Sophia there is an outer narthex (exonarthex) in addition to the main narthex [*341*].

NAVE (nayv, fr. L. *navis,* a ship). The great central space in a church. In longitudinal churches, it extends from the entrance to the *apse* (or only to the *crossing* or *choir,* when these exist) and is usually flanked by *side aisles* [fig. 14; *317, 318, 320, 321, 393, 470*].

NEGATIVE. A photographic image in which the *value* relationships are the opposite of those in the original subject, i.e. lights appear as darks, darks as lights. Transparent negatives on glass or *film* are used to make *positive* prints or *transparencies.* The first negative-positive photographic process was

invented by W. H. Fox Talbot and patented in 1841 under the name *calotype*. Using a single negative, it is possible to print a large number of identical positives by direct contact or through projection in an *enlarger*. Value relationships of the print may be altered by varying *exposure* times, varying development, using print emulsions of differing contrast, using *filters* on the enlarger lens, or by "dodging," i.e. limiting the exposure of selected areas by the use of opaque material of different shapes placed between the enlarger lens and the print.

NICHE (nitch *or* neesh; fr. L. *nidus*, nest). A hollow in a wall, often arched, intended to contain a statue, *bust*, vase, etc., or introduced solely to add depth and shadow to a surface [*273, 274, 277–279, 486, 550, 573, 578, 580, 607, 616, 647, 660, 661, 672, 701, 733, 754, 757*].

OBELISK. In ancient Egyptian architecture, a slender squared *monolith* tapering toward a pyramidal top. *Monumental* obelisks, carved with hieroglyphic inscriptions, were placed in Egyptian temple complexes as solar symbols [fig. 48 background; *95* background]. Obelisks, transported from Egypt by the ancient Romans, now stand near churches in Rome, surmounted by crosses as signs of the triumph of Christianity over paganism [*747, 759*]. Since the Renaissance, when obelisks were rediscovered, the form has been used for architectural ornamentation and monuments [*1081*], often on a very large scale. Nineteenth-century examples are the Bunker Hill monument in Boston and the 555-foot Washington monument in the District of Columbia.

ODALISQUE (oh'da-lisk; F., ohda-leesk'). A female harem slave. The reclining odalisque was as popular a *subject* for nineteenth-century French painters as the reclining Venus for Renaissance and Baroque masters [*863, 867*].

OIL PAINTING. Although Jan van Eyck is traditionally credited with the invention of oil painting, *pigments* mixed with drying oils (linseed, walnut, poppyseed, etc.) were used long before the fifteenth century for special purposes such as painting on stone or metal. Van Eyck and the Master of Flémalle, however, were among the first to use the medium for ordinary panel painting. With oils, which were far more flexible than the traditional *tempera*, they could create *illusionistic* effects of extraordinary subtlety, richness, and luminosity [*547, 548, 553, 555*]. Oils permitted the smooth blending of colors, high *saturation* even at low *values*, the use of transparent *glazes*, almost infinite detail, and the possibility of reworking the same area over and over again. Other capabilities of oil paint were realized in the sixteenth and seventeenth centuries, when it was sometimes roughly applied to coarse canvas in opaque "scumbles" and thick *impastos*, or mixed on the canvas with wet paint of another *hue* to create "shot colors" [*799*]. Oils are usually applied either to a panel covered with layers of smooth "gesso" (glue and gypsum or chalk), as in tempera painting, or to stretched canvas "sized" with a solution of glue and "primed" with a white pigment. When the finished painting is dry, a coat of varnish may be applied to protect the surface and to brighten and blend the colors. Since varnish will yellow in time, it must be periodically dissolved and renewed if the colors are to retain a semblance of their original appearance. *See* UNDERPAINTING.

OPEN FORM. An individual element or the whole *composition* of a painting, sculpture or building which extends into a surrounding environment. In pictures and *reliefs* with open compositions, forms, objects and figures are often *asymmetrically* disposed and overlapped by the border [*11, 694, 742, 773, 880, 818, 915–918, 922, 927, 1057*]. Figures sometimes look beyond the immediate setting toward something beyond the frame [*684, 774, 777, 780, 793, 802, 822, 823, 849, 860, 861, 874, 888, 889, 916, 944*]. In extreme cases, sections may even break out beyond the principal border [*745, 751–753, 768, 769*] or appear to penetrate the *picture plane* [fig. 16; *745, 769, 779, 784*]. Open form in freestanding sculpture and architecture usually consists of prominent projections, reaching out into the surrounding space, and numerous hollows, penetrating the basic mass of the work [*21, 221–225, 277, 278, 625, 627, 628, 700, 749, 760, 766, 815, 817, 821, 830, 890, 891, 972, 1090, 1069, 1076, 1097, 1100, 1115*]. In extreme cases, hollow volume may completely dominate mass [*1071, 1073, 1088, 1100, 1106*]. In an attempt to characterize major differences in Renaissance and Baroque *style*, the Swiss art historian Heinrich Wölfflin (1864–1945) distinguished *closed form* as generally characteristic of Renaissance art and open form as characteristic of Baroque. The other distinguishing " polarities" (pairs of opposites), which he proposed, were: *linear* vs. *painterly, plane* vs. recession, multiplicity vs. unity, and clearness vs. unclearness. In each pair, the first trait refers to the Renaissance and the second to the Baroque. Although highly questionable as absolute characteristics underlying all of the many different styles of art coexisting during these two complex periods, Wölfflin's polarities are nonetheless useful as universal concepts variously applicable to the art of many different times and places. *Cf.* CLOSED FORM.

ORDERS. An architectural "order" is one of the classical systems of carefully proportioned and interdependent parts which include a *column* (comprised of base, shaft, and *capital*) and its *entablature* (comprised of *architrave, frieze,* and *cornice*). Although the capital of each of the five generally recognized orders is its most distinctive feature, each order also has its own characteristic system of *proportion,* so that any alteration in the size of one part necessitates a change in the size of all the other parts [fig. 36]. The oldest, sturdiest, and most severe of the orders are the Greek Doric [*174, 181, 183–189*], which is the only order without a base, and the Tuscan [*830*], which is supposedly derived from ancient Etruscan temples [*246*]. The Roman Doric, while it has a frieze composed of *triglyphs* and *metopes* like the Greek Doric, differs from it in having a base [*647, 853*]. The Ionic order is more slender than the Tuscan or Doric and is quickly distinguished by the *volutes* of its capital; like the Corinthian and Composite orders, it has a three-part architrave [*181, 196, 226, 253, 704*]. The Corinthian [fig. 34; *181, 195, 198, 255, 278, 709, 757, 758, 850*] and Composite [*277*, bottom; *322, 705, 901*] orders are the most sumptuously ornamented and the most slender; both have capitals decorated with *acanthus* leaves, but in the capital of the Composite order the leaves are combined with the large volutes of the Ionic order. The pedestals, which are sometimes used to support the columns of an order, are not considered part of the order itself, but architectural theorists since the Renaissance have

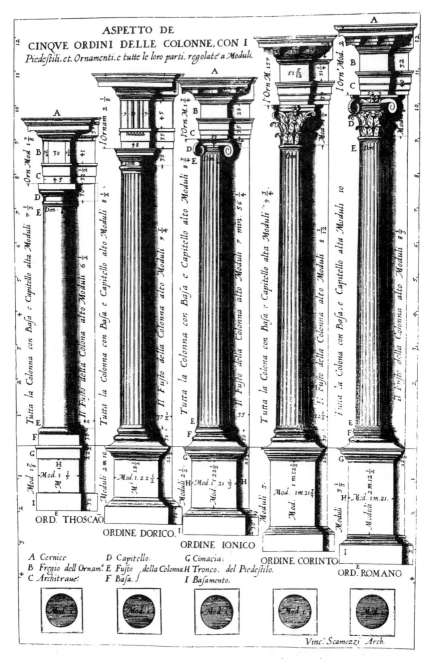

Fig. 36. The Tuscan, Roman Doric, Ionic, Corinthian, and Composite orders after Scamozzi: (A) cornice, (B) frieze, (C) architrave, (D) capital, (E) shaft, (F) base, (G) cap or cornice, (H) die or dado, (I) plinth; (A), (B), (C) comprise the entablature; (D), (E), (F) the column; (G) (H), (I) the pedestal.

provided appropriate proportions and *moldings* for pedestals for each of the orders [fig. 36]. Pedestals are useful devices for raising an order above a *balustrade* [*263, 827, 901*] or for raising the entablature above a row of windows [*665*] or above the crowns of the arches of an "arch order" (an order applied to an *arch* or arcade) [*300, 616, 733, 810*] without altering the width of the columns. If, in these cases, the columns were placed lower down, but allowed to rise to the same height, they would have to be thicker, because the proportion of each column is predetermined. In some cases, one of the more slender orders might be used to reach the same height without a corresponding increase in width, but the choice of another order would change the character of the building. The ornate Composite order, for example, would hardly be an appropriate substitute for the Tuscan if the architect had already fixed on just this order as the means of conveying an impression of a stern, martial character. Once a particular order has been selected, the classical or classicizing architect must abide by its traditionally accepted set of proportions. He cannot simply stretch or compress the shafts of his columns at will as Romanesque and Gothic architects chose to do [*413, 418, 433, 451, 454*]. *See* ABACUS, ARCHITRAVE, ATTIC, COLOSSAL ORDER, COLUMN, CORNICE, ECHINUS, ENTABLATURE, ENTASIS, FLUTING, FRIEZE, GUTTAE, METOPE, MODULE, MUTULE, PILASTER, REGULA, RESPOND, SUPERIMPOSED ORDERS, TAENIA, TRIGLYPH, VOLUTE.

ORIENTATION. In architecture, the positioning of a building along an east-west *axis*. In churches, the main *altar* is traditionally placed at the east end of the building and the principal entrance is placed at the west.

PAINTERLY. Works of visual art in any medium, whether actually painted or not, are called painterly when they are conceived in broad intermingling masses of light and dark, rather than sharply defined units with distinct edges. Edges are blurred and forms merge with one another and with their backgrounds [*11, 21, 675–680, 688–696, 749–753, 774–777, 784–787, 818, 822, 844, 902, 927, 934, 983, 985, 1037, 1039, 1041, 1043, 1044;* cf. *611* and *689, 613* and *760, 616* and *754, 624,* and *816, 863* and *867*]. The term is a direct translation of the German *malerisch*, which was first used in this special sense by the Swiss formalist art historian Heinrich Wölfflin (1864–1945) in his efforts to define differences between Renaissance (linear) and Baroque (painterly) styles in painting, sculpture, and architecture. *See* LINE, OPEN FORM, TONE.

PAINTING MEDIA AND TECHNIQUES. *See* ACRYLIC, ACTION PAINTING, AIR BRUSH, ATMOSPHERIC PERSPECTIVE, AUTOMATISM, CASEIN, CARTOON, CHIAROSCURO, COLLAGE, COLOR, COLOR FIELD PAINTING, DECALCOMANIA, ENCAUSTIC, FRESCO, FROTTAGE, GLAZE, GOLD GROUND, HARD-EDGE PAINTING, HIGHLIGHTS, IMPASTO, MAT, MEDIUM, MODELING, OIL PAINTING, PAINTERLY, PIGMENT, SFUMATO, SHADING, SHAPED CANVAS, SHADOW, SINOPIA, TEMPERA, TRANSPARENCY, UNDERPAINTING, WASH, WATERCOLOR.

PALAZZO (pa-lot′so; *pl.* palazzi; pa-lot′see). A large Italian town house [*597, 613, 760*].

PAPYRUS (pap-ire′-us; L. root of "paper"). A writing material of thin sheets made by slicing and pressing the pith of the papyrus plant of the Nile Valley, used in scroll form by the ancient Egyptians, Greeks, and Romans. Schematized versions of the papyrus plant, its bud, and its flower [*89*] were used as models for many Egyptian *columns* and *capitals* [*79*].

PARCHMENT (fr. Gk. Pergamum, the name of a city in Asia Minor). Any animal skin (sheep, goat, calf, etc.) prepared for writing or painting upon, including *vellum* [*328, 387, 388, 399, 408, 409, 447, 450, 538*].

PASTEL. 1. Powdered *pigments* mixed with gum and formed into sticks for drawing. Pastels are usually so broadly applied over the entire surface of the paper that the effect resembles *oil painting*, although the colors are generally rather pale and have a dusty look. The dry strokes are often blended with the fingers or with a "stump" (Fr. *tortillon*) of rolled paper. The surfaces of pastel drawings or "paintings," as they are often called, are very powdery and are sometimes sprayed with a protective "fixative" to stabilize the pigments, but even thin films of varnish may darken and dull the colors. The medium was popular with eighteenth- and nineteenth-century artists, especially in France. Degas was able to achieve unusually rich effects by roughly *hatching* one layer of intense color over another [*917*]. **2.** An adjective used to describe colors, in any medium, that are pale like pastels [*1026*].

PAVILION (fr. F. *pavillion*, a tent). **1.** Any light, ornamental building [*894*]. **2.** Any large-scale block or wing of a building projecting from the main body [*733, 765, 808, 901*].

PEDIMENT (ped′iment). **1.** In classical architecture, the low-pitched *gable*, or triangular area, formed by the two slopes of the low-pitched roof of a temple, framed by the horizontal and raking *cornices* and sometimes filled with sculpture [*173–176, 178, 253, 268, 616, 704, 710, 827, 830, 850, 853, 855*]. **2.** Any architectural member of similar shape, as over a door, *niche*, window, etc. [*618, 705, 847*]; sometimes, the upper cornice takes the curve of a segment of a circle, in which case it is called a "segmental pediment" [*660, 661, 733, 765, 826, 901*]. "Broken pediments," having parts of their cornices omitted or brought forward in advance of other sections, were sometimes used in later Roman and Baroque architecture [*277, 665, 702, 709, 751*].

PENDENTIVE (pen-den′tiv; fr. L. *pendere*, to hang). One of the curving triangular segments of *vaulting* which spring from the corners of a square plan to support a circular *dome* or *drum* [fig. 24; *351, 620, 829*], first used on a large scale at the church of Hagia Sophia in Istanbul [*340, 341, 344*]. Previously, the circular bases of domes had been supported by cylindrical walls, as at the Pantheon in Rome [*265–268, 322–324*] or more abruptly by the use of the "squinch," an arch, or series of arches, projecting over the angles of a square substructure [*348, 349*]. On a small scale, squinches are used to join the angles of Islamic *stalactite* ornament [*370*].

PERFORMANCE ART. A generic term encompassing various twentieth-century art activities involving aspects of such performing arts as mime, theater, dance, music, and video, but with a strong visual focus [*1094*]. While conceived outside the object-oriented traditions of the *fine arts*, performance art nevertheless often reaches its widest audience through photographs "documenting" the live event. Subclasses of performance art are: "Actions," which may be quite simple, solitary, and unwitnessed; "Body Art," in which the primary *medium* is the artist's body; and *Happenings*.

PERIPTERAL (peh-rip′teral). An adjective describing a building with a colonnade around its entire perimeter [*182–190, 226, 227, 647, 648*]. The "Maison Carrée" at Nîmes and the "Temple of Fortuna Virilis" at Rome [*253*] are "pseudo-peripteral" in that the columns around the *cella* are engaged (set in the wall) and not freestanding.

PERISTYLE (perry′-style; fr. Gk. *peri*, around, + *stylos*, a column). 1. The colonnade around a *peripteral* building [*182*] or around a court [*648*]. 2. An open garden court in a Roman house, surrounded by a colonnade [fig. 25].

PERSPECTIVE. The representation, on a two-dimensional surface, of three-dimensional objects in space. The term is sometimes restricted to the particular method of spatial representation developed during the fifteenth century, in which all parallel lines and edges of surfaces receding at the same angle are drawn, on the *picture plane*, in such a way that they converge toward a single *vanishing point* [fig. 37; *581, 583, 598, 602, 604, 606–611, 630, 634, 638, 642, 672, 689, 708, 719, 751, 757, 831, 838*]. This method of suggesting a single unified space is often called "linear perspective" to distinguish it from the many other methods of spatial representation which were developed long before the Renaissance. It is a highly artificial system presupposing a one-eyed observer standing stock still and staring dead ahead, but it has important advantages: a high degree of artistic focus and unity can be achieved because all receding surfaces are usually related to only one or two vanishing points; when only one vanishing point is used, it may be located within the principal figure or at some other significant *focal point* within the composition; a single *viewpoint* can be precisely established so that the *picture space* appears to be a continuation of the actual space in which the viewer stands; and, if the rate of diminution in the size of objects and the intervals between them is kept absolutely regular as they recede toward the background, the size of all similar objects can be precisely determined once the size of only one of them is known [*cf.* figs. 37 and 38]. In practice, however, even Renaissance artists seldom used the new invention with complete consistency; it took a great deal of time to apply the system with mathematical exactitude and strict adherence to it might even conflict with more important artistic concerns. At any rate, a very convincing illusion of space could be achieved if the older means of spatial representation were included within a general framework constructed according to the new system. Among these older means of suggesting depth are: (1) "vertical perspective," in which objects farther from the observer are shown higher on the picture plane than those which are closer [fig. 39; *17, 43, 103, 105, 314, 328, 382, 1026*]; (2) "diagonal perspective," in which farther

Fig. 37. Perspective diagram of Masaccio's "Trinity" fresco in Sta. Maria Novella, Florence.

Fig. 38. Diagram deduced from Masaccio's "Trinity" showing the ground plan of the chamber and the surface of the barrel vault (H. W. Janson).

Fig. 39. Figures arranged in "vertical perspective."

objects are not only higher on the picture plane than nearer objects but are also aligned along an oblique *axis,* thereby suggesting continuous recession [fig. 40; *115, 122, 292, 326* buildings, *359, 400* walls and temple, *446* tower, *535* coffins, *539* pool]; (3) overlapping [fig. 41; *89, 90, 92, 99, 102, 123, 143, 146, 162, 214, 322, 338, 381, 445, 447, 523, 540*]; (4) diminution in the size of objects and diminution of the interval between them according to their distance from the viewer [figs. 30e, 42; *306, 327, 534, 543*] ;(5) *foreshortening* [fig. 29; *163, 234, 250, 303*]; (6) *modeling* [*309, 311–313, 357, 397–400, 521*]; (7) cast *shadows* [fig. 50; *302, 306, 308, 314, 543, 546, 547,*

a b

Fig. 40. (a) Figures arranged in "diagonal perspective." (b) Cube represented in "diagonal perspective."

Fig. 41. Recession by overlapping.

Fig. 42. Recession by diminution of size and interval.

551]; (8) *atmospheric perspective* [243, 305, 307, 353, 548]. Each one of these "distal cues," or signs of spatial recession, may be used alone or in various combinations. All of them are either already included and refined within the system of linear perspective or can be combined with it to enhance the illusion of depth. They can also be combined with those earlier systems in which the parallel lines of receding surfaces converge in several unrelated vanishing points. [305, 524, 542, 525], along a "vanishing axis" [fig. 43; 522, 540], sometimes called "herringbone perspective," or in a "vanishing area" [529, 531, 547, 553]. *See* ATMOSPHERIC PERSPECTIVE, FORESHORTENING, PICTURE SPACE, VANISHING POINT, VIEWPOINT.

Fig. 43. Orthogonals converging along a "vanishing axis" (a).

PHOTOGRAM. A *photograph* made without a *camera* by placing objects directly on light-sensitive paper. Photograms were developed as a *medium* for abstract art by Moholy-Nagy [*1141*] and Man Ray [*1140*], who called his own photograms "Rayographs." The photographic pioneer W. H. Fox Talbot (1800–1877) called the process "photogenic drawing."

PHOTOGRAPH (fr. Gk. *phos*, light, + *graphos*, drawing). A permanent image formed by the action of light falling on a sensitized surface [*902–905, 907–909, 979–981, 1119–1150*]. Chemical methods of preserving the image formed by the *camera obscura* were developed during the first half of the nineteenth century by Niépce (*heliograph*), Daguerre (*daguerreotype*), Talbot (*calotype*) and Sir John Herschel (1792–1871), who, among his many contributions to photography, gave the new medium its name in 1839. The most promising photographic experiments were based on the darkening of silver salts upon *exposure* to light, a phenomenon observed by Johann Heinrich Schulze (1687–1744) and published in 1727. Silver salts are crystalline compounds of silver and the halogens (chlorine, bromine, and iodine). These silver halides produce silver when only slightly exposed to light. This "latent image" (fr. L. *latens,* hidden) can be chemically "developed" (made visible) and "fixed" (prevented from darkening further upon exposure to light). Herschel discovered that hyposulfite of soda ("hypo") was a solvent for silver salts in 1819 and used it to fix a *negative* early in 1839. It became the standard photographic fixing agent and remains so today. The invention of photography was as revolutionary as the development of printing in the West during the fifteenth century. It provided a new measure of reality and visual truth. During the last quarter of the nineteenth century, the two inventions were combined with the development of rapid printing techniques and the "halftone process" for reproducing pictures, by which continuous tone images are reduced to dots of varying size by photographing them through a fine linear grid or "screen" [fig. 16]. This photo-mechanical revolution changed the

world forever, replacing the relative uniqueness of the visual image with a mass of visual information so overwhelming that it can never be absorbed by a single individual. *See* HELIOGRAPH, DAGUERREOTYPE, CALOTYPE, POSITIVE, NEGATIVE, TRANSPARENCY, PRINTING OUT PAPER, ALBUMEN PRINT, WET PLATE PROCESS, SILVER BROMIDE PRINT, GELATIN-SILVER PRINT, PLATINUM PRINT, CHLORIDE PRINT, GUM PRINT, AUTOCHROME.

PHOTOGRAPHY. *See* CAMERA OBSCURA, CAMERA, PHOTOGRAPH, LENS, FILTER, *f*-STOP, SHUTTER, EXPOSURE, NEGATIVE, POSITIVE, TRANSPARENCY, FILM, PHOTOGRAM, PRINT, COMBINATION PRINT, PHOTOMONTAGE, CHRONOPHOTOGRAPH, ENLARGER, HELIO-GRAPH, DAGUERREOTYPE, CALOTYPE, PRINTING OUT PAPER, ALBUMEN PRINT, WET PLATE PROCESS, SILVER BROMIDE PRINT, GELALTIN-SILVER PRINT, PLATINUM PRINT, CHLORIDE PRINT, GUM PRINT, AUTOCHROME.

PHOTOMONTAGE (fr. Gk. *phos*, light, + F. *montage*, fr. *monter*, to mount). An image made by combining two or more separate photographic *prints* [*1138, 1139*] or the process of making such images. Prints or pieces cut from them are pasted together on a separate surface, as in *collage*. Edges may be concealed by scraping, sanding and painting. Then the entire image may be rephotographed to conceal variations in thickness and texture. Photo-montage was especially popular among artists and graphic designers in the 1920s and 1930s. Their bizarre, often Surrealistic, *juxtapositions* are espe-cially startling because of our tendency to equate *photographs* with reality. Photomontage is a process distinct from multiple-*exposure* photography and combination printing, although all can be used to combine separate images. *Cf.* COMBINATION PRINT.

PIAZZA (pee-at'-sa; *pl.* piazzas *or* piazze). Italian word for a public square [*350, 491, 747, 759*], called a "place" (plahss) in France, a "Platz" (plahtz) in Ger-many and Austria, and a "plaza" (plah'tha) in Spain.

PICTURE PLANE. The surface upon which a picture is painted [fig. 44; *719*].

Fig. 44. Transparent cube showing picture plane (a), picture space (b), ground plane (c), orthogonals (O), and transversals (T).

PICTURE SPACE. The space that appears to extend back beyond a *picture plane,* although it is only an illusion created by such pictorial devices as *foreshortening,* linear *perspective,* and *atmospheric perspective* [fig. 44; 719]. For ease in describing the location of objects on the ground plane, the picture space is usually divided into "foreground," "middle ground," and "background." Any object or figure in the extreme foreground which is used to lead the eye into the picture and to "push back" other objects, making them appear farther back in the picture space than they otherwise would, is called a "repoussoir" (ruh-poo-swahr; F. fr. repousser, to push back) [525, 528, 689, 783, 785, 915, 916, 956]. Planes which are established further back in the picture space and are placed parallel to the picture plane, to lead the eye back like the stage flats on either side of a theater set [918], are called "coulisses" (koo-leess), the French word for such side-scenes or "wings" [fig. 44; 306, 381, 635, 636, 805, 806, 872, 944]. Lines in the picture space which are perpendicular to the picture plane are called "orthogonals." Lines crossing orthogonals at right angles are called "transversals" [fig. 44b]. Distinctly drawn orthogonals and transversals, marking the edges of paving blocks or ceiling beams, are used to clearly define the picture space in many Late Gothic and Renaissance paintings and *reliefs* [524, 531, 540, 547, 581, 598, 638, 642, 672, 689].

PICTURESQUE. Literally, "like a picture" or providing a suitable subject for a painting. The eighteenth-century British gentlemen who used the term, however, had a very particular kind of painting in mind: seventeenth-century landscape paintings such as those by Claude Lorraine [805, 806], Nicolas Poussin [804], Jan van Goyen [788], and Jacob van Ruisdael [789]. In these paintings, they admired the broad handling of areas of light and dark and the subtle adjustment, or "keeping," of values in relation to the whole; they were intrigued by the "intricacy" of outline and texture, the sudden contrasts and "irritations" of the eye, the irregular "grouping" of elements which lead the eye gradually back into hazy "distances;" and they were delighted with the "partial concealment" of Gothic ruins, old castles, or ancient temples that stimulated curiosity and roused the imagination through "trains of associated ideas." These effects, which the British admired in the seventeenth-century landscape paintings which they collected, they also admired in the natural landscape around them. They saw the landscape of England, Scotland, and Wales with eyes accustomed to the effects of Baroque painting and, not content simply to travel in search of the Picturesque and to describe it, as the Rev. William Gilpin did in his "Picturesque Tours," or to write poems about it as John Dyer and James Thompson did, they "improved" their country estates to bring them into harmony with the effects of the landscape painting which they admired [849]. In the process, they created the "English garden," or "landscape garden," and provided an alternative to the formal gardens of the school of Le Nôtre [cf. fig. 45 and 812].

Architecture, too, was viewed with the painter's eye and analogies were drawn with landscape painting. James Adam, brother of Robert Adam [852], noted: "What is so material an excellence in landscape is not less requisite for composition in architecture, namely the variety of contour, a rise and fall of

Constant Bourgeois del. L'Architecture Gravée par D. la Porte. le Paysage par Hulk.

Fig. 45. Temple of Love by Richard Mique (1778) in the English Garden of the Petit Trianon, Versailles (Laborde).

the different parts and likewise those great projections and recesses which produce a broad light and shade." These qualities were considered essential to the creation of "movement." Movement in architecture, like movement in landscape, involves, as Robert Adam put it, "an agreeable and diversified contour, that groups and contrasts like a picture." Any building, then, which displays such movement is Pictureseque, i.e. it has qualities similar to those of a Baroque landscape painting. Toward the end of the eighteenth century, admirers of the Picturesque went so far as to model their buildings on the *asymmetrical* villas and castles depicted in the landscapes of Claude and Poussin, so that they too would blend into their surroundings and create a variety of interesting angle views. Not surprisingly, Sir John Vanbrugh, the first Englishman to design intentionally irregular buildings and one of the first to conceive the landscape garden, was also the architect who was most highly praised throughout the eighteenth century for his handling of movement [*830*]. Reynolds called him "an architect who composed like a Painter" and praised him for his skill in "affecting the imagination by means of association of ideas," a psychological factor that is almost inseparable from the Picturesque point of view, despite the high value that the enthusiasts of the Picturesque placed on the appreciation of abstract form. Reynolds explains the principle of association by offering an example which is particularly relevant to Vanbrugh's architecture:

Thus, for instance, as we have naturally a veneration for antiquity, whatever building brings to our remembrance ancient customs and manners, such as the Castles of the Barons of ancient Chivalry, is sure to give delight. Hence it is that *towers and battlements* are so often selected by the Painter and the Poet, to make a part of the composition of their ideal Landscape; and it is from hence in a great degree, that in the buildings of Vanbrugh, who was a Poet as well as an Architect, there is a greater display of imagination, than we shall find perhaps in any other . . . For the purpose, Vanbrugh appears to have had recourse to some of the principles of the Gothick Architecture; which, though not so ancient as the Grecian, is more so to our imagination . . . " (Discourse XIII)

It is chiefly the principle of association—especially, the evocation of the ancient and the exotic [*892, 894, 898*]—for which the Picturesque is remembered today; the importance of the Picturesque point of view in the evolution of abstract art and the direct dependence of twentieth-century site planning and asymmetrical architectural design upon the Picturesque [*1097–1100, 1102–1104, 1112–1118*] have only recently been acknowledged.

PIER (peer). Any vertical mass of *masonry* such as the supporting members of an arcade [figs. 3, 63].

PIGMENT. The powder which gives paint its color, obtained from any of a great variety of clays, stones, animal and vegetable matter, synthetic dyes, etc. To make paint, pigments are mixed with a "vehicle," or *medium* (glue, egg, oil, etc.), which allows the color to be easily spread and fixed to a surface.

PILASTER (pil-ass'ter). A flat, vertical member projecting slightly from a wall surface and divided, like a *column* of one of the classical *orders*, into a base, shaft, and *capital* [*251, 277, 613, 616, 623, 665*]. Pilasters, although they

customarily support an *entablature,* are usually introduced for decorative rather than structural reasons. The pilaster-like shafts projecting from the exterior walls of Romanesque churches, often without bases or capitals, are called "pilaster strips" to distinguish them from pilasters of the classical orders [*403, 423, 426*].

PILLAR. Any vertical support, a general term including *column, pilaster,* and *pier.*

PINNACLE (pin'a-kul; fr. L. *pinna,* a sharp point). A small ornamental *turret* placed, in Gothic architecture, atop *buttresses* and *piers* [fig. 63; *427, 435, 467, 468, 470, 471, 473, 475, 490*]. Although in some cases pinnacles may load buttresses and thereby help to counteract the *thrust* of *vaults,* they are primarily decorative, contributing to the splendid confusion of the exterior, breaking horizontal lines, and, like spearheads, emphasizing the vertical sweep of Gothic design. Just as pinnacles break the silhouette of the main body of a Gothic church and point heavenward, their own surfaces may be covered with pointed "gablets" (gay'blets; little *gables*), their edges may be broken with sprouting "crockets" of carved foliage [*435*], and the whole topped with a *finial.*

PLAN (fr. L. *planum,* a flat surface). **1.** A drawing representing those parts of a building or site that would lie on a horizontal plane cutting through the building close to the floor or the ground. Doorways, windows, staircases, domes, vaults, etc., which lie above or below this plane, are usually included in the plan [*323,* cf. *322, 324; 341,* cf. *340, 342, 344*]. The plan is a very old concept. An example over 4,000 years old is carved on the lap of a seated statue of the Sumerian ruler Gudea [*117*]. *See* ELEVATION, SECTION. **2.** The general arrangement of the parts of a building, a group of buildings, or site. Basic types of regular plans are: (1) the axial or longitudinal plan, arranged along a single *axis* [*97, 153, 182*] or arranged along a principal axis with parallel and transverse axes [*260, 317, 393, 419, 476*]; (2) the central plan, arranged about a single point, as in circular plans [*51, 323, 648*], polygonal plans [*335, 392, 596*], and Greek cross plans [*618*]; (3) the grid plan, two sets of parallel axes set at right angles to each other with neither dominating [*71*]. Various combinations of these regular plans have been used [*374, 487, 649, 814*] and, since the eighteenth century, intentionally irregular plans have also been cultivated [*892, 894, 973, 1098, 1103, 1115–1117*].

PLANE. A flat surface. In creating works of art and in analyzing them, it is often convenient to reduce complex three-dimensional bodies—whether a single object, figure, or an entire composition—to a few basic planes or facets. Sometimes this is done to establish the basic structure of what will be a very complicated work when it is finished, as in "blocking out" a sculpture or making a rough sketch for a painting or building [*3, 646, 719,* cf. *630* and *631,* cf. *864* and *865*], but often painters or sculptors are content with a simplification of natural forms [*57, 68, 84, 137, 169, 238*]. They may even make it one of the principal aims of their art [*609, 610, 941, 945, 949, 966, 1055, 1064*]. Some architects and abstract sculptors, too, prefer smooth surfaces and simple geometrical forms [*80, 93, 403, 431, 482, 486, 488, 618,*

851, 1067, 1075–1079, 1081, 1082, 1097–1118]. A painting, sculpture or building which is largely composed of planes which are parallel to each other and unforeshortened with relation to the viewer is said to be "planar" [*123, 177, 291, 540, 581, 598, 638, 675, 696, 719, 803, 804, 808, 838, 884, 926, 945, 961, 1012, 1033, 1053, 1087, 1100*]. Some artists may prefer the stability usually associated with planar organization, while others favor the relative dynamism of *foreshortened* planes and receding curves [fig. 16; *10, 278, 473, 689, 700, 728, 749–761, 767–776, 821, 822, 861, 891, 899, 956, 972, 1007, 1071*]. *See* VIEWPOINT.

PLASTICITY (fr. Gk. *plastos*, formed, molded). In the visual arts, the three-dimensional quality of a form, its roundness, palpability, apparent solidity, or quality of relief. The adjective "sculptural" is often used to suggest the same quality in painting and architecture [*10, 278, 309–311, 527, 596, 604, 632, 647–649, 658, 666, 718, 742, 838, 972, 1013, 1111–1114*].

PLATINUM PRINT. A photographic *print* on paper coated with an emulsion of platinum salts rather than silver salts [*983, 984*]. Platinum printing paper (Platinotype) was marketed from 1879 until World War I when its cost became prohibitive. During the later twentieth century, the platinum process was revived by some photographers despite its cost, because of its very subtle range of *values* and extraordinary permanence.

PODIUM (L., fr. Gk. *podion*, little foot). 1. The high platform serving as a base for an Etruscan or Roman temple [*246, 253*]. 2. The ground floor of a building treated so that it resembles such a base [*704, 808, 847, 901*].

POLYCHROME (fr. Gk. *poly*, many, + *chromos*, colored). Made with different colors. "Polychromy" is the practice of coloring sculpture [*56, 66, 698*] or architecture [*352, 540, 541, 607, 609*] with different *hues*. Polychromed, or "polychromatic," sculpture was common in antiquity [*86, 101, 104, 172, 247*] and the Middle Ages [*502–505*] although the color has often faded or been lost over time. During the Renaissance, it became the practice to leave the various sculptural *mediums* in their natural state, perhaps in imitation of surviving pieces of classical sculpture which had by then lost their color. The painting of sculpture was gradually revived during the twentieth century and by the 1960s became quite common [*7, 1075, 1088, 1090, 1092*].

PORTICO (por'tiko). A porch treated in the classical manner, with a colonnade supporting an *entablature* and *pediment*, usually approached by a wide flight of steps [*183, 253, 268, 704, 765, 847, 850, 853*].

POSITIVE. A photographic image having the *value* relationships of the original subject. The use of the terms *negative* and *positive* to describe *photographs* was introduced in 1840 by the astronomer and photographic pioneer Sir John Herschel (1792–1871). The *heliograph* and *daguerreotype* are early forms of photograph which are "direct positives," i.e. made without an intermediate negative.

POST-AND-LINTEL SYSTEM. The simple and very ancient system of construction in which the basic unit consists of two or more uprights, or "posts,"

Fig. 46. Egyptian temple construction (Chipiez).

supporting a horizontal beam, or *lintel* [51, 52]. Across two lintels, laid parallel to each other, other lintels may be laid at right angles to support a roof or ceiling; this is basically the system of the Egyptian temple [fig. 46; 93, 95]. When stone lintels are used, however, the supports must be close together because of the brittleness of stone, which lacks tensile strength (the ability to resist bending and stretching), although it has great strength under compression. When blocks of stone are supported throughout their length, as

in a wall, they can bear a tremendous weight placed directly above them [251], but when a stone lintel is used to span an opening it may sag in the middle, causing the top to be squeezed shorter and the bottom to be stretched [fig. 47]. If the supports are very widely spaced, the lintel will crack and collapse of its own weight even if nothing is placed on top of it. No large hall, then, can be covered with a post-and-lintel system of stone unless the supports are placed close together, as in the many-pillared hall of an Egyptian temple, called the "hypostyle" hall (fr. Gk. *hypostylos,* resting on pillars, fr. *hypo,* under, + *stylos,* a pillar) [fig. 48; 97]. The sanctuary, or *cella,* of a Greek temple [182] however, is not cluttered with columns because the roof beams were made of wood, which has much greater tensile strength than stone and therefore can be used to span much greater distances without bending and breaking. The Romans were able to cover vast, uninterrupted spaces by using an "arcuated" system, i.e. one employing the principle of the *arch,* which utilizes the high compressive strength of stone without overstraining its low tensile strength. However, they retained the post-and-lintel system, or "trabeated" system (fr. L. *trabs,* beam) as it is sometimes called, for the visual *articulation* of walls [253] and arcades [263]. The post-and-lintel system is still widely used for construction in wood, steel, and *ferroconcrete* which are all high in tensile strength [970, 1110].

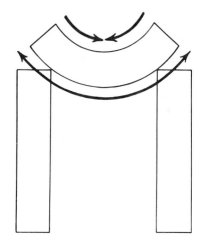

Fig. 47. Exaggeration of stretching of the lower part of a lintel and compression of the upper part due to the pull of gravity.

PREDELLA (pray-del′la; *pl.* predellas *or* predelle; It., kneeling-stool). The base of a large *altarpiece,* frequently decorated with painted predella panels or sculpture expanding the theme of the major panel or panels above [545, 546, 567].

PRIMARY COLORS. The three basic *hues*—red, yellow, and blue—from which, theoretically, all others can be mixed. When strong color contrast is desired the primaries are often *juxtaposed* [102, 104, 912, 1017, 1018, 1037, 1053, 1055, 1092, 1100, 1113, 1116] and used in conjunction with their

complementary colors [*101, 381, 383, 384, 387, 450, 530, 540, 541, 711, 949, 1008, 1029, 1044, 1051, 1057*]. Red, yellow and blue are the primaries for the mixture of *pigments* to be seen by reflected light. We see only the hue which is reflected; all other colors (wavelengths) of light are absorbed (subtracted) by the pigment. In the case of transmitted light, such as that seen emanating from stained glass, the glass blocks out all but the color seen. When colored light itself is mixed, the primaries are red, green, and blue. Thus, when red light is superimposed on green light, yellow is produced. *See* SECONDARY COLORS.

PRIMARY STRUCTURE. *Minimal* sculpture, common in the 1960s, employing basic geometrical *shapes* and solids, sometimes on a very large, architectural scale [*1076–1079, 1081–1083*]. In many cases, the surfaces of primary structures were flat, smooth and, if painted, *monochrome.*

PRINT. Originally, an impression made from a woodblock [*569, 719*], *engraving* plate [*5, 571, 716, 717*], etc. By extension, any image made by a process, including *photography,* which can produce nearly identical copies. With the spread of *printmaking* in Europe during the fifteenth century, it became possible for almost anyone to possess a picture. Before the invention of printing, every image was necessarily unique, as it could never be copied by hand without the introduction of some new variation. The printing of numerous identical images and texts greatly stimulated the spread of precise scientific and artistic information with a previously unattainable degree of accuracy. An "original print," as distinguished from a "reproduction," is one which has been printed from a master image made by the artist and printed either by the artist or under the artist's supervision. Original twentieth-century prints are usually signed by the artist in pencil in the margin. While older prints are not usually individually signed, the original artist, the printmaker (if distinct from the original artist), and the publisher are often identified in the margin. The following Latin words and abbreviations were commonly used during the sixteenth century and after: **f., fec., fecit** (he made it); **inv., invenit** (he invented it); **p., pinx., pinxit** (he painted it); **del., delin., delineavit** (he drew it); **inc., incidit** (he cut it); **sculp., sculpsit** (he engraved it); **imp., impressit** (he printed it); **exc., excud., excudit.** (he executed it; usually identifies the publisher). *See* ENGRAVING, PHOTOGRAPH.

PRINTING OUT PAPER. Photographic paper in which an image is produced solely by *exposure* to light without chemical development [*1120*]. During the nineteenth century, most *prints* were made by exposing printing out paper to sunlight passing through a *negative.* The papers were relatively "slow" (insensitive to light) and exposures were long. Until the development of electric light, artificial sources of illumination were too weak for effective exposure. After exposure, the image was chemically "fixed" (preserved) to prevent further darkening.

PRINTMAKING. See PRINT, WOODCUT, BLOCK BOOK, ENGRAVING, BURIN, DRYPOINT, ETCHING, AQUATINT, LITHOGRAPH, SILKSCREEN, HATCHING.

PROFILE. 1. The side view of an object. Profile and *frontal* views of objects are usually preferred in the early stages of the development of the representational arts, and frequently long after, because they reveal objects in their most characteristic aspect, without *foreshortening*. This makes them clearly recognizable and gives them an air of permanence [*38, 74, 132, 146, 160–162, 331, 716, 945, 985, 991, 993, 1008, 1064, 1130*]. *See* FRONTAL, VIEWPOINT. 2. A portrait showing the sitter's head and shoulders as seen from the side; this usually lends the sitter an air of nobility and a measure of eternity not attainable in the more accidental and ephemeral three-quarter view [*236, 722*]. 3. In architecture, the cross-section of a *molding*. Profiles were of intense concern to Gothic and Renaissance architects, as evidenced by the many carefully measured drawings of them that survive. Much of the apparent weightlessness of Gothic architecture results from the deeply grooved profiles of *ribs* and *tracery* which break up all masses into slender lines and edges [fig. 63; *451, 473, 479*].

PROGRAM. 1. In complex works of painting or sculpture, such as the Sistine Ceiling [*656*] or the portals of Chartres Cathedral [*493*], the underlying conceptual scheme—theological, humanistic, political, or personal—determining the choice of *subject* matter and symbolism. 2. In architecture, all the requirements for a project, including use, materials and appearance, drawn up before construction begins. When a program exists in writing, or can be inferred historically with some accuracy, it provides an important basis for criticizing the effectiveness or success of the project and can be used to ward off irrelevant criticism.

PRONAOS (pro-nay'os, Gk. *pro*, before, + *naos*). The entrance chamber preceding the *naos*, or *sanctuary*, of a Greek temple, having continuations of the walls of the naos for its sides and a colonnade in front [*175, 176, 182, 186, 254*].

PROPORTION. In any object, figure, or composition, the relation, or ratio, of one part to another and of each part to the whole in regard to size, height, width, length, or depth. The proportions of an object are usually considered in relation to those of other objects of its kind or in relation to the normal proportions of the human body. A *column,* a man, or a statue of a man is called tall, short, thick, or thin in respect to its deviation from an established norm, or "canon," of proportion. The canon is usually based on a unit of measure called the *module*. The module most frequently taken to determine the proportions of the human body, for example, is the head, the normal human body being 7 or 7½ "heads" tall. In determining the proportions of a classical column, the module taken is usually its diameter (or sometimes half of its diameter) measured at the base of the shaft [fig. 36]; the slender Corinthian column may be 10 diameters high, but a column of the Greek Doric *order* may be 6½ or only 4 diameters. Thus, when the Greek Doric order was revived during the eighteenth century, at a time when the Corinthian was the most common order, it appeared remarkably austere and vigorous to those who liked the effect, but crude and squat to those who did not [cf. *850, 855*]. During the Romanesque and Gothic periods, the classical

canons of proportion were often completely abandoned. Although the traditional division into base, shaft, and *capital* was retained, slender shafts, which to the classical eye appear as thin as sticks, sometimes sweep straight up from the pavements of churches to the ribs of the vaults [*378, 385, 413*]. Deviations from normal proportions are often found in the works of artists who, like the German Expressionists, were concerned with portraying powerful emotional states; certain parts of the body, which may be emotionally significant, are enlarged or the body as a whole may be subject to various "distortions" by being compressed or attenuated [*965, 966, 993, 994, 1027–1029; cf. 37, 62, 63, 333, 399, 408, 433–438, 444, 446, 505, 669, 691, 957, 958, 990, 998, 1008, 1015, 1037–1039, 1062*]. Other artists, concerned with creating figures of unearthly beauty, grace, or elegance will also deviate from the norm, often establishing their own peculiar system of proportion [*101, 102, 222, 356, 359, 522, 684, 698, 699, 863*]. Renaissance architects such as Alberti and Palladio, and probably Brunelleschi, sought beauty in the system of "harmonic proportions," based on the arithmetical ratios of musical harmony (1:2, 2:3, 3:4). A taut string which is half the length of another, for example, will produce a sound one octave higher when vibrated. A ratio of 2:3 will produce a musical fifth and 3:4, a fourth. It was thought that visual harmony would result by observing the same proportions in architecture [*589, 590, 595, 703, 704*].

PSALTER (sawl′ter). A book containing the Psalms of the Bible. Many Psalters, richly *illuminated* with pictures illustrating literally the poetic imagery of the Psalms, have survived from the Middle Ages; the most famous is the Psalter in the library at the University of Utrecht [*400*].

PYLON (pī′lon; Gk., gateway). 1. In Egyptian architecture, the monumental gateway to the forecourt of a temple, having in its developed form battered

Fig. 48. Perspective section of the Temple of Khonsu at Karnak (Chipiez: (a) sanctuary, (b) hypostyle hall, (c) forecourt, (d) pylon.

(sloping) walls edged with roll *moldings* and divided at the top into twin towers capped with large cavetto (quarter-round concave) moldings [fig. 48; 95]. **2.** Each one of the towers of such a gateway.

QIBLA (kib'la; Arabic). The direction faced by Moslems when praying, the direction of Mecca. The center of the "qibla wall" of a mosque is marked by a *niche* called the *mihrab*.

QUATREFOIL (kat'ruh-foyl; F. *quatre*, four, + *foil*, leaf). An ornamental figure composed of four lobes or foils [500, 502, 516]. A trefoil (tree'foyl *or* treh'foyl) has three foils [531, 551]. Both are common *motifs* in Gothic decoration and sometimes were intended as symbols, the trefoil referring to the Trinity and the quatrefoil to the Four Evangelists.

READY-MADE. A mass-produced utilitarian object which is transformed into a work of art simply by being placed in an artistic context or by being looked at as though it *were* a work of art [1072]. Marcel Duchamp was the first to demonstrate the principle of the ready-made by exhibiting such industrial products as a bottle-rack, a snow shovel and a urinal, ironically labeled "Fountain." Any accidentally encountered object, mass-produced or not, is known as a *found object,* or *objet trouvé* (oh-zhay troo-vay; F.). If it has been altered in any way, it is known as a "Found Object Assisted", and if two or more found objects are put together, the work so contrived is called an *assemblage.*

RED-FIGURED. A term applied to a type of Greek vase painting in which the figures were first outlined in black and the background then painted in with solid black, leaving the figures the reddish color of the baked clay after firing [160, 163, 164, 215]. The red-figured style replaced the *black-figured* style toward the end of the sixth century B.C., probably because of the greater flexibility afforded by drawing with the brush rather than with the incising needle required for internal details in black-figure.

REFECTORY (re-fek'toree). The dining hall of a *monastery,* sometimes decorated with a representation of the *Last Supper* [fig. 35; 611, 642].

REGISTER. One of a series of horizontal bands, placed one above the other, in a carved or painted decoration, as on the walls of an Egyptian tomb or on a Greek vase [73, 113, 122, 130, 156, 329].

REGULA (reg'yuh-la; *pl.* regulae; reg'yuh-lee; L., a straight-edge, rule). In an *entablature* of the Doric *order,* one of the series of short, projecting bands with *guttae,* placed beneath the *taenia,* just under each *triglyph* [181, 183, 188, 191]. Regulae should not be confused with *mutules,* the flat blocks with guttae beneath the Doric *cornice.*

RELIEF SCULPTURE. Sculpture which is not freestanding, but is carved or cast so that it projects from a surface of which it is part. The degree of projection is described as high (It., *alto rilievo;* ahl'toh ree-lyeh'voh), medium (It., *mezzo rilievo*), or low (It. *basso rilievo;* Fr. *bas-relief;* bah'ree-leef), high relief being almost detached from the surface and low relief being only slightly raised. Low relief was very widely used by the ancient Egyptians [72, 74, 99, 103],

but they also used "sunk relief" which is much the same as ordinary relief sculpture except that the stone around the carving has not been cut back to form a background plane; instead, the highest points of the carving are on a level with the surface into which the carving has been cut [100]. Sunk relief not only saved the Egyptian sculptors the trouble of cutting away the stone to form a background plane, but it is a particularly effective form of exterior decoration in the bright sunlight of Egypt: the sharp edges surrounding the relief brilliantly catch the light on one side and cast a deep shadow on the opposite side, making the outlines of the figures visible at a great distance. During the fifteenth century, an extremely delicate form of low relief, called "rilievo schiacciato" (skyah-chyah'toh; It. flattened, crushed) was introduced by Donatello [578, 579]. With the slightest undulations of the surface, Donatello was able to catch and modulate the light in such a way as to achieve atmospheric effects which had hardly even been achieved in painting before his time.

RESPOND. A half-column, *pilaster*, or shaft projecting from a wall to support an *arch, rib, entablature,* etc., "in response" to a supporting member opposite, as in the wall at the end of an arcade or colonnade [321, 488, 607]. The shafts attached to, and rising from, the *compound piers* used in medieval churches, although they may not strictly be considered part of a wall, are sometimes called responds [fig. 63; 418, 422, 424, 462, 465], as are the pilasters on a wall behind a colonnade [277, 300, 589, 591, 647, 808].

RHYTHM. In the visual arts, the regular repetition of a form. Rhythm varies according to the interval between repetitions, so one may speak of quick, moderate, measured, and slow rhythms. To a certain degree, the terms used to describe musical rhythms (allegro, presto, andante, largo, etc.) may be helpful in describing works of the visual arts as well, but it is important to realize that music is a temporal art and its terms cannot always be adequately applied to those effects in the visual arts which are largely spatial. If the columns of a colonnade are closely spaced, for example, they do not suggest quick movement to the viewer, but, instead, present a static barrier, even when the colonnade is seen frontally, but especially when it is seen at an angle; on the other hand, if columns are very widely spaced, the viewer may not relate them to each other at all. Some of the ways in which simple rhythms may be enriched are by varying the intervals between the units [fig. 52; 161, 338, 638, 729, 818, 857, 945, 961, 972, 1033, 1075, 1142, 1146], by contrasting a quick sequence with a slower one in a kind of visual counterpoint [261, 414, 781, 967], by introducing dissimilar units between similar units [132, 329, 701, 702, 769], or by intermixing one set of similar units with another set of units so that the different units alternate with each other [26, 250, 263, 287, 315, 363, 447, 452, 665, 901]. Rhythmic patterns are sometimes conveniently described by assigning letters of the alphabet to each unit, as in outlining the rhyme scheme of a poem. Thus, a simple repetition of a single unit might be indicated as AAAA . . . , an alternating pattern as ABABA, etc. A very common pattern in architecture is the ABA pattern used, for example, on the Arch of Constantine [300] and imitated by Alberti at S. Andrea in Mantua [616].

The undulating rhythms of continuous lines and outlines are less precisely designated, but are often more suggestive of movement than the rhythm of detached units [*54, 127, 144, 230, 387, 947, 988, 1023, 1024, 1069, 1071, 1088, 1092, 1140*].

RHYTON (rī'tahn; Gk. fr. *rhytos*, flowing). An ancient drinking horn, often shaped like the head or body of an animal [*133, 149*].

RIB. A slender arched support such as those projecting from the surfaces of Romanesque and Gothic *vaults*. Transverse ribs were often used to stiffen the tunnel vaults of Romanesque churches [*412, 413*] and, in a few later Romanesque churches with cross-vaults, diagonal ribs along the groins were also used [*418–422, 424*]; this became customary in Gothic architecture [fig. 63; *452–454, 462–466, 476, 477*]. In Early and High Gothic architecture, the analogy with the ribs of the human body is particularly appropriate since the masonry ribs form a delicate framework which supports the thin web of the vaults. The ribs were apparently erected first and then a portable "centering" (wooden support) was hung from them to hold the web of each section of the vault until the mortar dried. In much of later Gothic architecture, however, the ribbing, often very elaborate, is largely ornamental rather than structural [*478*]. In Renaissance and Baroque architecture, ribs are sometimes used both on the interiors and exteriors of *domes* in a form of *skeletal construction* directing *thrust* to *buttresses* around the *drum* [*666, 668, 759, 765, 813*].

ROMAN ARCHITECTURE. See AQUEDUCT, ARCH, BASILICA, CATACOMB, COFFER, DOME, DOMUS, FORUM, **GREEK AND ROMAN TEMPLE ARCHITECTURE**, INSULA, ORDERS, TABLINUM, THERMAE, VAULT.

ROSETTE (ro-zet'). Any ornament resembling a flower and approximately circular in shape [fig. 34, right; *139, 158, 363, 390*].

ROSE WINDOW. A great circular window with an elaborate pattern of *tracery* and stained glass, frequently found on the façades and at the ends of the *transepts* of Gothic churches [*455, 457–459, 468*].

RUSTICATION. The method of cutting and laying up *masonry* so that the joints are deeply recessed. This reveals the mass of each block and gives the wall an appearance of great strength, especially appropriate for the base or ground floor of a building [*810*]. The blocks may be either smooth-faced with beveled (champfered) edges [*613, 826*] or rough-hewn [*491, 967*]. In the Palazzo Medici in Florence [*597*], the different types are clearly *juxtaposed;* rough-hewn rustication is used for the ground floor, smooth-faced rustication for the second, and unrusticated "ashlar" (blocks of smooth-faced stone laid up evenly with fine joints) for the top story. Rustication was so admired during the sixteenth century that even *columns* were bound by rough-hewn segments and projecting bands, conveying a sense of unresolved conflict between the smooth, obviously man-made members, and the rough, apparently natural, segments [fig. 49; *702, 775*].

Fig. 49. Sixteenth-century project for a rusticated gateway (Delorme).

SACRISTY (sak'ris-tee). A room in a church, usually near the main *altar,* where the sacred vessels and vestments used in the performance of the services are kept.

SALON (sah-lon', F. fr. It. *salone*). 1. A reception room in a large French house [*820*]. In Germany, such a room [*769*] is called a "Saal" (zahl). 2. An art exhibition, such as the great exhibition of the French Royal Academy of Painting and Sculpture held annually at Paris since the eighteenth century. Many of the large carefully prepared paintings by David [*838*], Géricault [*860, 861*], Delacroix [*866*], and Courbet [*910*]—so huge that they are sometimes called "salon machines"—were painted for these great public exhibitions.

SANCTUARY (fr. L., *sanctus,* holy). A sacred place [*106–108*]. In a temple or church, a space containing sacred objects. The sanctuary of Egyptian temples [fig. 48] was located deep within the walls on the main *axis,* beyond the forecourt and the hypostyle (columned) hall. It was relatively small, slightly elevated and dimly lit. Only priests were permitted access. The sanctuary (*cella*) of an ancient Greek or Roman temple contained a statue of the god to whom it was dedicated. The sanctuary of the Jewish temple at Jerusalem—the "holy of holies"—contained the Ark of the Covenant. In churches, the sanctuary is the area around the main *altar.*

SANGUINE (sang'gwin; fr. L. *sanguis,* blood). A reddish-brown chalk frequently used by Renaissance and Baroque artists for drawing [*682*].

SARCOPHAGUS (sar-kof'a-gus; *pl.* sarcophagi; sar-kof'a-jī). A large, and often impressively ornamented, stone coffin [*239, 329, 660*].

SATURATION. That property of a color by which its vividness or purity is distinguished; also called "intensity" or "chroma." A color may have the same *hue* or *value* as another, but differ from it in saturation; the more vivid of two such colors is said to be of "higher saturation;" the less distinct of the two, which may be so neutral that its hue is hardly discernible, is said to be of "low saturation." The purity and amount of *pigment* applied to a given area will affect its degree of saturation, but the different hues, by the nature of their pigments, are normally higher or lower in saturation at one level of value than at another. Red-orange and green-blue, for example, are most highly saturated at a medium level of value and lose their saturation if their values are raised or lowered [*857*]. Yellow, however, is highly saturated only when it is high in value [*794, 857*] and violet, when it is low in value. The relative level of value at which each hue reaches its highest saturation is indicated in the following diagram:

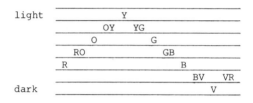

By using highly saturated violets in shadows, Turner and the Impressionists were able to increase the intensity of their paintings without upsetting the usual scale of values; their shadows could be both dark *and* intense. This can be seen by squinting at one of their paintings or good color reproductions of them, because squinting reduces the effect of hue and saturation and emphasizes value contrasts. Colors which are highly saturated and insistent when the eyes are wide open will be reduced largely to value alone when one squints. It will then be seen that the insistence or prominence of colors like violet is due to their high saturation, not their value level; they may, indeed, be very dark [*881, 945, 949, 956, 996, 1017, 1044*]. The relative insistence of highly saturated colors at various levels of value can also be gauged by comparing accurate black-and-white reproductions with accurate color reproductions of the same painting. The highly saturated yellows, since they are most intense at high values, remain insistent when reduced solely to value in black and white reproductions, but the reds, blues, and violets lose much of their distinctness when reduced to dull grays and blacks.

SCALE (fr. L. *scala,* ladder, staircase). **1.** Any graduated series, as a "scale of *values* from white to black." **2.** A measuring strip on a *plan, elevation,* map, etc., indicating the precise degree to which all parts have been reduced in size so that their true dimensions can be quickly determined [*107, 190*]. **3.** The relative size of an object, usually considered in relation to other objects of its kind or to the size of a man. When certain figures in a painting or relief are

presented as larger in scale than others because of their importance in a social or religious hierarchy, the device is known as "hierarchic scaling" [73, 89, 105, 115, 160, 436, 509, 557, 710, 1027]. Relative importance within a general system of values also accounts for the exaggerated or diminished scale of some classes of inanimate objects [122, 161, 292, 314, 525]. Certain parts of the body, too, may be represented on a larger scale than others, because of their special psychological or expressive significance [37, 48, 62, 63, 65, 173, 357, 399, 408, 444, 993, 994, 1015, 1037, 1060, 1062]. In architectural design, more purely visual or structural reasons usually account for the appearance of the same *motif* at different scales [270, 351, 352, 373, 376, 416, 616, 709, 855]. Architecture is said to lack "human scale" when its parts are not clearly related to the normal size of a person. Some parts of a building must be of a familiar size or its true dimensions cannot be grasped [488, 748]. 4. The apparent size of an object regardless of its absolute or precisely measurable size. Some objects are very small in size but large in scale [37, 159, 232, 234, 235, 985, 1073, 1127]; others are very large in size but surprisingly small in scale [173, 517, 522, 866, 889]. In studying works of art from small reproductions it is always necessary to note their true dimensions before one can gain any idea of the full effect of the original. *See* MONUMENTAL.

SCHOOL. A group of artists working in a similar *style* (e.g. Impressionist School), often influenced by a leading artist (e.g. School of Leonardo), or simply working in the same city (e.g. New York School), region or nation.

SCRIPTORIUM (skrip-toh'ree-um; *pl.* scriptoria, fr. L. *scribere, scriptum,* to write, + *-orium,* place for). The workroom in a *monastery* where *manuscripts* were copied and *illuminated.*

SCULPTURE. *See* ARMATURE, ASSEMBLAGE, BUST, CASTING, CONSTRUCTION, EARTH ART, ENVIRONMENT, ENVIRONMENTAL SCULPTURE, FOUND OBJECT, INSTALLATION, KINETIC SCULPTURE, MOBILE, MODELING, PRIMARY STRUCTURE, READY-MADE, RELIEF SCULPTURE, SOFT SCULPTURE, TERRACOTTA.

SECONDARY COLORS. The hues resulting from the mixture of two *primary colors.* The secondaries are orange (red + yellow), green (blue + yellow), and violet (blue + red). In the "color wheel" in fig. 15, each shaded circle is a secondary, obtained by mixing the primaries to either side of it.

SECTION. A representation of a building, object or site showing it as it would appear if it were cut open along a plane passing through it vertically [76, 82, 148, 324]. A "longitudinal section" shows the building as though it had been cut lengthwise [340, 405, 425, 668] and a "transverse section," or "cross-section," shows it as though it had been cut crosswise [267, 420]. Most sections are made to *scale* so that all vertical dimensions can be measured accurately, but horizontal dimensions, which are not parallel to the picture plane, are *foreshortened.* A "perspective section" [757], while gaining in pictorial effect, is directly measurable only at the plane of the cut. *See* ELEVATION, PLAN, AXONOMETRIC DRAWING.

SFUMATO (sfoo-mah'toh; It., vanished, gone up in smoke). The very subtle gradations of light and dark developed by Leonardo to *model* his figures. Leonardo's *sfumato* lends a sensuous softness and, at times, a tantalizing ambiguity to his forms, as in the famous smile of the *Mona Lisa* [*640–642, 644;* cf. *634, 670, 675, 683*]. The use of *sfumato* in the mythologies of Correggio, however, is frankly voluptuous [*694*]. *See* CHIAROSCURO, SHADOW, TONE, VALUE.

SHADE. An old and convenient term still used to designate a color mixed with black. Since black lowers the *value* of the basic color (i.e., darkens it), shades were frequently used to model forms before the advent of color *modeling* with the Impressionists. When a color is mixed with white it is called a *tint.* Hogarth makes this distinction between shades and tints in his book *The Analysis of Beauty* (1753), but the terms are also still generally used as synonyms for "color" or to describe any variation of color.

SHADING. In drawing, painting, or printmaking, the darkening of parts of an object and its surroundings to suggest the effect of light falling upon it. In drawings and prints this may be done by *hatching* and in paintings, by using *shades* of the *local color,* or basic *hue,* of the object. *See* HIGHLIGHTS, MODELING, SHADOW.

SHADOW. In painting, drawing, and printmaking, a darkened portion of a picture representing areas of the subject cut off from direct illumination. A "cast shadow" is a shadow of more or less definite shape formed on a surface behind a body that blocks the light. The strong spatial effect created solely by a cast shadow is demonstrated in fig. 50. This effect can be seen in Manet's *Fifer* [Louvre, *912*]. This is a remarkably flat, shadowless painting for its period, but if the cast shadows (beneath the right foot and behind the left leg) and the shadows at the top and bottom of the canvas are covered, it will look even flatter. Cast shadows first appear in Hellenistic and Roman painting [*302, 304, 305, 308, 309*], but they were not represented again until the early fifteenth century [*543*]. The Master of Flémalle carefully reproduced the double cast shadows created by two different sources of light falling on the same object [*547*] and Jan van Eyck regularly distinguished between the darker central portion of cast shadows, called the "umbra," and the lighter periphery, the "penumbra" [*550, 551, 553*]. The Venetian painters of the

Fig. 50. Spatial effect of a cast shadow.

sixteenth century and many Baroque masters used shadows more arbitrarily; by veiling the less important parts of their compositions in shadow, they gave dramatic emphasis to the figures in the light [11, 676–680, 689]. Caravaggio's dramatic use of such shadows has come to be called "tenebroso" (It., obscure, murky). His shadows, however, are offset by dramatic "spotlighting" [13, 739]. The many seventeenth-century painters throughout Europe who borrowed this device from Caravaggio are called "tenebrists" and their style "tenebrism" [740, 773, 778, 783, 797, 800]. See CHIAROSCURO, HIGHLIGHTS, TONE.

SHAPE. A shape is formed whenever a line turns or lines meet, even though an area may not be entirely enclosed. Thus, we speak of C-shapes, S-shapes, T-shapes, X-shapes, etc. The shape of a three-dimensional form is determined by its outline or silhouette. A shape need not be entirely delineated before it becomes distinctly recognizable; it may only be implied. Figs. 51 and 52, for

Fig. 51. Implied shape formed by heads in Masaccio's "Trinity" [598].

Fig. 52. Implied shape formed by heads in Poussin's "Rape of the Sabine Women" [803].

example, show triangular and oval shapes implied on the *picture planes* of paintings by the arrangement of the heads of figures; both of these configurations have a directional character because they have been extended in one direction more than another: the triangle points upward and the oval is formed along a dynamic oblique *axis*. Repetitions of shapes, all pointing in the same direction, can give a *composition* a powerful directional character as in the sweeping vertical shafts, *buttresses*, *pinnacles*, and towers of a Gothic church [fig. 63; 458, 465, 468, 473, 490]. Fig. 53 shows the upward-pointing shapes in the famous mosaic of the Emperor Justinian at San Vitale in Ravenna [cf. 338]; a similar diagram might be made of the downward-pointing shapes as well. In the work of artists who are not overly concerned with *illusionism*, the harmony attained by variations of a basic shape, or by repetition of the smaller shapes within a work, may be the chief means by which the artist builds a composition [12, 37, 64–66, 161, 359, 381–383, 945, 947, 954, 988, 1023–1026, 1032, 1034–1036, 1063–1071, 1123, 1125–1130]; this is especially true of architecture [270, 344, 352, 367–376, 464, 492, 649, 709, 973, 1100, 1114, 1115]. See BIOMORPHIC, COMPOSITION, CONTOUR, FIGURE-GROUND RELATIONSHIP.

Fig. 53. Upward-pointing shapes in the Justinian mosaic, San Vitale, Ravenna [*338*].

SHAPED CANVAS. A painting on canvas attached to a non-rectangular stretcher. During the 1960s, shaped canvases of relatively complex geometrical shapes were used by such non-representational artists as Frank Stella [*1046*] and Ellsworth Kelly, who conceived their paintings as abstract sculptural objects.

SHUTTER. 1. A hinged cover for a window, frequently fitted with louvers (slats) to allow diffused illumination. Shutters may be attached to either the interior [*547, 553*] or exterior [*853*] side of the window. **2.** A *camera* mechanism for controlling the length of time the *film* or plate is exposed to light. After 1880, as photographic emulsions became more light sensitive (faster), spring-operated or pneumatic mechanical shutters, fitted to the front of the *lens,* replaced manual removal of a lens cap as the principal means of controlling *exposure.* They could be set for speeds varying from one to 1/100 second. By World War I, speed was increased to 1/500 second. Modern focal-plane shutters, placed just in front of the film, normally allow speeds to 1/2000 second. The international standard sequence of shutter speeds is 1, 1/2, 1/4, 1/8, 1/15, 1/30, 1/60, 1/125, 1/250, 1/500, 1/1000, 1/2000, 1/4000 second. A shutter speed of no longer than 1/30 second is usually required for satisfactory results with a handheld camera.

SIDE AISLE. One of the corridors running parallel to the *nave* of a church and separated from it by an arcade or colonnade [figs. 14, 63; *317, 318, 320, 470*].

SILKSCREEN. A *print* made by a stencil process in which ink or paint is forced with a rubber-bladed squeegee through fine silk or synthetic mesh stretched on a frame. The areas to be printed are left unblocked, while the rest of the screen is blocked with a liquid filler or a knife-cut stencil of paper or film. Shapes and colors of considerable complexity can be created by overprinting with different stencils or by successively altering the stopped-out areas on a single screen. Images can also be transferred to the screen photographically by covering it with a photo-sensitive emulsion which hardens upon exposure to light. Areas left unexposed remain soft and are washed away [*1056*]. The silkscreen process was developed early in the twentieth century for commercial printing on textiles, wallpaper, posters, stickers, etc. American artists

began using it for original prints in the 1930s and it is still widely used, especially by those artists who prefer the bold shapes and intense *flat color* to which it is particulatrly suited. The silkscreen process is also called "serigraphy" (ser-rig'ruf-ee; fr. L. *sericum*, silk + Gk. *graphein*, to write, draw). A silkscreen print is also called a "serigraph" (ser'ruh-graf).

SILVER BROMIDE PRINT. A photographic *print* on paper coated with an emulsion containing silver bromide [*1141*]. Silver bromide papers were introduced in the 1870s and are noteworthy for their "speed" (light sensitivity).

SIMULTANEITY. The suggestion of the fourth dimension (time) in two- and three-dimensional works of art. Cubist and Futurist artists broke away from the Renaissance notion that art should represent a single moment frozen in time. They challenged assumptions of the unity of time, place and action by dislocating and fragmenting objects, showing them simultaneously from different *viewpoints* and in successive stages of motion [*998–1004, 1008, 1009, 1012, 1014–1017, 1027, 1069, 1150*]. Interpenetration and *transparency* of *planes* further enhanced the *four-dimensional* effect. These complex twentieth-century devices are different in intent from the clarity of pre-Renaissance modes of *continuous narration*, in which the same character may appear more than once in a single spatial setting, and "simultaneous" or "fractional representation," in which a sense of completeness is given an object or figure by showing its separate parts in their most characteristic aspect even though this may entail presenting them from different viewpoints [*72–74, 99, 100*].

SINOPIA (see-noh'pee-a; *pl.* sinopie; see-noh'pee-ay; It., fr. Sinope, a city in Asia Minor famous for its red earth pigment). **1.** A reddish-brown earth color. **2.** In *fresco* painting, a full-scale drawing, usually red, made on the rough plaster of a wall to establish the main parts of a composition before the final coat of plaster is applied for painting [*536*].

SKELETAL CONSTRUCTION. A form of construction in which the weight-bearing members are reduced to a slender framework, walls and windows being no more than thin membranes either hung from the structural skeleton or supporting only themselves as in Gothic churches [fig. 63; *465, 471, 478*] and nineteenth- and twentieth-century buildings with frames of iron, steel or *ferroconcrete* [*938, 969–971, 1102–1111, 1116; cf. 1073*].

SOFT SCULPTURE. Three-dimensional *constructions* made of materials such as canvas, felt, latex, vinyl sheeting and foam rubber rather than the traditional hard sculptural *mediums*. Although the Surrealists occasionally used soft materials in *assemblages* and *environments* during the 1930s, soft sculpture did not become widespread until the American Pop artist Claes Oldenburg produced a variety of soft enlargements of such commonplace objects as hamburgers, french fries, toilets, and cigarette butts during the 1960s [*1080*].

SPAN. The distance between the members supporting a *lintel, arch, truss, vault,* etc. [fig. 3].

STALACTITES. Tiny pendant *arches* used as an ornament in Islamic architecture; they resemble the natural stalactites hanging like icicles from the ceilings of caverns [*370*].

STELE (stee'lee; Gk., standing rock). An upright slab carved with commemorative reliefs or inscriptions [*115, 118, 213*].

STEREOBATE. A solid mass of *masonry* serving as the visible base of a building, especially a Greek temple [*181, 186*]. In the crepidoma (kreh-pee-doh'ma), or stepped base, of a Greek temple, only the lower steps are called the stereobate; the top step, on which the columns rest, is called the "stylobate" (sty'lo-bayt).

STEREOMETRIC (fr. Gk. *stereos*, solid, + *metron*, measure). Pertaining to stereometry, the science of measuring solids. "Stereotomy" is specifically the art of cutting stones into geometrical forms, as for Gothic *vaulting* and *tracery* [fig. 63; *451, 454*]. The figures painted by such Renaissance perspectivists as Piero della Francesca [*609*] and Paolo Uccello [*610*] are sometimes described as stereometric because of their apparent solidity and their geometrical clarity and simplicity.

STEREOSCOPE (fr. Gk. *stereos*, solid, + *skopos*, watcher). A device for viewing two *photographs* of the same subject, taken from slightly different *viewpoints*, to enhance the effect of depth through binocular (two-eyed) vision [fig. 54; *908*]. Stereoscopy, invented in 1832 by Sir Charles Wheatstone

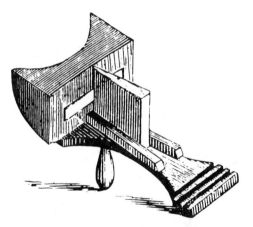

Fig. 54. Stereoscope invented by Oliver Wendell Holmes (1859).

(1802–1875), is nearly as old as photography, but Wheatstone used geometrical drawings rather than photographs at first. Stereoscopic photography did not become practical until the introduction of the collodion *wet plate process* in the 1850s when *exposure* times and the mass production of high-quality multiple *prints* made from glass *negatives* became possible. Stereoscopic *cameras* with twin *lenses*, taking two views of the same subject simultaneously, were also manufactured in the 1850s and the new medium captured the

imagination of the world. As early as 1858, the London Stereoscopic Co. advertised the availability of 100,000 different views. Popular stereoscopic photography had something of the impact of television during the twentieth century in presenting distant corners of the earth and current events, including the horrors of war, with astonishing and sometimes disturbing immediacy. The standard format for "stereographs" (a mounted pair of stereoscopic photographs), also called "stereograms," was two 3x3″ photographs mounted on a 3½x7″ card. These were clipped into a holder which slid on a bar to focus the image viewed through two hooded lenses. A masking divider, projecting between the lenses, insured that each eye would see only one of the two photographs, taken from viewpoints about 2½″ apart, equivalent to the distance between the human eyes. Stereoscopic (or "3-D") photography had a brief popular revival in the 1940s and 1950s when convenient twin-lens cameras for 35mm color *film* were manufactured. Color lent additional depth for binocular vision when *transparencies* were seen through the twin lenses of illuminating stereo-viewers.

STUCCO. (stuck′o). A strong, slow-drying plaster, containing lime (calcium carbonate), powdered marble, glue, and animal hair, used for sculptural and architectural decoration [*758, 852*]. Stucco is ideally suited to *modeling* and can be coaxed into subtle effects of *atmospheric perspective* in low *relief* [*289*], but it is also suited to sculpture in very high relief [*699*]. It can be colored, gilded, molded and polished to a brilliant finish much like marble. The ancient Romans used stucco extensively [*289*] and its use was revived during the Renaissance and Baroque periods when it was often used in conjunction with painting [*699, 753, 770, 811*] and sculpture [*752, 809*]. Dazzlingly intricate decorative effects were achieved by late Baroque and Rococo *stuccatori* (It., stucco workers) [*768, 769, 771, 820*].

STYLE. The distinctive and characteristic way of making and arranging the forms of a work of art by which it may be assigned to a particular period, place, artist or period within an artist's life. *See* HAND, HANDLING, SCHOOL.

STYLOBATE. *See* STEREOBATE.

SUBJECT. In the representational arts, that which is represented, as distinguished from the particular form and expressive content of any single representation of it. *See* ANDACHTSBILD, BUST, EQUESTRIAN, FÊTE GALANTE, GENRE, ODALISQUE, PROGRAM. The subject of a work of art is usually determined before work is begun. However, if a specific subject has not been commissioned by a patron or if the artist is not working directly from nature, the subject may change as the artist works or emerge only gradually in the process of working with purely abstract forms. This is particularly true of twentieth-century painting and sculpture. Although an artist may occasionally attempt a strikingly original subject, the general subject-matter of a work of art is usually traditional and has been treated many times before. Even if an artist deliberately sets out to copy another work, however, this particular version will be distinguished from all others by the copyist's own personal

handling of the forms and the way in which they have been organized [*643*]. With the alteration of form there will be a concomitant change in the expressive effect of the work on the viewer. Sometimes the expressive effect of the work (as distinguished from both its subject and its form) is called its "content." Subject, form, and content, however, are necessarily interrelated and can only be separated for purposes of analysis. Examples of some of the ways in which they are related in the treatment of a particular subject are given in the entry for COMPOSITION.

SUBLIME. During the eighteenth century, the Sublime and the *Picturesque* came to be distinguished as *aesthetic* categories separate from the Beautiful. The Sublime was characterized by awe-inspiring grandeur, immensity, or irresistible power. The British statesman and philosopher Edmund Burke, in his *Philosophical Enquiry into the Origin of our Ideas of the Sublime and Beautiful* (1757), singled out the emotion of terror as the underlying principle of the Sublime: "Whatever is fitted in any sort to excite the ideas of pain, and danger, that is to say, whatever is in any sort terrible . . . is the source of the sublime." There followed a century-long vogue for depictions of vast wilderness landscapes [*843*], storms [*881*], shipwrecks [*861, 882*], snarling beasts [*843, 890*], and violence of all kinds [*841, 857, 860, 866, 888*], but, perhaps, Burke's most far-reaching contribution to aesthetics was his recognition of the power of obscurity to exercise the imagination. In art, as in politics, the conservative Burke was mistrustful of stark rationalism. "Dark, confused, uncertain images," he noted, "have a greater power on the fancy to form the grander passions than those which are more clear and determinate [*858, 876, 888*]." The suggestiveness of the indeterminate was exploited by Burke's contemporary, Horace Walpole, to evoke terror in his *Castle of Otranto* (1765), the first Gothic romance, and in the novel *asymmetrical* design of his Gothic country house, Strawberry Hill [*892*].

SUN-BREAK (fr. F. *brise-soleil;* breez-so-lay'). A screen of large horizontal or vertical fins projecting from the walls of a building to shade the windows. Le Corbusier was the first to use the device on a large scale [*1111*].

SUPERIMPOSED ORDERS. *Orders* placed one above the other on the face of a building of more than one story [*263, 277, 613, 618, 702, 813, 826*]. Superimposition of the orders is also known simply as "superposition" or "supercolumniation." When different orders are used, the stoutest is placed at the bottom and the most slender at the top.

SYMMETRY. Balance achieved by correspondence of parts on either side of a central *axis*. The corresponding parts may be identical or, when irregular shapes are used, one side may be reversed, as in a mirror image [figs. 14, 43, 48; *37, 44, 48, 58, 73, 97, 121, 127, 152, 166, 325, 377, 385, 390, 1049, 1077, 1138*]. In either case, the term "bilateral symmetry" is sometimes used to stress the extreme regularity of the arrangement. In the composition of figure groups, figures on one side of a central vertical axis are sometimes given the same postures as those on the other side, but, to insure the symmetry of the group, their outlines may have to be reversed by representing them as though

seen from the other side or from behind [*178, 673*]. There may be some degree of variation to either side of the axis, but as long as a group is arranged about a dominant central axis and there is a considerable degree of correspondence between forms on both sides, the arrangement may be called symmetrical [*288, 330, 355, 359, 361, 493, 540, 638, 642, 672, 1064*]. Symmetry almost completely dominated monumental architecture until the nineteenth century, but painters and sculptors had a strong aversion to it from the seventeenth century to the mid-twentieth century. Architects and landscape designers began to experiment with intentionally asymmetrical *composition* in the eighteenth century [fig. 45; *849, 892*] and in the nineteenth and twentieth centuries it became quite common [*892, 898, 1097–1109, 1112–1118*]. See BALANCE.

TABERNACLE (fr. L. *tabernaculum*, tent). **1.** The portable tent-like *sanctuary* for the Ark of the Covenant carried by the Jews during their wanderings in the desert [*314*]. **2.** A small cupboard on a Christian *altar* for the consecrated host (bread or wafer) and wine of the Eucharist (sacrament of Holy Communion)

Fig. 55. Gothic tabernacle, Queen Eleanor's Cross, Northampton, England (Sturgis).

3. In classical architecture, a space, often containing a statue, framed by *columns* or *pilasters* supporting an *entablature* or *pediment* [*265, 661, 705, 751, 762*]. When used to enclose a door, window, or painting, the unit is called a "tabernacle frame" [*665, 827*]. **4.** In Gothic architecture, a similar space with an often highly ornamental framework of small *columns, buttresses, tracery, gables, pinnacles,* and *finials* [fig. *55; 468*]. **5.** A synonym for a *canopy* on columns (baldachin).

TABLINUM (ta-bly'num; L. fr. *tabula,* record, writing tablet). In a Roman house, a recess or chamber, usually at the far end of the *atrium,* where family records and portraits were kept [fig. *25; 275*].

TACTILE (fr. L. *tactus,* touch). Pertaining to the sense of touch. The "tactile values," which the *connoisseur* Bernard Berenson (1865–1959) thought were the essence of Renaissance painting, refer to the impression of three-dimensional relief and apparent tangibility created by painters on the two-dimensional surfaces of their pictures. In describing works of art, "tactile" is sometimes used as a synonym for "plastic." *See* PLASTICITY.

TAENIA (tee'nee-a; L., fillet or headband). In an *entablature* of the Doric *order,* the thin, flat *molding* running beneath the *triglyphs* and separating the *architrave* from the *frieze* [fig. *36; 181, 183, 191*].

TEMPERA. *Pigments* mixed, or "tempered," with any of a number of water soluble media—including egg, glue, and *casein* —which leave a *mat* surface when dry. A bright and very durable tempera, made with egg yolk, was widely used for panel painting by fourteenth- and fifteenth-century Italian artists, and it is generally egg tempera which is meant when the word "tempera" alone is used by art historians and *connoisseurs* [*522–525, 529–531, 540*]. Since tempera dries very quickly and does not blend easily, the paint was usually applied in a fine *hatching* of short strokes which allow lower layers of color, such as the green *underpainting* customary during the fourteenth century, to show through the spaces between them. Tempera, unlike *oil paint* or *watercolor,* is an opaque medium encouraging clear, sharp outlines and does not permit the use of transparent *washes* and *glazes.* To relieve the dry effect of pure tempera painting, many fifteenth- and sixteenth-century painters employed a "mixed method," superimposing oil glazes over a tempera underpainting, thereby uniting the precision of tempera with the luminosity of oil.

TERRACOTTA (It., baked earth). **1.** Fired clay, *modeled,* or molded, and baked until it is very hard. Terracotta has been used since ancient times for pottery and sculpture and as a building material. It may be coated with a *glaze* of molten glass [*125, 622, 971*], painted [*239, 240, 247*], or left untreated after firing [*815, 816, 821*]; after the first firing, but before glazing, it is sometimes called "biscuit" or "bisque" because of its porousness. **2.** An object made of terracotta. **3.** A color resembling the brownish red hue of terracotta.

TESSERAE (tess'er-ee; *sing.* tessera; L.). The small squares of stone or glass used in making a *mosaic* [302, 338, 345].

THERMAE (thur'mee; L., hot baths, fr. Gk. *therme*, heat). One of the great Roman public baths, which besides providing various rooms for bathing and swimming (a "tepidarium" or warm room, a "caldarium" or hot room, a "frigidarium" or cool room, etc.) was also equipped with almost all the conveniences of a modern social and athletic club.

THOLOS (thoh'los; *pl.* tholoi; Gk.). In Greek and Roman architecture, a circular building [198, 255].

THRUST. The downward and outward pressure exerted by an *arch* or *vault*, resulting from the pull of gravity on its members. Within the arch or vault itself, thrust is strongest at the haunches and if the arch or vault is not loaded or abutted at these critical points [fig. 5], it may collapse. Every vault or roof *truss*, as a whole, also exerts thrust against the walls supporting it; unless the walls are thick enough to contain this thrust, *buttresses* must be set against the wall at those points where the pressure is greatest [figs. 14, 63; 410, 483].

TINT. Loosely, a synonym for "color," but more specifically a color obtained by mixing a basic *hue* with white to raise its *value*, i.e. to lighten it. Tints are frequently used for *highlights* in *modeling. Cf.* SHADE.

TONE. Loosely, any color, but more specifically a *value* or *shade*. During the sixteenth and seventeenth centuries, tonal painting, in which an entire *composition* is treated in broad areas of light and dark, largely replaced the bright and even hues, the regular *modeling*, and overall clarity favored by artists of the Early Renaissance [figs. 16, 22; 11, 18, 675–680, 688–696, 739, 740, 744–746, 773–806, 818, 822–825, 831–835, 837–844, 856–884, 911]. *See* CHIAROSCURO, SFUMATO, SHADOW.

TRACERY. In Gothic architecture, the ornamental stonework carved in geometrical patterns, originally in the upper part of pointed windows, but then applied to almost any surface in any medium [fig. 63; 435, 474]. In the earliest form of tracery, called "plate tracery," the glass has the appearance of having been inserted into holes punched into solid stone, as at Chartres Cathedral [458, 462, 464, 469]. In the later "bar tracery," the glass predominates over the slender stone bars, which flow from the vertical "mullions" dividing each window into "lights" [471]. In Flamboyant Gothic, which takes its name from the flame-like patterns of the tracery of later Gothic churches, the bars flow in restlessly undulating curves [473, 567, 568].

TRANSEPT (fr. L. *trans*, across, + *septum*, an enclosure). In a cruciform church, the whole arm set at right angles to the *nave*. The separate projections on

either side of the nave, which constitute the transept as a whole, are distinguished as the "north transept" and the "south transept." The area of the transept which intersects the nave is called the *crossing* [fig. 14; *393*].

TRANSPARENCY. 1. An image, usually photographic but sometimes painted, on glass, *film*, or some other transparent material, intended to be seen by projection or by viewing against a light source [*1119, 1149*]. 2. A surface through which one or more other surfaces can be seen. Glass windows and window-walls in architecture [*938, 1102, 1106*], glass, plastic and metal mesh *planes* in sculpture [*1067, 1071, 1088*], or *washes* in drawing and painting are all examples of transparency. In painting, transparencies may be actual or only implied. Areas may appear to be covered by transparent planes, although they are indicated by the definition of only an edge or two. The implied transparency is one of the principal devices of Cubism [*999, 1000, 1002–1004, 1008, 1009, 1015, 1017, 1024, 1027, 1057*].

TREFOIL. *See* QUATREFOIL.

TRIFORIUM (try-for'ee-um; *pl.* triforia). In a church without a *gallery*, the arcaded level of the *nave* wall between the great nave arcade and the *clerestory* [fig. 63; *470*]. In some Early Gothic churches which have galleries, the triforium lies between the gallery and the clerestory to form a four-story *elevation*. Since it is usually at the level of the lean-to roofs over the *side aisles*, the triforium arcade may be *blind* [*414*] or have only a narrow passageway set behind it [*464*]. In some High Gothic churches, in which the roofs covering the side aisles and the *ambulatory* do not obscure the triforium, the triforium, as well as the clerestory, is glazed [*465*].

TRIGLYPH (try'glif; fr. Gk. *tri*, three, + *glyphe*, carved work). In the *frieze* of the *entablature* of the Doric *order*, the vertical blocks which are divided by channels into three sections. Originally, in wooden construction, the triglyphs were probably the ends of ceiling beams [fig. 36; *181, 183, 188, 189, 191, 647, 853, 855*].

TRIPTYCH (trip'tik). An *altarpiece* of three panels, usually hinged so that the outer "wings" or "shutters" cover the larger central panel when closed [*360, 531, 547, 557, 559*]. *Cf.* DIPTYCH.

TROPHY. An ornament composed of the instruments and spoils of war—arms, armor, standards, and drums—heaped up like the victory memorials of antiquity [*630, 810, 830*].

TRUMEAU (troo-moh; *pl.* trumeaux, F.). A *pillar* placed in the center of a large doorway to support the *lintel* [fig. 56; *435*]. The trumeaux of medieval church portals frequently bear figures or statues [*433, 502, 506*].

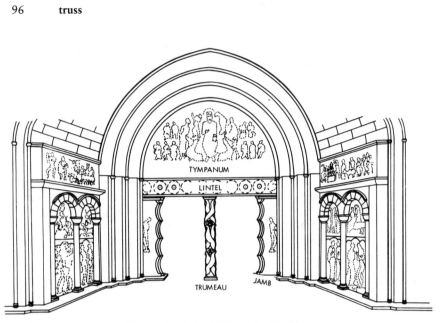

Fig. 56. South Portal, St.-Pierre, Moissac.

TRUSS. A framework of wood or metal composed of members fastened to form rigid triangles [fig. 57]. Timber trusses were used in roofing many medieval and Early Renaissance churches; in these, the trusses may be left exposed [*318, 484*] or covered with a flat wooden ceiling, which is often *coffered* [*406, 430, 589*].

Fig. 57. Sixteenth-century design for roof truss (Serlio).

TURRET. A small slender tower, often containing a staircase for access to the upper levels of the building or tower to which it is attached [*393, 394, 404, 543, 892*], but sometimes added solely to lend variety and "movement" (projection and recession) to the surface and *contour* of a building [*416, 475*].

TYMPANUM (tim'pa-num; *pl.* tympana; fr. L., drum). 1. In classical architecture, the recessed face of a *pediment*. 2. In medieval architecture, the surface enclosed by the arch and *lintel* of an arched doorway, frequently carved with *relief sculpture* [fig. 56; *435, 437, 493, 496*].

UNDERPAINTING. The preparatory painting, in line and broad *washes*, applied directly to the gesso (jess'oh; glue and gypsum or chalk) ground of a canvas or panel to establish the main *contours* and *values*. In Italy, during the fourteenth century, green was usually used, but, from the fifteenth century on, a warm brown *monochrome* became customary. The brown underpainting, often quite dark, was then largely covered over with opaque layers of paint or semi-transparent *glazes* which allowed parts of the underpainting to show through. Sometimes, because of the tendency of the upper layers of paint to become transparent with age, the underpainting shows through in spots, and, although this spoils the effect intended by the artist, it may have much to tell us about the method of working and about the original intent which may change as the work progresses. "Pentimenti" (It., regrets; *sing.* pentimento)— parts that were altered by overpainting—for example, often show up and sometimes indicate, not only corrections, but significant changes in subject-matter. In some cases, the underpainting can be examined directly, because the work was never finished [*640*], or it can be studied through X-ray photographs. Since the nineteenth century, however, the "alla prima" technique (al'la pree'ma; It., at once)—painting without any preparatory drawing or painting—has become customary. *See* SINOPIA.

VALUE. That property of a color by which it is distinguished as light or dark, as in the distinction between "light green" and "dark green" or "light blue" and "dark blue." The values of colors—and only their values—are seen in black-and-white reproductions of paintings; the other properties of the colors, their *hue* and *saturation*, are not reproduced [cf. colorplates with their corresponding black-and-white reproductions]. Value is the sole distinguishing feature of the "achromatic" colors—white, black, and the range of grays between them; they do not have the additional properties of hue and saturation shared by the "chromatic" colors. Therefore, reproductions of achromatic prints and drawings are likely to be more accurate than even color reproductions of paintings because of the fewer factors involved and the consequently smaller margin of error.

Colors which are light are said to be "high" in value; those that are dark are said to be "low" in value. Paintings which are predominantly high in value, such as Impressionist landscapes, are called "high-key" [*913, 943, 944, 947*]. Paintings like many of those by Tintoretto, Caravaggio or Rembrandt, which are mostly dark, are said to be low in "key" [fig. 16; *13, 688, 739, 740, 784, 787*]. Colors may be raised in value by mixing with white to make a *tint* or lowered in value by mixing with black to make a *shade*. Tints and shades of a basic color are often used in *modeling*, but the addition of the white or black pigment usually weakens the effect of hue and saturation. Since only effects of light and dark can be rendered when working in black and white, artists sometimes raise or lower the normal values of objects, or parts of objects, represented in their drawings to compensate for the loss of contrast resulting from the elimination of hue and saturation. Drawings in which this is done systematically are called "color value" drawings. Sometimes, as in the "spotlighting" used by Rembrandt [fig. 16; *784, 787*], the lights and darks in pictures are "crowded" toward the extremes of the value scale and the middle

values are reduced. This increases dramatic effect and emphasizes the parts in the light. Crowding of the lights and darks is especially characteristic of sixteenth-century Venetian painting and much Baroque painting [675, 680, 688, 695, 739, 740, 753, 789, 796, 797, 800, 843, 857, 860, 861, 911, 912]. In many of these pictures, edges are often lightened where dark shapes lie against dark grounds and darkened when light shapes lie against light grounds, thereby snapping the shapes forward by increasing the separation of *figure and ground* [13, 676, 689, 691, 692, 773]. See CHIAROSCURO, HIGHLIGHTS, SFUMATO, SHADE, SHADING, SHADOW, TONE.

VANISHING POINT. In pictures constructed according to the principles of linear *perspective*, the point or points of convergence for all lines forming an angle with the *picture plane*. In single-point perspective, all "orthogonals" (lines which are perpendicular to the picture plane) [fig. 44b] converge toward a vanishing point, presumed to lie directly opposite the eye of the observer (eye level) [fig. 37]. The imagined position of the observer's eye, opposite the picture, is called the "station point." The vanishing point lies on a "horizon line," actually drawn or imaginary, crossing the picture plane at eye level. Surfaces which are perpendicular to the picture plane and lie directly on the horizon (i.e., at eyelevel) will not be visible. Perpendicular surfaces will be increasingly revealed, however, according to their distance above or below the horizon line. In two-point perspective, in which objects are placed at an

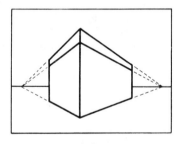

(a)

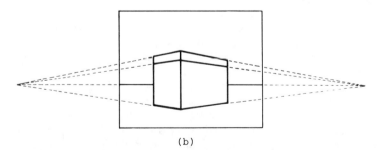

(b)

Fig. 58. Building drawn in two-point perspective from a near station point (a) and from a more distant station point (b).

angle other than a right angle with the picture plane, the vanishing points lie on the horizon to either side of the object drawn in perspective [fig. 58; *916*; cf. *614, 618*]. Their distance from the object depends on the distance of the viewer: if the viewer is near the object, the vanishing points will be close to the object and it will be sharply *foreshortened* [fig. 58a]; if the viewer is far from the object, the vanishing points will be farther away from it and may even lie outside the picture plane [fig. 58b]. Three-point perspective was sometimes used in constructing *illusionistic* ceiling decorations [*769, 770*; cf. *1109*]; this is the same as two-point perspective with respect to the convergence of horizontal lines, but a third vanishing point is added to allow for the convergence of all vertical lines. To maintain a sense of structure and stability, however, this very natural and easily observed effect of convergence is usually ignored and all verticals are kept rigidly parallel to one another and to the sides of the picture, even when a low *viewpoint*, close to the object, is assumed [*630*]. In photographing tall buildings, the same convention of keeping vertical edges parallel is maintained by "correcting" natural convergence [*1109, 1113*] with movements of the film plane or lens board of a view *camera* or *enlarger* [*969, 974, 1110, 1111*]. See FOCAL POINT, PERSPECTIVE, VIEWPOINT.

VAULT. A ceiling or roof of brick, stone, or concrete, built on the principle of the *arch*. A "tunnel vault," or "barrel vault," is a tunnel-like semi-cylindrical extension of an arch, which may be thought of as an unbroken series of arches pressed together, one behind the other [fig. 59]. A tunnel vault cannot be

Fig. 59. Tunnel vault.

lighted by windows except at the ends without being structurally weakened, because, as in an arch, continuous abutment must be applied to absorb the *thrust* carried down along the haunches to the supporting walls [fig. 59; cf. fig. 5; *300, 371, 598, 630, 672*]. However, arches may be introduced in the supporting walls [*270, 271, 322–324, 415, 748*] and transverse *ribs* may be inserted in the vault [*413*] to concentrate thrust at a few strongly *buttressed* points [*411, 412*], thereby permitting a reduction of weight and thrust in the segments of vaulting between the ribs. If a tunnel vault is intersected at right angles by another tunnel vault of the same size [fig. 60], a "cross vault," or "groin vault," is formed [figs. 61, 62; *264*]. This is a very efficient form of vault allowing full illumination from the sides; thus, a series of groin vaults is

Fig. 60. The groin vault conceived as two intersecting tunnel vaults.

Fig. 61. Groin vault seen from below.

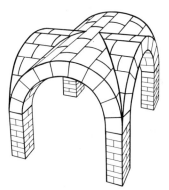

Fig. 62. Groin vault seen from above.

often used at a high level to form a range of *clerestory* windows lighting a great hall [271] or *nave*. Groin vaults also allow a great saving in material and labor over the simple tunnel vault; thrust is concentrated along the "groins" (the four diagonal edges formed along the points where the tunnel vaults intersect), so the vault need only be abutted at its four corners [271]. In some Romanesque churches [418, 421] and most Gothic churches, the groins of the cross vaults are ribbed. The use of diagonal *ribs* along the groins—together with wall ribs and transverse ribs at the four sides of the vault—radically changed the basic visual effect of vaulting from one of broadly curving surfaces to one of cellular division and linear movement [fig. 63; 451–454, 462,

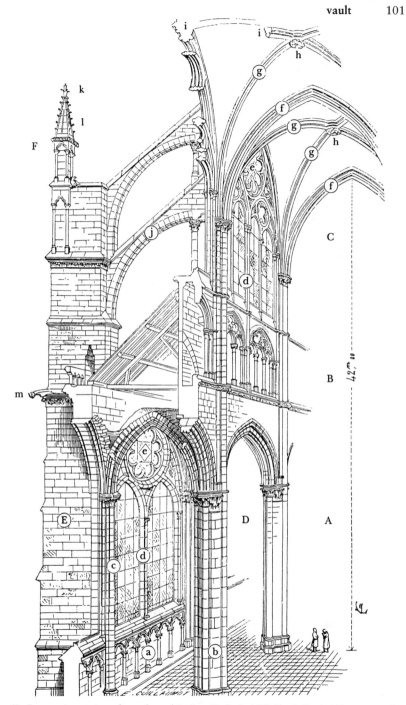

Fig. 63. Perspective section of nave bay of Amiens Cathedral (Viollet-le Duc): (A) nave arcade, (B) triforium, (C) clerestory, (D) side aisle, (E) buttress, (F) pinnacle, (a) blind arcade, (b) compound pier, (c) respond, (d) mullion, (e) tracery, (f) transverse rib, (g) diagonal rib, (h) boss, (i) molding profile, (j) strut, (k) finial, (l) crocket, (m) gargoyle.

465]. The ribs reduced the quantity of centering (wooden supports) required during construction and also permitted a thinner vault. Thrust and mass were reduced throughout the building, allowing larger areas for stained-glass windows. The pointed arches used for the ribs of Gothic vaulting are more stable than the semi-circular ribs used in Romanesque vaulting, because they are more nearly vertical. They also permit greater variety in planning without the awkward changes in the heights of ribs which occur when strictly semi-circular arches are used. When a vault with semi-circular ribs is raised over a square *bay,* for example, the crowns of the arches will be at two different levels, because the diagonal ribs must span a greater distance than the ribs at the sides of the square [fig. 64; *424, 425*]. Over an oblong bay, the crowns will be at three different levels because there will be three different *spans* [fig. 65]. If pointed arches are used, however, the crowns can all be raised to the same height [fig. 66] without the obvious distortions of shape which occur when what one expects to be a semi-circular rib is depressed or has the level of its springing raised, or "stilted" [*422*]. In later Gothic vaulting, ribs proliferate in complex ornamental patterns which obscure divisions between bays and visually unify the vault [*478*].

Fig. 64. Semicircular ribs of a cross vault raised over a square bay; the crowns of the ribs at the sides of the square are lower than the crowns of the diagonal ribs.

Fig. 65. Semicircular ribs of a cross vault raised over an oblong bay; ribs of three different heights.

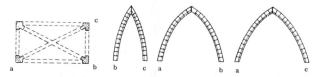

Fig. 66. Pointed ribs of equal height raised over an oblong bay.

VELLUM (fr. Middle Fr., *veel,* calf). Calfskin prepared for writing or painting upon, a superior type of *parchment* widely used for medieval manuscripts.

VESTIBULE (ves'tih-byool). A hall or passage between the main entrance and the interior of a building [661, 807]. In the ancient Roman house, the "vestibulum" was a recess between the front door and the street [fig. 25].

VIEWPOINT. The point from which a viewer looks at an object or visual field. In an ordinary photograph or in a picture constructed according to the principles of linear *perspective*, everything is represented as seen from a single viewpoint; every object can be clearly located in relation to this viewpoint according to its position above or below it, to the left or right of it, and close to it or far from it [figs. 37, 58]. Thus the general position of the viewpoint assumed by an artist in making a picture can be quickly determined by observing which parts of the objects represented can be seen and which cannot: if the top of something is shown, the viewpoint must be located above it; if the bottom is shown, then it is seen from below, etc. Most pictures, however, are not systematically constructed and sometimes parts of a composition or parts of a single object may be represented as though seen from an entirely different viewpoint than others [305, 525, 917, 942, 1007]. When this is done as a matter of course, as in Egyptian painting or the pictures of Picasso in which a *frontal* eye may be placed in a head shown in *profile* or legs in profile attached to a frontal torso, the method is called "fractional representation" or "simultaneous representation. " In this natural mode of representation, parts of the body are shown in their most distinct and characteristic aspect, according to their "memory image" [12, 74, 89, 100, 102, 162, 1014, 1015]. During the sixteenth century, artists such as Titian, Tintoretto and Bruegel began to show figure groups and their architectural settings from a dynamic oblique viewpoint [688, 727–729] rather than in the traditional *frontal* views with central *vanishing points* and *symmetrical* composition [cf. 642 and 689; 634 and 677]. Such "angle views" reached a high degree of virtuosity during the eighteenth century in the design of stage sets and *illusionistic* ceiling paintings employing two- and three-point perspective systems [769]. Mannerist and Baroque sculptors also emphasized oblique viewpoints [21, 700, 749, 817, 821] and Baroque and Rococo architects enforced them by the frequent introduction of curving surfaces, concavities and pronounced projection and recession [747, 754–761, 765–772, 820, 830]. See FOCAL POINT, KINETIC SCULPTURE, PERSPECTIVE, VANISHING POINT.

VILLA. A luxurious rural or suburban residence serving as a retreat from the cares of city life [310, 703, 704, 847, 848, 1105, 1106].

VOLUME. Any three-dimensional quantity bounded or enclosed, whether a solid or a void. Although "volume" is frequently used as a synonym for "mass," it is very useful, in analyzing works of art, to distinguish between solid volumes and hollow volumes, or "positive volumes" and "negative volumes." Many buildings, for example, appear from the outside to be a single solid volume, but on the inside may contain a spatial volume which is at least as impressive as the mass which bounds it [851; cf. 268 and 265; 342 and 344; 666 and 668]. In Egyptian architecture and sculpture, solids usually predominate over voids [80–86], but in architecture and sculpture of the Gothic period and of the twentieth century, hollows are often more important

than masses [465, 473, 499, 566, 1071, 1073, 1075, 1106, 1116, 1118]. In classical and High Renaissance art there is usually a balance of solid volumes and hollow volumes [188, 212, 224, 261–264, 647, 648, 652, 653].

VOLUTE (vo-loot'; fr. L. *volutus*, rolled). An ornament resembling a rolled scroll, especially prominent on the *capitals* of the Ionic and Composite *orders* [fig. 36; 181, 196, 253, 322]. Similar spirals, but smaller in size, curl out from the tops of Corinthian capitals as well [fig. 34; 181, 195]. In Renaissance and Baroque architecture, volutes were used on a large scale to link even such major units as the upper story of a church façade with the lower [661, 765, 813].

VOUSSOIR (voo-swar; F.). One of the wedge-shaped stones used to construct an *arch* [figs. 3, 7].

WALL. Any very broad upright structure or surface serving as a barrier, enclosure or support. Walls may be freestanding and self-supporting, as a city-wall, parapet, or sacred enclosure [78, 120, 152, 285, 364]; they may be non-structural "screen walls" or "curtain walls" shielding the interior of a building against the weather and the noise of the outside world but permitting light to enter through glass windows as in the almost wall-less structure of a Gothic church or modern steel-frame office building [fig. 63; 451, 465, 471, 478, 938, 970, 1102–1111, 1116]. Inside a building, walls may be no more than space dividers [893]; or they may be thick structural "bearing walls" supporting a roof, a *vault*, or floor beams [318, 403, 414, 597, 667, 757, 967].

WARM COLORS. The *hues* commonly associated with fire: reds, oranges, and yellows. Titian and Rubens are notable among painters who developed the color composition of their works with contrasting warm and *cool colors* [775]. Normally, warm colors appear to advance and *cool colors* to recede, a tendency exploited in color *modeling*. A warm color in which this tendency is significant is called an "advancing color." Contrarily, a cool color is called a "retreating color." The color and quantity of illumination received by an object may alter this effect, however. Yellow, although very insistent under ordinary natural light, loses its insistency when the illumination falls off, whereas blue, a cool color, gains in insistence. This is very noticeable if, while looking at a painting or color reproduction in natural light, a cloud passes over the sun; the balance of the colors changes: the blues may suddenly appear to "jump out" and the yellows to recede relative to the blues. To demonstrate this to yourself, look at 833, 947, 1026, 1029, and 1044 in strong sunlight and then in a dark corner.

WASH. In painting, especially *watercolor*, and brush drawing, a broad, thin film of highly diluted pigment [8, 713, 805, 897]. A brown pigment, called "bistre," made by boiling soot, was often used by Renaissance and Baroque artists for wash drawings. Before beginning a wash drawing, a graduated series of washes, arranged from dark to light may be prepared before work is begun. These may each be used separately to *model* forms, but different *values* can also be created by using overlapping applications of a single semi-transparent wash. In watercolor painting especially, superimposed washes of a given *hue* will also increase *saturation*.

WATERCOLOR. *Pigments* mixed with water-soluble gum, usually applied in broad *washes* on white paper, unstained areas serving as *highlights* ("reserve lights"). Sometimes opaque watercolor ("body color") is added for color accents and highlights in areas already painted, but the essence of watercolor technique is *transparency* [713, 1025]. A painting made primarily with opaque watercolor is called a "gouache" (gwahsh).

WESTWORK (fr. G. *Westwerk;* vest-verk). The broad, multistoried and turreted church front developed by Carolingian and Ottonian architects, including, variously, a western *transept, crossing* tower, *apse,* and stair *turrets* to upper *galleries* and *chapels* [393–396, 403–405].

WET PLATE PROCESS. The collodion wet plate process, the most popular method of making *photographs* [905, 907, 909] during the third quarter of the nineteenth century, was published in 1851 without copyright or patent by Frederick Scott Archer (1813–1857), an English sculptor who died destitute. Although it was a cumbersome procedure, it quickly replaced the *daguerreotype* and *calotype*, because *exposure* times were reduced to a matter of seconds rather than minutes. It produced a relatively grainless glass *negative* from which large numbers of contact *prints* on *albumen* paper and glass lantern slides (*transparencies*) could be made. Outdoor photography,

Fig. 67. Landscape photographer with portable collodion wet plate equipment.

however, required a burdensome apparatus including a portable darkroom [fig. 67]. The basis of the process was collodion (guncotton dissolved in alcohol and ether). In the darkroom, or light-proof tent, the sticky liquid, mixed with potassium iodide, was spread over a glass plate and exposed while still tacky. Coating, exposure, development, and fixing had to take place while the plate was still "wet," hence the popular name "wet plate." It was replaced by the *gelatin-silver* "dry plate" process which began to supersede it after 1875.

WOODCUT. A print made from a design raised in relief on a wooden block. All parts of the design which are not to be printed are cut away with knives and gouges; therefore it is a negative or subtractive process which does not directly register the lines made by the hand of the artist as in *engraving* and *etching* [fig. 26]. Sometimes, the designer and the cutter are different people; this was regularly the case in the preparation of Japanese woodcuts which required still another person, a highly skilled printer, who inked and printed the separate color blocks used in making each print. Although the lines in woodcuts may imitate the elegant swelling and tapering of engraved lines [fig. 27a; *714, 719*], they are usually thicker and more uniform [*569, 924*]. The ink lies flat on the surface of the paper or may be slightly sunk into it by the pressure of the printing press, but the ink is never raised from the surface as in an engraving. In the relief process known as "wood-engraving," the method preferred for newspaper and book illustration during the nineteenth century, lines are cut with an engraver's *burin* into the end-grain of a very hard block of wood. The wood-engraver usually works positively, each cut printing as light on dark rather than dark on light as in woodcuts. Gauguin, although he worked on soft wood, used the positive cutting technique of the wood-engraver [*950*]. During the twentieth century, a popular form of relief printing called "linocut" (lī'no-cut) was developed by gluing linoleum to a block of wood. Although linoleum is brittle and does not allow fine detail, it is much less resistant to gouges than wood, so curves are easier to cut and the whole process is much quicker. Matisse and Picasso made linocuts, working positively to produce striking effects of white on solid black. *See* BLOCK BOOK.

WORKSHOP. The apprentices and assistants who help an artist, as well as the building or room in which they work, also called the artist's "studio." It is called "atelier" (at-lyay') in France and "bottega" (bot-tay'ga) in Italy. In a large workshop such as that of Raphael, Rubens, or Bernini, many people often worked on a single piece. The master might make a full-scale *cartoon* or a small-scale study, called a "modello" [*774*], from which his assistants would work in sketching out the final version which the master would then finish. A specialist in flower painting or animal painting might also be called in as needed. Many *hands* are often distinguishable in a large-scale work from a big workshop. Sometimes one or more assistants might do all the work on a large picture, while only under the general supervision of the master; when this is the case, the piece is known as a "workshop production," "shop work," or "studio work." The value of a work usually depends on the degree

of direct participation by the master, but this is often problematical and a matter of dispute among *connoisseurs*.

ZIGGURAT (zig'uh-rat; fr. Assyrian-Babylonian *ziqquratu,* mountain top). In Sumerian and Assyrian architecture, the high temple platform, built of mud brick, in the form of a truncated stepped pyramid with ramplike stairways leading to the *sanctuary* at the top [*106–109, 120*].

CHAPTER 2

Gods, Heroes, and Monsters

ABU, Sumerian god of vegetation. A statue of Abu, formerly in his temple (c. 2700–2500 B.C.) at Tell Asmar, has survived together with a group of statues of his priests and worshipers [*111*].

ACHILLES (uh-kil'eez), son of *Thetis* and *Peleus,* was the bravest and strongest of the Greek warriors sent against Troy.

ACIS (ay'sis), the lover of the beautiful sea *nymph Galatea.* He was crushed under a rock thrown by the jealous giant *Polyphemus,* but his blood was transformed by Galatea into a river. One of the simulated easel pictures in Annibale Carracci's decoration of the gallery of the Farnese Palace in Rome [*742*] shows Polyphemus about to hurl the rock after the fleeing Acis.

AENEAS (eh-nee'us), Trojan hero who was forewarned by *Laocoön* of the fall of Troy and escaped to Italy where he founded the Roman nation. He is the ancestor of *Romulus* and *Remus* and ancestor of members of the Julian family, among them Caesar and the Emperor Augustus. The dolphin and Cupid at the base of the Primaporta statue of Augustus [Vatican, *284*] allude to the Emperor's supposed descent from Aeneas, who was the son of *Venus.*

AHRIMAN. In the dualistic Zoroastrian religion of the ancient Persians, the principle of evil and darkness. Ahriman is the opponent of *Ahuramazda* and the leader of evil spirits who are determined to destroy all that is good.

AHURAMAZDA. The Zoroastrian creator god and leader of the good spirits against the evil *Ahriman.* Ahuramazda is himself the principle of light, purity, truth and goodness.

ALCESTIS (al-ses'tis), devoted wife of Admetus, king of Thessaly. Admetus had been promised by *Artemis* that, when Death came for him, he would be

spared, if he could find a substitute. Alcestis [19] gave her life in exchange for her husband's, but was rescued from *Hades* by Admetus' friend *Herakales.*

ALCYONEUS (al-sī'oh-nus), one of the *Giants* who attacked the Greek gods. On the Altar of *Zeus* from Pergamum [Berlin, 228], Alcyoneus is shown naked and winged; he struggles to free himself from *Athena* who pulls him by the hair as his mother *Gaea,* the earth goddess, watches in despair from below.

AMAZONS, a nation of fierce warrior women who were supposed by the Greeks to live in Asia Minor. Their battles with the Greeks, which they always lost, were a popular subject with Greek artists, who sometimes used the theme as a means of alluding to contemporary military victories [217].

AMUN (also Amen, Ammum, Ammon, Amon), an Egyptian wind god who was originally the local ram-headed deity of the city of Thebes, but was later united with the sun-god as Amun-Ra, the ruler of all the gods. A great temple [95, 97] begun c. 1390 B.C. by Amenhotep III at Luxor, across the Nile from Thebes, was dedicated to Amun, his wife *Mut,* and their son *Khonsu.* The oracle of Amun at Siwa in the Libyan desert was visited by Alexander the Great who was hailed as the son of Amun. Alexander appears with the horns of Amun on Hellenistic coins [236]; by associating himself with Amun, as the Pharaohs had done before him, he asserted his divine kingship. The Greeks and the Romans identified Amun with their supreme gods, *Zeus* and *Jupiter,* calling him Zeus-Ammon and Jupiter-Ammon.

ANTAEUS (an-tee'us). In Greek mythology, a Libyan giant, son of *Poseidon* and *Gaea* (Earth), who wrestled with *Herakles* (Hercules). Herakles, who discovered that Antaeus received his strength from contact with his mother, the Earth, lifted him off the ground and crushed him to death. The struggle, represented on Greek vases and coins, was revived as a subject, during the Renaissance, by Antonio del Pollaiuolo, who emphasized the violent action and tense musculature of the two wrestlers in a large (lost) painting for Lorenzo de' Medici, a little panel (Uffizi), and a small bronze [National Museum, Florence, 625].

ANU (ah'noo), the Sumerian god of the sky. The "White Temple" atop the ziggurat at the Sumerian city of Uruk (c. 3500–3000 B.C.) [106–108] was probably dedicated to Anu.

APHRODITE (af-roh-dī'tee), the irresistible Greek goddess of Love, Beauty and Fertility. The Romans identified her with *Venus.* According to one legend she sprang from the sea (*aphros* = sea foam), as in Botticelli's "Birth of Venus" [Uffizi, 635], a painting suggested by the great literary reputation of the lost Aphrodite Anadyomene (= rising from the sea) by Apelles, court painter of Alexander the Great. The pose of Botticelli's goddess is ultimately derived from such classical statues as Praxiteles' "Aphrodite of Cnidos" [nī'dus'; Roman copy in the Vatican, 220], renowned in antiquity for its perfection and for its nudity since the goddess had previously been represented as clothed. Cythera (sih-thir'uh) near which Aphrodite was said to have risen from the

sea, as well as Cnidos, was a center of her worship, and it is to this island that Watteau's lovers, in the painting in the Louvre [818], make their pilgrimage.

APOLLO, the Greek and Roman god of the sun, music, poetry, healing, plagues, and prophecy, was the son of *Zeus* and Leto (Latona) and the twin brother of *Artemis*. He is often called the "Delian Apollo" after his birthplace, the island of Delos. Other common epithets reveal his various roles: as "Phoebus (Radiant) Apollo" he is the god of the sun and is shown driving the sun-chariot across the heavens [743]; as "Apollo Musagetes" he is the leader of the *Muses;* and as the "Pythian Apollo" he is the Python Slayer and god of prophecy, since he killed the monstrous serpent Python. Apollo is represented as the most handsome of masterful young men; he has long golden locks and his beautiful body is usually only partially draped [204, 222, 247]. As the ideal image of the youthful god, the type was adopted for early representations of both Christ [330] and Buddha. Apollo's special attributes are: the serpent Python [222, 301]; the wreath of laurel leaves [235] or the laurel tree [301] in honor of the chaste *nymph* Daphne who was turned into a laurel so that she might escape Apollo's embrace [21]; the bow and arrows with which he sent plagues and slew Python, the *Giants* [177] and the *Niobids;* the lyre which he played as god of music and poetry [672]; and the tripod [301] in which his oracle sat at Delphi.

ARIADNE (ar-ee-ad'nee), the daughter of King Minos of Crete, who fell in love with the Athenian hero Theseus. She helped him escape from the Labyrinth of the *Minotaur* by giving him a ball of thread with which to find his way out again after killing the monster. They fled together from Crete, but Theseus abandoned Ariadne on the island of Naxos where she was discovered by *Dionysus* (Bacchus) who married her and gave her a crown which he set among the stars, as a constellation, upon her death. Ariadne frequently appears as the companion of Dionysus in representations of his drunken revels [636]. In the frieze of the Dionysian rites in the Villa of the Mysteries at Pompeii [310], the wine god blissfully lies in her lap as she enfolds him in her arms.

ARTEMIS (ahr'tuh-mis), daughter of *Zeus* and Leto (Latona), was the twin of *Apollo.* Artemis, like the Roman *Diana,* was goddess of the Moon and the proud virgin goddess of the Hunt. Tall, slender, and athletic, her attributes are the crescent moon and the bow and quiver. She is sometimes shown with her brother Apollo, who was also an archer, as they shoot their deadly arrows in depictions of the "Battle of the Gods and the *Giants"* [177] or the "Death of the *Niobids."* In many respects, Artemis, the moon goddess, is the female counterpart of her twin brother, the sun god: both were unwed, both healed the sick, but both also punished the wicked and sent plagues with their arrows.

ATEN (ah'ten), the sun god imposed upon Egypt as the one and only god by the monotheist Amenhotep IV [100], who changed his name to Akhenaten ("Aten-is-satisfied"). Aten was represented as a golden disc extending beneficent rays, each one terminating in a human hand. Some of the hands may offer an "ankh," the loop-topped cross which is the Egyptian symbol for "life."

ATHENA (uh-thee'nuh), Greek goddess of Wisdom and all the arts of civilization, including righteous warfare. Athena, who was the favorite child of *Zeus,* sprang full-grown and fully armed from his head: her miraculous birth was the main subject of the east pediment of the Parthenon [*190*], her chief temple on the Acropolis, the citadel of Athens. When Athena won possession of Attica in a contest with *Poseidon,* Athens, the principal city of the territory, was named after her. When coins were minted for the city, they bore her emblem, the owl. The Parthenon was dedicated to her as "Athena Parthenos" (Maiden) and contained the colossal gold and ivory statue, of the same name, by Phidias, but she was also worshiped as "Athena Nike" (Victory) in the Ionic temple overlooking the entrance to the Acropolis [*190, 193*], and as "Athena Polias" (of the city) in the eastern chamber of the Erechtheum [*190, 196*]. Phidias' great bronze statue of "Athena Promachus" (Champion) dominated the view as one passed up through the Propylaea, the monumental gateway to the Acropolis [*190*]. Every four years, as part of the Greater Panathenaea, Athena's chief festival, a procession, represented on the Parthenon frieze [*189, 211, 287*], wound up through the Propylaea [*191*] to wrap a richly embroidered robe (peplos) around the Athena Polias in the Erechtheum. Athena is represented as a fully draped mature and majestic woman wearing a helmet and holding a spear and shield; over her breast she wears the terrifying aegis (ee'jis), a short cloak or breastplate bearing the head of a *Gorgon* [*160, 162, 228, 672, 745*]. See MINERVA.

AURORA, the Roman goddess of Dawn, identified with the Greek *Eos.* She is often shown riding across the sky in a chariot while scattering roses in allusion to her epithet "rosy-fingered Dawn" [*744*]. When Aurora is represented as the herald of *Apollo,* she flies ahead of his sun-chariot [*743*].

BACCHANTE (ba-kant'ee), one of the female followers of the Roman wine god Bacchus, noted for their gaiety, mad songs, and frenzied dancing [*821*]. Their Greek counterparts, the ecstatic female companions of *Dionysus,* were called Maenads (mee'nadz).

BACCHUS (bak'us), the Latin name for the Greek wine god *Dionysus,* who was also sometimes called "Bakchos" by the Greeks. The Dionysia, the Greek festival honoring Dionysus, was adopted by the Romans, who called it the "Bacchanalia." This degenerated into the sort of drunken revelry (Bacchanal) depicted by Renaissance artists [*676*].

CENTAURS (sen'torz), a race of wild creatures, half man and half horse, living in Thessaly in northern Greece. Their animal natures dominate their actions, which are marked by sudden violence. Invited to the wedding festivities of Hippodamia (hip-pod-uh-my'uh) and Pirithous, king of the *Lapiths,* the centaurs, as usual, drank too much and attacked the bride and her guests. The ensuing battle, which resulted in the rout of the centaurs, was frequently represented in Greek art [*163, 205*], sometimes as a moral lesson demonstrating the conquest of reason over passion or the victory of the Greeks over the Persians.

CEPHALUS (sef'uh-lus), son of *Hermes* and Herse, was married to Procris, daughter of *Erechtheus,* but Eos (Aurora), the goddess of Dawn, abducted

him. Cephalus, proclaiming his love for Procris, at first rejected her advances [*802*], but yielded after putting his wife's fidelity to a test devised by Eos. Disguised as a handsome stranger, he returned to Procris and, to his grief, successfully seduced her. Later, Cephalus killed the jealous Procris with a spear, mistaking her for an animal as she spied upon him from a thicket.

CERBERUS (ser'ber-us) was the three-headed watchdog who guarded the entrance to *Hades* [*245*].

CUPID or AMOR, son of *Venus,* was the Roman counterpart of the Greek god of Love, Eros, son of *Aphrodite.* He is represented as a handsome winged youth or as a mischievous toddler [*284*]: his attributes are the quiver and bow which he uses in shooting his darts of love [*720*]. When one or more winged *putti* appear with the attributes of Cupid, they are called "cupids" or "amoretti" [*sing.* amoretto; *673, 775*].

CYBELE (sib'uh-lee), the great mother goddess of Phrygia in Asia Minor. She was called "Mother of the Gods" and, when the performance of her fertility rites spread to Greece, she was identified with Rhea, daughter of *Gaea,* and mother of the Olympian gods. She wears a crown in the form of a turreted wall, symbolizing her role as protectress in time of war, and she is often shown standing in a chariot drawn by lions [*177*], symbolizing her position as goddess of wild nature.

CYCLOPES (sī'klohp-eez), a race of one-eyed giants who lived in Sicily. Some were shepherds like *Polyphemus,* the most famous Cyclops; others helped Hephaestus (Vulcan), the divine blacksmith, forge the thunderbolts of *Zeus* beneath fiery Mount Aetna. In tribute to the great strength of the Cyclopes, walls of enormous stones, such as those of Mycenae [*152*], are sometimes called "Cyclopean."

DEMETER (duh-mee'ter), Greek goddess of grain, agriculture, and fertility. She is represented as a fully clothed, mature, and dignified woman [*219*]. Her attributes are ears or sheaves of grain.

DIANA, the ancient Italian moon goddess, was later identified with the Greek *Artemis.*

DIONYSUS (dī-uh-nī'sus), the Greek wine god, called *Bacchus* by the Romans, was the son of *Zeus* and Semele. Before Dionysus was born, however, Semele was killed by the thunderbolts of Zeus when she insisted that her divine lover appear to her in his full majesty as king of the gods. Zeus snatched the unborn child from her womb and kept it sewed up in his thigh until it was ready to be born. Then *Hermes* carried the infant to the nymphs of Nysa [*221*] who raised him. *Silenus* was his tutor and helped him discover the art of making wine, which Dionysus, accompanied by his wife *Ariadne,* Silenus, and his band of Maenads (*Bacchantes*) and *satyrs* (fauns), introduced to the peoples of the world. He also introduced many of the other early arts of civilization such as bee-keeping [*636*] and was regarded as the patron of song and drama. Each year at Athens he was honored in the festival of the Great Dionysia for which Aeschylus, Sophocles, Euripedes, and Aristophanes wrote their great plays. Dionysus and his companions appear on thousands of Greek vases

which were used for storing, drinking, and mixing wine. On the older vases he is represented as a majestic bearded old man [161]; later, however, he is portrayed as a handsome, semi-nude, and sometimes rather girlish youth [209, 310, 636]. His special attributes are ivy and the grapevine, which he wears as a wreath, the thyrsus (a staff topped by a bunch of ivy leaves) [310], and the special form of wine cup called a "kantharos," which has two large handles looping high above the lip of the bowl [234] and usually a tall stem and broad circular base [160].

EOS (ee'os), Greek goddess of Dawn, called *Aurora* by the Romans. After driving her chariot across the sky each morning [744], Eos spent much of her time pursuing and carrying off handsome young men, among them *Cephalus* [802] and Tithonus, the brother of King Priam of Troy. By Tithonus she became the mother of *Memnon* whose death during the Trojan War was the greatest grief of her life [164].

ERECHTHEUS (eh-rek'thoos or eh-rek'thee-us), legendary king of Athens, was the son of *Gaea* and the fire god Hephaestus, but he was raised by *Athena*. The Erechtheum [190, 196], in which Erechtheus, Athena, *Poseidon*, and Hephaestus were worshiped, marks the spot on the Acropolis where Erechtheus judged the contest of Athena and Poseidon for possession of Athens. Athena gave the Athenians the olive tree which was judged more valuable than Poseidon's gifts of the horse and a spring of salt water. In honor of the new protectress of the city, Erechtheus instituted the Panathenaic festival which was celebrated with athletic and musical contests and the great procession represented on the frieze of the Parthenon [189, 211, 287].

EUROPA (yoo-roh'puh), a Phoenician princess, was playing by the seashore with her friends one day when *Zeus* approached her in the form of a handsome white bull. Charmed by the gentle bull, Europa sat on his back, as he kneeled before her, and was carried off to Crete [11] where she bore Zeus three sons, among them King Minos.

FAME. In classical and Renaissance art, fame is usually personified as a winged female figure holding or blowing a long trumpet [774, 809].

FAUN. In Roman mythology, one of the lustful creatures of the forest—half goat and half man—who join in the revels of *Bacchus* and spend much of their time drinking wine and annoying the *Bacchantes* [225, 636]. Fauns are Roman counterparts of the Greek *satyrs*.

FORTUNA, the Roman goddess of Chance and Happiness (identified with the Greek goddess Tyche), whose attributes are the horn of plenty or "cornucopia" (symbolizing the bounty she can bestow), a ball (indicating her instability), and a rudder with which she steers men's fates. Her oracle could be consulted at Praeneste (Palestrina), southeast of Rome, where a vast sanctuary honoring her as "Fortuna Primigenia" (the firstborn child of *Jupiter*) was built in the early first century B.C. [257–259].

GAEA (jee'uh), the Greek earth goddess who sprang directly from Chaos. She was both the mother and spouse of the sky god Uranus by whom she con-

ceived the Titans, the *Giants* and *Cyclopes*. The Roman equivalent of Gaea was *Tellus*.

GALATEA (gal'uh-tee uh), the beautiful sea *nymph* [673] who loved *Acis*, but was relentlessly pursued by the enamored Cyclops *Polyphemus*. Galatea was one of the fifty daughters of the sea god Nereus, the Old Man of the Sea, who were called Nereïds (nee'ree-ids).

GANYMEDE (gan'ih-meed). The youthful cup bearer of the gods, renowned for his beauty. According to Ovid, *Zeus*, disguised as an eagle, swooped down on Ganymede one day and carried him off to Olympus and immortality [742]. Renaissance Neo-Platonists interpreted the myth as an allegory of the ascent of the soul to heaven.

GENIUS. In classical and Renaissance art, a spirit represented in human form, often semi-nude and winged, who acts as a protector of a person, a people, or a place. Genii are often merely decorative [289, 623], but they may also appear as personifications of important abstract concepts, as the Genius of Liberty [889] or the Genius of the Roman People [291].

GIANTS, the great and powerful sons of *Gaea* who piled Mount Pelion on top of Mount Ossa to scale Olympus and attack the gods. After a great battle (the Gigantomachy), during which *Herakles* came to the aid of the gods, the Giants were overcome and buried beneath volcanoes throughout Greece and Italy [177, 228]. See ALCYONEUS.

GORGONS. In Greek mythology, female monsters whose hideous gaze turned men to stone. They are usually represented with frightfully large heads and writhing snakes for hair [158, 173, 174]. The most famous Gorgon was *Medusa*.

HADES (hay'deez). In Greek mythology, the lord of the Underworld whose name was synonymous with his realm, the abode of the spirits of the dead. The spirits were escorted by *Hermes* to the banks of the River Styx where they had to pay the boatman Charon to ferry them across to the entrance of the Underworld. The entrance was guarded by the monster *Cerberus* who let everyone in but no one out. Hades ruled the Underworld with his wife Persephone (per-sef'o-nee), daughter of *Zeus* and *Demeter*, the goddess of Agriculture. Hades surprised Persephone one day while she was picking flowers and carried her off to the Underworld. She was permitted to return to the upper world each spring, but had to return to Hades during the winter. This myth, like that of the annual death and return of the Babylonian god *Tammuz*, serves to explain the death and regeneration of plant life each year. Hades, whose very name was feared by the Greeks, was also called Pluto (Wealth), as he was responsible for the treasures which come from the earth.

HERA (hee'ruh), sister and wife of *Zeus* and queen of the Greek gods, was the protectress of women. Her Roman counterpart was *Juno*. Hera was worshiped from early times on the island of Samos, which the Samians claimed as her birthplace. The famous Archaic statue in the Louvre called the "Hera of Samos" [170] was found in her sanctuary there.

HERAKLES (herr'uh-kleez), the most famous of the Greek heroes, was renowned for his courage and his superhuman strength. He was the son of Alcmene by *Zeus*, who visited her in the form of her husband, Amphitryon of Thebes. Although "Herakles" means "Hera's glory," the hero was hated by the jealous *Hera* who sent a fit of madness upon him during which he killed his children. Seeking expiation, Herakles consulted the Delphic oracle and was sent to serve King Eurystheus of Tiryns who commanded him to perform the famous Twelve Labors. Some of his more famous labors were strangling the Nemean lion [162], cleaning the stables of King Augeas which had been befouled by three thousand cattle for thirty years, bringing back the golden apples of the Hesperides (the daughters of the Titan Atlas), and capturing *Cerberus*, the watchdog of *Hades*. Herakles is represented as powerful, muscular, and even brutish. He is frequently bearded; he carries a great club, and wears or carries a lion's skin [309, 625]. Sometimes he wears the lion's head as a helmet [180].

HERCULES (her'kyoo-leez), the Roman name for *Herakles*.

HERMES (her'meez), the herald of the Greek gods, who was noted for his persuasiveness and shrewd trickery. Since he was the god of Commerce, he was identified by the Romans with their *Mercury*. His attributes are the caduceus (ka-doo'see-us; a herald's rod entwined by serpents), winged sandals, and a winged cap. Although originally represented as bearded and muscular, by the fourth century B.C., Hermes is young, slender, and beardless [19, 221, 741].

HORUS, Egyptian god of Light and Day who was incarnate in each Pharaoh. He is represented as a falcon [72, 84] or falcon-headed man.

IO (eye'oh), daughter of the river god Inachus, was ravished by *Zeus* (Jupiter) who visited her in a dark cloud. To conceal Io's identity from his jealous wife *Hera*, Zeus transformed her into a heifer, which Hera later had relentlessly pursued from country to country by a gadfly. Even when Io is represented in human form, there is often the suggestion of small horns projecting from her temples [694].

IPHIGENIA (if'ih-juh-nī'uh), the daughter of the Mycenaean king Agamemnon who prepared to sacrifice her to *Artemis* so that the goddess would release the Greek fleet which was becalmed off Aulis while on its way to war against Troy [361]. At the last minute, however, Artemis substituted a hind for Iphigenia and transported her to Tauris (the Crimea) to be her priestess.

ISHTAR, the Babylonian mother goddess, whose murder and resurrection of her lover *Tammuz* is a symbol of death and regeneration. Each year, when Ishtar descends into the Underworld to retrieve Tammuz, the fertility of the earth is suspended, but, with the return of the goddess and her lover, it is restored. In the city wall of Babylon, near the palace of Nebuchadnezzar (604–562 B.C.), a great gate [125], dedicated to Ishtar, opened onto the main processional street which was lined with life-size reliefs in glazed brick of her sacred beast—the lion.

JUNO, the wife of *Jupiter* and queen of the Roman gods, was identified with the Greek *Hera.*

JUPITER, the Italian sky god, who became wholly identified with the Greek *Zeus* as king of the gods.

KHONSU, Egyptian moon god, son of *Amun* and *Mut.* All three were known as the Theban Triad and were worshiped together in the great temple at Luxor [*95, 97*], across the Nile from Thebes. At Karnak, each member of the triad had a separate temple [fig. 48].

LAESTRYGONIANS (les-trih-go'nee-ans), the race of man-eating giants who smashed the fleet of *Odysseus* (Ulysses) by hurling huge rocks [*306*]. Only Odysseus' own ship, which was anchored outside the narrow entrance to their harbor, managed to escape.

LAOCOÖN (lay-ok'oh-on), the priest of *Apollo* who warned the Trojans not to take the Wooden Horse, in which the Greeks lay concealed, into their city. To discredit Laocoön and permit the entry of the Greeks and the consequent destruction of Troy, *Athena* had the priest and his two sons crushed to death by two monstrous serpents from the sea [*230*].

LAPITHS (lap'iths). In Greek mythology, a people of Thessaly in northern Greece who defeated the *Centaurs* in the battle which was represented on the west pediment of the Temple of Zeus at Olympia [*205*], on the metopes of the Parthenon, and on the Mausoleum at Harlicarnassus [*216*]. The subject also appears on ancient Greek vases [*163*].

MAENAD. *See* BACCHANTE.

MARS, the Roman war god, was originally a god of agricultural fertility after whom the month of March was named. He was highly revered by the Romans as the father of *Romulus,* the founder of Rome. The Greek counterpart of Mars was Ares (air'eez).

MEDUSA (meh-doo'suh), one of the snake-haired *Gorgons* who turned to stone all those who looked at them. Medusa was beheaded by *Perseus.*

MEMNON, king of Ethiopia, the son of *Eos* (Aurora) and Tithonus, came to the aid of his uncle, King Priam of Troy, during the Trojan War, but was finally slain by *Achilles.* His mother, the goddess of Dawn, was so griefstricken that she threatened to leave the world in darkness [*164*]. *Zeus* granted Memnon immortality, but each morning Eos still weeps tears of dew.

MERCURY, the Roman god of Commerce, became identified with the Greek *Hermes,* the messenger of the Olympian gods.

MINERVA, goddess of Wisdom and patroness of arts and crafts, was, with *Jupiter* and *Juno,* one of the three deities most highly honored by the Romans. She absorbed the mythology and attributes of her Greek counterpart *Athena.*

MINOTAUR (min'uh-tor; fr. Gk. *Minotauros,* Minos' bull). The monster with the body of a man and the head of a bull which was kept by King Minos of

Crete in the Labyrinth built by his architect Daedalus. The beast was born to Pasiphaë, the wife of Minos, as a result of her unnatural union with a bull which *Poseidon* had given to Minos with the understanding that it would be sacrificed to him. Instead, Minos kept the bull and the Minotaur was his punishment. Each year, Athens paid tribute to Minos by sending seven youths and seven maidens which the Minotaur devoured. The Minotaur was finally killed by the Athenian hero Theseus who was aided by Minos' daughter *Ariadne*.

MUSES (myoo'zez), the Greek goddesses of the arts and sciences who inspired poets and authors. *Apollo*, as god of music and poetry, was their leader and they assembled with him near the inspiring waters of the Castalian Spring on Mount Parnassus where they are shown in one of Raphael's frescoes in the "Stanza della Segnatura" in the Vatican. Nine Muses are generally recognized: (1) Calliope, Muse of Epic Poetry, usually shown holding a tablet and stylus. (2) Clio, Muse of History, holds a scroll or book. (3) Erato, Muse of Love Poetry, sometimes holds a lyre. (4) Euterpe, Muse of Music, holds a flute. (5) Melpomene, Muse of Tragedy, wears an ivy wreath and carries a tragic mask and a sword or the club of *Herakles*. (6) Polyhymnia, Muse of Sacred Song, is veiled and contemplative. (7) Terpsichore, Muse of Dancing, plays the lyre. (8) Thalia, Muse of Comedy, wears an ivy wreath and holds a comic mask and a shepherd's staff. (9) Urania, Muse of Astronomy, holds a rod and a globe. Our word "museum" ("place of the Muses") derives from the association of the Muses with the arts and sciences.

MUT, the vulture-headed mother (mut) of the Egyptian gods, wife of *Amun* and queen of the heavens. The great temple at Luxor [95, 97], near Thebes, was dedicated to Amun, Mut, and their son *Khonsu*, who were known as the "Theban Triad."

NEPTUNE, Roman god of the Sea, was identified with the Greek *Poseidon* and was represented with the same attributes.

NIKE (nee'kay *or* nī'kee), the Greek goddess of Victory, called "Victoria" by the Romans. She is represented as a draped, winged woman and is often shown flying or with wind-blown drapery [229]. Her attributes are the palm branch or a laurel wreath which she may hold over the head of the victor [160, 228, 291, 809]. Sometimes a number of victories, or nikai, may be represented in a single composition as on the balustrade of the Temple of Athena Nike on the Acropolis [212].

NIOBE (nī'oh-bee), a queen of Thebes in Greece whose overbearing pride in her seven sons and seven daughters led her to refuse to worship Leto (Latona), the mother of only two. Leto punished her by sending her own two children, the archers *Apollo* and *Artemis*, to kill all fourteen of Niobe's children (the *Niobids*) with their arrows [208]. Niobe, frozen with grief, was turned into a stone by *Zeus*, but the stone was always wet with her tears.

NIOBIDS (nī'oh-bids), the children of *Niobe*, who were killed by *Apollo* and *Artemis* to punish the pride of their mother.

NYMPH. In Greek and Roman mythology, one of the countless minor female nature deities. Each tree, grove, grotto, stream, rock and region could have its

own attendant nymph. As their name ("young woman") implies, nymphs are represented as young and beautiful; they are usually lightly clad and carry attributes, such as flowers or water jars, which are appropriate to their province [734, 735]. They are usually kind to strangers but some have a lascivious nature and abduct handsome young men. Nymphs, in turn, are frequently pursued by *satyrs* and courted by men and gods alike. Achilles, for example, was the son of *Peleus*, a mortal, and the sea nymph *Thetis*.

ODYSSEUS (oh-dis'us, called "Ulysses" by the Romans), the wily hero of Homer's "Odyssey." After fighting for ten years in the Trojan War, it took Odysseus another ten years of wandering and hardship before he was able to return to his kingdom of Ithaca and his faithful wife Penelope. Most of his troubles on his return from Troy stemmed from his blinding of *Polyphemus*, the *Cyclops*, who sought vengeance through his father *Poseidon*. This and other adventures, such as the destruction of his fleet by the *Laestrygonians*, were frequently represented by Greek and Roman painters [158, 306].

ORPHEUS (or'fee-us), son of *Apollo* and the *Muse* Calliope, who sang and played his lyre so beautifully that he charmed the birds and beasts and even the trees and stones followed after him. When Orpheus descended into *Hades* to seek his wife Eurydice (yoo-rid'uh-see), the gods and demons were so moved by his plaintive song that they permitted him to return with his wife under the condition that he not look back at her on the way to the upper world. As they were about to leave the Underworld, Orpheus turned to see whether Eurydice was still following him and thus lost her forever.

PAN, the mischievous Greek god of the Arcadian woods and fields, was the protector of flocks and herds and had the power to "panic" all those who threatened his charges. Pan, whom the Romans associated with the wood god Faunus, is represented as a *satyr* (faun) and like the satyrs is often shown in the company of *Dionysus* (Bacchus). He is distinguished from them by his shepherd's crook and the Panpipe, or "syrinx," which he fashioned from reeds of unequal length [309] when the nymph Syrinx, whom he was pursuing, was turned into a bed of reeds to escape his embrace.

PARIS, son of Queen Hecuba and King Priam of Troy, was abandoned by his parents because of a prophecy that he would be the ruin of Troy. However, he was rescued by shepherds and reared on Mount Ida where he was chosen by *Zeus* to decide the dispute among *Aphrodite, Hera,* and *Athena* [720, 741 top] as to which one of them deserved the golden apple, inscribed "For the Fairest," which the goddess of Discord had thrown among them at the wedding of *Peleus* and *Thetis.* Hera promised Paris that he would be ruler of all Asia if he decided in her favor; Athena promised him wisdom and glory in battle; and Aphrodite promised him the most beautiful woman in the world. Paris gave the apple to Aphrodite and later carried off Helen, the wife of King Menelaus of Sparta, as his reward. This act, which was the cause of the Trojan War, ultimately resulted in his own death and the destruction of Troy.

PELEUS (pee'lee-us), king of the Myrmidons of Thessaly and father of *Achilles* by the sea-nymph *Thetis*, whom he took by force [215]. At the wedding festivities for Peleus and Thetis, the dispute which ultimately led to the

Judgment of *Paris* and the Trojan War was started when Eris, the goddess of Discord, who was furious at not having been invited, cunningly threw a golden apple, inscribed with the words "For the Fairest" among the guests.

PERSEUS (per'see-us) was the son of Danaë, daughter of King Acrisius of Argos, whom *Zeus* visited in a shower of gold. Acrisius, to prevent the fulfilment of a prophecy that he would be killed by his grandson, put Danaë and her baby into a chest and had it thrown into the sea. The chest drifted to the island of Seriphus where they were rescued by a fisherman. Polydectes, the ruler of Seriphus, fell in love with Danaë who resisted his advances. Wishing to rid himself of Perseus, who had grown up and now stood in his way, Polydectes commanded Perseus to bring back the head of the Gorgon *Medusa,* whose gaze turned men to stone. Managing to decapitate Medusa while watching her reflection in his shield, Perseus returned with the head to Polydectes and turned him to stone. Arriving at Argos with his mother and his bride Andromeda, whom he had rescued from a monster while on his way back to Seriphus, Perseus found that his grandfather Acrisius had fled out of fear of the prophecy that the son of Danaë would kill him. Perseus set out to persuade Acrisius to return, but, while participating in funeral games at Larissa, in Thessaly, he threw a discus which accidentally struck and killed a man in the crowd. The man was Acrisius.

POLYPHEMUS (pol'ih-fee'mus), the ugly man-eating *Cyclops* who fell in love with the sea nymph *Galatea* and slew her lover *Acis* [742]. Polyphemus' single eye was gouged out by *Odysseus* and his men after the giant trapped them in his cave and began eating them two at a time [158].

PORTUNUS, the Roman god of Harbors. The Ionic temple by the Tiber in Rome [253], formerly called "Fortuna Virilis," may have been dedicated to Portunus.

POSEIDON (poh-sī'dun), the Greek god of water and the sea, took possession of his realm when he and his brothers, *Zeus* and *Hades,* divided the universe among themselves after they had defeated their father Cronus (Saturn). Hades received the Underworld and Zeus, the sky; the land was common to all. Poseidon took up residence at the bottom of the sea, but repeatedly tried to extend his dominion to the land, as in his contest with *Athena* for possession of Attica. When Poseidon travels, his entourage is as numerous as that of *Dionysus* and usually far more stately [774]. He often rides in a splendid chariot drawn by horses or hippocamps (horses with fishtails) and is accompanied by splashing dolphins, curious creatures of the deep, and a multitude of sea gods, among them, perhaps, Nereus and his daughters (the Nereïds) or Oceanus and his daughters (the Oceanids) or Amphitrite, Poseidon's wife, and their son Triton, who uses a shell as a trumpet. Poseidon, like his brother Zeus, is represented as a powerful bearded figure [206], but he is distinguished from Zeus by his special attribute, the trident [698], the three-pronged spear with which he strikes forth horses and springs, shakes the earth, raises tempests, or calms the sea.

PUTTO (poo'toh; It., boy; *pl.* putti). The chubby little nude boys, usually winged, who frequently lend an air of levity to classical and Renaissance

paintings and sculpture [623, 628, 743, 744]. When they carry bows and arrows, they are personifications of love and are called "cupids" or "amoretti" [sing. amoretto; 673, 775].

RA (rah), the Egyptian sun god, was called "first king of Egypt" and the Pharaohs were thought to be his descendants. The obelisk and the solar disk were his emblems. The worship of Ra was originally centered at Heliopolis, but during the second millenium B.C. he became identified through a process of syncretism with *Amun,* the local god of Thebes, capital of the Egyptian Empire, and as Amun-Ra became the supreme god of all Egypt.

REMUS, twin brother of *Romulus,* the legendary founder of Rome. Soon after they were born, the twin brothers, who were sons of *Mars* and the vestal virgin Rhea Silvia, were set adrift on the Tiber by Amulius, who had seized the throne of Alba Longa from his brother Numitor, Silvia's father. The babies were washed ashore and found by a she-wolf who suckled them in her den [248]. Raised by a shepherd, the twins grew up and killed Amulius, restoring Numitor to the throne. They then set out to found a new city, but fell to quarreling over where it should be built and after whom it should be named. Romulus settled the dispute by killing his brother and naming the town after himself.

ROMULUS, twin brother of *Remus,* and legendary founder of Rome. Romulus laid out the walls of Rome on the Palatine Hill and attracted men to the new town by setting aside an asylum for fugitives on the neighboring Capitoline Hill. After the men seized wives for themselves in the Rape of the Sabine Women [700, 803], a war broke out between the Romans and the *Sabines,* but when the wives threw themselves between the opposing armies it was decided to unite the Sabines and Romans under the joint rule of Romulus and Titus Tatius, the Sabine king. After the death of Tatius, Romulus alone ruled over both peoples and, at the end of a long reign, was carried to heaven by his father *Mars.* Thereafter he was worshiped as a god under the name of Quirinus.

SABINES (say'bīns), an ancient people of the Sabine Hills, northeast of Rome. According to legend, *Romulus,* the founder of Rome, in order to provide wives for his men, invited the Sabines to a festival in the new settlement. During the festivities, the Romans seized the Sabine women and drove off their men [700, 803].

SATYR (say'ter). One of the rustic creatures with the body of a man and the shaggy legs of a goat who are boisterous and lustful companions of *Dionysus.* Satyrs, like their Roman counterparts, the *fauns,* are represented with pointed ears, two horns and a tail [636, 821].

SHAMASH (shah'mahsh), the Babylonian sun god and supreme judge. King Hammurabi, the "favorite shepherd" of Shamash, appears before the throne of his god at the top of the stele inscribed with his famous code of laws [Louvre, 118].

SIBYL. (sib'ill). In Greek and Roman mythology, the prophetess, inspired by *Apollo,* who lived in a cave at Cumae in southern Italy. In time, as many as

twelve "sibyls" came to be recognized, among them the Persian, Erythraean, Delphic, and Libyan sibyls who share places of honor with the Cumaean Sibyl and the prophets of the Old Testament on Michelangelo's Sistine Ceiling because they were thought to have foretold the coming of Christ [10, 656].

SILENI (sī'lee-nī), minor woodland deities in the entourage of *Dionysus* (Bacchus). Like *Silenus*, they are snub-nosed and thick-lipped and share his passion for wine. Sileni are distinguished from the goat-like *satyrs* by their horse's ears and tails; they are sometimes represented with horse's legs as well, but they are usually essentially human in form except for their ears and tails [234].

SILENUS (sī-lee'nus), the jolly old fat man who was the tutor and constant companion of the wine god *Dionysus* (Bacchus). Silenus is usually so befuddled with wine that he must be supported by *satyrs* or ride on an ass [636]. Despite his drunkenness—or because of it—he was noted for his wisdom and prophetic powers. In the frieze of the Villa of the Mysteries near Pompeii [310], Silenus and a satyr, who peers into the silver wine cup which the old man holds, may be practicing an ancient method of prophecy whereby the future is seen in a vessel filled with a liquid.

SPHINX, a creature with the body of a lion and the head of a man or woman. A double row of sphinxes was placed before Egyptian temples to form a grand avenue leading to the entrance [fig. 48]. The head of the Great Sphinx at Giza may have been intended as a portrait of the Pharaoh Chefren [cf. 83 and 84]. Sphinxes, frequently represented with the breasts of a woman, appear as decorative features in classical and Renaissance art [284, 742 top] and may sometimes allude to the Sphinx sent against Thebes by *Hera* and vanquished by Oedipus who solved the riddle it posed.

TAMMUZ (tam'mooz), the Sumerian fertility god of flocks, herds, crops and vegetation, whose annual death in the autumn and rebirth in the spring symbolized the cycle of nature. Tammuz, who was called "leading goat of the land" in honor of his generative powers, may be symbolically represented in the gold-covered stands for offering tables, carved in the form of a rearing goat resting his forefeet against a flowering tree, which have been excavated at Ur [112]. *See* ISHTAR.

TELEPHUS (tel'uh-fus), the son of *Herakles* and Auge (aw'jee), a priestess of *Athena*, who, in her shame, left the baby to die on Mount Parthenius in Arcadia. Telephus, however, was suckled by a hind [309] and years later, according to one legend, was about to marry his mother when her identity was miraculously revealed at the last minute.

TELLUS, or Terra Mater (Mother Earth), was identified by the Romans with the Greek earth goddess *Gaea*. She was the goddess of marriage and the fertility of flocks and fields. On the Ara Pacis (Altar of Peace) of the Emperor Augustus [288], she sits among plants and animals and holds two babies in her fruit-filled lap; to either side of her are the personified elements of Air and Water. Tellus also appears on another important Augustan work: the Prima-

porta statue of Augustus himself [Vatican, *284*]; here Tellus appears at the bottom of the breastplate as a reclining figure holding a cornucopia (horn of plenty) and looming protectively over two babies. Considering the propagandistic function of these two works as emblems of the peace and prosperity of the Augustan age, the babies may very well have been intended to represent the Roman twins, *Romulus* and *Remus*.

THETIS (thee'tis), one of the fifty daughters of the sea god Nereus who were called Nereïds (nee'ree-ids). The gods allowed Thetis to be abducted by *Peleus* [*215*], a mortal, when it was learned that her son was to be mightier than his father. The son was *Achilles*, the great Greek hero of the Trojan War, the seeds of which were sown at Thetis' wedding when the Apple of Discord was thrown among the guests.

VENUS, an ancient Italian goddess of Spring and vegetation, was only a minor deity until the Romans identified her with the Greek *Aphrodite* as the goddess of Love and Beauty. As the mother of *Aeneas*, who was the ancestor of *Romulus*, the founder of Rome, she was revered as the ancestress of the Roman People. Julius Caesar, whose family claimed descent from Aeneas, dedicated a temple to her as "Venus Genetrix" (Ancestress) in his forum at Rome [*260*]. The little *Cupid* riding a dolphin at the base of the Primaporta statue of the Emperor Augustus [Vatican, *284*], who was adopted by Caesar, symbolizes the divine descent of the Julian family since Cupid was the son of Venus and the dolphin alludes to the birth of Venus from the sea [*635*]. In the "Garden of Love" by Rubens [Prado, *775*], where Venus appears as a fountain of fertility, the goddess herself rides a dolphin. In Watteau's "Pilgrimage to Cythera" [sih-thir'uh; *818*], her presence is also marked by a statue; it is entwined with roses, her sacred flower. The apple which Venus sometimes holds [*886*] is the prize awarded to her by *Paris* in recognition of her supreme beauty [*720*].

ZEPHYR or ZEPHYRUS (zef'ih-rus), the Greek personification of the gentle West Wind, was the son of *Eos* (Aurora). He married Chloris (Flora), the goddess of flowers and Spring. In Botticelli's "Birth of Venus" [Uffizi, *635*], the winged Zephyr wafts the newborn goddess as he glides through the air, embracing a wind goddess with one arm and scattering flowers with the other.

ZEUS (zoos), the supreme god of the ancient Greek religion, was identified by the Romans with *Jupiter*. He was the great father of the gods and men, who enforced the moral law and could crush all who defied him. Zeus was the son of the Titan Cronus (Saturn) and the Titaness Rhea who were the children of the sky god Uranus and the earth goddess *Gaea*. Cronus castrated his father Uranus with a sickle given to him by his mother Gaea, who was angry with Uranus for banishing their monstrous children, the *Cyclopes*. As Uranus lay dying, he prophesied that Cronus, in turn, would be overthrown by one of his own children. To prevent this, Cronus ate each of his children as they were born. This was the fate of Hestia (goddess of the Hearth), *Demeter, Hera, Hades,* and *Poseidon,* but Rhea hid her sixth child, Zeus, with Gaea and gave

her husband a stone wrapped in swaddling clothes to eat in place of the baby. When Zeus was fully grown, he forced Cronus to disgorge his brothers and sisters who made war on their father and overthrew him. Zeus, Hades, and Poseidon then divided the universe among themselves. The sky became the special province of Zeus and he built his palace atop Mount Olympus, the highest mountain in Greece, but he was more powerful than all the other gods put together and became supreme ruler of the entire universe. He married his sister Hera, who, as queen, had considerable power, but could not prevent her husband's notorious infidelities [11, 694]. Zeus is represented as a majestic, bearded figure [206], whose special attributes are his mighty thunderbolts and his messenger, the eagle. In antiquity, the most famous representation of Zeus was the colossal seated figure of ivory and gold made by Phidias for the great temple at Olympia where, every four years, athletes assembled from all parts of the Greek world to participate in the games held in honor of the one god they all worshiped as supreme.

PARALLEL *Greek* AND Roman GODS

Aphrodite	/ Venus	*Eros*	/ Cupid or Amor	
Apollo	/ Apollo	*Gaea*	/ Tellus	
Ares	/ Mars	*Hephaestus*	/ Vulcan	
Artemis	/ Diana	*Hera*	/ Juno	
Athena	/ Minerva	*Hermes*	/ Mercury	
Demeter	/ Ceres	*Poseidon*	/ Neptune	
Dionysus	/ Bacchus	*Tyche*	/ Fortuna	
Eos	/ Aurora	*Zeus*	/ Jupiter	

CHAPTER 3

Christian Subjects

DEVOTIONAL SUBJECTS

THE TRINITY. Although God the Father, God the Son, and God the Holy Ghost are three persons of one and the same God, who may be represented by a single figure, each person of the Trinity has his own individuality, both theologically and in representations in art. God the Father, the Creator, was at first represented simply by a *hand* issuing from a cloud [*447*], sometimes he appeared as a head or a bust [*441, 541* upper left], and, later, as a full-length figure of a rather old man with a long beard [*584, 657*]. Jesus Christ, in the words of the Nicene Creed, is "the only-begotten Son of God, born of the Father before all ages; God of God; Light of Light; true God of true God; begotten not made; consubstantial with the Father, by whom all things were made." In Early Christian art, he appears as the Good Shepherd [*315*, cf. Luke 15:3–7; John 10:1–18] and sometimes he is represented by the cross alone— the most common symbol of his sacrifice—even in narrative scenes [*321*]. While the Son proceeds from the Father, the Holy Ghost proceeds from both the Father and the Son and is that person of the Trinity still immanent in the world, sent to inspire the Apostles and the Church during *Pentecost*. The *dove* has remained, since Early Christian times, the universal symbol of the Holy Ghost. The Trinity as a whole is now usually represented by abstract figures such as the *trefoil* or *triangle*, but, at times, three separate but identical figures have been used, as in depictions of the three angels received by Abraham [*359; Genesis 18*], who were interpreted as prefiguring the Trinity. The most common representations of the Trinity as a separate subject, however, are those showing God the Father as an older man sitting or standing with Christ, who holds the cross or is actually crucified, while the Dove of the Holy Ghost hovers between them [*598*].

THE PANTOCRATOR. The awesome image of Christ the Pantocrator (the Almighty Ruler of the Universe), which looks down from the domes of Byzantine churches [349], combines the forbidding qualities of God the Father with the features of the Son, suggesting Christ's appearance at the *Last Judgment* when he will mete out justice to the living and the dead.

DEËSIS. The image of Christ Enthroned between the Virgin Mary and *St. John the Baptist*, who act as intercessors for mankind, appears so frequently in Byzantine art [345, 360] that it has been given a special name, the Deësis (deh-ee'sis, Gk., supplication). The group also occasionally appears in Western art [549, 691] and is a regular feature of depictions of the *Last Judgment* [548].

THE VIRGIN AND CHILD. The Virgin Mary with the Christ Child is one of the most common subjects of Christian art and, since many variants of the theme have been developed over the centuries, a number of special designations are regularly used to differentiate the types. In these various images, the Virgin Mary is often called the "Madonna" (It., my lady) even though the work may have been created outside the immediate sphere of Italian art. The type called the "Madonna Enthroned" [358, 605] is one of the oldest and emphasizes Mary's position as Queen of Heaven. The motif may be expanded to include attendant angels [493, right tympanum; 604], the prophets who foretold the coming of Christ, and various saints as well [522, 529]. This grand, expanded form of the subject, when it appears in Italian art, is sometimes called the "Maestà" [It., majesty; 523]. When the figures in a "Madonna and Child with Saints" are shown in a unified spatial setting and converse or join in silent communion with one another, as in Renaissance versions of the subject [607, 634, 677], the picture is called a "Sacra Conversazione" (It., holy conversation). The throne in these images of the seated Virgin establishes her rank as Queen, but when she is shown standing, a type which becomes common in the fourteenth century, she may wear a crown as a symbol of her status [499, 511]. About the same time, the Coronation of the Virgin, by Christ, in Heaven, after her death and Assumption [rising to Heaven borne by angels; 693] began to be treated as a separate subject [567]. Contrasting with the regal images of Mary are those which emphasize her humility, mercy, and motherhood [670]. When Mary sits on the ground or on the floor rather than on a throne, she is the "Madonna of Humility;" when she is shown nursing the Christ Child, she is the "Madonna Lactans;" and when she spreads her mantel to shelter a group of the faithful, she is the "Madonna della Misericordia" (It., Madonna of Mercy). When Mary and the infant Jesus are joined by their relatives, St. Joseph (Mary's husband), St. Anne (Mary's mother), or St. Elizabeth (Mary's cousin and the mother of *St. John the Baptist*), the group is known as the "Holy Family" [572].

THE FOUR EVANGELISTS. *St. Matthew, St. Mark, St. Luke,* and *St. John,* the authors of the accounts of the life of Jesus known as the four Gospels, are called the Evangelists. They are symbolically represented by a man (Matthew), a lion (Mark), an ox (Luke), and an eagle (John), in accordance with the vision of the four "living creatures" seen by Ezekiel [1:4–14; *390,*

493 center]. The "beasts" are also used as a means of identifying the "portraits" of the Evangelists [*399, 409, 444, 447, 695*]. In church decoration, the surfaces of the four pendentives used to support a dome have been considered appropriate places for portraying the Evangelists or for displaying their symbols [*351, 620*].

THE TWELVE APOSTLES. The traditional list of the twelve disciples of Christ is composed of Peter, Andrew, James, John, Philip, Bartholomew, Matthew, Thomas, James (son of Alphaeus), Jude (or Thaddeus), Simon Zelotes, and Judas Iscariot. These disciples, with the exception of Judas, who betrayed Christ and hanged himself, became the Apostles (fr. Gk. *apostolos,* one sent forth) who preached the gospel throughout the world. St. Matthias was chosen by lot to replace Judas and bring the number of Apostles to twelve (Acts 1:23–26). In pictures, the number of Apostles is kept at twelve, but it is not always the same twelve who are represented, because more than twelve men came to be called Apostles. St. *Paul* and St. Barnabas, for example, were also called Apostles. In fact, St. Paul is almost always included among the Twelve Apostles in hierarchical and symbolic works or in pictures of those events, occurring after his conversion, such as the "Death of the Virgin" [*496, 540*] and the *Last Judgment* [*548*], when he might reasonably be expected to be present. Paul is often substituted for St. Jude, and the Evangelists St. *Mark* and St. *Luke* may replace Simon Zelotes and Matthias.

THE FOUR LATIN FATHERS. St. *Jerome,* St. Ambrose, St. *Augustine,* and St. *Gregory* are often grouped together as the Four Latin Fathers, or Doctors, of the Church [*568*]. As scholars, teachers, and interpreters of Scripture, the Fathers are leading representatives of Christ's Church on earth, the Church Militant, and are thus sometimes grouped with the *Four Evangelists,* who represent the Spiritual Church. The Four Greek Fathers are St. John Chrysostom, St. Basil the Great, St. Athanasius, and St. Gregory Nazianzus, but they are seldom represented in Western art. As an ecumenical gesture, Bernini's splendid encasement for the throne of St. Peter in the Vatican [*752*] is borne by two of the Latin Fathers, St. Ambrose and St. Augustine (wearing peaked bishops' mitres on their heads), and two of the Greek Fathers, St. Athanasius and St. John Chrysostom.

NARRATIVE SUBJECTS

The Fall of Man

FIGURES OF ADAM AND EVE [*329, 550, 585*] and the story of their creation [*559* left; *584, 657*], their disobedience, their censure by the Lord [*354* bottom; *407*], and their expulsion from the Garden of Eden [*603, 658*] are common subjects of Christian art, because in the sin of the first man and the first woman all mankind sinned and thus lost the promise of eternal life which was regained only through Christ's sacrifice on the Cross. In serial depictions of the life of Christ, the story of their fall from grace often appears as a necessary prelude, because it explains the necessity of the Incarnation. If only one picture appears, it almost always shows the central act of their disobedience

when, tempted by the serpent, Eve ate of the fruit of the Tree of the Knowledge of Good and Evil and gave Adam some of the fruit to eat also (Genesis 3:1–6). The fruit is not specified in the Bible, but it is usually represented as an *apple*. Adam and Eve are shown reaching for the fruit [*658, 716*], just holding it, eating it [*354* bottom left], or covering their nakedness with fig leaves [*329, 354*], since, after having eaten of it, "the eyes of them both were opened, and they knew that they were naked; and they sewed fig leaves together and made themselves aprons" (Genesis 3:7).

The Incarnation

THE ANNUNCIATION. Mankind had lost the gift of eternal life through the sin of Adam and Eve, but Jesus Christ, the second person of the *Trinity*, "for our salvation came down from heaven, and was incarnate by the Holy Ghost of the Virgin Mary: and was made man" (Nicene Creed). Christ, the second Adam, through his sacrifice on the Cross, washed away the sin of the first Adam and regained the gift of eternal life for all mankind. On the day of the Incarnation, when God was made flesh, the Archangel Gabriel appeared to the Virgin Mary and announced that she had been chosen to bear the Son of God (Luke 1:26–38). In the simplest representations of this "Annunciation," the figures of Gabriel and Mary appear without any indication of setting [*349* lower left; *434* lower left; *497* left], although Luke specifically mentions that "the angel came *in* unto her." Mary is often pensive, because when Gabriel appeared he said, "Hail thou that art highly favoured, the Lord is with thee: blessed art thou among women," and Mary "was troubled at his saying, and cast in her mind what manner of salutation this should be." In the more illusionistic depictions of the scene, Mary is shown indoors or in a kind of porch [*538, 541, 547, 551, 606, 711* left] and may be represented in an attitude of humility, with her hands crossed on her breast as though saying: "Behold the handmaid of the Lord; be it unto me according to thy word." A *dove* is sometimes shown hovering over her as an indication of the very moment of incarnation through the Holy Ghost. Explanations of the symbols of the purity of the Virgin appearing in depictions of the Annunciation are given in Chapter Five in the entries for *garden, glass, lily,* and *washbasin*.

THE VISITATION. After the *Annunciation*, Mary went to visit her cousin Elizabeth, of whom the Archangel Gabriel had said: " . . . she hath also conceived a son in her old age: and this is the sixth month with her, who was called barren" (Luke 1:36). The child whom Elizabeth bore was *St. John the Baptist* and when "Elizabeth heard the salutation of Mary, the babe leaped in her womb; and Elizabeth was filled with the Holy Ghost: and she spake out with a loud voice, and said, Blessed art thou among women, and blessed is the fruit of thy womb" (Luke 1:41, 42). Elizabeth is honored as the first to recognize the true identity of Mary's child, because she then said: "And whence is this to me, that the mother of my Lord should come to me?" Elizabeth and Mary are usually easily distinguished in representations of the scene, because Elizabeth is "in her old age" [*434* bottom right; *497* right; *541, 557* top center background].

THE NATIVITY. A scene depicting the birth of Christ (Luke 2:1–7) is known as a "Nativity"; the term is usually reserved for depictions of the Holy Family alone, although angels may be included [558] and sometimes two midwives, Zebel and Salome [509, 510, 546], in accordance with a legend that Salome doubted the virgin birth and suffered a withered hand.

THE ANNUNCIATION TO THE SHEPHERDS. On the night Christ was born, according to the Gospel of St. Luke (2:8–14), an angel appeared to shepherds tending their flock and told them of the birth of the Saviour. The subject often appears in the background of representations of the Nativity [509, 510]. In paintings, from the fifteenth century on, highly dramatic interpretations may be given the passage: " . . . the glory of the Lord shone round about them: and they were sore afraid" [546 background; 557 center, top right background; 558 background].

THE ADORATION OF THE SHEPHERDS. After the angel had appeared to the shepherds, they went to Bethlehem to see the Christ Child (Luke 2:15–20): "and they came with haste and found Mary, and Joseph and the babe lying in a manger." The haste of the shepherds is emphasized by Hugo van der Goes in the "Portinari Altarpiece" [Uffizi, 557]. They are usually shown in an attitude of quiet reverence.

THE ADORATION OF THE MAGI. The Magi were wise men who came from the East to offer gifts to the newborn King of the Jews (Matthew 2:1–12). They followed the star which had appeared in the heavens with the birth of Christ and had moved before them until it came to rest over Mary and Jesus in Bethlehem [545]. Only the Magi and Mary, who holds the Christ Child in her lap, appear in early representations [434 center]. There are always three Magi and they came to be represented as kings, offering gifts of gold, frankincense, and myrrh: gold symbolizes the royalty of Christ; frankincense is an emblem of his divinity; and myrrh, a symbol of death, foreshadows his suffering during the Passion. In later representations, the Magi are distinguished according to the ages of man: Caspar, the oldest magus, has a long white beard; Melchior is middle-aged; and Balthasar, who is sometimes represented as a Moor or black, is a handsome young man. In International Gothic paintings, they are frequently accompanied by a host of retainers of various ages, dressed in exotic costumes and leading a menagerie of curious beasts. The retinue of the Magi, then, amplifies the significance of the distinctions made among the three kings themselves, who represent the reverence of all nations, all races, and all ages for Christ. The Adoration of the Magi is celebrated, on January 6, by the feast of the Epiphany, the manifestation of Christ to the Gentiles.

THE PRESENTATION IN THE TEMPLE. According to Jewish custom the infant Jesus was brought to Jerusalem by Mary and Joseph who presented him to the Lord in the Temple (Luke 2:22–39). At the Presentation were St. Simeon, to whom it was promised that "he should not see death, before he had seen the Lord's Christ," and St. Anna the Prophetess, who hailed the Child as the Redeemer [434 top right; 440 top; 545 bottom right panel]. In

Melchior Broederlam's "Presentation" [Dijon, *541*], Anna and Simeon are prominent; Simeon, in accordance with the Gospel, takes the Child into his arms; Mary holds a pair of turtledoves with which "to offer a sacrifice according to . . . the law of the Lord." On the western portals at Chartres [*493*], on the second register of the right-hand tympanum, the sacrificial nature of the Presentation is emphasized: the Christ Child is placed directly on the altar, thereby foreshadowing his sacrifice on the Cross.

THE FLIGHT INTO EGYPT. In serial depictions of the life of Christ, the "Presentation in the Temple" is customarily presented immediately after the "Adoration of the Magi." According to St. Matthew (2:13–18), however, an angel appeared to St. Joseph in a dream, after the Magi had departed, and warned him to take Mary and Jesus and flee into Egypt, because King Herod the Great was about to order the death of all the babies in and around Bethlehem to insure the elimination of the child whom the Magi had called the King of the Jews. In representations of the "Flight" [*545* bottom center; *746*], Mary is usually shown cradling the Christ Child in her arms while sitting on an ass led by the aged Joseph. Sometimes idols are shown toppling from their pedestals as the Holy Family passes by [*434* upper left; *541* right]; sometimes the Holy Family is miraculously nourished in the wilderness; and sometimes they are simply shown resting by the roadside, in which case the subject is known as the "Rest on the Flight into Egypt." When Herod's soldiers are shown killing the babies of Bethlehem, the subject is called the "Massacre of the Innocents."

The Public Ministry of Christ

THE BAPTISM. After the death of Herod, the Holy Family returned to Israel and settled at Nazareth where Jesus grew to manhood. The beginning of his public ministry is marked by his baptism in the River Jordan by *St. John the Baptist* (Matthew 3:13–17; Mark 1:9–11; Luke 3:21, 22). In representations of the subject [*349* upper right; *441*], Christ is shown standing in the river as St. John pours the waters over his head and the dove of the Holy Ghost descends from God the Father. Two angels stand on the bank, ready to clothe the naked Christ when he steps from the river.

THE CALLING OF ST. MATTHEW. The drama of Christ's calling of *St. Matthew*, one of the twelve disciples, is heightened by the abruptness of the Gospel accounts (Matthew 9:9; Mark 2:14; Luke 5:27, 28): "And as he passed by, he saw Levi the son of Alphaeus sitting at the receipt of custom, and said unto him, Follow me. And he arose and followed him." Caravaggio [*739*] and Terbrugghen [*778*] make the most of the movement implied in the narrative and translate it into a drama of gestures. St. Matthew, the tax-collector, seated at the counting table, surrounded by misers and spendthrifts, is startled by the sudden appearance of Jesus, who points to Matthew as Matthew questioningly points to himself.

THE SUPPER IN THE HOUSE OF LEVI. Before abandoning everything to follow Jesus, *St. Matthew,* who was also called Levi, "made him a great feast

in his own house: and there was a great company of publicans and of others that sat down with them. But their scribes and Pharisees murmured against his disciples, saying, Why do ye eat and drink with publicans and sinners? And Jesus answering said unto them, They that are whole need not a physician; but they that are sick. I came not to call the righteous, but sinners to repentance" (Luke 5:29–32; also see Matthew 9:10–13, Mark 2:15–17). Thus the "buffoons, drunkards, Germans, dwarfs, and similar vulgarities" which Veronese put into the painting [696], which the tribunal of the Inquisition at Venice took to be the *Last Supper,* were quite appropriate to the "Supper in the House of Levi," the title which Veronese ultimately assigned the painting to escape a charge of blasphemy.

CHRIST WALKING ON THE WATER AND THE MIRACULOUS DRAUGHT OF FISHES. One of the miracles demonstrating the divinity of Christ occurred one night while the disciples, having been sent ahead, were crossing the Sea of Galilee in a boat. In the midst of a storm, which had blown up, Christ came walking to them upon the surface of the waters and when he reached their boat the storm was stilled (Matthew 14:22–33; Mark 6:45–52; John 6:15–21). According to Matthew, *St. Peter* left the boat and attempted to walk to his master over the waves: "But when he saw the wind boisterous, he was afraid; and beginning to sink, he cried, saying, Lord, save me. And immediately Jesus stretched forth his hand, and caught him, and said unto him, O thou of little faith, wherefore didst thou doubt?" When this incident is included, the subject is often called the "Navicella" (It., little ship). The panel by Conrad Witz [Geneva, *561*], which is sometimes identified as "Christ Walking on the Water," also shows the disciples trying to haul a net full of fish into the boat. When the only disciples shown pulling in the catch are St. Peter, *St. James the Great,* and *St. John the Evangelist,* the subject represented is clearly the "Miraculous Draught of Fishes" (Luke 5:1–11) after which Peter, James, and John "forsook all" and followed Christ, who told Peter: "Fear not; from henceforth thou shalt catch men." In the painting by Witz, however, seven disciples are present, Peter is in the water, and Jesus, with the weightlessness of an apparition, glides near the shore. All of these elements are in keeping with the account of the appearance of Christ by the Sea of Galilee (also called the "Sea of Tiberias"; John 21) after his *Resurrection,* when a second miraculous draught was made and Peter "did cast himself into the sea."

THE DELIVERY OF THE KEYS TO ST. PETER. In giving *St. Peter* the authority to lead the Church, Christ said: "I will give unto thee the keys of the kingdom of heaven: and whatsoever thou shalt bind on earth shall be bound in heaven: and whatsoever thou shalt loose on earth shall be loosed in heaven" (Matthew 16:19). In the scriptural account, Christ only speaks metaphorically, but the "Delivery of the Keys" is sometimes depicted as an actual event [*638*] emblematic of papal authority, which is believed to have descended directly from St. Peter, the first pope.

THE TRANSFIGURATION. Perhaps the most dramatic revelation of the divinity of Christ before his *Resurrection* is his "Transfiguration" (Matthew 17:1–

13; Mark 9:2–13; Luke 9:28–36) when, after the first missionary journey of the twelve disciples, he took "Peter, James, and John his brother, and bringeth them up into an high mountain apart, and was transfigured before them: and his face did shine as the sun, and his raiment was white as the light. And, behold, there appeared unto them Moses and Elias talking with him" (Matthew 17:1–3). In the apse mosaic at S. Apollinare in Classe [321], the subject is presented in a very elliptical fashion. Christ is represented by a large golden cross, perhaps because Moses and Elijah (Elias) "spake of his decease which he should accomplish at Jerusalem" (Luke 9:31); Christ's head appears in a medallion at the intersection of the arms of the cross. The three disciples are represented as three *lambs* and Moses and Elijah, who stand for the Law and the prophecies of the Old Testament, which were fulfilled in Christ, are represented as bust-length figures, miraculously emerging from the vari-colored clouds of a sunset sky. The Hand of God, emerging from the clouds at the apex of the apse, is a visual sign of the voice of God: "And there was a cloud that overshadowed them: and a voice came out of the cloud, saying, This is my beloved Son: hear him" (Mark 9:7). A more literal interpretation of the scene appears in a mosaic covering one of the corners of the nave of the monastery church at Daphne, Greece [349 upper left]. The most famous version of the subject is the painting by Raphael in the Vatican.

THE TRIBUTE MONEY. One of Masaccio's well-known frescoes in the Brancacci Chapel [602] depicts a story told in the Gospel of St. Matthew (17:24–27). When a collector of tribute came to *St. Peter* and asked if his master paid tribute, Jesus told Peter: " . . . lest we should offend them, go thou to the sea, and cast an hook, and take up the fish that first cometh up; and when thou hast opened his mouth, thou shalt find a piece of money: that take, and give unto them for me and thee." On a later occasion (Matthew 22:15–22; Mark 12:13–17; Luke 20:19–26), when the spies of the chief priests and scribes tried to trick Jesus into open sedition by asking whether or not it was lawful to give tribute to the Roman emperor, he took a coin and asked them whose image it bore. When they answered, "Caesar's," Jesus said, "Render therefore unto Caesar the things which be Caesar's, and unto God the things which be God's" (Luke 20:25).

THE PARABLE OF THE PRODIGAL SON. Although pictures which simply show Christ preaching [785] are not common, many of the parables, which he used as vivid examples of moral or immoral behavior, have been literally depicted as actual events. Among the most popular is the parable of the Prodigal Son (Luke 15:11–32), which typifies the central Christian concept of Repentance and forgiveness [787]. The Prodigal, having asked for his share of the family goods, "wasted his substance with riotous living," but on his return to his father's house, "his father saw him, and had compassion, and ran, and fell on his neck, and kissed him. And the son said unto him, Father, I have sinned against heaven, and in thy sight, and am no more worthy to be called thy son. But the father said to his servants, Bring forth the best robe, and put it on him; and put a ring on his hand, and shoes on his feet: and bring hither the fatted calf, and kill it; and let us eat, and be merry: for this my son was dead, and is alive again; he was lost, and is found."

The Passion

THE ENTRY INTO JERUSALEM. Serial depictions of the Passion (the sufferings of Christ during the last days of his earthly life) often begin joyfully with his triumphal entry into Jerusalem [329 center of lower register; 525, 527; Matthew 21:1–11, Mark 11:1–11, Luke 19:28–44, John 12:12–19]. When Christ and his disciples were just outside Jerusalem, at the Mount of Olives, he sent two of them to fetch an ass and her colt. This was done to fulfill the prophecy of Zechariah: "Tell ye the daughter of Sion, Behold, thy King cometh unto thee, meek, and sitting upon an ass, and a colt the foal of an ass. And the disciples went, and did as Jesus commanded them, and brought the ass, and the colt, and put on them their clothes, and they set him thereon. And a very great multitude spread their garments in the way; others cut down branches from the trees, and strawed them in the way. And the multitudes that went before, and that followed, cried, saying, Hosanna to the son of David: Blessed is he that cometh in the name of the Lord; Hosanna in the highest" (Matthew 21:5–9). This scene is usually set just outside one of the gates to Jerusalem and is depicted much as it is described in the Gospels. In Giotto's fresco in the Arena Chapel [527] even the mouths of the multitudes are opened wide as they cry, "Hosanna!" The man looking down from the branches of a tree is a traditional feature of the scene which is probably borrowed from a slightly earlier episode described by St. Luke (19:1–6). As Jesus was passing through Jericho on his way to Jerusalem, Zacchaeus, a rich publican (tax-collector), who "was little of stature," ran before Jesus and "climbed up into a sycamore tree to see him: for he was to pass that way. And when Jesus came to the place, he looked up, and saw him, and said unto him, Zacchaeus, make haste, and come down; for today I must abide at thy house."

THE LAST SUPPER. The Passover meal, which was the last Christ was to eat together with his disciples (Matthew 26:17–30; Mark 14:12–26; Luke 22:7–38), is usually represented either at the moment of the institution of the Eucharist (the Sacrament of Holy Communion) or at the moment of Christ's announcement that one among those present at the table would betray him. In representations of the latter type, it was customary, before Leonardo painted his famous version of the subject in Milan [642], to isolate Judas Iscariot, the betrayer, alone on one side of the table [611]. In Leonardo's painting, as in earlier examples, the disciples are shown reacting variously to the words: "Verily I say unto you, that one of you shall betray me." But the youthful St. John, who is usually shown drowsily leaning against Jesus (John 13:25) or with his head on the table, leans away from Jesus. John's silhouette forms the edge of one of the two great wave-like movements to either side of Christ, who is a still point in a storm of emotions. Although the gesturing figures in Tintoretto's "Last Supper" at S. Giorgio Maggiore, Venice [689], are even more turbulent than Leonardo's, the artist stresses the sacramental nature of the subject rather than the drama of betrayal. This was appropriate at a time, during the Counter Reformation, when the doctrine of transubstantiation (the transformation of the bread and wine of the Eucharist into the very substance of the body and blood of Christ) was under sharp attack by the Protestants. Tintoretto, or his patrons, chose to present the moment when Christ "took bread, and gave thanks, and brake it, and gave unto them,

saying, This is my body which is given for you: this do in remembrance of me" (Luke 22:19). The sacramental meaning of the subject is also stressed by Emil Nolde in his modern primitivistic interpretation [993].

CHRIST WASHING THE FEET OF THE DISCIPLES. According to the Gospel of St. John (13:1–17), Christ rose from the table after eating the Last Supper with his twelve disciples and, as an example of humility, washed their feet: "If I then, your Lord and Master, have washed your feet; ye also ought to wash one another's feet . . . Verily, verily, I say unto you, The servant is not greater than his lord; neither he that is sent greater than he that sent him." When he came to *St. Peter*—the moment usually chosen for representing the subject [408]—Peter protested, saying: "Thou shalt never wash my feet. Jesus answered him, If I wash thee not, thou hast no part with me. Simon Peter saith unto him, Lord, not my feet only, but also my hands and my head. Jesus saith to him, He that is washed needeth not save to wash his feet, but is clean every whit: and ye are clean, but not all. For he knew who should betray him; therefore said he, Ye are not all clean."

THE AGONY IN THE GARDEN. Leaving the upper room in the house where they ate the *Last Supper,* Jesus and his disciples went beyond the walls of Jerusalem to a garden called Gethsemane (Matthew 26:36–46; Mark 14: 32–42; Luke 22: 39–46). Taking *St. Peter, St. James,* and *St. John* apart with him, he said: "My soul is exceeding sorrowful, even unto death: tarry ye here, and watch with me. And he went a little farther, and fell on his face, and prayed, saying, O my Father, if it be possible, let this cup pass from me: nevertheless not as I will, but as thou wilt" (Matthew 26:38–39). In representations of the subject, the cup of suffering is shown physically present in the form of a Eucharistic chalice. Sometimes, it is held by the angel mentioned by St. Luke (22:43, 44): "And there appeared an angel unto him from heaven, strengthening him. And being in an agony he prayed more earnestly: and his sweat was as it were great drops of blood falling down to the ground." Peter, James, and John are usually shown near Jesus, but they are sound asleep [18]. In the accounts in Matthew and Mark, Jesus wakes Peter and asks: "What, could ye not watch with me one hour? Watch and pray, that ye enter not into temptation: the spirit indeed is willing, but the flesh is weak" (Matthew 26:40, 41). Returning to the three disciples a second time, Jesus again finds all three asleep and, after leaving to pray again, returns and finally says: "Sleep on now, and take your rest: behold the hour is at hand, and the Son of man is betrayed into the hands of sinners" (Matthew 26:45). The praying Christ, the chalice, and the three sleeping disciples can be seen at the start of the Passion series painted around the mirror in the background of Jan van Eyck's Portrait of Giovanni Arnolfini and his bride [554 bottom].

THE BETRAYAL. Immediately after Christ's *Agony in the Garden,* when it was still dark, Judas came to the garden of Gethsemane with "a great multitude with swords and staves, from the chief priests and the elders of the people. Now he that betrayed him gave them a sign, saying, Whomever I shall kiss, that same is he: hold him fast. And forthwith he came to Jesus, and said, Hail, master; and kissed him. And Jesus said unto him, Friend, wherefore art thou

come? Then came they, and laid hands on Jesus, and took him" (Matthew 26:47–50; cf. Mark 14:43–52, Luke 22:47–54, John 18:1–13). *St. Peter* attempted to defend his master and struck out with his sword, cutting off the ear of Malchus, a servant of the high priest [503, 538], but Jesus said: "Put up thy sword into the sheath: the cup which my Father hath given me, shall I not drink it?" (John 18:11).

THE DENIAL OF PETER. *St. Peter*, keeping at a distance, followed the band of men that took Jesus to the palace of Caiaphas, the high priest. He entered the palace and sat with the servants while, in another part of the building, Christ was being charged with blasphemy. As Peter was warming himself by the fire, one of the maids accused him of being a follower of Jesus, but Peter denied it. Two others also came and accused him of knowing Jesus. "Then began he to curse and to swear, saying, I know not the man. And immediately the cock crew. And Peter remembered the word of Jesus, which said unto him, Before the cock crow, thou shalt deny me thrice. And he went out, and wept bitterly" (Matthew 26:74, 75; also see Mark 14:54, 66–72, Luke 22:54–62, John 18: 15–18, 25–27). On the choir screen at Naumburg Cathedral [502], just to the left of the gable over the entrance to the choir, Peter is shown shrinking from the accusing hand of the maid of the high priest.

CHRIST BEFORE PILATE. The morning after Christ was accused of blasphemy before Caiaphas, the high priest, he was taken before Pontius Pilate, the Roman governor of Judea, and charged with treason for calling himself "King of the Jews" (Matthew 27:11–26, Mark 15:1–15, Luke 23:1–7, 13–25, John 18:28–40, 19:4–16). After a preliminary examination by Pilate, Jesus, according to St. Luke (23:8–11), was sent for judgment to Herod Antipas, governor of Galilee, who was in Jerusalem for the Passover, but the subject is seldom represented. Herod's soldiers mocked Jesus, arraying him in a "gorgeous robe," and then returned him to Pilate, who presented him to the multitude and offered to release him as the prisoner who, according to custom, the governor was to free each year during Passover. But the mob, stirred up by the priests, cried out for the release of Barabbas, a murderer, and demanded that Jesus be crucified. Whereupon, Pilate "washed his hands before the multitude, saying, I am innocent of the blood of this just person: see ye to it" (Matthew 27:24). This is the moment usually chosen for representing Christ's appearance before Pilate [329 upper right; 554 left; 688]. Pilate again appears with Jesus in the subject which is called the "Ecce Homo" (Behold the man) after his words to the multitude during a second appeal for their sympathy, after Christ had been scourged and mocked (John 19:4–7).

THE FLAGELLATION. After the mob cried out for the release of Barabbas instead of Christ, Pilate had his soldiers take Jesus away to be scourged and crucified (Matthew 27:26, Mark 15:15, John 19:1). The "Flagellation" (or "Scourging") of Christ, although only mentioned in passing by the Evangelists, is usually fully treated as a separate scene in serial representations of the Passion [554 left]. Christ, naked except for a loin cloth, is usually shown bound to a column while he is being lashed by two men, each holding a cat-o'-nine-tails or a bundle of switches.

CHRIST CROWNED WITH THORNS. Unlike the *Flagellation,* the "Mocking of Christ" by the soldiers of Pilate [*680, 990*]—also called "Christ Crowned with Thorns"—is described in considerable detail by the Evangelists: "Then the soldiers of the governor took Jesus into the common hall, and gathered unto him the whole band of soldiers. And they stripped him, and put on him a scarlet robe. And when they had platted a crown of thorns, they put it upon his head, and a reed in his right hand: and they bowed the knee before him, and mocked him, saying, Hail, King of the Jews! And they spit upon him, and took the reed, and smote him on the head" (Matthew 27:27–30; cf. Mark 15:16–19, John 19:1–3). Although it is the mocking of Christ by the soldiers of Pilate that is most frequently portrayed, he had already been mocked twice before: first, in the palace of Caiaphas, the high priest (Matthew 26:67–68, Mark 14:65, Luke 22:63–65), and, second, when he was brought before Herod Antipas (Luke 23:11), a subject which is seldom represented, probably because it includes no action not described at greater length in the other accounts. The mocking of Christ before Caiaphas is easily distinguished from his mocking by the soldiers of Pilate, because Christ does not wear a crown of thorns and is shown blindfolded while men hit him saying, "Prophesy unto us, thou Christ, Who is he that smote thee?" (Matthew 26:68).

THE BEARING OF THE CROSS. Of the Gospel account of the "Road to Calvary" (Via Crucis), only John (19:17) states that Christ carried his cross himself; the other Evangelists say that a passerby, Simon of Cyrene, was compelled to carry his cross for him (Matthew 27:32, Mark 15:21, Luke 23:26), but in most depictions of the subject, Christ himself struggles beneath the weight of the cross, although Simon is often present and may assist him [*554* upper left; *530*]. Often, the "great company of people, and of women, which also bewailed and lamented him" (Luke 23:27) are shown issuing from the city gate through which, only a few days before, Christ had entered in triumph. St. Luke (23:27–31) recounts Christ's admonition to the "Daughters of Jerusalem," but the Gospel accounts are bare compared to the wealth of incident with which legend has enriched the Via Crucis. Many of the legendary incidents which appear in paintings and reliefs stem from the popular devotion known as the "Stations of the Cross," which was developed by the Franciscans. The fourteen "stations" or scenes are: (1) Jesus condemned to death; (2) Jesus taking up his cross; (3) Jesus falling for the first time beneath the cross; (4) Jesus meeting his sorrowing mother; (5) Simon of Cyrene compelled to help Jesus carry the cross; (6) St. Veronica wiping the face of Jesus with her veil (sudarium), which miracuously retained his likeness; (7) Jesus falling the second time; (8) Jesus admonishing the Daughters of Jerusalem; (9) Jesus falling the third time; (10) Jesus stripped of his garments; (11) Jesus nailed to the cross; (12) Jesus dying on the cross; (13) the descent from the cross; (14) the entombment.

THE CRUCIFIXION. Early representations of the Crucifixion are essentially symbolic or devotional rather than historical in character. Instead of showing the subject as it might have appeared to a spectator at a particular moment and from a particular viewpoint [*548*], artists stressed the timeless significance of the sacrifice by which all mankind was redeemed. No attempt was

made to include the wealth of detail which is implied by the descriptions in the Gospels (Matthew 27:33–56, Mark 15:22–41, Luke 23:32–49, John 19: 17–37). In fact, the Crucifixion may be represented by no more than a crucifix, showing only the body (called the "corpus") on the cross [402]. Mourning angels, swooping and diving in their grief, and weeping personifications of the sun and moon may be added as an expression of cosmic woe [353, cf. Luke 23:44, 45], but the Virgin Mary, on Christ's right, and *St. John the Evangelist*, on his left, are often the only mortals present [355, 502, 554 top; see John 19:26, 27]. One early type of Crucifixion shows Christ on the cross flanked by two soldiers [389], one holding the reed topped by the vinegar-soaked *sponge* from which Christ drank (Matthew 27:48) and the other (traditionally, St. Longinus) holding the spear with which he pierced Christ's side (John 19:34). This group may be expanded by the addition of Mary and John to either side. In these early representations of the Crucifixion, Christ is nailed to the cross with four nails [355, 401, 508], but, beginning in the thirteenth century, three nails become customary: one through each hand and one piercing both feet [355, 508, 555]. This permitted the artist to dispose the limbs of the corpus either more gracefully or in a more anguished position than is possible if each foot is nailed separately. The *skull*, which sometimes appears at the base of the cross [355, 508, 555], marks the place of crucifixion as Golgotha ("the place of a skull"), according to tradition, the very spot where Adam was buried. The skull, then, is the very skull of Adam, whose sin is washed away by the blood trickling from the wounds of Christ.

THE DESCENT FROM THE CROSS. Matthew (27:57–59), Mark (15:42–46), Luke (23:50–53), and John (19:38–40) all recount how Joseph of Arimathaea, a rich counsellor and a follower of Christ, begged the body of Jesus from Pilate, took it down from the cross, and wrapped it in fine linen. John, alone, mentions Nicodemus, who brought a mixture of myrrh and aloes and helped Joseph wind the body "in linen clothes with the spices, as the manner of the Jews is to bury." Only Joseph of Arimathaea and Nicodemus, then, are specifically mentioned in the Gospels as being present during the "Descent from the Cross" (or "Deposition" as it is sometimes called), but, in representations of the subject [555, 681], the Virgin Mary, *St. John the Evangelist, St. Mary Magdalen,* and a few disciples are usually included as well. Joseph of Arimathaea, the rich counsellor, is usually older than Nicodemus, whose attribute is the jar of spices which he brought.

THE PIETÀ. The image of the sorrowing Virgin holding the dead Christ [505, 537, 564, 669] is usually known by the Italian word *Pietà* (literally, "pity," fr. L. *pietas,* piety), although it was a type of devotional image (*Andachtsbild*) first developed in Northern Europe. An expanded version of the subject, with a number of additional figures such as *St. John, St. Mary Magdalen,* Joseph of Arimathaea, Nicodemus, and the disciples, is usually known as the "Lamentation" [528] instead of the *Pietà.* Both types are artistic inventions which have no specific basis in Scripture.

THE ENTOMBMENT. The actual burial of the body of Christ, as distinct from the Lamentation over the body, is known as the "Entombment"; Joseph of Arimathaea and Nicodemus are usually shown lowering the body by means of

the linen winding sheet mentioned by all four Evangelists [554 upper right]. The Virgin, *St. Mary Magdalen, St. John,* and other disciples may assist or look on. St. Luke (23:55) mentions specifically that the "women also, which came with him from Galilee, followed after, and beheld the sepulchre, and how his body was laid," while St. John (19:41) states that the sepulchre (tomb) was in a garden in the very place where Christ was crucified. According to Matthew and Mark, when Joseph had laid the body in the sepulchre, which is described as Joseph's "own new tomb, which he had hewn out in the rock," he "rolled a great stone to the door of the sepulchre, and departed" (Matthew 27:60). The sepulchre, which is clearly described as a cave hewn out of a large outcropping of rock (Mark 15:46), is not often represented in medieval and Renaissance Entombments; the body is usually shown being lowered into a conventional rectangular sarcophagus without any suggestion of the rock-hewn sepulchre and its great stone door.

THE DESCENT INTO LIMBO. It is a point of Christian doctrine that, in the interval between the *Entombment* and the *Resurrection,* Christ descended into Hell, although the event is not actually described in the canonical books of the Bible, but in the apochryphal "Gospel of Nicodemus, or the Acts of Pilate." The "Descent" is sometimes called the "Harrowing of Hell" and Christ is sometimes shown freeing souls from the very jaws of Hell [554 right], but it is generally believed that the place to which he descended was not the region of the eternally damned, nor even Purgatory, but a special place called Limbo, the abode of the souls of those good people who awaited the Redemption of man's sins (through Christ's sacrifice on the Cross) before they could be admitted to Heaven. Prominent among the patriarchs and prophets of the Old Testament, whom Christ frees, are Adam and Eve, whose sin made Christ's sacrifice necessary. Christ usually carries the triumphal banner of the Cross and is sometimes shown trapping Satan beneath the prison gates which he has just battered down. In Byzantine art the subject is called "Anastasis" [Resurrection; 356].

THE RESURRECTION. The moment of the actual Resurrection of Christ from his tomb is not directly described in the Bible, but it often appears as a triumphant conclusion to serial presentations of the Passion. As proof of the bodily Resurrection (restoration to life), the soldiers, whom the priests and Pharisees had requested from Pilate to keep watch on the tomb (Matthew 27: 62–66), are shown sprawled on the ground while Christ steps out of a sarcophagus or hovers weightlessly above it [554 lower right; 622, 711]. The motif of the sleeping or falling soldiers is taken from the description by St. Matthew (28:1–8) of the appearance of the angel of the Lord to *St. Mary Magdalen* and Mary, the mother of James, on Easter morning: "And behold, there was a great earthquake: for the angel of the Lord descended from heaven, and came and rolled back the stone from the door, and sat upon it . . . And for fear of him the keepers did shake, and became as dead men."

THE ASCENSION. During the forty days between his *Resurrection* on Easter morning and his Ascension into Heaven, Christ appeared several times to his followers. His first appearance, to *St. Mary Magdalen* (Mark 16:9–10, John

20:11–18), is known in art as the "Noli me tangere" (Touch me not), because of his injunction to Mary, at the time, not to touch him because he had not yet ascended to his Father. Another appearance, which is sometimes represented, was to two of his disciples on the road to Emmaus (Luke 24:13–29) after which he broke bread with them during the "Supper at Emmaus" (Luke 24: 30–35). Christ also appeared to *St. Thomas*, who doubted the truth of his bodily resurrection, and allowed him to thrust his finger into the wound in his side (John 20:24–29), a subject known as the "Incredulity of Thomas." Christ's final appearance to the disciples was at his Ascension, which is described by St. Luke, in his Gospel (24:50–53) and in the Acts of the Apostles: " . . . while they beheld, he was taken up; and a cloud received him out of their sight. And while they looked stedfastly toward heaven as he went up, behold, two men stood by them in white apparel; which also said, Ye men of Galilee, why stand ye gazing up into heaven? this same Jesus, which is taken up from you into heaven, shall so come in like manner as ye have seen him go into heaven" (Acts 1:9–11) [cf. *493*, left tympanum].

The Mission of the Apostles and the Second Coming

PENTECOST. Ten days after the *Ascension* of Christ, on the day of the Jewish harvest festival of Pentecost, when the Apostles were gathered together, "suddenly there came a sound from heaven as of a rushing mighty wind, and it filled all the house where they were sitting. And there appeared unto them cloven tongues like as of fire, and it sat upon each of them. And they were all filled with the Holy Ghost, and began to speak with other tongues, as the Spirit gave them utterance" (Acts 2:2–4). This "Descent of the Holy Ghost upon the Apostles," or "Pentecost" as the subject is also called, marks the beginning of the mission of the Apostles to spread the gospel throughout the earth (hence, the gift of tongues). An unusual version of the subject is found at Vézelay [*437*], where Christ appears in a *mandorla*, with rays spreading from his fingers to the heads of the Apostles; ordinarily, small tongues of flame are shown hovering over the heads of the Apostles. The Virgin and others are also often included and the *Dove* of the Holy Ghost usually represents the Godhead rather than the figure of Christ, as at Vézelay.

THE LAST JUDGMENT. The Second Coming of Christ at the end of the world, when he shall come in glory "to judge both the living and the dead," is part of the Nicene Creed, the "Credo" of the Mass, but it is not fully developed as a subject for art until the Romanesque period when it appears carved on a large scale on the tympana of the portals of churches [*436*]. There is no single Biblical text which served as a source for artists; rather, the image was formed from parts of the many references and descriptions of the day of judgment which are scattered throughout the Bible. In its complex late Gothic form, the subject is divided into several zones [*548*]. In the zone of Heaven, Christ appears in glory, displaying the wounds of the crucifixion as a sign of his right to judge (cf. Revelation 1:7). He is surrounded by angels (Mark 13:26, 27), some of whom bear the *Instruments of the Passion* and some of whom blow trumpets to wake the dead (I Corinthians 15:52). To either side of Christ, the Virgin Mary and *St. John the Baptist* kneel as intercessors for mankind. The

twelve Apostles (Luke 22:30) and a host of the saints (I Corinthians 6:2) fill the rest of the heavenly zone about the figure of Christ [659]. Depending on the format of the picture, the naked souls who have been saved and are welcomed to Heaven and clothed by St. Peter and the angels, may also be included near Christ. St. Michael (Daniel 12:1), in full armor and carrying the scales of justice, may serve as a transitional figure between the zone of Heaven and the zone of Earth, where the naked figures of the dead rise from their graves (Daniel 12:2). Those who were lost or buried at sea may also be shown rising from their watery graves (Revelation 20:13). The just rise toward Heaven but the damned fall into the zone of Hell, where they are tormented by demons [513, 659]. The Last Judgment should not be confused with another subject commonly carved on the tympana of church portals: the Apocalyptic vision of the throne of God (Revelation 4), in which Christ, enclosed by a *mandorla*, appears with the four symbols of the Evangelists and the "four and twenty elders."

Old Testament Prefigurations of New Testament Events

Events of the Old Testament are frequently represented in Christian art because they were thought to foreshadow, or prefigure, the events of the New Testament. Beneath the literal meaning of the Biblical narrative was found a mystical, or "anagogical," meaning relating to the life of Christ. Scripture was searched for corresponding passages and the most tenuous parallels were drawn to construct a system of Old Testament "types " and New Testament "antitypes." Moses, Samson, David, Job and many others were interpreted as types of Christ and the various circumstances of their lives were seen as "figures" of incidents recounted in the Gospels. A few of the more common types and figures are explained below.

ABEL'S SACRIFICE. Cain and Abel, the sons of Adam and Eve, both offered sacrifices to the Lord (Genesis 4:3–7). Cain, who "brought of the fruit of the ground," is shown with a sheaf of grain and Abel, who was a "keeper of sheep" and "brought the firstlings of his flock," is shown offering a lamb [550 top left]. The Lord, "who had respect unto Abel and his offering," is sometimes represented by a large hand reaching out of the clouds toward Abel's lamb [439 bottom]. Medieval commentators linked Abel and his lamb with Jesus, the Lamb of God, who sacrificed himself to redeem mankind.

CAIN KILLING ABEL. The Lord accepted Abel's sacrifice, "but unto Cain and his offering he had not respect. And Cain was very wroth, and his countenance fell" and, out of envy, he "rose up against Abel his brother, and slew him" (Genesis 4:8). This was the first murder, clear evidence of the sin of man which was washed away by the blood of Christ the Lamb [549, 550 top right]. Abel, killed by his brother Cain, was seen as a type of Christ betrayed by Judas.

MELCHIZEDEK OFFERING ABRAHAM BREAD AND WINE. When Abraham returned from his victory over the kings who had sacked Sodom and captured his nephew Lot, "Melchizedek king of Salem brought forth bread and

wine: and he was the priest of the most high God" (Genesis 14:18). The author of the Epistle to the Hebrews (Chapter 7) compares the priesthood of Melchizedek to the priesthood of Christ who "offered up himself." Commentators developed the analogy, pointing out the kingship as well as the priesthood of both Melchizedek and Christ and interpreting the offering of bread and wine to Abraham as a prefiguration of the institution of the Eucharist. In the carving of the subject at Reims [498], Melchizedek, in fact, holds a Eucharistic chalice in one hand and offers Abraham a consecrated wafer with the other.

ABRAHAM'S SACRIFICE OF ISAAC. Among the prefigurations which frequently accompany representations of the Crucifixion in medieval art, the "Sacrifice of Isaac" (Genesis 22:1–19) is the most common [329 upper left; 516]. Analogies were drawn between Abraham's willingness to sacrifice his beloved only son, Isaac, and God the Father's sacrifice of his Son, Jesus. Isaac carrying the wood to the sacrifice was seen as a type of Christ Bearing the Cross and the "ram caught in a thicket by his horns," which Abraham sacrificed in place of his son, was taken as an allusion to Christ's crown of thorns. The two horns of the ram were interpreted as a symbol of the two arms of the Cross. In Early Christian art, as on the sarcophagus of Junius Bassus [Vatican, 329], the allusion to Christ's sacrifice was made more pointed by substituting a *lamb* for the ram.

JACOB WRESTLING WITH THE ANGEL. One night, during his journey to meet his brother Esau, Jacob wrestled until daybreak with an angel and "touched the hollow of his thigh," refusing to release him until he had received the angel's blessing [Genesis 32:24–32; 328, 949]. "And Jacob called the name of the place Peniel [face of God]: for I have seen God face to face, and my life is preserved." This was interpreted as a figure of the "Incredulity of St. Thomas" (John 20:24–49), because Thomas touched the wound in the side of the risen Christ as Jacob touched the hollow of the angel's thigh.

JACOB BLESSING THE SONS OF JOSEPH. Joseph took his sons, Manasseh and Ephraim, who were born in Egypt, to be blessed by his dying father Jacob (Genesis 48). In blessing his grandsons, Jacob (or Israel, as he was called after wrestling with the angel at Peniel) crossed his arms, laying his right hand on Ephraim's head and his left on Manasseh's. The crossing of Jacob's arms was seen as a figure of the Cross. The special favor shown Ephraim, who was blessed with Jacob's right hand, although he was the younger of the two brothers, was interpreted as a sign of the supplanting of the Old Covenant by the New, through Christ's sacrifice on the Cross. Thus, Manasseh represents the Jews, and Ephraim, the younger brother, symbolizes the Christians who replaced the "chosen people" in God's favor.

THE CROSSING OF THE RED SEA. The miraculous passage of the Israelites through the Red Sea and the drowning of the pursuing Egyptians [Exodus 14:21–31; 449], not only appears as an example of salvation through divine intervention, but, more abstractly, as a type of the *Baptism* of Christ. Moses [507, 653], who led the Israelites out of Egypt and brought them God's

commandments from Sinai, represents the Old Law and is the chief type of Christ, who brought the New.

DAVID AND GOLIATH. David's victory over Goliath, the prideful Philistine giant [I Samuel 17:38–54; *13, 521, 586, 612, 652, 749*], was understood as a prefiguration of Christ's triumph over the Devil through his sacrifice on the Cross. As David saved the Israelites from Goliath and the Philistines, so Christ saved the souls in Limbo from the prideful power of the Devil and his demons [*356*].

THE MISERY OF JOB. The story of Job, the upright and God-fearing man of the land of Uz, whom God allowed to suffer at the hands of Satan, was seen as an allegory of the Passion of Christ. Job, as Christ, triumphed over the Devil and, after a period of profound anguish, was restored to a position of honor, receiving "twice as much as he had before" (Job 42:10). On the sarcophagus of Junius Bassus [Vatican, *329* lower left], Job's wife stands off from her debased and diseased husband, covering her nose and mouth, as she offers him food on a stick.

JONAH AND THE WHALE. The miraculous delivery of Jonah from the belly of the "great fish" which "vomited out Jonah upon the dry land" [Jonah 2; *315*], like Daniel's delivery from death in the lion's den [Daniel 6:16–23; *329* lower right], was a common Early Christian emblem of the certainty of salvation for those who had faith in the Lord. Christ himself, however, lent a deeper significance to the story by drawing an analogy with his own coming death and resurrection: "Even as Jonah was three days and three nights in the belly of the whale, so shall the Son of man be three days and three nights in the depths of the earth" (Matthew 12:40).

CHAPTER 4

Saints and Their Attributes

ST. AGNES (*It*. Agnese, *Fr*. Agnès, *Sp*. Inez), d. c. 304, beautiful, young virgin martyr, patroness of maidens, who chose dishonor and death rather than desert Christ, her spiritual lover, for the pagan son of a prefect of Rome. Stripped naked by order of the prefect, she was led to a brothel on the site of Borromini's S. Agnese [*759*], on the Piazza Navona in Rome, but her hair suddenly grew so long that it covered her shame. In commemoration of this miracle, she is often represented with long tresses. Sometimes, she is shown with a sword, the instrument of her martyrdom, but her special attribute is the lamb (*agnus*), a punning reference to her name, and sign of her meekness and innocence. She is represented holding her lamb on Duccio's "Maestà" altarpiece [*523*] and on the Ghent Altarpiece [*549*], where she appears in the forefront of the company of virgin martyrs.

ST. ANTHONY ABBOT (*It*. Antonio, *Fr*. Antoine, *Sp*. Antonio, *Ger*. Antonius), c. 251–356, Egyptian hermit, venerated as the founder of monasticism. As a young man, he renounced the world, divided his wealth among the poor, and went into the desert where he led a solitary and ascetic life. In his solitude, he was tempted by demons, who, despairing of corrupting him with lures of the flesh, fell on him and beat him senseless [*571*]. Anthony is represented as an old man with a long, white beard; he is dressed in the habit of a monk, which is often marked with a blue letter T (for "Theos," God), as in the Ghent Altarpiece [*549*] where he leads the group of Holy Hermits. He is usually shown resting his aged bones on a rustic crutch and carrying a bell with which to exorcize demons [*557*]. St. Anthony Abbot should not be confused with St. Anthony of Padua, who lived in the thirteenth century, and was famous for his preaching and his miracles. St. Anthony of Padua is represented as a young Franciscan monk and is often shown carrying a lily and holding the Christ Child.

ST. AUGUSTINE (*It.* Agostino, *Fr.* Augustin, *Sp.* Augustino, *Ger.* Augustinus), 354–430, one of the Four Latin Fathers of the Church (Augustine, Ambrose, *Jerome,* and *Gregory*). After the profligate youth and the long period of spiritual turmoil described in his "Confessions," Augustine embraced Christianity and was baptized by St. Ambrose in Milan, where he had settled as a teacher of rhetoric. Returning to his native North Africa, he became a priest and was appointed bishop of Hippo, where he died during a siege of the city by the Vandals. The brilliance of his theological writings, the most famous of which is the "City of God," has assured his veneration as patron saint of theologians and scholars. St. Augustine is usually shown wearing the mitre (tall pointed hat) and vestments of a bishop [*691*]; often, he holds one of his many books [*752*]. The little child with the spoon, shown at his feet in Michael Pacher's "Altarpiece of the Four Latin Fathers" [Munich, *568*], is a reference to a vision he had while writing his discourse on the Trinity. Walking along the seashore, he came upon a child who told him that he was trying to pour all the water of the sea into a hole which he had dug in the sand. When Augustine told him that it was impossible, the child replied, "Not more impossible than for thee, O Augustine, to explain the mystery on which thou art now meditating."

ST. BARBARA (*Fr.* Barbe), third century?, one of the most popular virgin saints, protectress against fire, lightning, and sudden death. Barbara's special attribute is a tower, which appears behind her in a landscape or is held, as a model, in her hand. The tower is an allusion to the legend that she was shut up in a high tower at Heliopolis in Egypt by her pagan father, Dioscorus, who loved her so much that he wished to keep her from the sight of men. Visited by a disciple of Origen, who disguised himself as a physician, she was converted and baptized. Often, as in the Ghent Altarpiece [*549*], where Barbara, holding her attribute, appears with *St. Agnes* in the forefront of the group of Holy Virgins, the tower is pierced with precisely three windows. This is in reference to the third window which Barbara told workmen to insert into the splendid bath-chamber which her doting father had ordered to be built for her. When questioned by Dioscorus about the extra window, Barbara answered: "Know, my father, that through three windows doth the soul receive light–the Father, the Son, and the Holy Ghost; and the Three are One." She thus betrayed her new faith and Dioscorus, faithful to the old gods, turned upon his daughter and, when she refused to recant, beheaded her. For this unnatural act he was consumed in a sudden crash of thunder and lightning. Thus Barbara is patroness of powder magazines, fortifications, artillerymen, firefighters, and all who are exposed to sudden and violent death.

ST. BARTHOLOMEW (*It.* Bartolommeo, *Fr.* Barthélemy, *Sp.* Bartolomé, *Ger.* Bartholomäus), one of the lesser known of the twelve Apostles. He is easily distinguished in art by the large knife which he holds, in reference to the legend of his horrible martyrdom in Armenia where he was flayed alive. In his other hand, he often holds a book, the Gospel of St. Matthew, which he is said to have carried with him while preaching the gospel as far as India. In Michael Pacher's "Altarpiece of the Four Latin Fathers" [Munich, *568*], a statuette of Bartholomew with knife and book is painted to the right of *St. Gregory*.

Sometimes, as in Michelangelo's *Last Judgment* [659], Bartholomew is shown holding the very skin that was stripped from his body.

ST. CATHERINE OF ALEXANDRIA (*It.* Catarina, *Sp.* Catalina, *Ger.* Katharina), third century, a virgin princess of Egypt, who, among the female saints, ranks in popularity just after *Mary Magdalen,* with whom she is often represented [634]. A Christian counterpart of the goddess Athena, she is noted for her beauty, wisdom and eloquence. She is patroness of learning, of scholars, schools and colleges, and, therefore, is often depicted with *St. Jerome* or another of the learned Doctors of the Church. Her special attribute is the spiked wheel, part of the machine devised by the Emperor Maximin to tear apart her body as punishment for having converted the fifty philosophers whom he had futilely employed to reason against her overwhelming arguments for the Faith. Catherine's wheel is often shown broken as a sign of her deliverance from Maximin's sentence when an angel broke the machine with such violence that fragments killed thousands of pagan onlookers. Catherine is also often shown holding the sword with which she was finally beheaded after rejecting the emperor's offer of marriage. So great was her beauty that even after she had converted the fifty philosophers, the emperor's wife, his most trusted counselor, and his soldiers, all of whom he had executed, Maximin offered to make her empress of the world. Catherine, however, had already chosen Christ as her spouse; her "Mystic Marriage," in which the Christ Child places a ring on her finger, is often represented as a separate subject.

ST. CHRISTOPHER (*It.* Cristoforo, *Fr.* Christophe, *Sp.* Cristóbal, *Ger.* Christophorus), third century?, a giant from the land of Canaan, who sought to put his great strength at the service of the most powerful monarch in the world. First he served a rich and powerful king, who, nonetheless, trembled before the name of Satan. Seeing this, Christopher then served Satan himself until one day the Prince of Evil admitted his fear of Christ when he avoided a roadside cross. Christopher then set out to find Christ. He asked the advice of a holy hermit who, when Christopher refused to fast or pray, suggested that he might serve Christ by carrying travellers across a deep and swollen river; then, the hermit said, Christ might appear to him. Christopher did this and one night he was awakened by the voice of a small boy who asked to be carried across the river. Christopher placed the child on his shoulders, but, as he waded across the river, a great storm blew up, the child became heavier and heavier, and he was barely able to reach the opposite bank without going under. When Christopher finally set the child safely down he asked, "Who art thou, child, that hath placed me in such extreme peril? Had I carried the whole world on my shoulders, the burden had not been heavier!" And the child answered, "Wonder not, Christopher, for thou hast not only borne the world, but Him who made the world, upon thy shoulders."

Christopher, whose name means "Christ-bearer," is often represented [570] in midstream, leaning on the uprooted palm tree which he used as a staff; he struggles beneath the load of the Christ Child who raises one hand in blessing and carries the orb of the world in the other. In the Ghent Altarpiece [549], Christopher, since he is the patron saint of travelers, leads the Holy

Pilgrims at the extreme right. The prominent date palm (growing in the middle ground behind the giant), while it is a symbol of everlasting life, may also have been intended as an allusion to Christopher's palm-tree staff, which miraculously bore fruit when Christ told him to plant it in the earth as proof of his identity.

ST. DOROTHY (*It.* Dorotea, *Fr.* Dorothée, *Sp.* Dorotea, *Ger.* Dorothea), d. c. 300, a Christian virgin of the city of Caesarea in Cappadocia, was renowned for her beauty and piety. Brought before the governor of the city, a terrible persecutor of the Christians, she was commanded to worship the pagan gods or die. She explained that she would gladly accept death so that she might join Christ, her betrothed, in the gardens of Paradise where fruits and roses are eternally fresh. While Dorothy was being led away to be decapitated, a lawyer named Theophilus called out and mockingly asked her to send him some of the fruits and flowers, of which she had spoken, when she got to heaven. Upon her arrival at the place of execution, a beautiful boy suddenly appeared at her side carrying a basket of fresh fruit and flowers even though it was still winter. Dorothy, just before she died, asked the boy to take the basket to Theophilus and tell him that she had sent it. When Theophilus ate of the heavenly fruit, he was converted and willingly suffered martyrdom himself. The basket of fruit and flowers, usually apples and roses, is Dorothy's special attribute which she carries together with the palm or crown of martyrdom. When she is not accompanied by other saints, the basket is often carried by the child who may be given a cruciform nimbus to identify him as the Christ Child [*569*].

ST. FRANCIS OF ASSISI (*It.* Francesco, *Fr.* François, *Sp.* Francisco, *Ger.* Franziskus *or* Franz), 1181/2–1226, the son of a well-to-do merchant, abandoned a carefree life spent in the pursuit of pleasure for one of simplicity and poverty dedicated to the service of God. He was joined by others in his attempt to revive the humble life of the disciples of Christ and eventually Pope Innocent III granted St. Francis and his followers recognition as an order of mendicant friars and approved the simple rules of the order which required chastity, poverty, and obedience, but, above all, poverty. Thousands joined the new order and were sympathetically received by the people who were impressed by their simple way of life and their popular sermons which emphasized the charity and humanity of Christ. St. Francis is represented in the plain habit of his order, a long robe, originally gray but now brown, tied with a length of common rope [*607*]. Sometimes he bears the "stigmata" [*677*], the wounds of the crucified Christ which were miraculously imprinted on his hands, feet and side while he was fasting alone on Mount Alverna [*633*].

ST. GEORGE (*It.* Giorgio, *Fr.* Georges, *Sp.* Jorge, *Ger.* Georg), d. c. 300, a Christian tribune from Cappadocia in Asia Minor, who, during the persecutions ordered by the Emperor Diocletian, renounced his command and was finally beheaded after attempts to kill him with poisoned wine, a sword-studded wheel, and boiling lead had failed through divine intervention. St. George is the patron saint of England, Portugal, and Germany and the patron saint of all soldiers and armorers. He is represented as a handsome young knight

[360] and is usually distinguished from other knights by a red cross on his shield or banner, as in the Ghent Altarpiece [549] or in the statue of St. George which Donatello carved for the armorers' and swordsmiths' guild of Florence [578]. The relief beneath Donatello's statue [579] shows St. George killing the dragon, a symbol of the triumph of good over evil or, more specifically, of the triumph of Christianity over the Devil. The dragon, according to legend, threatened the town of Silene in Libya. To placate the monster, whose breath was poisoning the air, the citizens were reduced to giving it their sons and daughters to feed upon. One day, the lot fell to the king's daughter. As she was approaching the dragon's lair, St. George rode up and, making the sign of the cross, wounded the monster with his lance. St. George told the princess to put her girdle about the dragon's neck and she and St. George led it back to the city like a dog on a leash. St. George finally dispatched the beast after the people of Silene agreed to be baptized.

ST. GREGORY THE GREAT (*It.* Gregorio, *Fr.* Grégoire, *Sp.* Gregorio, *Ger.* Gregor), c. 540–604, one of the Four Latin Fathers of the Church, was born at Rome where he was appointed prefect of the city; after a period of monastic withdrawal, he served as deacon and as nuncio to Constantinople, and finally became pope, as Gregory I, in 590. Gregory was both a great scholar, in whose works the basic dogma of the church is fully developed, and a superb administrator, who during his reign saved Rome from the Lombards, began the conversion of Britain, and established rules for the clergy (including mandatory celibacy) and rules for the performance of ritual and liturgical chant. Gregory is represented in the rich vestments of a pope and crowned with the papal tiara (triple crown); he usually holds a book in reference to his many theological works and the inspiring *dove* of the Holy Ghost sometimes hovers close to his ear. Some paintings show Gregory raising the Emperor Trajan from the flames of Hell [568] in accordance with the story that one day he was so moved while meditating on the piety of Trajan, who had given his own son as a slave to the mother of a man whom the son had accidentally killed, that he prayed for the release of the dead emperor's soul from the torments of Hell.

ST. HELENA c. 250–c. 330, the mother of the emperor Constantine the Great, became a Christian and while on a pilgrimage to Jerusalem discovered the True Cross, her customary attribute [609].

ST. JAMES THE GREAT (*It.* Giacomo, *Fr.* Jacques, *Sp.* Santiago, *Ger.* Jakobus), one of the twelve Apostles, was the brother of *St. John the Evangelist*. In the gospel accounts, James, John, and *St. Peter* are often called apart from the other disciples by Jesus; they were chosen to witness the *Transfiguration* and to accompany Christ during the *Agony in the Garden*. After the *Ascension*, James spread the gospel throughout the world, going as far as Spain where he is revered as the national saint. Returning to Judea, he was beheaded by order of Herod Agrippa (grandson of Herod the Great) and thus received the distinction of being the first of the apostles to be martyred. The incidents of his martyrdom were painted by Mantegna on the walls of the Ovetari Chapel in the Erimitani Church in Padua [630]. James' body was sent to Spain where,

after being lost during the Moslem incursions, it was enshrined at Compostela which became the most important pilgrimage center in Western Europe. St. James is often represented as a pilgrim to his own shrine, as in the group of Holy Pilgrims in the Ghent Altarpiece where he appears behind the giant *St. Christopher* [549]. He is usually shown leaning on a pilgrim's staff and wearing the pilgrim's great cloak, large wallet, and flap-brimmed hat with scallop shell.

ST. JEROME (*It.* Geronimo *or* Girolamo, *Fr.* Jérome, *Sp.* Jerónimo, *Ger.* Hieronymus), c. 340–420, one of the Four Latin Fathers of the Church, was born in Dalmatia and studied at Rome where he became a priest and secretary to the pope, but, being of an irascible temperament, he retired to the Holy Land, where he had lived as a hermit, and, settling at Bethlehem, spent the rest of his long life translating and interpreting the Bible. Jerome's Latin translation of the Bible (the Vulgate) became the standard Catholic text. He is usually represented as an old, bearded scholar holding the Vulgate in his hand [634] or working on his translation in his study, but he is also shown in the wilderness as a penitent ascetic. Sometimes he is accompanied by the lion he tamed by removing a thorn from its paw and quite frequently he is shown with a crimson cardinal's hat although the rank was not instituted until long after his death.

ST. JOHN THE BAPTIST (*It.* Giovanni Battista, *Fr.* Jean Baptiste, *Sp.* Juan Bautista, *Ger.* Johannes der Täufer), considered the last prophet of the Old Testament and the first saint of the New Testament, was the forerunner of Christ, whom he hailed as the Messiah. Conceived six months before Christ, by Elizabeth, the wife of Zacharias, John lept for joy in his mother's womb when during the *Visitation* [434] the Virgin Mary, Elizabeth's cousin, announced that she had conceived the Son of God (Luke 1:39–44). Even as an infant, John is shown reverently kneeling before the Christ Child [641]. John became an ascetic living in the wilderness of Judea, "his raiment of camel's hair, and a leathern girdle about his loins; and his meat was locusts and wild honey" (Matthew 3:4). John is readily identified by his rude camel's skin tunic, which he wears under even the richest robes, as well as by his lean, ascetic figure and his long, unkempt hair and beard [523, 607]. People went to John in the wilderness to be baptized, as a sign of repentence, and he told them of the coming of the Messiah. Jesus himself came from Galilee to Jordan to be baptized by John [441]. Because John hailed Jesus as the "Lamb of God, which taketh away the sin of the world" (John 1:29), the lamb is John's chief attribute [551, 697, 710]. John was eventually imprisoned by King Herod Antipas (son of Herod the Great) for speaking out against his marriage to his brother's wife, Herodias, and was finally beheaded at the request of Salome, the daughter of Herodias [581, 954] (Matthew 14:3–11; Mark 6:17–28). John is of very high rank in the heavenly hierarchy and regularly appears with the Virgin Mary at the side of Christ as an intercessor pleading for mankind [548, 691]. When Mary, John, and the enthroned Christ are treated as a separate subject, the group is called the *Deësis* [345, 360, 549].

ST. JOHN THE EVANGELIST (*It.* Giovanni, *Fr.* Jean, *Sp.* Juan, *Ger.* Johannes) and his brother *St. James the Great* were fishermen of Galilee and among the

first disciples of Christ. With *St. Peter* they formed an inner group among the disciples which received the special confidence of Jesus. John, the youngest of the disciples, is sometimes called the "Beloved Disciple" because he is identified with the one "whom Jesus loved" and "leaned on Jesus' bosom" at the *Last Supper* [*611*] (John 13:23). During the *Crucifixion*, when Jesus saw Mary and John standing at the foot of the cross [*355, 502, 598*], he said to Mary, "Woman, behold thy son!" and he told John, "Behold thy mother!" (John 19:26, 27). In the various Passion scenes, John is usually shown comforting Mary [*710, 530, 548, 555*] or mourning the loss of his master [*528, 564, 681*]. After the Crucifixion, John is said to have taken Mary into his own home and after her death [*496, 540*] and Assumption to have preached the gospel throughout Judea with St. Peter. He settled at Ephesus and during the persecutions of the Emperor Domitian, he was taken to Rome where he is said to have miraculously survived an attempt to kill him with a cup of poisoned wine, one of his special attributes [*551*], and an attempt to boil him in oil. John was banished as a sorcerer to the island of Patmos, where he wrote the last book of the New Testament, called the "Apocalypse" or the "Revelation of St. John the Divine" (i.e., the theologian). He is also credited with the three epistles and the Gospel which bear his name. According to *St. Jerome*, the eagle is John's special attribute as one of the Four Evangelists [*447*], because he soared aloft to contemplate the divinity of Christ, which he emphasizes more than the other Evangelists. In any group of the Apostles, John is usually quickly singled out by his prominent position (often near Peter or Christ) and by the youthfulness of his features. In the West, John is usually depicted as beardless and with long curly hair of a light color, frequently blond [*525, 602, 638, 642, 718*], despite his supposed death at a very advanced age of one hundred years or more, after returning to Ephesus from his exile on Patmos.

ST. LAWRENCE (*It*. Lorenzo, *Fr*. Laurent, *Sp*. Lorenzo, *Ger*. Laurentius *or* Lorenz) , d. 258, a native of Spain, went to Rome where he became archdeacon during the papacy of Sixtus II. When Sixtus was condemned to die for refusing to renounce the faith, Lawrence wished to be martyred with him, but the pope told him that he should first distribute the treasure of the Church among the poor to prevent it from being seized by the state. When Lawrence was called before the Emperor Valerian to deliver the treasure, he came with a great crowd of the impoverished and the infirm and told Valerian that he must search for the treasure of the Church in heaven where the poor had stored it up. For his impudence, Lawrence was imprisoned, tortured and finally martyred on a gridiron placed over burning coals. While he was being roasted, Lawrence, who had joyously sought his martyrdom, called out merrily to Valerian: "I am well cooked on one side. Turn the other and eat!" Lawrence, like *St. Stephen* with whom he is often represented, is handsome, youthful, and mild; both wear the dalmatic (a long-sleeved outer tunic) proper to deacons. Lawrence's special attribute is the gridiron upon which he was martyred [*659*]. On the base of his statue on the south transept portal at Chartres [*495*] is a relief of Valerian being choked by a devil.

ST. LUCY (*It*. Lucia, *Fr*. Luce *or* Lucie, *Sp*. Lucia, *Ger*. Luzia), d. c. 300, a young virgin of a noble family of Syracuse whose fiancé had denounced her as a Christian when she gave all her possessions to the poor. Lucy was martyred by

a dagger thrust in the neck, but her usual attribute is a pair of eyes lying on a dish held in her hand [607]. The eyes were probably first introduced as an indication of her name, which means "light," but according to a legend which seems to have been invented in explanation of the attribute, Lucy cut out her eyes and gave them to a suitor who had pursued her out of admiration for their dazzling beauty.

ST. LUKE THE EVANGELIST (*It.* Luca, *Fr.* Luc, *Sp.* Lucas, *Ger.* Lukas), a physician of Antioch, became a disciple of *St. Paul* and accompanied him to Rome. After Paul's martyrdom, according to one tradition, he went as a missionary to Greece where he was crucified, but according to the Greek tradition he died a natural death. He is regarded as the author of two books of the Bible, the Gospel which bears his name and the Acts of the Apostles. Luke is also the patron saint of painters since he is said to have won converts by exhibiting his own paintings of Christ and the Virgin. His special attribute is the winged ox [409], which frequently appears in conjunction with the symbols of the other three Evangelists [390, 493]. Since the ox was a sacrificial animal in antiquity, it is interpreted as referring to the emphasis Luke places on the priesthood of Christ.

ST. MARGARET (*It.* Margherita, *Fr.* Marguérite, *Sp.* Margarita, *Ger.* Margarete), d. c. 300, virgin martyr of Antioch and patron saint of women in childbirth. The dragon upon which Margaret usually stands and the cross which she holds [553 bedpost; 557 right] refer to an episode during her torture and imprisonment for refusing to renounce Christ and become the wife of Olybrius, governor of Antioch. Satan visited her dungeon in the form of a terrible dragon and, according to one version, swallowed her alive, but she made the sign of the cross and the monster's belly burst. Shortly before Olybrius had her beheaded, Margaret prayed that all pregnant women who called upon her name might be granted the safe delivery of a healthy baby.

ST. MARK THE EVANGELIST (*It.* Marco, *Fr.* Marc, *Sp.* Marcos, *Ger.* Markus), like his friend and fellow Evangelist *St. Luke*, was not one of the twelve Apostles, although he accompanied *St. Paul* and *St. Peter* on some of their missionary journeys. While Luke's gospel is sometimes called "St. Paul's Gospel" because Luke was Paul's disciple, Mark's is thought to be composed of the personal reminiscences of St. Peter, who converted Mark and called him his son (I Peter 5:13). Mark is said to have become the first bishop of Alexandria where he was martyred by being dragged through the streets with a rope around his neck. In the ninth century, his body was stolen from his tomb at Alexandria by Venetians and buried on the site of the great church of San Marco [350, 351]. Mark's special attribute is the winged lion, which, according to one interpretation, is said to stand for the emphasis placed on Christ's royal dignity in his Gospel [399 , 444]. In Dürer's painting, "The Four Apostles" [Munich, 718], Mark, who was probably intended by Dürer to represent the choleric temperament, seems to have absorbed some of the fearful physical characteristics of his attribute [388].

ST. MARY MAGDALEN (*It.* Maria Maddalena, *Fr.* La Madeleine, *Sp.* Maria Magdalena, *Ger.* Maria Magdalena), who is mentioned in the Gospels as a

woman from whom Christ cast out seven devils (Luke 8:2) and later witnessed his Passion and *Resurrection,* has been identified in the West, since the time of *St. Gregory the Great,* with the penitent sinner who anointed Christ's feet (Luke 7:37, 38) and with Mary, the sister of Martha and Lazarus, who also anointed his feet (John 12:3). Mary frequently appears in depictions of the *Bearing of the Cross* [530], the *Crucifixion* [548, 710], the *Descent from the Cross* [555], the *Lamentation* [528, 537, 564], and the *Entombment.* She is usually richly dressed, in allusion to her sinful life of luxury before her repentence; her hair is usually unbound and very long since she used it to wipe Christ's feet; her special attribute is the pyxis, or ointment jar, by which she is readily identified when she appears alone or as a patron saint [557]. In paintings of the *Descent from the Cross,* the *Lamentation,* and the *Entombment* she mourns near those very feet which she anointed while Christ lived. Mary was the first to see the risen Christ (John 20:11–17), a subject which is sometimes represented separately and called the "Noli me Tangere" (Touch me not). It is said that, many years after the *Ascension* of Christ, Mary, together with Martha and Lazarus and other Christians, was seized by infidels and set adrift in a rudderless ship which was carried to Marseilles. After persuading the people of the city to give up their idols and be baptized, Mary retreated into the wilderness where, sustained by celestial food, she did penance for thirty years until she was borne aloft by angels. The penitent Magdalen is usually represented as a beautiful young woman, but Donatello carved her as a toothless old recluse, her wasted body covered with the snarled and tangled tresses which were once her sinful pride [587].

ST. MATTHEW THE EVANGELIST (*It.* Matteo, *Fr.* Matthieu, *Sp.* Mateo, *Ger.* Matthäus), one of the twelve Apostles, was a tax-collector (publican) at Capernaum where Christ approached him in the custom house and said: "Follow me" [739, 778] (Matthew 9:9). Matthew, who was also called Levi, followed Christ and, after preparing a great feast for him [696] (Luke 5:29, 30), joined the small band of disciples. After the *Ascension,* he preached "to the Hebrews" and, before traveling to Egypt and Ethiopia, is said to have written his gospel for them. According to the "Golden Legend," Matthew was stabbed in the back while praying at the altar of his Ethiopian church. Thus, he is sometimes represented with a sword, but his special attribute is the winged man [695], or angel, which is thought to be appropriate because Matthew begins his Gospel with the human ancestry of Christ and emphasizes his humanity. Like the other Evangelists, he is often shown writing his Gospel [397] and, when the symbols of the Four Evangelists are grouped together, Matthew may be represented by the winged man alone [390, 493].

ST. MICHAEL (*It.* Michele, *Fr.* Michel, *Sp.* Miguel), the greatest of the archangels, whose name means "like unto God," is captain of the heavenly hosts, whom he led against Satan's rebellious angels during the great war in heaven (Revelation 12:7–9). In the Book of Daniel (12:1), he is described as "the great prince which standeth for the children of thy people." From being lord and protector of the Chosen People, he became patron saint of the Church Militant. Michael is also lord of the souls of the dead and therefore plays a prominent part in depictions of the *Last Judgment* [548], in which he

appears in full armor, frequently holding the scales of justice. In Signorelli's fresco of "The Damned Cast into Hell" [639] Michael appears as commander of the other archangels venerated by the Church: Gabriel and Raphael. Michael is always depicted winged, eternally youthful and as beautiful as the artist can make him [332].

ST . PAUL (*It.* Paolo, *Sp.* Pablo, *Ger.* Paulus) was born at Tarsus of Jewish parents who named him Saul. He undertook rabbinical studies at Jerusalem and became a fanatical persecutor of the Christians. He was an approving witness to the stoning of *St. Stephen* (Acts 7:58) and was on his way to Damascus to arrest any Christians he might find there when he was blinded by a light from heaven and heard the voice of Christ (Acts 9). This experience resulted in his conversion and he devoted the rest of his life to spreading the gospel of Christ as zealously as he had at first attacked it. St. Paul and *St. Peter* are frequently represented together or on either side of Christ [330, 691] since the two are considered to be the founders of the Church: Peter as Apostle to the Jews and Paul as Apostle to the Gentiles. Paul's customary attributes are the sword, with which he was martyred in Rome under Nero, and the book of his epistles to the faithful [523, 718]. Among the Apostles, Peter, Paul and the youthful *St. John* are the most distinctly characterized. Paul has a high forehead, his hair is brown, and his beard is full; he has a long prominent nose and usually a very determined visage [496, 540].

ST. PETER (*It.* Pietro *or* Piero, *Fr.* Pierre, *Sp.* Pedro, *Ger.* Petrus), a fisherman of Galilee, was one of the first disciples of Christ. His name was Simon, but Jesus called him Cephas (Peter), which means "rock." In the Gospels, Peter frequently acts as the spokesman of the twelve disciples and was chosen by Christ as the leader of his Church: "thou art Peter, and upon this rock I will build my church" (Matthew 16:18). The large key or keys, which are Peter's special attribute [437, 638, 659, 677, 691, 718], signify the power to loose and bind which was granted to him by Christ: "whatsoever thou shalt bind on earth shall be bound in heaven: and whatsoever thou shalt loose on earth shall be loosed in heaven" (Matthew 16:19). Peter was impetuous. He recognized Jesus as "the Christ, the Son of the living God" (Matthew 16:16) and fervently swore that he was ready to follow him to prison and to death (Luke 22:33). When the soldiers came to arrest Jesus, Peter struck out with a sword and cut off the ear of Malchus, a servant of the high priest [503] (John 18:10), but, soon after, he thrice denied that he even knew Jesus (Mark 14:66–72). After the *Ascension*, Peter spread the gospel throughout Asia Minor and then is said to have gone to Rome where he was martyred on the cross. At his own request the cross was inverted and he was nailed to it upside down since he felt unworthy of being crucified in the same way as his master. Bramante's "Tempietto" [647] is thought to mark the place where he was martyred; his presumed burial place, beneath the high altar of the basilica of St. Peter's [748], is marked by Bernini's great bronze canopy (baldacchino). Bernini also encased the wooden chair, which is thought to be Peter's cathedra (episcopal throne), in a magnificant display of bronze sculpture at the far end of the basilica [752]. Peter is always clearly distinguishable when he appears among

the Apostles or other saints. He is usually given a prominent place among them and is shown as a stolid, robust old man with plain but vigorous features; his face is rather square and is framed by a short, curly beard [*408, 523* second row right, *525, 527, 540, 602*]; he may be balding [*634, 638, 677, 691*] and sometimes he is shown with a circular bald spot at the top of his head like a monk's tonsure.

ST. SEBASTIAN (*It.* Sebastiano, *Fr.* Sébastien, *Ger.* Sebastian), d. 288?, an officer in the imperial guard and a favorite of the Emperor Diocletian, who nonetheless ordered him executed by archers for refusing to deny Christ. Although left for dead, Sebastian was nursed back to health by the widow of a martyred friend and again testified to his faith before Diocletian, who had him clubbed to death. Sebastian is represented as a handsome, almost nude, young man, bound to a tree or column, his body pierced with arrows. It is probably the ancient association of these arrows with Apollo, the archer whose darts brought pestilence and sudden death, that accounts for both the beauty of Sebastian and his veneration as a plague saint. The ruined triumphal arch to which Sebastian is tied in Mantegna's depiction of his martyrdom [Vienna, *632*] is probably intended as an allusion to the decay of the pagan world, a theme familiar from representations of the *Nativity.*

ST. STEPHEN (*It.* Stefano, *Fr.* Étienne, *Sp.* Esteban, *Ger.* Stephanus *or* Stefan), d. 33, the first deacon and the first martyr; his story is told in the sixth and seventh chapters of the Acts of the Apostles. Accused of blasphemy, Stephen was brought before the council of the Jews in Jerusalem to whom he delivered a fiery sermon accusing them of stubbornness and blindness before the Holy Ghost. This so infuriated them that they "ran upon him with one accord, and cast him out of the city, and stoned him." Saul (later *St. Paul*) was among those who consented to his death. Stephen is represented as a young man dressed in the wide-sleeved dalmatic of a deacon. Despite the rather choleric temperament displayed in his denunciation of the Jews, his face is usually gentle, since "all that sat in the council . . . saw his face as it had been the face of an angel." In El Greco's "Burial of Count Orgaz" [Santo Tomé, Toledo, *691*], Stephen assists *St. Augustine* in lowering the body into the grave; his martyrdom is depicted on his vestment. Stephen's particular attribute is the stone, or stones, of his martyrdom which sometimes lie on the Scriptures he frequently holds, as in the panel with the portrait of Étienne Chevalier [Berlin, *562*] from a diptych by Jean Fouquet. Because Stephen was reburied with *St. Lawrence,* the two saints are often represented together, as on the south porch at Chartres [*495*] where a small figure of Saul looks up from the base of Stephen's statue. Stephen and Lawrence are both deacons, both martyrs, both young and of a mild disposition.

ST. THEODORE (*It.* Teodoro, *Sp.* Teodoro, *Ger.* Theodor), the name of two warrior saints of the late third century, St. Theodore Tyro of Amasea and St. Theodore Stratelates of Heraclea. The two may originally have been one and the same person whose separate identities may be accounted for by the development of different legends in separate localities. The two Theodores appear on the left-hand wing of the Harbaville Triptych [*360*]. The handsome young

knight on the left portal of the south porch at Chartres [*495*] should probably be identified as St. Theodore Tyro, since he is said to have set fire to a temple of Cybele and is shown in the act on one of the windows at Chartres; for this he was burned alive. On the base of the statue, Theodore is shown kneeling before an idol which, according to one legend, he later secretly broke up, distributing the precious pieces to the poor.

ST. THERESA OF AVILA (*It.* Teresa, *Fr.* Thérèse, *Sp.* Teresa, *Ger.* Theresia), 1515–1582, Spanish mystic, founder of the Discalced (Barefoot) Carmelite Order. Many of her visions are represented in the churches of the Order; the most famous is Bernini's group, usually known as "The Ecstasy of St. Theresa" [*750, 751*], in the Cornaro Chapel at the Carmelite Church of Sta. Maria della Vittoria, Rome. Bernini's representation corresponds exactly with Theresa's description of her "transverberation" (the piercing of her heart by the arrow of Divine Love), the vision mentioned in her Bull of canonization.

ST. THOMAS (*It.* Tommaso, *Sp.* Tomé), one of the twelve disciples of Christ, called "Doubting Thomas" because of his refusal to believe in the *Resurrection* until Christ appeared to him and he touched his wounds. Thomas is traditionally the Apostle to India, where he was martyred. He bears a lance, the instrument of his martyrdom, on the left wing of the Portinari Altarpiece [Uffizi, *557*]. More frequently, he holds a carpenter's square, as in El Greco's "Burial of Count Orgaz" [Santo Tomé, Toledo , *691*]. The square alludes to a moralizing legend in which Thomas is directed by Gondoforus, King of the Indies, to build a magnificent palace. While the king is away, Thomas gives the gold for the palace to the sick and the poor, thereby assuring the king a palace in heaven rather than on earth. The legend has assured Thomas his position as patron saint of architects and builders.

CHAPTER 5

Christian Signs and Symbols

APPLE. Although the fruit of the Tree of the Knowledge of Good and Evil in the Garden of Eden is not specified in the Bible (Genesis: Chapter 3), it was commonly thought to be an apple tree, perhaps because the Latin word for "apple" and for "sin" (*malum*) are the same. When Adam and Eve are shown with an apple [716] or some other fruit [550], it is a symbol of their sinfulness in disobeying the injunction of God not to eat the fruit of the Tree of Knowledge. When the apple is held by Mary or the infant Jesus, or when it simply appears near them [572], it alludes to their rôles as the Second Eve and the Second Adam who took away the sin of the first man and woman and restored to mankind the promise of eternal life.

BIRD. Birds of many species appear in Christian decoration, from the earliest times, as emblems of the soul [325, 390, 634]. In narrative representations, however, the soul is depicted as a little doll-like figure [354 upper right; 496, 540, 691]. Particular species of birds have special meanings: the peacock is a symbol of immortality because it was thought that its flesh does not decay; the goldfinch, since it eats thorny plants, refers to Christ's *crown* of thorns and, therefore, to his Passion in general; the *eagle* is the attribute of St. John; the *dove* is the emblem of the Holy Ghost; and the *pelican* is an emblem of Christ's sacrifice.

CHALICE. A chalice, the metal drinking goblet used to hold the consecrated wine during the performance of the Eucharist (the sacrament of Holy Communion), refers to the *Last Supper* and to Christ's sacrifice on the Cross. At the Last Supper, when Jesus gave the cup of wine to his disciples, he said: "this is my blood of the new testament, which is shed for many for the remission of sins" (Matthew 26:28). The identification of the Eucharistic wine with the sacrificial blood of the crucified Christ is made most directly in images of the

155

Lamb of God in which the blood issuing from the breast of the Lamb flows directly into a large chalice [549, 710]. The cup of suffering, mentioned by Christ during the *Agony in the Garden,* is usually represented as a Eucharistic chalice and sometimes appears among the *Instruments of the Passion.* The cup held by Melchizedek when he gives Abraham bread and wine [498] is also usually given the shape of a Eucharistic chalice since Melchizedek, the priest-king, was seen as an Old Testament type of Christ and his offering of wine was seen as a prefiguration of the *Last Supper.* The *serpent* or serpents in the chalice which *St. John the Evangelist* carries as an attribute [551] allude to various legends according to which he was given a cup of poisoned wine to drink.

CITY. In medieval church decoration and manuscript illumination, the City of God, the Heavenly Jerusalem described in the Revelation of St. John (Chapter 21), is usually represented in schematized form with crenellated walls and towers [chandelier in *391, 408*]. In Early Christian art, however, the image of the resplendent city is sometimes based on the type of ancient Roman stage setting elaborated in Pompeian wall decoration [cf. *304* and *325*]. On the Ghent Altarpiece [549], it is marked by a multitude of towers and turrets, rising above the horizon in the panels depicting the Adoration of the Lamb. The clusters of such towers, which were originally planned for many Romanesque and Gothic churches [403, 426, 427], were quite likely intended to convey the impression of the Heavenly City on earth described by St. John: "the city of my God, which is new Jerusalem, which cometh down out of heaven . . . " (Revelation 3:12).

COLUMBINE. The columbine, which is called "ancolie" in French, was used in fifteenth- and sixteenth-century paintings as a symbol of melancholy and sorrow because of its name and its dark violet color. In paintings of the Virgin Mary it refers to her sorrow for her crucified son. When seven flowers are represented [557], they may refer to the Seven Sorrows of the Virgin: (1) the Prophecy of Simeon during the *Presentation in the Temple,* (2) the *Flight into Egypt,* (3) Jesus lost by his mother in Jerusalem, (4) the *Bearing of the Cross,* (5) the *Crucifixion,* (6) the *Descent from the Cross,* (7) the *Entombment.* However, the columbine (fr. L. columbinus, dovelike) may also be used as an emblem of the Holy Ghost because the flower resembles the shape of a *dove.* In this case, when there are seven flowers or seven petals on a flower, they refer to the Seven Gifts of the Holy Spirit: Wisdom, Understanding, Counsel, Strength, Knowledge, Piety, and Fear of the Lord (Isaiah 11:2).

COLUMN. A single prominent column in a painting of the infancy of Christ [557] may be intended as an allusion to the column to which Christ was bound during his *Flagellation.* Thus, by foreshadowing the Passion of Christ through which mankind was saved, the column indicates the reason for the Incarnation. *See* INSTRUMENTS OF THE PASSION.

CROSIER (croh'zhur), the ornate staff, resembling a shepherd's crook, which is carried by bishops [567, 607], symbolizes their role as shepherds of the "flock of Christ."

CROSS. The cross is the most common emblem of Christ and his Church. Since it is the chief instrument of his Passion, the cross is a sign of the sacrifice through which mankind won redemption and salvation. When the cross surmounts a *globe* [570], it is a sign of the triumph of Christ and Christianity over the world; when it is placed atop an obelisk [747], it specifically refers to triumph over the pagan world. The cross may even appear, somewhat anachronistically, in paintings of the infant Christ as an allusion to his future sacrifice [677, garden gate in 711] and as an indication of the reason for his Incarnation. In the central panel of the Merode altarpiece by the Master of Flémalle [547], a tiny figure of the infant Jesus, borne on rays of light, carries the cross, at the very moment of the Annunciation of his conception. Some fifty forms of the cross have commonly been used in Christian art and church decoration; some of the most frequently encountered forms and the names by which they are usually known are indicated below.

Fig. 68. Types of crosses: (a) Latin, (b) St. Andrew's, (c) Greek, (d) Tau.

CROWN. A crown is a symbol of victory or of royalty. It is the chief attribute of emperors, kings and queens [338, 339, 440, 494] and is worn by God the Father, Christ, and the Virgin Mary as a sign of their sovereignty over the kingdom of heaven [499, 511, 540, 567]. When the three persons of the *Trinity* are represented by a single figure [549], he may wear the papal tiara, a triple crown surmounted by a cross [568]. The crown of thorns which Christ wears in depictions of his Passion [505, 555, 680, 710, 990] was placed on his head in mockery (Matthew 27:29) but it is a sign of his suffering and of his triumph over death. Martyrs are also sometimes shown wearing or carrying crowns as a sign of their victory over death [569].

DEAD TREE. According to a medieval tradition alluded to in many fifteenth- and sixteenth-century paintings, the Tree of the Knowledge of Good and Evil withered when Adam and Eve, disobeying God, ate of its fruit, but was restored to life through Christ's sacrifice on the Cross. Thus, a conspicuously dead tree in a painting of the "Fall of Man" [658], the *Nativity* [546], the Passion [528], or the *Resurrection* [711] may refer to the original sin of Adam and the redemption of mankind through Christ.

DOG. The dog, "man's best friend," is a common emblem of faithfulness in marriage [553] and religion [717].

DOVE. The third person of the Trinity, the Holy Ghost, is represented as a dove in accordance with the descriptions of its descent upon Jesus during his *Baptism* (Matthew 3:16, Mark 1:10, Luke 3:22). The dove of the Holy Ghost regularly appears in representations of the *Trinity* [598], the *Baptism* [441], and the *Annunciation* [551, 711]. [*Also see 447, 549, 567, 568, 752, 762*].

DRAGON. The dragon is an emblem of evil and is often identified with Satan, who may assume the form of a dragon [407] rather than that of a *serpent* or demon of more or less human form. On the central panel of the Portinari Altarpiece [557], Satan appears as a dragon-like demon above the head of the ox. He is caught between the column and the wall, frustrated and angry because he has been trapped by the Incarnation. The mouth of Hell, the realm of Satan, was frequently represented as a great dragon's head devouring the bodies of the damned [714]. Among the saints, *George* [579] and *Michael* fought the evil dragon and *Margaret* was swallowed by a dragon, but she split him open with a cross and as a sign of her triumph is often shown standing on his head, as on the right-hand panel of the Portinari Altarpiece [557].

EAGLE. The eagle is the attribute of *St. John the Evangelist* and, according to tradition, symbolizes the soaring spirit of John in his contemplation of the divine nature of Christ [447]. John's eagle frequently appears with the symbols of the other Evangelists: the winged man of *St. Matthew*, the *lion* of *St. Mark*, and the *ox* of *St. Luke* [390, 493].

FOUNTAIN. The "fountain of life" or the "fountain of living waters" is used as a symbol of salvation in various books of the Old Testament and in the Revelation of St. John (7:17; 21:6). An inscription based on Revelation 22:1 appears on the basin of the prominent fountain on the interior of the Ghent Altarpiece [549] identifying it as the "fountain of life proceeding out of the throne of God and the Lamb." From a spout at the base of the fountain issues the "pure river of water of life, clear as crystal" which is described in the same passage. During the fifteenth and sixteenth century the identification of Christ with the "fountain of life" or the "well of living water" was so complete that the crucified Christ was shown as a fountain: blood spurts from his wounds into a basin and flows from there into a Eucharistic chalice. Claus Sluter's "Well of Moses" [507], when it was surmounted with a crucifix, presented a three-dimensional image of the mystic fountain. Mary is also associated with a fountain; sometimes, when she is depicted in the enclosed *garden*, the "fountain of gardens" or the "well of living waters" of the Song of Songs (4: 15) is shown nearby. The *wash basin* and water pitcher in Flemish paintings of the Virgin [547, 551] may have been intended as an indoor equivalent of the fountain or well.

GARDEN. When the Virgin Mary is represented within or near a garden surrounded by a wall [547, 572, 606, 711] the garden refers to the "garden enclosed" (L., *hortus conclusus*) of the Song of Songs (4:12). It is one of the many metaphors of chastity which were taken from the poem and given visual form in fifteenth- and sixteenth-century paintings of the Virgin.

GLASS. A transparent glass window or vase through which rays of *light* pass was sometimes used in fifteenth- and sixteenth-century paintings of the Virgin

Mary as a disguised symbol of the Virgin Birth [*541, 547, 711* center]. The symbol is derived from a medieval Nativity hymn in which an analogy is drawn between the miraculous birth and the phenomenon of light passing through glass without breaking it.

GLOBE. The globe or orb is a symbol of the world. When it is held in the left hand by Christ or by God the Father, it is a sign of their sovereignty [*499, 567, 570*]. When a *cross* surmounts the globe, it is a symbol of the triumph of Christ and of Christianity over the world [*332, 618, 666, 748*].

GRAPES. A symbol of the Eucharist, the sacrament of the Lord's Supper (Holy Communion). As *wheat* refers to the bread which Christ said was his body, grapes refer to the wine which he said was his blood: "And he took the cup, and gave thanks, and gave it to them, saying, Drink ye all of it; For this is my blood of the new testament, which is shed for many for the remission of sins" (Matthew 26:28). When the Christ Child holds a bunch of grapes [*604*] it is a sign of his earthly mission and foreshadows his Passion.

HALO. The halo or nimbus is a conventional symbol of radiant *light* placed around the heads of saints as an indication of their holiness. Originally, however, it was a mark of distinction placed around the heads of gods and kings; in S. Vitale at Ravenna, for example, the mosaic images of the Emperor Justinian and the Empress Theodora are given imperial haloes even though they were living when the mosaics were made and certainly never became saints [*338, 339*]. The tradition also survives in representations of Buddha. Haloes are usually circular, but sometimes God the Father is given a triangular halo signifying the Trinity [*584*] and sometimes living persons, such as donors, are distinguished from the saints by square haloes. Only Christ is given a cruciform nimbus [*345, 408, 527, 540*] because it refers directly to his sacrifice on the Cross.

HAND. A large hand or arm issuing from the heavens is a direct translation in visual terms of the "Hand" or "Arm of the Lord" frequently used in the Bible as a metaphor of the power and will of God [*447*].

HOURGLASS. The movement of the grains of sand as they fall from the upper compartment of an hourglass to the lower is a sign of the unceasing passage of time and a symbol of the brevity of human life. As such, it is an appropriate attribute of the *skeleton* of Death [*717*].

INSTRUMENTS OF THE PASSION. A term usually applied to the implements used in the *Crucifixion* of Christ or associated with his suffering during the Passion. The chief instrument of the Passion is the *cross*, but many others, such as the *nails, lance, sponge, column, crown of thorns, chalice,* and *wash basin,* may be presented quite apart from any rendering of a specific moment of the Passion. They may appear, for example, in depictions of the *Last Judgment* [*548*] where they are emblems of Christ's right to judge mankind, in representations of Christ as the Man of Sorrows or the *Lamb* of God [*549*], or even heraldically grouped as an emblem in a kind of picture writing summarizing the chief events of the Passion. Other common Instruments, besides those already mentioned and treated in separate entries, are the lantern, torch,

rope, sword, club, staff, and the purse of Judas (all associated with the *Betrayal*], the cat-o'-nine-tails and scourges of the *Flagellation,* a crowing rooster alluding to the *Denial of Peter,* and the ladder, hammer, pincers, robe, and dice (John 19:23, 24) associated with the *Crucifixion* itself.

IRIS. The iris, which was known in Latin as the "gladiolus," or "sword-lily," because of its sword-shaped leaves, appears in fifteenth- and sixteenth-century paintings of the Virgin and Child [557] as a disguised symbol fore-shadowing the grief of Mary at the *Crucifixion* of Christ. The iris replaced the more obvious symbol of the sword which was formerly shown stuck in Mary's heart in allusion to old Simeon's prophecy to Mary during the *Presentation in the Temple:* "Yea, a sword shall pierce through thy own soul also" (Luke 2:35).

KEYS. One or two large keys are the special attribute of *St. Peter* and distinguish him from other bearded, balding and white-haired old men [677, 691, 718]. The keys allude to the passage in the Gospel of St. Matthew (16:19) in which Christ, addressing Peter, says: "And I will give unto thee the keys of the kingdom of heaven." The *Delivery of the Keys to St. Peter* is represented in the fresco by Perugino on one of the side walls of the Sistine Chapel [638]. Since this act is interpreted as a token of the transmission of authority from Christ to Peter, who is considered the first pope, the keys are a prominent feature of the papal coat of arms [748, 752].

LAMB. The lamb, used as a sacrificial animal in antiquity, is most commonly used as a symbol of Christ's redeeming sacrifice on the Cross. In the New Testament, Christ is frequently referred to as the Lamb. *John the Baptist,* upon seeing Christ, says: "Behold the Lamb of God, which taketh away the sin of the world" (John 1:29). And in the Revelation of *St. John the Evangelist,* which is the primary literary source for the "Adoration of the Lamb" in the Ghent Altarpiece [549], the Lamb is used throughout as a metaphor for Christ: "And I looked and, lo, a Lamb stood on the mount Sion, and with him an hundred forty and four thousand . . . " (14:1). The Lamb of God (L. *Agnus Dei*) is usually represented with a wound in its side from which blood flows into a *chalice* [549], one leg is frequently lifted to hold a cross [710] which often has a pennant of triumph flying from it to indicate Christ's triumph over death. The lamb is the special attribute of St. John the Baptist [551, 697] and *St. Agnes* [523 right]. In Early Christian art, the lamb is not only used as a symbol of Christ, but is also used to represent the Apostles and all Christians in general. The twelve lambs at the base of the semi-dome of the apse of S. Apollinare in Classe [321] represent the twelve Apostles; the three lambs, further up, represent the three disciples who accompanied Christ to the Mount of the *Transfiguration;* and the lambs, along the arch, represent the faithful issuing from the city gates of Jerusalem and Bethlehem, symbolizing the union of Jews and Gentiles through Christ. As the Good Shepherd [315] of the parables (Luke 15:3–7, John 10:1–18), Christ is shown with the lambs of his flock. On the sarcophagus of Junius Bassus [Vatican, 329], the subjects from both the Old Testament and the New Testament, which are carved on the spandrels (the Three Children in the Fiery Furnace, Moses Striking Water

from the Rock, the Multiplication of the Loaves, and the *Baptism* of Christ), are enacted by lambs rather than by human figures.

LANCE. One of the *Instruments of the Passion* and the attribute of both St. Longinus, the centurion who pierced the side of Christ [*548*], and *St. Thomas the Apostle* [*557* left]. The warrior saints, such as *St. George* [*549*] and *St. Theodore* [*360, 495*] also regularly carry lances as part of their military equipment.

LIGHT. Light is one of the most ancient signs of divinity and holiness. The imagery of light as goodness and wisdom and darkness as ignorance and evil is used throughout both the Old and the New Testaments, but it especially pervades the Gospel of St. John in which Christ himself says: "I am the Light of the World" (8:12), a sentence which in Latin is "Ego sum lux mundi" and frequently occurs in church decoration. The *halo* and *mandorla* are conventional symbols of radiant light and were the devices most frequently used to indicate the holiness of Christ and the saints in medieval art, but more illusionistic devices have been used from time to time, especially in depictions of the persons of the Trinity. In early Christian mosaics, for example, Christ sometimes appears against a glorious sunset sky of many hues [*321*]. With the preference for more illusionistic modes of representation in the late Middle Ages and the Renaissance, amorphous glories or aureoles radiate from the body and, for a time, haloes were foreshortened in such a way that they appeared to be golden plates riveted to the heads of the saints [*527, 598, 602*] or hoops of gold hovering above them [*607*], but these obviously artificial emblems were generally given up by the sixteenth century when the holy figures either appeared without any indication of supernatural illumination or were given amorphous glories and aureoles which, except for their emanation from human bodies, approximated the effect of normal sources of illumination [*546, 558, 689, 711*]. In Baroque sculpture and architecture, concealed sources of natural light were sometimes used in rather dark interiors to flood the holy figures and emblems with an apparently supernatural light and cause the gilt rays surrounding them to glisten [*750, 751, 756, 762*]. Occasionally, stained glass was also used [*752*], as in Gothic church windows [*451, 464, 517*], to transmute natural light into an apparently supernatural radiance emanating from within the holy image itself.

LILY. The lily is a symbol of purity and is therefore frequently used as an emblem of the Virgin Mary. In representations of the *Annunciation*, lilies are often shown in a vase [*541, 547*] or held by the Archangel Gabriel [*551*] as a sign of Mary's chastity at the moment of the Incarnation. The species of lily most particularly identified with the Virgin is the *Lilium Candidum*, or Madonna Lily.

LION. The lion, usually winged, is the attribute of *St. Mark*, one of the Four Evangelists [*388, 399, 444*]. According to one interpretation, the lion alludes to the emphasis Mark places on the majesty of Christ in his Gospel. According to another, it refers to his extensive treatment of the *Resurrection*, since an analogy was drawn between the three days that elapsed between Christ's

death on the Cross and his Resurrection with the three days that were thought to pass between the birth of lion cubs (which were supposedly always still-born) and their awakening to life when their sire roared or breathed upon them. The lion is frequently grouped with the symbols of the other Evangelists: the winged man of *St. Matthew,* the winged *ox* of *St. Luke,* and the *eagle* of *St. John* [*390, 493*]. The lion that accompanies *St. Jerome* is the one who faithfully followed the saint after he took compassion on the suffering beast and extracted a thorn from its paw.

MANDORLA (It., almond), a large oval surrounding the figure of God, Christ, the Virgin, and, on rare occasions, the saints as a symbol of divinity or holiness [*356, 409, 437, 493*].

MONOGRAMS OF CHRIST. Many monograms and abbreviations of the name of Christ occur from time to time in works of art. Some of the most common are explained below:

☧. The two Greek letters Chi (X) and Rho (P), the first two letters of the Greek word for Christ, were combined by the early Christians so that they formed a cross [*338*]. Sometimes the first and last letters of the Greek alphabet, Alpha (A) and Omega (Ω), are placed to either side of the cross in allusion to a passage in the Revelation of St. John (1:8): "I am Alpha and Omega, the beginning and the end, saith the Lord . . . "

IHS or IHC. In the late Middle Ages, the IHS and IHC monograms became more popular than the Chi Rho symbol. They are derived from the first three letters of the Greek word for Jesus, which is spelled either "Ihsus" or "Ihcuc." Very often the horizontal line above the monogram, which indicates that it is an abbreviation, intersects the "h" to form a cross and sometimes a cross is placed above the crossbar of the "H" [*709*]. According to a more recent tradition, the IHS stands for the Latin phrase "Iesus Hominum Salvator" (Jesus, Saviour of Mankind).

IC XC. A very common abbreviation in Byzantine art [*345, 349, 356, 360*] is derived from the first and last letters of the Greek "Ihcuc" (Jesus) and "Xpictoc" (Christ). The horizontal line which usually appears over each pair of letters indicates that it is an abbreviation.

I. N. R. I. The letters frequently placed on a tablet or scroll attached to the cross of the crucified Christ [*710*] are an abbreviation of the Latin inscription "Iesus Nazarenus Rex Iudaeorum" which, according to the Gospel of St. John (19:19–22), Pilate placed on the cross:

> And Pilate wrote a title, and put it on the cross. And the writing was, JESUS OF NAZARETH THE KING OF THE JEWS. This title then read many of the Jews: for the place where Jesus was crucified was nigh to the city: and it was written in Hebrew, and Greek, and Latin. Then said the chief priests of the Jews to Pilate, Write not, the King of the Jews; but that he said, I am King of the Jews. Pilate answered, What I have written I have written.

Sometimes the whole trilingual inscription is written out [*773*].

NAILS. Large nails or spikes, held by an angel or appearing in association with other *Instruments of the Passion,* signify the suffering of Christ while he was nailed to the cross [*548, 565*]. The hammer with which the nails were driven into his flesh and the pincers with which they were withdrawn are often shown as well.

OX. A winged ox is the attribute of *St. Luke,* one of the Four Evangelists [*409*]. The ox, holding a book (the Gospel of St. Luke), frequently appears together with the winged man of *St. Matthew,* the winged *lion* of *St. Mark,* and the *eagle* of *St. John.* The ox, a sacrificial animal [*314*], presumably alludes to Luke's emphasis on the priesthood of Christ. The twelve oxen at the base of the baptismal font by Renier of Huy, in the church of S. Barthélemy in Liège, are symbols of the twelve Apostles [*441*]. They were probably suggested by the description (II Chronicles 4:4) of the great basin set up by Solomon for the ablutions of the priests in the Temple at Jerusalem.

PALM BRANCH. An ancient Roman symbol of Victory; in Christian art, it is the attribute of martyrs, symbolizing their triumph over death [*549, 607, 634*].

PALM TREE. The palm tree, because it is always green, was frequently used in Early Christian art as a symbol of the promise of immortality [*321* either side of apse, *549*].

PELICAN. The image of a pelican piercing her breast with her beak and feeding her young with her own blood is a symbol of Christ's self-sacrifice for the salvation of man. This image of loving sacrifice, sometimes called the "Pelican in her Piety," is derived from descriptions in medieval bestiaries (books on the habits of beasts). It is repeated many times in the brocade behind the figure of God on the Ghent Altarpiece [*549*].

ROSES. In representations of the Virgin, roses are an emblem of her charity [*547, 572, 711*]. The rose was formerly the flower of Venus, goddess of Love. Mary herself is called "the rose without thorns."

RUINS, usually Roman or Romanesque, are found in representations of the birth of Christ as signs of that decay of the pagan world which, from the Christian point of view, made the Incarnation necessary [*545, 546, 557*].

SCROLL. In later Christian art, scrolls, the older form of manuscript, are frequently used as attributes of the Old Testament prophets and the pagan sibyls who foretold the coming of Christ [*409, 433, 522, 551, 684*].

SERPENT. In representations of the "Fall of Man," Satan appears in the guise of a serpent [*716*]. In Michelangelo's representation of the subject on the Sistine Ceiling [*658*], Satan assumes the body of a beautiful temptress with a long serpent's tail. The serpent is also an ancient symbol of death [*535, 717*]. *St. John the Evangelist* is sometimes shown holding a cup with a serpent in it [*551*] in allusion to various stories according to which he was given a cup of poisoned wine.

SHOES. When shoes or sandals are prominently displayed in a picture in which figures stand barefoot or in their stocking feet, it is a sign that they are on holy ground [*553, 557, 633; cf. 72*].

SKELETON. A human skeleton, or a human *skull*, is a "memento mori," or reminder of death; it is a forceful sign of the ephemeral character of life on earth and a check to the pursuit of worldly vanities [535]. Skeletons, representing the deceased, were sometimes carved or painted on late medieval tombs together with such admonitory inscriptions as: "What you are, I once was; what I am, you will be" [598] or simply "memento mori" ("Remember that you must die"). When a skeleton is animated, it is a personification of Death [548] and may bear such attributes as an *hourglass*, serpents [717], a scythe with which to cut men down, or a pitchfork with which to toss them into Hell [714].

SKULL. Any skull, but especially a human skull, or death's-head, is a reminder of death (memento mori) suggesting the vanity of man's transitory life on earth [lower right corner of 691, 717]. The skull frequently appears as an attribute of penitent saints and hermits [633]. When a skull appears near the base of the cross of the crucified Christ [355, 555], it marks the site of the *Crucifixion* as Golgotha (Calvary), "the place of the skull" (John 19:17). According to a medieval tradition, this was the burial place of Adam, whose disobedience lost for mankind the gift of eternal life and made it necessary for Christ to suffer on the cross so that man might be absolved of his sins and regain the promise of immortality. Sometimes, the blood trickles from the wounds of Christ down over the skull at the foot of the cross [355], symbolizing the washing away of Adam's sin and the sin of all mankind through Christ's sacrifice (Revelation 1:5).

SPONGE. A sponge attached to the top of a staff is one of the *Instruments of the Passion* [548, 549]. It refers to the incident described in the accounts of the *Crucifixion* just before Christ cried aloud and gave up the ghost: "And straightway one of them ran, and took a sponge, and filled it with vinegar, and put it on a reed, and gave him to drink" (Matthew 27:48). This may have been done as an act of mercy to quench his thirst, but it is traditionally regarded as a final act of humiliation in the long series of abuses against the person of Christ during the Passion.

TOWER. The fortified tower which appears in the backgrounds of many fifteenth- and sixteenth-century pictures of the Virgin Mary [572] refers to the Tower of David mentioned in the Song of Songs (4:4) and was intended as a symbol of Mary's chastity. Jan van Eyck, in the painting of the *Annunciation* on the exterior of the Ghent Altarpiece [551] seems to have placed the Virgin inside the tower, far above the rooftops seen from the window of her high chamber.

TREFOIL. The trefoil, since it is a single figure composed of three lobes, is often used as a symbol of the three persons of the Trinity [531, 551].

TRIANGLE. The triangle, which like the *trefoil* is a single figure formed of three parts, is sometimes used as a symbol of the Trinity [531 top; 756 lantern]. Occasionally, the image of God the Father is given a triangular halo [584] to indicate the presence of the other two persons of the Trinity.

VINE. Vines, especially grapevines, have been used since the time of the early Christians [*330, 390, 496, 565, 633*] to allude to Christ's description of himself as a vine: "I am the true vine, and my Father is the husbandman . . . I am the vine, ye are the branches: He that abideth in me, and I in him, the same bringeth forth much fruit: for without me ye can do nothing" (John 15: 1–5). When there are bunches of *grapes* on the vine, they refer to the sacrament of the Eucharist and to Christ's Passion.

VIOLETS symbolize humility and are therefore one of the flowers used to indicate aspects of the character of the Virgin Mary. When violets appear in representations of the *Annunciation* [*547*] and the *Nativity*, they may also refer to the humility of the Son of God as revealed in his incarnation.

WASH BASIN. In Flemish paintings of the Virgin Mary a wash stand or a niche, with a wash basin, a water pitcher (ewer), and a towel, sometimes appears as an emblem of Mary's chastity [*547, 551*]. The ewer and basin, besides being common signs of cleanliness and purity, may also have been intended as disguised symbols serving as indoor counterparts of the "spring shut up" and the "fountain sealed" or the "fountain of gardens" and the "well of living waters" (Song of Songs 4:12, 4:15) which were interpreted as metaphors of the Virgin. Sometimes a ewer and basin appear among the *Instruments of the Passion* in reference to the washing of guilt from Pilate's hands [*688; Matthew 27:24*].

WHEAT. A sheaf of wheat is sometimes included in representations of *Nativity* and *Adoration* scenes [*557*] as an emblem of the Incarnation and as a foreshadowing of the *Last Supper* and the *Crucifixion*. In the Gospel of St. John (12:24), Jesus, foretelling his death, compares himself to a grain of wheat: "Except a corn of wheat fall into the ground and die, it abideth alone: but if it die, it bringeth forth much fruit." Jesus also says that he is "the living bread which came down from heaven: if any man eat of this bread, he shall live for ever: and the bread that I will give is my flesh, which I will give for the life of the world" (John 6:51). And, at the Last Supper, when he gives the bread to the disciples to eat, he says: "This is my body which is given for you: this do in remembrance of me" (Luke 22:19). The sheaf of wheat, then, is a Eucharistic symbol revealing Christ's mission as the savior of mankind. It also alludes to the place of his birth, Bethlehem, which means "House of Bread."

WHEEL OF FORTUNE. A wheel with human figures along its rim, rising or falling as it revolves, is an emblem of the instability of Fortune and the vanity of worldly pursuits: as some of the figures rise to power and riches, others must inevitably fall [*518*].

ZODIAC. The twelve signs of the zodiac, which were often carved around the portals of Romanesque and Gothic churches together with emblems of the Labors of the Months, suggest the omnipresence and omnipotence of God throughout time and space and lend universal significance to the other subjects represented near them [*437, 493, 500*].

Chronology of Painters, Photographers, Sculptors, and Architects

Pronunciations are given inside parentheses immediately following the most common name by which the artist is known. (') after a syllable indicates that it takes the primary accent or stress. The following symbols are used in pronunciations: (ī) as in ice, high, tie; (kH) as in German ich, ach, hoch, approximated by pronouncing 'h' while clearing the throat; (N) indicates that the preceding vowel sound is nasal as in French bon (boN), cinq (saNk); (ö) as in French feu, peu and German Hölle, approximated by rounding the lips for 'o' and pronouncing 'ay'; (ü) as in French duc, rue and German grün, approximated by rounding the lips for 'oo' and pronouncing 'ee'.

The following biographical abbreviations are used: (act.) active in, (Amer.) American, (archt.) architect, (b.) born, (Brit.) British, (Eng.) English, England, (Flem.) Flemish , (Fr.) French, France, (Ger.) German, Germany, (It.) Italian, Italy, (N.) North, (ptr.) painter, (Russ.) Russian, (sculp.) sculptor, (Scot.) Scottish, Scotland, (Sp.) Spanish, Spain, (U.S.) United States.

ACTIVE 1300s

CAVALLINI, Pietro. c. 1250–c. 1330 . It. ptr. act. Rome.
DUCCIO (doot'cho) di Buoninsegna. c. 1255 –c. 1318. It. ptr. act. Siena.
GIOTTO (jot'toh) di Bondone. c. 1267–1337. It. ptr./archt. act. Florence, Assisi, Padua.
LORENZETTI, Pietro. c. 1280–c. 1348. It. ptr. act. Siena.
MARTINI, Simone. c. 1284–1344. It. ptr. act. Siena, Naples, Avignon (Fr.)
LORENZETTI , Ambrogio. c. 1285–c. 1348 . It. ptr. act. Siena.

ACTIVE 1400s

GENTILE (gen-tee'lay) da Fabriano. c. 1370–1427. It. ptr. act. Venice, Florence, Siena, Orvieto, Rome.

QUERCIA (kwer'cha), Jacopo della. c. 1374–1438. It. sculp. act. Siena, Bologna.

BRUNELLESCHI (broo-nel-les'kee), Filippo. 1377–1446. It. archt./sculp. act. Florence.

CAMPIN (kahm'piN), Robert. c. 1378–1444. Flem. ptr. act. Tournai.

GHIBERTI (gee-ber'tee), Lorenzo. c. 1381–1455. It. sculp. act. Florence.

NANNI di Banco. c. 1384–1421. It. sculp. act. Florence.

DONATELLO (doh-na-tel'lo). c. 1386–1466. It. sculp. act. Florence, Padua.

VAN EYCK (van'ike), Jan. c. 1390–1441. Flem. ptr. act. The Hague, Lille, Bruges.

MICHELOZZO (mee-kay-lot'tso) di Bartolommeo. 1396–1472. It. archt./sculp. act. Florence.

UCCELLO (oo-chel'lo), Paolo. 1397–1475. It. ptr. act. Florence.

WITZ (vits), Conrad. c. 1400 –c. 1445. Swiss ptr. (b. Ger.) act. Basel, Geneva.

ANGELICO, Guido di Pietro, called Fra. c. 1400–1455. It. ptr. act. Florence.

VAN DER WEYDEN (vahn-der-vī'den), Rogier. c. 1400–1464. Flem. ptr. act. Brussels.

ROBBIA (rawb'byah), Luca della. 1400–1482. It. sculp. act. Florence.

MASACCIO (ma-zaht'cho; 'ugly Tom'), Tommaso di Ser Giovanni, called. 1401–1428?. It. ptr. act. Florence.

ALBERTI, Leone Battista. 1404–1472. It. archt./humanist act. Florence, Rome, Rimini, Mantua.

LIPPI (lee'pee), Fra Filippo . c. 1406–1469. It. ptr. act. Florence, Prato, Spoleto.

ROSSELLINO, Bernardo. 1409–1464. It. sculp./archt. act. Florence.

VENEZIANO (vay-nay-tsyah'no), Domenico. c. 1410–1461. It. ptr. act. Florence.

LOCHNER (lokH'ner), Stefan. c. 1415–1451/52. Ger. ptr. act. Cologne.

BOUTS (bowts), Dirk. c. 1415–1475. Dutch ptr. act. Louvain, Brussels.

CASTAGNO (kahs-tah'nyo), Andrea del. c. 1420–1457. It. ptr. act. Florence.

FOUQUET (foo-kay'), Jean. c. 1420–c. 1480. Fr. ptr.

PIERO (pyer'o) della Francesca. c. 1420–1492. It. ptr./theorist act. Central It.

ROSSELLINO, Antonio. 1427–1479. It. sculp. act. Florence.

BELLINI, Giovanni. c. 1430–1516. It. ptr. act. Venice.

POLLAIUOLO (pol-lie-yo'lo), Antonio. 1431–1498. It. ptr./printmaker/sculp. act. Florence, Rome.

MANTEGNA (mahn-teh'nya), Andrea. 1431–1506. It. ptr./printmaker act. Padua, Mantua.

VERROCCHIO (vayr-rok'kyo), Andrea del. 1435–1488. It. sculp./ptr. act. Florence.

PACHER (pah'kHur), Michael. c. 1435–1498. Ger. ptr./sculp. act. Tyrol.

VAN DER GOES (vahn der goos'), Hugo. c. 1440–1482. Flem. ptr. act. Ghent.

MEMLING, Hans. c. 1440–1494. Flem. ptr. (b. Ger.) act. Bruges.

BRAMANTE (brah-mahn'tay), Donato. 1444–1514. It. archt./ptr. act. Milan, Rome.

BOTTICELLI (baht-tih-chel'lee; It. bawt-tee-chel'lee), Sandro. c. 1445–1510. It. ptr. act. Florence.

SANGALLO, Giuliano da. c. 1445–1516. It. archt. act. Tuscany.

PERUGINO (per-oo-jee'no), Pietro. c. 1445–1523. It. ptr. act. Perugia, Florence, Rome.

SIGNORELLI (seen-yo-rel'lee), Luca. c. 1445–1523. It. ptr. act. Central It.

STOSZ (shtos), Veit. c. 1445–1533. Ger. sculp./ptr./printmaker act. Nuremberg, Cracow (Poland).

GHIRLANDAIO (geer-lahn-dah'yo), Domenico. 1449–1494. It. ptr. act. Florence.

SCHONGAUER, Martin. c. 1450–1491. Ger. printmaker/ptr. act. Colmar.

BOSCH (boss), Hieronymus. c. 1450–1516. Dutch ptr. act. s'Hertogenbosch.

LEONARDO da Vinci. 1452–1519. It. ptr./sculp./archt./engineer/scientist act. Florence, Milan, Rome, France.

PIERO (pyer'o) di Cosimo. 1462–1521. It. ptr. act. Florence.

GEERTGEN (gart'gen) tot Sint Jans. c. 1465–c. 1495. Dutch ptr. act. Haarlem.

ACTIVE 1500s

GRÜNEWALD (grün'uh-vahlt), Mathis Neithardt-Gothardt, called. c. 1470/80-1528. Ger. ptr.

DÜRER (dü'rur), Albrecht. 1471–1528. Ger. ptr./printmaker act. Nuremberg.

CRANACH (krah'nahkH), Lucas, the Elder. 1472–1553. Ger. ptr./printmaker.

PATINIR (pah-tih-neer'), Joachim. c. 1475–1524. Flem. landscape ptr. act. Antwerp.

MICHELANGELO (my-kul-an'juh-lo or mee-kay-lahn'djay-lo) Buonarroti. 1475–1564. It. sculp./ptr./poet act. Florence, Rome.

GIORGIONE (jor-jo'nay) da Castelfranco. c. 1478–1510. It. ptr. act. Venice.

GOSSAERT (gaws-art), Jan; called Mabuse (mah- büz'). c. 1478–c. 1535. Flem. ptr. act. Antwerp.

ALTDORFER (ahlt'dor-fur), Albrecht. c. 1480–1538. Ger. ptr./printmaker act. Regensburg.

SAVOLDO, Giovanni Girolamo. c. 1480–c. 1550. It. ptr. act. N. It.

RAPHAEL (raf'ee-ul); It. Raffaello Sanzio. 1483–1520. It. ptr. act. Rome.

CLOUET (kloo-ay), Jean. c. 1485–1541. Fr. portrait ptr.

BERRUGUETE (ber-roo-gay'tay), Alonso. c. 1489–1561. Sp. sculp.

TITIAN (tish'un); It. Tiziano Vecellio. 1488/90 -1576. It. ptr. act. Venice.

CORREGGIO (kor-red'jo), Antonio Allegri da. c. 1489–1534. It. ptr. act. Parma.

PONTORMO (pon-tor'mo) , Jacopo Carucci da. 1494–1557. It. ptr. act. Florence.

FIORENTINO (fyo-ren-tee'no), Rosso. 1495–1540. It. ptr. act. Florence.

HOLBEIN, Hans, the Younger. 1497–1543. Ger. portrait ptr. act. Basel and England.

CELLINI (chel-lee'nee), Benvenuto. 1500–1571. It. sculp. act. Florence, Rome, France.

PARMIGIANINO (par-mee-djah-nee'no), Francesco Mazzola, called. 1503–1540. It. ptr./printmaker act. Parma.

BRONZINO (bron-zee'no), Agnolo. **1503**–**1572**. It. portrait ptr. act. Florence.
PRIMATICCIO (pree-ma-teet'cho), Francesco. **1504**–**1570**. It. ptr./sculp./archt. act. Mantua and France.
VIGNOLA (vee-nyo'lah), Giacomo da. **1507**–**1573**. It. archt. act. Rome.
AERTSEN (art'sen), Pieter. **1508/9-1575**. Dutch still-life & genre ptr. act. Amsterdam, Antwerp.
PALLADIO (pa-lah'dee-o), Andrea. **1508**–**1580**. It. archt. act. Vicenza, Venice.
GOUJON (goo-zhoN'), Jean. c. **1510**–**1568**. Fr. sculp.
LESCOT (les-ko'), Pierre. **1510**–**1578**. Fr. archt.
VASARI (vah-zah'ree), Giorgio. **1511**–**1574**. It. ptr./archt./art historian act. Florence, Rome.
AMMANATI (ahm-ahn-nah'tee), Bartolommeo. **1511**–**1592**. It. archt./sculp. act. Florence.
TINTORETTO (tin-toh-ret'toh *or* teen-toh-rayt'toh; 'little dyer'), Jacopo Robusti, called. **1518**–**1594**. It. ptr. act. Venice.
BRUEGEL (brü'gul), Pieter, the Elder. c. **1525/30-1569**. Flem. genre ptr. act. Antwerp, Brussels.
BOLOGNA (bo-lo'nyah), Giovanni; Jean de Boulogne. **1529**–**1608**. Flem. sculp. act. Florence.
PILON (pee-loN), Germain. c. **1535**–**1590**. Fr. sculp.
ANGUISSOLA (ahn-gwee'so-lah), Sofonisba. c. **1535**–**1625**. It. portrait ptr. act. Cremona, Madrid, Palermo, Genoa.
PORTA, Giacomo della. c. **1537**–**1602**. It. archt. act. Rome.
EL GRECO, Domenikos Theotocopoulos, called. **1541**–**1614**. b. Crete. ptr. act. Venice, Toledo (Sp.).
HILLIARD, Nicholas. **1547**–**1619**. Eng. portrait ptr.

ACTIVE 1600s

MADERNO (mah-dehr'no), Carlo. **1556**–**1629**. It. archt. act. Rome.
CARRACCI (kah-raht'chee), Annibale. **1560**–**1609**. It. ptr. act. Bologna, Rome.
CARAVAGGIO (kahr-ah-vahd'jo), Michelangelo Merisi da. **1573**–**1610**. It. ptr. act. Rome.
JONES, Inigo. **1573**–**1652**. Eng. archt.
RENI (ray'nee), Guido. **1575**–**1642**. It. ptr. act. Bologna, Rome.
RUBENS (roo'benz), Peter Paul. **1577**–**1640**. Flem. ptr. act. Antwerp.
HALS, Frans. **1580/85-1666**. Dutch portrait ptr. act. Haarlem.
DOMENICHINO (doh-may-nee-kee'no), Domenico Zampieri, called. **1581**–**1641**. It. ptr. act. Bologna, Rome.
TERBRUGGHEN (ter-bruhg'hen), Hendrick. **1588**–**1629**. Dutch ptr. act. Utrecht.
RIBERA (ree-bay'rah), Jusepe *or* José. **1591**–**1652**. Sp. ptr./printmaker act. Naples.
GUERCINO (gwer-chee'no; 'squint-eyed'), Francesco Barbieri, called. **1591**–**1666**. It. ptr. act. Bologna, Rome.
LE NAIN (luh-naN'), Louis. **1593**–**1648**. Fr. genre ptr.
LA TOUR (lah-toor'), Georges de. **1593**–**1652**. Fr. ptr. act. Lorraine.
GENTILESCHI (jen-tee-les'kee), Artemisia. **1593**–c. **1653**. It. ptr. act. Naples.

POUSSIN (poo-saN'), Nicolas. 1593/94-1665. Fr. ptr. act. Rome.
VAN GOYEN, Jan. 1596–1656. Dutch landscape ptr. act. The Hague.
CORTONA, Pietro Berrettini da. 1596–1669. It. ptr./archt. act. Rome.
ZURBARAN (thoor-bah-rahn'), Francisco de. 1598–1664. Sp. ptr. act. Seville.
MANSART (mahN-sar'), François. 1598–1666. Fr. archt.
BERNINI (bayr-nee'nee), Gianlorenzo. 1598–1680. It. sculp./archt. act. Rome.
VAN DYCK (van-dike'), Anthony. 1599–1641. Flem. portrait ptr. act. England, Italy.
VELAZQUEZ (vay-lahth'kayth or vay-las keth), Diego Rodriguez de Silva y. 1599–1660. Sp. ptr. act. Seville, Madrid.
BORROMINI (bor-ro-mee'nee), Francesco. 1599–1667. It. archt. act. Rome.
CLAUDE (klohd) Gellée; called Claude Lorraine. 1600–1682. Fr. landscape ptr. act. Rome.
REMBRANDT van Rijn. 1606–1669. Dutch ptr. act. Leyden, Amsterdam.
LEYSTER (lie'stur), Judith. 1609–1660. Dutch genre ptr. act. Haarlem.
LE VAU (luh-vo'), Louis. 1612–1670. Fr. archt.
PERRAULT (per-o), Claude. 1613–1688. Fr. physician/archt.
LE NÔTRE (luh-no'truh), André. 1613–1700. Fr. landscape archt.
LEBRUN (luh-bröN), Charles. 1619–1690. Fr. ptr.
PUGET (pü-zhay), Pierre. 1620–1694. Fr. sculp.
GUARINI (gwah-ree'nee), Guarino. 1624–1683. It. mathematician/archt. act. Turin.
RAGGI (rah'jee), Antonio. 1624–1686. It. sculp. act. Rome.
STEEN (stayn), Jan. 1625/26-1679. Dutch genre ptr.
GIRARDON (zhee-rahr-doN), François. 1628–1715. Fr. sculp.
RUISDAEL (roys'dahl), Jacob van. 1628/29-1682. Dutch landscape ptr. act. Haarlem, Amsterdam.
VERMEER (ver-mayr'), Jan. 1632–1675. Dutch genre ptr. act. Delft.
WREN, Sir Christopher. 1632–1723. Eng. mathematician/archt.
HOBBEMA (hob'uh-mah), Meyndert. 1638–1709. Dutch landscape ptr. act. Amsterdam.
GAULLI (gah'ool-lee), Giovanni Battista; called Baciccio (bah-cheet'cho). 1639–1709. It. ptr. act. Rome.
COYSEVOX (kwahz-vo), Antoine. 1640–1720. Fr. sculp.
POZZO (poht'tso), Andrea. 1642–1709. It. ptr.
HARDOUIN-MANSART (ar-dwaN' mahN-sar'), Jules. 1646–1708. Fr. archt.

ACTIVE 1700s

FISCHER VON ERLACH (fisher-fun-er'lahkH), Johann Bernhard. 1656–1723. Austrian archt.
VANBRUGH (van'bruh), Sir John. 1664–1726. Eng. playwright/archt.
BOFFRAND (bo-frahN), Germain. 1667–1754. Fr. archt.
WATTEAU (vah-toh'), Antoine. 1684–1721. Fr. ptr.
KENT, William. 1685–1748. Eng. ptr./archt./landscape archt.
ZIMMERMANN (tsim'ur-mahn), Dominikus. 1685–1766. Ger. archt.
NEUMANN (noy'mahn), Balthasar. 1687–1753. Ger. archt.
BURLINGTON, Richard Boyle, Third Earl of. 1695–1753. Eng. archt.

TIEPOLO (tyay'po-lo), Giovanni Battista. **1696**–1770. It. ptr. b. Venice.
HOGARTH, William. **1697**–1764. Eng. ptr./printmaker.
GABRIEL (gah-bree-el'), Ange-Jacques. **1698**–1782. Fr. archt.
CHARDIN (shahr-daN'), Jean-Baptiste-Siméon. **1699**–1779. Fr. still-life & genre ptr.
BOUCHER (boo-shay'), François. **1703**–1770. Fr. ptr.
SOUFFLOT (soo-flo'), Jacques Germain. **1713**–1780. Fr. archt.
FALCONET (fahl-ko-nay'), Étienne -Maurice. **1716**–1791. Fr. sculp.
REYNOLDS, Sir Joshua. **1723**–1792. Eng. portrait ptr.
STUBBS, George. **1724**–1806. Eng. animal ptr.
GREUZE (gröz), Jean-Baptiste. **1725**–1805. Fr. genre ptr.
GAINSBOROUGH (gaynz'buhr-uh), Thomas. **1727**–1788. Eng. portrait & landscape ptr.
ADAM, Robert. **1728**–1792. Scottish archt.
BOULLÉE (boo-lay'), Étienne -Louis. **1728**–1799. Fr. archt.
FRAGONARD (frah-go-nahr'), Jean-Honoré. **1732**–1806. Fr. ptr.
LANGHANS (lahng'hahns), Karl. **1732**–1808. Ger. archt.
CLODION (klo-dee-oN'), Claude Michel, called. **1738**–1814. Fr. sculp.
COPLEY (kahp'lee), John Singleton. **1738**–1815. Amer. portrait ptr. act. Boston & England.
WEST, Benjamin. **1738**–1820. Amer. history ptr. act. England.
KAUFFMANN (kah'oof-mahn), Angelica. **1741**–1807. Swiss ptr. act. England.
FUSELI (fyoo'zel-ee), John Henry. **1741**–1825. Eng. ptr. (b. Zurich, Switzerland).
HOUDON (oo-doN'), Jean-Antoine. **1741**–1828. Fr. sculp.
JEFFERSON, Thomas. **1743**–1826. Amer. statesman/archt.
GOYA (go'yah) y Lucientes, Francisco José de. **1746**–1828. Sp. ptr./printmaker.
DAVID (dah-veed'), Jacques-Louis. **1748**–1825. Fr. ptr.
VIGRÉE-LEBRUN (vee-zhay'luh-bröN'), Marie-Louise-Elisabeth. **1755**–1842. Fr. portrait ptr.
CANOVA (kah-no'vah), Antonio. **1757**–1822. It. sculp.
BLAKE, William. **1757**–1827. Eng. poet/ptr./printmaker.
LATROBE (luh-trohb'), Benjamin Henry. **1764**–1820. Amer. archt. (b. England).

ACTIVE 1800s

GROS (gro), Antoine-Jean. Baron. **1771**–1835. Fr. ptr.
FRIEDRICH (free'drikH), Caspar David. **1774**–1840. Ger. landscape ptr. act. Dresden.
TURNER, James Mallord William. **1775**–1851. Eng. landscape ptr.
CONSTABLE, John. **1776**–1837. Eng. landscape ptr.
INGRES (aN'gr), Jean-Auguste-Dominique. **1780**–1867. Fr. ptr.
RUDE (rüd), François. **1784**–1855. Fr. sculp.
DAGUERRE (da-gehr'), Louis-Jacques-Mandé. **1789**–1851. Fr. ptr./photographer.
GÉRICAULT (zhay-ree-ko), Théodore. **1791**–1824. Fr . ptr.

BARRY, Sir Charles. **1795**–1860. Eng. archt.
BARYE (bah-ree'), Antoine-Louis. **1796**–1875. Fr. animal sculp.
COROT (ko-ro), Jean-Baptiste-Camille. **1796**–1875. Fr. landscape ptr.
DELACROIX (duh-lah-krwah'), Eugène. **1798**–1863. Fr. ptr./printmaker.
COLE, Thomas. **1801**–1848. Amer. (b. Eng .) landscape ptr.
PAXTON , Sir Joseph. **1801**–1865. Eng. archt.
LABROUSTE (lah-broost'), Henri. **1801**–1875. Fr. archt.
DAUMIER (doh-myay'), Honoré . **1808**–1879. Fr. ptr./printmaker.
PRÉAULT (pray-o'), Auguste. **1809**–1879. Fr. sculp.
BINGHAM, George Caleb. **1811**–1879. Amer. ptr.
PUGIN (pyoo'jin), Augustus Welby. **1812**–1852. Eng. Gothic Revival archt.
ROUSSEAU (roo-so'), Théodore. **1812**–1867. Fr. landscape ptr.
MILLET (mee-lay') , François. **1814**–1875. Fr. genre ptr.
CAMERON, Julia Margaret. **1815**–1879. Eng. photographer.
REJLANDER (ray'lan-der), Oscar. **1818**–1875. Eng. ptr./photographer (b. Sweden).
COURBET (koor-bay'), Gustave. **1819** –1877. Fr. Realist ptr.
NADAR (nah-dahr'), pseudonymn of Gaspard-Félix Tournachon. **1820**–1910. Fr. journalist/caricaturist/portrait photographer.
GARDNER, Alexander. **1821**–1882. Amer. photographer (b. Scotland).
BROWN, Ford Madox. **1821**–1893. Eng. ptr.
BONHEUR (bo-nör'), Rosa. **1822**–1899 . Fr. ptr.
BRADY, Mathew. **1823**–1896. Amer. photographer.
PUVIS DE CHAVANNES (pü-vee' duh shah-vahn'), Pierre. **1824**–1898. Fr. mural ptr.
GARNIER (gar-nyay'), Charles. **1825**–1898. Fr. archt.
CARPEAUX (kar-po'), Jean-Baptiste. **1827**–1875. Fr. sculp./ptr.
ROSSETTI, Dante Gabriel. **1828**–1882. Eng. Pre-Raphaelite ptr./poet.
ROBINSON, Henry Peach. **1830**–1901. Eng. photographer.
PISSARRO (pee-sah'ro), Camille. **1830**–1903. Fr. Impressionist ptr.
MAREY (mah-reh), Étienne-Jules. **1830**–1904. Fr. physiologist/photographer.
MUYBRIDGE (my'brihj), Eadweard. **1830**–1904. Amer. photographer (b. England).
MANET (mah-nay'), Édouard. **1832**–1883. Fr. ptr./printmaker.
WHISTLER, James McNeill. **1834**–1903. Amer. ptr./printmaker act. England.
DEGAS (duh-gah'), Edgar. **1834**–1917. Fr. Impressionist ptr./sculp.
HOMER, Winslow. **1836**–1910. Amer. ptr./illustrator.
RICHARDSON, Henry Hobson. **1838**–1886. Amer. Romanesque Revival archt.
SISLEY (sis'lee; Fr. sees-lay), Alfred . **1839**–1899. Fr. Impressionist landscape ptr. (b. Paris, of Eng. parents).
CÉZANNE (say-zan'), Paul. **1839**–1906. Fr. Post-Impressionist ptr.
O'SULLIVAN, Timothy. **1840**–1882. Amer. photographer.
REDON (ruh-doN'), Odilon. **1840**–1916. Fr. Symbolist ptr./printmaker.
RODIN (ro-daN'), Auguste. **1840**–1917. Fr. sculp.
MONET (mo-nay'), Claude. **1840**–1926. Fr. Impressionist landscape ptr.
MORISOT (mo-ree-zo'), Berthe. **1841**–1895. Fr. Impressionist ptr.

RENOIR (ruh-nwahr'), Auguste. **1841–1919**. Fr. Impressionist ptr.
ROUSSEAU (roo-so'), Henri. **1844–1910**. Fr. ptr.
EAKINS (ay'kinz), Thomas. **1844–1916**. Amer. ptr./photographer/sculp.
CASSATT (kuh-sat'), Mary. **1845–1926**. Amer. Impressionist ptr./printmaker
act. France.
GAUGUIN (go-gaN'), Paul. **1848–1903**. Fr. Symbolist ptr./printmaker/sculp.
RIIS (rees), Jacob. **1849–1914**. Amer. reporter/photographer (b. Denmark).
GAUDÍ (gow-dee'), Antoní. **1852–1926**. Sp. archt. act. Barcelona.
VAN GOGH (van-go'; Dutch: vahn khokH), Vincent. **1853–1890**. Dutch Post-
Impressionist ptr. act. France.
KÄSEBIER, Gertrude. **1854–1934**. Amer. photographer.
SULLIVAN, Louis. **1856–1924**. Amer. archt.
SARGENT, John Singer. **1856–1925**. Amer. portrait ptr. act. Paris, London,
U.S.
EMERSON, Peter Henry. **1856–1936**. Eng. photographer.
ATGET (at-zhay), Eugène. **1857–1927**. Fr. photographer.
SEURAT (sö-rah'), Georges. **1859–1891**. Fr. Post-Impressionist ptr.
TANNER, Henry Ossawa. **1859–1937**. Amer. ptr. act. Paris.
ENSOR, James. Baron. **1860–1949**. Belgian ptr./printmaker act. Ostend.
MAILLOL (mah-yawl), Aristide. **1861–1944**. Fr. sculp./printmaker/ptr.
HORTA, Victor. Baron. **1861–1947**. Belgian Art Nouveau archt.
KLIMT, Gustav. **1862–1918**. Austrian ptr.
MUNCH (moonk), Edvard. **1863–1944**. Norwegian Expressionist ptr./print-
maker.
LAUTREC (lo-trek'), Henri de Toulouse- (too-looz). **1864–1901**. Fr. ptr./print-
maker.

ACTIVE 1900s

CLAUDEL (clo-del'), Camille. **1864–1943**. Fr. sculp.
STIEGLITZ (steeg'lits), Alfred. **1864–1946**. Amer. photographer act. New
York.
MINNE (min), George. **1866–1941**. Belgian sculp.
KANDINSKY, Wassily. **1866–1944**. Russ. abstract ptr. act. Germany, France.
KOLLWITZ (kol'vits), Käthe . **1867–1945**. Ger. Expressionist printmaker/sculp.
act. Berlin.
NOLDE (nol'duh), Emil. **1867–1956**. Ger. Expressionist (*Brücke*) ptr./print-
maker.
WRIGHT, Frank Lloyd. **1867–1959**. Amer. archt.
MACKINTOSH, Charles Rennie. **1868–1928**. Scottish Art Nouveau archt.
MATISSE (ma-teess'), Henri. **1869–1954**. Fr. ptr./printmaker (Fauve).
BARLACH (bar'lakH), Ernst. **1870–1938**. Ger. Expressionist sculp./print-
maker/playwright.
ROUAULT (roo-oh'), Georges. **1871–1958**. Fr. Expressionist (Fauve) ptr./print-
maker.
MONDRIAN (mon'dree-ahn), Piet. **1872–1944**. Dutch abstract (De Stijl) ptr.
act. Paris, London, New York.

MODERSOHN-BECKER (mo'der-zohn-bek'ur), Paula. **1876**–1907. Ger. Expressionist ptr.
DUCHAMP-VILLON (du-shahN'vee-yoN'), Raymond. **1876**–1918. Fr. Cubist sculp.
GONZÁLEZ (gohn -thah'leth), Julio. **1876**–1942. Sp. Cubist/Surrealist sculp./ ptr. act. Paris.
BRANCUSI (bran-koo'zee), Constantin. **1876**–1957. Rumanian sculp. act. Paris.
STELLA, Joseph. **1877**–1946. Amer. Cubist/Futurist ptr. (b. nr. Naples, Italy).
MÜNTER, Gabriele. **1877**–1962. Ger. Expressionist (*Blaue Reiter*) ptr. act. Munich.
MALEVICH (mal-yay'vitch), Kazimir. **1878**–1935. Russ. abstract (Suprematist) ptr.
KLEE (clay), Paul. **1879**–1940 . Swiss ptr./printmaker act. Germany.
MARC, Franz. **1880**–1916. Ger. Expressionist (*Blaue Reiter*) ptr. act. Munich.
KIRCHNER (kirkH'nur), Ernst Ludwig. **1880**–1938. Ger. Expressionist (*Brücke*) ptr./printmaker/sculp. act. Dresden, Berlin, Switzerland.
DOVE, Arthur. **1880**–1946. Amer. abstract ptr.
HOFMANN, Hans. **1880**–1966. Amer. Abstract Expressionist ptr. (b. Germany) act. Munich, New York.
LEHMBRUCK, Wilhelm. **1881**–1919. Ger. Expressionist sculp.
LÉGER (lay-zhay), Fernand. **1881**–1955. Fr. Cubist ptr.
GONTCHAROVA (gun-chahr'uh-vuh), Natalya. **1881**–1962. Russ. abstract (Rayonist) ptr.
LARIONOV (lur-ih-yo'nuf), Mikhail. **1881**–1964. Russ. abstract (Rayonist) ptr.
PICASSO (pee-kah'so), Pablo Ruiz y. **1881**–1974. Sp. ptr. act. France.
BOCCIONI (bot-cho'nee), Umberto . **1882**–1916. It. Futurist ptr./sculp.
BELLOWS, George. **1882**–1925. Amer. Realist (Ashcan School) ptr./printmaker.
BRAQUE (brack), Georges. **1882**–1963. Fr. Cubist ptr.
HOPPER, Edward. **1882**–1967. Amer. Realist ptr./printmaker.
DEMUTH (day'mooth), Charles. **1883**–1935. Amer. Precisionist ptr.
OROZCO (o-ro'sko), José Clemente. **1883**–1949. Mexican Expressionist ptr.
GROPIUS (gro'pee-uhs), Walter. **1883**–1969. Ger./Amer. archt. (International Style).
BECKMANN, Max. **1884**–1950. Ger. Expressionist (*Neue Sachlichkeit*) ptr./ printmaker act. Berlin, Frankfurt, Amsterdam, New York.
DELAUNAY (duh-lo-nay), Robert. **1885**–1941. Fr. abstract (Orphist) ptr.
TATLIN, Vladimir. **1885**–1953. Russ. abstract (Constructivist) sculp.
WESTON, Edward. **1886**–1958. Amer. photographer act. California.
PEVSNER, Antoine. **1886**–1962. Russ. abstract (Constructivist) sculp.
MIES VAN DER ROHE (mees'vahn-der-ro'uh), Ludwig. **1886**–1969. Ger./ Amer. archt. (International Style).
KOKOSCHKA (ko-kosh'ka), Oskar. **1886**–1980 . Austrian/Brit. Expressionist ptr./printmaker/playwright act. Vienna, London.
SCHWITTERS (shvit'urs), Kurt. **1887**–1948. Ger. abstract ptr./sculpt. (constructions, environments) act. Hanover, Norway, England.

ARCHIPENKO (ahr-kih-pen'ko), Alexander. 1887–1964. Russ./Amer. Cubist sculp. act. Paris, Berlin, New York, Chicago.

ARP, Hans (Jean). 1887–1966. Fr. (b. Strasbourg) abstract (Dada/Surrealist) ptr./sculp./poet.

LE CORBUSIER (luh kor-bü-syay'), pseudonymn of Charles-Édouard Jeanneret. 1887–1965. Fr. (b. Switzerland) archt. (International Style)/ptr. (Purism).

DUCHAMP (dü-shahH'), Marcel. 1887–1968. Fr. Cubist/Dada/Surrealist ptr./ sculp. act. Paris, New York.

CHAGALL (sha-gal'), Marc. 1887–1985. Russ. ptr./printmaker act. Paris, New York.

O'KEEFFE, Georgia. 1887–1986. Amer. abstract ptr.

RIETVELD (reet'velt), Gerrit. 1888–1964. Dutch archt. (De Stijl).

CHIRICO (kee'ree-ko), Giorgio de. 1888–1978. It. (b. Greece) Metaphysical ptr.

POPOVA (pa-po'vah), Liubov. 1889–1924. Russ. abstract ptr.

RAY, Man. 1890–1976. Amer. Dada/Surrealist ptr./sculp./photographer act. New York, Paris.

GABO (gah'bo), Naum. 1890–1977. Russ./Amer. abstract (Constructivist) sculp. act. Munich. Moscow, Berlin, London, New York.

HEARTFIELD, John. 1891–1968. Ger . ptr./graphic designer.

LIPCHITZ (lip'shits), Jacques. 1891 –1973. Fr. (b. Lithuania) Cubist sculp. act. Paris, New York.

ERNST, Max. 1891–1976. Ger. Dada/Surrealist ptr./sculp. act. Cologne, Paris, U.S.

GROSZ (gross), George. 1893–1959. Ger./Amer. Expressionist (*Neue Sachlichkeit*) ptr./printmaker act. Berlin, New York.

MIRÓ (mee-ro'), Joan. 1893–1983. Sp. Surrealist ptr./printmaker/sculp.

SOUTINE (sue-teen'), Chaim. 1894–1943. Fr. (b. Lithuania) Expressionist ptr.

DAVIS, Stuart. 1894–1964. Amer. Cubist ptr.

NICHOLSON, Ben. 1894–1982. Brit. abstract ptr.

KERTÉSZ (kur-tez'), André . 1894–1985. Hungarian/Amer. photographer. act. Budapest, Paris, New York.

MOHOLY-NAGY (mo-ho'lee-nahj'), László. 1895–1946. Hungarian abstract ptr./sculp./photographer act. Germany, London, Chicago.

LANGE (lang), Dorothea. 1895–1965. Amer. documentary photographer.

MAGRITTE (mah-greet'), René. 1898–1967. Belgian Surrealist ptr./sculp.

AALTO, Alvar. 1898–1976. Finnish archt.

CALDER, Alexander. 1898–1976. Amer. abstract sculp./ptr.

MOORE, Henry. b. 1898–1986. Eng. sculp.

ABBOTT, Berenice. b. 1898. Amer. photographer.

BRASSAÏ, pseudonymn of Gyula Halasz. 1899–1984. Fr. (b. Transylvania) documentary photographer.

BAYER, Herbert. 1900–1985. Amer. (b. Austria) ptr./graphic designer.

NEVELSON, Louise. b. 1900–1988. Amer. (b. Kiev, Russia) abstract sculp.

GIACOMETTI (jah-ko-met'tee), Alberto. 1901–1966. Swiss Surrealist sculp./ ptr.

DUBUFFET (dü-bü-fay'), Jean. 1901–1985. Fr. Expressionist ptr./sculp.

ADAMS, Ansel. 1902–1984. Amer. photographer act. California.

ROTHKO, Mark. 1903–1970. Amer. (b. Russia) abstract (Color Field) ptr.
HEPWORTH, Barbara. 1903–1975. Eng. abstract sculp.
SISKIND, Aaron. b. 1903. Amer. abstract photographer.
GORKY, Arshile. 1904–1948. Amer. (b. Armenia) Abstract Expressionist ptr.
BOURKE-WHITE, Margaret. 1904–1971. Amer. photojournalist.
BRANDT, Bill. 1904–1983. Brit. photographer.
DALI (dah'lee), Salvador. b. 1904–1989. Sp. Surrealist ptr./printmaker.
DE KOONING, Willem de. b. 1904. Amer. (b. Rotterdam) Abstract Expressionist ptr./sculp.
NEWMAN, Barnett. 1905–1970. Amer. abstract (Color Field/Minimalism) ptr./sculp.
SMITH, David. 1906–1965. Amer. abstract sculp.
WHITE, Minor. 1908–1976. Amer. abstract photographer.
KRASNER, Lee. 1908–1984. Amer. Abstract Expressionist ptr.
CARTIER-BRESSON (kar-tyay-bruh-soN'), Henri. b. 1908. Fr. photojournalist.
VASARELY, Victor. b. 1908. Fr. (b. Hungary) abstract (Op) ptr./printmaker/ sculp.
BACON, Francis. b. 1909. Eng. (b. Dublin) Expressionist ptr.
KLINE, Franz. 1910–1962. Amer. Abstract Expressionist ptr.
POLLOCK, Jackson. 1912–1956. Amer. Abstract Expressionist ptr.
LOUIS (loo'us), Morris. 1912–1962. Amer. abstract (Color Field) ptr.
DOISNEAU (dwah-no), Robert. b. 1912. Fr. documentary photographer.
CAPA, Robert. 1913–1954. Amer. (b. Budapest) photojournalist.
WYETH, Andrew. b. 1917. Amer. Realist ptr.
SMITH, W. Eugene. 1918–1978. Amer. photojournalist.
BLADEN, Ronald. b. 1918–1988. Canadian abstract (Minimalist) sculp.
BEUYS (boys), Joseph. 1921–1986. Ger. sculp./conceptual and performance artist.
APPEL (ahp'ul), Karel. b. 1921. Dutch Abstract Expressionist (CoBrA) ptr.
HAMILTON, Richard. b. 1922. Brit. Pop ptr.
ARBUS, Diane. 1923–1971. Amer. documentary photographer.
JENKINS, Paul. b. 1923. Amer. abstract (Color Field) ptr.
KELLY, Ellsworth. b. 1923. Amer. abstract (hard-edge Color Field) ptr./printmaker/sculp.
LICHTENSTEIN, Roy. b. 1923. Amer. Pop ptr./printmaker/sculp.
RIVERS, Larry. b. 1923. Amer. Pop ptr./printmaker.
FRANK, Robert. b. 1924. Swiss/Amer. documentary photographer/filmmaker.
NOLAND, Kenneth. b. 1924. Amer. abstract (hard-edge) ptr.
SEGAL, George, b. 1924. Amer. Pop sculp.
HANSON, Duane. b. 1925. Amer. Hyper Realist sculp.
RAUSCHENBERG, Robert. b. 1925. Amer. Pop ptr./printmaker/sculp.
STIRLING, James. b. 1926. Brit. Post-Modern archt.
KAPROW, Alan. b. 1927. Amer. Happening artist.
KIENHOLZ, Edward. b. 1927. Amer. sculp. (Pop environments).
KLEIN, Yves. 1928–1962. Fr. conceptual artist.
WARHOL, Andy. 1928–1987. Amer. Pop ptr./printmaker/sculp./film-maker.
FRANKENTHALER, Helen. b. 1928. Amer. abstract (Color Field) ptr.

INDIANA, Robert. b. **1928**. Amer. Pop ptr./printmaker/sculp.
JUDD, Donald. b. **1928**. Amer. abstract (Minimalist) sculp.
OLDENBURG, Claes. b. **1929**. Amer. (b. Stockholm) Pop sculp./ptr./printmaker.
ANUSZKIEWICZ (ahn-uhs-skyay'vitch), Richard. b. **1930**. Amer. abstract (Op) ptr./printmaker.
JOHNS, Jasper. b. **1930**. Amer. Pop ptr./printmaker/sculp.
FLACK, Audrey. b. **1931**. Amer. Photo-Realist ptr.
PAIK, Nam June. b. **1932**. Korean sculp./video and performance artist.
ROGERS, Richard. b. **1933**. Brit. archt.
GRAVES, Michael. b. **1934**. Amer. Post-Modern archt.
MEIER, Richard. b. **1934**. Amer. Post-Modern archt.
UELSMANN, Jerry. b. **1934**. Amer. photographer.
CHRISTO, Javacheff. b. **1935**. Bulgarian environmental sculp.
HESSE (Hes'uh), Eva. **1936**–**1970**. Amer. (b. Hamburg) abstract (Process) sculp.
ESTES, Richard. b. **1936**. Amer. Photo-Realist ptr.
STELLA, Frank. b. **1936**. Amer. abstract ptr.
HOCKNEY, David. b. **1937**. Eng. ptr./printmaker/stage designer/photographer.
PIANO, Renzo. b. **1937**. It. archt.
SMITHSON, Robert. **1938**–**1973**. Amer. environmental sculp.
SAFDIE (sahf'dee), Moshe. b. **1938**. Israeli archt.
GRAVES, Nancy. b. **1940**. Amer. ptr./sculp.
MURRAY, Elizabeth. b. **1940**. Amer. abstract ptr.
DE ANDREA, John. b. **1941**. Amer. Hyper Realist sculp.
WILLIAMS, William T. b. **1942**. Amer. abstract ptr.
EDDY, Don. b. **1944**. Amer. Photo-Realist ptr.
KIEFER, Anselm. b. **1945**. Ger. Neo-Expressionist ptr./printmaker.
KOSUTH, Joseph. b. **1945**. Amer. conceptual artist.
ROTHENBERG, Susan. b. **1945**. Amer. Neo-Expressionist ptr/printmaker.
PFAFF, Judy. b. **1946**. Amer. abstract ptr./sculp.
CLEMENTE (klay-men'tay), Francesco. b. **1952**. It. Neo-Expressionist ptr.
LONGO, Robert. b. **1953**. Amer. Neo-Expressionist ptr./printmaker.

Maps

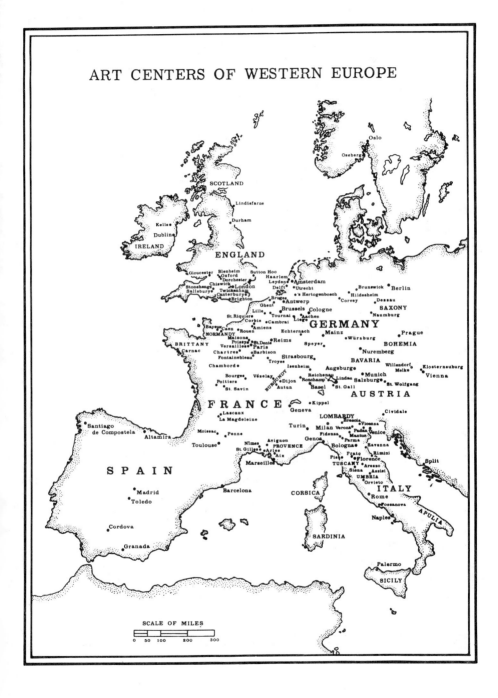

ART CENTERS OF WESTERN EUROPE

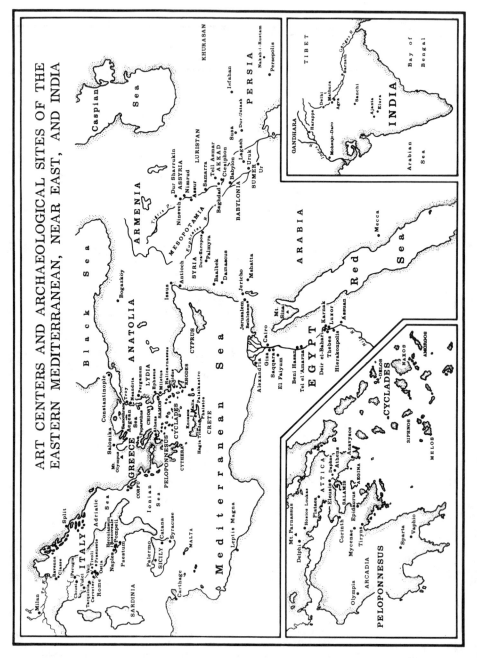

ART CENTERS AND ARCHAEOLOGICAL SITES OF THE
EASTERN MEDITERRANEAN, NEAR EAST, AND INDIA

Index

All numbers in the index refer to page numbers and illustrations in this book only. Figure numbers are preceded by "fig." When a series of numbers is given, numbers in **boldface** indicate the location of the principal definition, discussion or illustration. Subjects, represented in works of art, and foreign terms are *printed in italics*. Topical entries, listing titles of all relevant entries are in CAPITALS.

181

Table of Parallel Illustrations in Gardner, Janson, and Hartt

Illustrations in H.W. and A.F. Janson, *History of Art* (fourth edition), are in **boldface.** Identical or similar illustrations in Horst de la Croix and Richard G. Tansey, *Gardner's Art through the Ages* (ninth edition), are listed to the left of the number of the equivalent Janson illustration. Figure numbers in Frederick Hartt, *Art* (third edition), are listed to the right of the Janson number. Illustrations in Gardner and Hartt which are similar, but not identical, are followed by 's'. When no parallel illustrations appear in Gardner or Hartt, the Janson illustration number is omitted.

4-2	**1**	155	1-13	**37**	37	14-37	**67**	
10s	**3**	791	1-11	**38**	17	3-1	**71**	70
21-65	**4**	1118	14-72s	**39**		3-2	**72**	71
	10	797a	2-2	**40**	28	3-2	**73**	72
	11	851	2-1s	**41**	27	3-3	**74**	81
	15	979s	2-3	**42**	29s	3-5	**75**	73
	21	913		**45**	30	3-6	**77**	74
23-7	**23**		2-8	**47**	33	3-7	**78**	75
23-8	**24**		1-15	**51**	37	3-10	**80**	82
	26	1252	1-16	**52**	38s	3-11	**82**	83
	30	20	14-29	**54**	51	3-13	**83**	86
1-1	**32**	21	14-68s	**55**		3-15	**84**	9
1-2	**33**	19		**57**	50		**85**	87s
1-4s	**34**	24s		**58**	44s		**86**	88
	35	26		**59**	44s		**87**	91
	36	18s		**60**	39s		**88**	89

3-18	89	92	4-28s	150	174	5-57	212	243
	90	95	4-28s	151	175	5-56	213	248
3-24s	91	99s	4-23	152	169		214	253
3-23	92			154	176		216	258
3-25	93	102	5-5s	155			217	260s
	94	103	5-3	156	179s	5-65	218	259
3-33	95		5-4	158	181	5-63	220	262
	97	108	5-7	161	206	5-62	221	263
	100	116s		165	183	5-66	223	264
3-39	101	117	5-15s	166	184s	5-76	224	283
3-41	104	118	5-16	167	185		225	279
3-43	105			168	186	5-77	226	284
2-10	106	123	5-14	170	188		227	285
2-12	107	124	5-17	171	189	5-78	228	
2-13	109	125	5-18	172		5-75	229	282
2-15	110	127	5-30	173	196	5-79	230	287
2-16	111	128	5-28	176	198	6-6s	238	296s
	112	130	5-29	177	197	6-7	239	297
2-19	113	129	5-31	178		6-7	240	297
2-22	114	132	5-32	179	203		242	305
2-24	115	133	5-33	180			243	
2-25s	116	135	5-21s	181	192s	6-4s	243	
	117	134		182	191	6-3	245	306
2-26	118	137	5-26s	183	220	6-1s	246	294
2-27	119	138	5-24s	184	194	6-8	247	298
2-28	120	139	5-27s	185	221	6-10	248	299
2-30s	121	141	5-27	186	200s	6-12	250	
2-33s	123	144	5-44	188	229	6-16	253	311
2-34	124	145	5-42	190		6-17	255	312
2-36	125	147	5-51	191	241	6-18	257	313
	126	153		192	240s	6-19	258	314
	128	489s	5-54s	193		6-20	259	
2-39	129	148	5-69	195	254	6-45	260	333
2-38	130	149	5-54s	196	244	6-42	261	337
2-40	131		5-53	197	246	6-47	262	
	132	150	5-70	198	255	6-48	263	339
	133	152s	5-71	199	256		264	340
	135	463	5-72	200	257	6-58	265	7
4-1s	137	154	5-19	201	211	6-57	266	359
4-8	138	159	5-58	202	215s	6-57	267	
4-9	139	161	5-37	203	210	6-56	268	358
4-21	140	164	5-40	204	223	6-91	270	388
4-4	141	156	5-41	205		6-92	271	390
4-11	143	160		206	213		272	389
4-16	144	157	5-38	207	214	6-25	275	318
4-18	146	166	5-46	209	233		278	381
4-25s	147	171	5-47	210	232	6-82	280	386
4-24	148	170	5-49	211	236s		281	307
						6-14	282	

	283	308	7-42	340	428		416	538
6-62	284	326	7-42	341	428	9-13	417	559
6-63	285	328	7-40	342	429	9-16	418	555
6-65	286	329	7-41	344	427	9-17	419	556
5-50	287	237		345	453	9-14	422	558
6-64s	288	330	7-43	346	441	9-10	423	552
	289	349	7-44	347		9-12	424	554
6-67	290	343	7-46s	348	442	9-6s	426	
6-68	291	342	7-47s	350	447s	9-18	428	542
6-70s	292	353	7-49	351	448	9-19	430	543
6-74	293	344		352	458		431	540
6-75	294	345	7-58	353	439	9-29	433	535
6-77	296	363	7-53	355	444	9-32	436	532
6-79	297	374	7-57	356	455	9-33	437	531
6-93	299	384	7-60	359	460	9-34	438	
6-95	300	383	7-62	360			440	548
6-96	301	356	7-61s	361			441	539
6-37	302	266	7-71s	363	466	9-36s	445	570s
6-32s	304	346s	7-64	364	467s	10-1	451	571
6-27	305	321	7-63	365	468	10-2	452	572
6-29s	306	322	7-65	366		10-11	453	582
6-30	307	325	7-66	367	472	10-12	454	583
6-34	308		7-75	369	479	10-10	455	
6-36	309	290	7-76	370		10-9	457	581
	310	323		371	474	10-13	458	573
6-40s	312	371s	7-77	372	476	10-16	459	
	313	376s	7-79	373	478	10-18	462	585
7-3	315	397	7-80	375	477	10-17	463	584
7-6	316	402	8-3	385	492	10-26	465	598
7-4	317	401	8-5	386	493	10-25s	466	
7-5	318		8-8	387	494s		468	593
7-29	319		8-20	391	497	10-19s	469	
7-30s	321	426s		393	499	10-40	473	605
7-7s	322	405s	8-23	394			474	608s
7-8	323	404	8-22	395	500	10-42	475	624s
7-8	324		8-12	397	502	10-43	476	622
7-13	325	409s		398	503	10-44	477	623
7-12	326		8-14s	400		10-46	478	625
7-14	327			401	507	10-47	479	626
	329	415		402	516	10-52s	481	
	330	415		403	509		482	628
7-19	331		8-25	404	510		484	629
7-20	332		8-25	405		10-58	486	630
7-32	334	418	8-26	406	512	10-59	487	631
7-33	335	419	8-27	407	514	10-60	488	632
7-35s	337	421s	9-3	410	524s	10-62s	490	635
7-36	338	424	9-4	411	525		491	637
7-37	339	425	9-5	413	526	10-14	493	575

10-15	494	576s	16-5s	577	679		643	788
16-7s	495	587	16-6s	578	680	17-4	644	790
10-53	496	616		579	681	17-5	645	
10-34	497	594	16-8s	580	682	17-6	647	800
10-39	499	609	16-9	581	683		648	801
	500	602	16-10	582		17-7	649	802
10-54	504	618	16-11	583	690	17-8	650	803
	506	737		584	692	17-19	652	793
18-1	507	738	16-12	586	684	17-20	653	794
15-1s	508	640s	16-14	587	686	17-21	654	795
15-2	509		16-13	588	685	17-22	655	796
15-3s	510			589	664	17-23s	656	
	511	644s		590	665	17-25	657	799
16-2	516	687	16-20	591	666		658	798
13	519		16-22	592	668	17-35	659	818
15-10	522	645	16-21	593	667	17-27	660	814
	523	651	16-19	595		17-28	661	817
15-8	524		16-23	596		17-29s	663	823
	525	653	16-24s	597	669	17-30	664	
15-13	528	649	16-28	598	701	17-31s	665	
15-11	529	647	16-27	602	697	17-33	666	822
15-19	531	654		603	699	17-32	667	821
15-20	533	655		604	700		669	824
15-21	534	656		606		17-16	672	808
15-22	535	658	16-36	607	708	17-17	673	812
	536	659s	16-32	610	707		674	811
	537	660	16-29	611	710		675	843
18-2s	541	740s	16-30	612	711		676	845
	542	743		613	672	17-61	677	847
16-26	545	695	16-38	614	673	17-63	678	848
	546	696	16-41	616	674		679	850
18-5	547	747	16-42	617	675	17-64	680	852
18-7	549	750	16-43	618	677		681	828
	550	753	16-45	619			683	834
18-6	551	751	16-46	620	678	17-41	684	833
18-9	552	758		623	716	17-66	689	855
18-10	553	756	16-48	624	718	18-59	691	896
18-11	554	757	16-49s	625	722	18-60	692	
18-12	555	759	16-54	626	721	17-37	693	831s
18-16	557	762	16-55	629	724	17-38	694	832
	558	768	16-53	630	730	17-67	696	856
18-20	559		16-63	634	735		699	879
	560	771	17-57	635	726	17-46	700	837
18-26	561	775	16-60	638	728		701	838s
18-23	562	778	16-62	639	729		702	839
18-24	564	780	16-61	640	785	17-52	703	
18-30	571	777		641	786	17-51	704	859
16-4	573	691	17-1	642	787	17-53s	705	860

19-2	707			781	987		866	1081
	708	840		784	991	21-17s	868	
19-1s	709	841	19-51s	786	996s	21-29	870	1106
18-33	710	870	19-50	787	995		874	1103
	711	872		788	975s		875	1110
18-34	712	872		790	983	20-47s	876	
18-35	714	863	19-55s	791	982s	21-30	880	1089
18-36	716	864		793	980s	21-23	881	1092
	717	865	19-38	799	970	21-2	886	1068
18-40	718	869	19-58	801			887	1069
18-32	720			803	937	21-6	889	1085
18-31	721	873	19-61	804		21-7	890	
	723	877		806	939s		891	1086
18-48	724	878	19-64	808	946	20-33	892	1040
18-46	727	893		809	950		893	1041s
18-50	731		19-67	810	947	21-5	894	1093
18-51	733	881	19-68	811	949		895	1054
18-52	734	885	19-65	812	948		896	1053
18-52	735	886	19-70	813	954	21-4	898	1094
	739	906		814	955		899	1097
19-30	740	908	19-72	817	959		900	1096
19-24	741	900	20-6	818	1017	21-8	901	1095
19-25	743	903	20-3	820	1011		910	1107
19-26	744	905	20-9	821	1026		911	1108
	745	927		822	1023	21-67	914	1123
19-31	746	902		824	1021s	21-72	915	1127
19-3	747	910s	19-74	826	1000		916	1131
19-8s	748	911	19-75	827	1003	21-76s	917	1130s
19-10	749	912		828	1002		918	1129s
	750	915		829	1004		919	1140
19-11	751	916	20-1s	830	1035	21-77	920	1140
19-9	752	918	20-41	839	1060		921	1124s
	753	928	20-32	840	1050		922	1116
19-14	754	920	20-46s	843			927	1139
19-15	755	921	20-25s	845	1066s	2	932	
19-18	758	924		846	1067		933	1134
	759	925	20-2	847	1038	21-56	934	1137
19-19	760	932	20-36	850	1012	21-94	937	1111
19-20	762	933		851	1055	21-95s	938	1112
	765	1027	20-37s	852		21-82s	942	1144s
	767	1028	20-42	853	1051	21-81s	943	1143s
	768	1029s		855	1057		944	1148
	769	1009	21-25	856	1070		948	1155
19-39	773	960	21-26	857	1072		949	1152
19-42s	774			860	1077	21-87	956	1150
	775	964	21-12	861	1078		957	1159s
19-44	777	966	21-13s	862		21-92s	958	1160
	780	986	21-14	863			962	1172

22-44s	963	1181		1022	1229s	22-52s	1075	
22-21	965	1183	22-36	1023	1232	23-6s	1078	1265
21-97	967	1286	22-37	1024	1230s	23-24s	1079	1266
21-98s	969	1287	22-42	1025		23-76	1083	1268
21-99	970	1288	22-43s	1026			1084	1269s
22-3	972	1290		1028	1179s	23-11s	1087	1264s
	973	1291	22-24	1029			1089	1256s
	988	1163		1031	1242s		1090	1271
	989	1166		1032	1239s	23-57s	1092	1281s
22-17	991	1170		1034	1244s	23-74s	1094	
	994	1178	23-1s	1035	1246s	22-53	1097	1296
22-47	996	1175s	23-3s	1037		22-54	1098	1295
	997	1237s	23-28s	1040			1099	1299
22-6	998	1186	23-14s	1041			1100	1298
22-7s	999	1189s	23-15s	1042	1278s	22-59	1102	1300
22-9	1000		23-23	1045	1261s	22-57	1105	1301
	1001	1190s		1046	1262s		1106	1302
	1003	1206		1049	1258s	22-62s	1109	1307
	1006	1209	23-36	1050		23-17	1110	1308
22-31s	1007	1219s	23-40s	1056	1255s		1111	1311
	1009	1196		1061	1283s	23-9	1112	1312
22-11	1012	1191s		1063	1280s	23-10s	1113	1313
	1013	1192s	22-46s	1066	1275s		1115	1320
22-83	1015	1193	22-45	1068	1198	23-61s	1116	1318
	1016	1194s	22-14	1069	1205	22-64	1125	1236
22-50s	1018	1216		1070	1199	22-75	1136	
	1019	1217s	22-76	1071	1211	22-58s	1150	
22-27s	1021							